ART HISTORY:
THE KEY CONCEPTS

Art History: The Key Concepts offers a systematic, reliable, accessible, and challenging reference guide to the disciplines of art history and visual culture. Containing entries on over 200 terms integral to the historical and theoretical study of art, design, and culture in general, *Art History: The Key Concepts* is an indispensable source of knowledge for all students, scholars, and teachers. Each entry contains a succinct definition, an exploration of its history, use, and significance, and suggestions for further reading. Entries include:

- Abstract expressionism
- Epoch
- Hybridity
- Semiology
- Zeitgeist

Through extended cross-referencing, *Art History: The Key Concepts* builds a radical intellectual synthesis for understanding and teaching art, art history, and visual culture.

Jonathan Harris is Professor of Art History at the University of Liverpool. He is the author of *Writing Back to Modern Art: After Greenberg, Fried, and Clark* (Routledge, 2005) and *The New Art History: A Critical Introduction* (Routledge, 2001). Jonathan Harris also wrote introductions to the four volumes of Arnold Hauser's 1951 classic *The Social History of Art*, republished by Routledge in 1999.

ALSO AVAILABLE FROM ROUTLEDGE

ART HISTORY

The Key Concepts

Jonathan Harris

Routledge
Taylor & Francis Group

LONDON AND NEW YORK

First published 2006
by Routledge
2 Park Square, Milton Park, Abingdon, Oxon OX14 4RN

Simultaneously published in the USA and Canada
by Routledge
711 Third Ave, New York, NY 10017

Routledge is an imprint of the Taylor & Francis Group, an informa business

Reprinted 2007, 2008

© 2006 Jonathan Harris

Typeset in Bembo by Taylor & Francis Books

British Library Cataloguing in Publication Data
A catalogue record for this book is available from the British Library

Library of Congress Cataloging in Publication Data
A catalog record for this book has been requested

ISBN10: 0–415–31976–5 (hbk)
ISBN10: 0–415–31977–3 (pbk)
ISBN10: 0–203–62719–9 (ebk)

ISBN13: 978–0–415–31976–8 (hbk)
ISBN13: 978–0–415–31977–5 (pbk)
ISBN13: 978–0–203–62719–8 (ebk)

As ever: for Jules and Jim, my extraordinary sons

CONTENTS

LIST OF KEY CONCEPTS

abstract expressionism
abstraction
academy
advertising
aesthetic
agency
allegory
alternative
analysis
appropriation
architecture/architect
art
art-for-art's-sake
art history
art world
artefact
artisan
artist
artwork
author
autonomy
avant-garde

baroque
bauhaus
beauty/ugliness
body
byzantine

canon
capitalism

career
cinema
civilisation
classical/class
commission
communication
complexity
composition
concept
conceptual art
connoisseurship
consumption
contemporary
content
convention
craft
creativity/creator
critic
critical theory
criticism
cubism
cultural imperialism
cultural policy
cultural studies
culture
curation

dada
deconstruction
design

desire
development
discourse
dominant

effects studies/effects
emergent
epoch
ethnicity
exhibition
explanation
expressionism

fashion
feminism
figurative
film
form
formalism
formation
functionalism/function
futurism

gaze
gender
genius
genre
globalisation/global
gothic

hegemony
hermeneutics
high art
history
history painting
humanism/human
hybridity

iconography/iconic
ideal
identification
identity
ideology
illusionism

image
impressionism
influence
installation/installation art
institution
intention
interpretation
intertextuality
ism

kunstwollen

landscape
language/linguistics
look

mannerism
marxism
mass culture/mass
masterpiece/old master
materials/matter
meaning
means of production
media
mediation
medieval art/medieval/middle ages
metropolitan
minimalism
modernism/modern
movement
mural painting
museum
myth

narrative
nation
naturalism
neoclassicism
new art history
new media
nude

oppositional
organisation

originality
orientalism

painting/painter
patriarchy
patron
performance/performance art
period
perspective
photography
picture
pop/pop art/popular
popular culture
portraiture
postcolonial
postcolonial studies
postmodernism
poststructuralism
practice/practical
primitivism
producer/product
production
progress
psychoanalysis/psychology
public art/public

quality

race
reader
realism/real
renaissance
representation
reproduction
residual
revolutionary
rococo
romanticism

school
sculpture/sculptor

semiology
sex
sign/significance/significant/signifying system
social/society/sociology/socio-social history of art
social order
social realism/socialist realism
social relations of production and consumption
specialist
sponsorship
state
still-life
structuralism/structure
style
subculture
subject matter
subjective/subject
surface
surrealism
symbolism

taste
technology/technique/technical
television/tv
text
theory
title
tradition

value/evaluative
view/viewer
visual/visible/vision
visual culture
visual pleasure

western

zeitgeist

ACKNOWLEDGEMENTS

Writing this book has involved much reflection on the last 25 years of my academic and personal life. My debts are many and deep. I am glad to say that my friendships and intellectual relations have merged in nearly all significant cases. Raymond Williams remains my mentor, example, and was the inspiration for this project, yet he died not long after I had finished my PhD in 1986. I am very glad to say that Tim Clark – worthy supportive adversary of Williams! – has been a personal and intellectual beacon of light for me from our first meeting at Harvard the following year. Fred Orton, Alan Wallach, Colin Trodd, Marcia Pointon, Al Boime, David Craven, Eric Fernie, and Anne MacPhee have been very valuable friends, defenders, and critical interlocutors for many years on both sides of the Atlantic. I should like particularly to thank two professors of science (the dark arts, as far as I'm concerned) in the School of Architecture at the University of Liverpool – David Oldham and Barry Gibbs – whose amiability and good humour have been a valuable support to me over the last seven years. My 'extended' family – Lucy, Tom, Kate, Pie, Tim, Phil and their families – have been crucial to my stability and happiness for many years now. I must thank Tom Hills in particular for his careful reading and assiduous commentary on my book in an earlier form. Jane Linden has stuck to me through thick and thin times, tenaciously caring and interested in me and my obsessions. Oh that I could repay you! Thank you. And to my beloved sons, Jim and Jules: I hope you might open this book if you ever become interested in art history. You'll glimpse me here and there amongst the pages.

INTRODUCTION

This book is designed specifically for use by students and scholars of art history and visual culture. It is intended as a reference source for those involved in teaching and learning (on either side of the fence, as teacher or pupil) and as an aid for those carrying out research activities. These two areas overlap considerably: 'research' isn't just the province of PhD students or professional academics or museum curators. Any student – of any age – trying to answer an essay question, or preparing a presentation for a seminar, or following up notes made after attending a lecture or reading a book, is engaged in a research task too. *Art History: The Key Concepts*, if it is to succeed as I intend and hope, will help people in all of these situations. Each entry provides: (1) the basic definition of a term; (2) an exploration of some of the complexities of its development, function, and significance; (3) some illustrative historical or contemporary examples of artworks or items of visual culture related to this concept; and (4) some bibliographic references that will enable the reader to follow up the term and the ways in which it has been used in actual research and scholarship. After consulting an entry the reader should feel confident that they could use the term appropriately themselves and have some insight into its range of meanings and contexts of application.

Each entry begins with the term (and occasionally a related term or terms) identified in bold, followed by other important forms of the word identified in italics. For example:

explanation *explain, explanatory*

As the example indicates, this reference book is not limited to words thought of as specifically, or uniquely, 'art historical'. I have included many terms here which inevitably and necessarily form part of *any* serious pedagogic or research task. I indicate both their general and specific art historical significance. In addition, I have tried to show that art history is a changing and contested discipline, subject to

long-standing debates over arguments and methods, values and basic principles for many decades now.[1] These debates inform all of the components of the contemporary language of art history. Beyond that situation internal to the discipline, however, a new, related field of inquiry – visual culture – has developed over the past decade or two. Though certainly still reliant on art history for much of its terminology, visual culture also takes its leave of it in many ways: for instance, by fashioning its 'own' concepts. So, in a way, this book through its range of entries charts the intersection or convergence of one *traditional* disciplinary inquiry (art history) with another *emergent* one (visual culture). In the text for the entries you will see some words identified in bold – sometimes several consecutively. This means that the word, or term involving more than one word, in bold (e.g. **cultural imperialism**) has its own entry. Occasionally the sign ^ accompanies a word in bold which is followed by another in bold (e.g. **critical^ analysis**): this tells you that there are separate entries for both words, though sometimes there is also an entry for the term formed by the words in combination (e.g. **art^ history** – entries are provided for art, history, and art history).

Use of the term 'language', however, can be confusing and misleading. People *do not* speak 'art history' or 'visual culture' the way they speak English or French: you cannot make sense of the world (either in giving lectures or presentations or writing books or essays) simply through the use of what are regarded as disciplinary terms. Much intellectual work and its communication lies in the procedures – and the words we have for them – that appear to be non-disciplinary specific and even non-conceptual. These procedures and terms are indispensable to the general activity of students and scholars of art history and visual culture: the attempt to *explain*, involving processes of *analysis* and *interpretation* (all key terms included here). At some level, then, all of us involved in art history and visual culture have to grapple with the most basic of things – questions, for instance, to do with *meaning* and *conceptual* thinking (both terms included here). Scholarship and research is actually built up from these core assumptions and the forms of thinking and acting they generate. I try to relate many of these 'building block' terms and values to the orthodox concepts constituting art history as a disciplinary (yet plural, disputed) field, while at the same time indicating

1 For an account of this, see my *The New Art History: A Critical Introduction* (Routledge: London and New York, 2001).

that visual culture – not yet a fixed discipline – offers some new and valuable insights.

Given this range of terms included and an inevitable limit on the word-length for the book, it is no surprise that not every term I would have liked to include is actually here. More will be included, I hope, in a subsequent edition – including many suggestions supplied by my four anonymous readers who made extremely helpful comments on the manuscript at an early stage in its development. My criteria for inclusion of terms have been partly intellectual and partly pragmatic: I wanted to get a reasonable mixture – given its primary intended use – of orthodox *art historical*, new *visual cultural*, and what I've called *building block* terms. As a reference source aiming at reasonable comprehensiveness, yet exploring the concerns and limits of art history thinking, it bears most useful comparison in method and ambition with the book that influenced me greatly as a student, Raymond Williams's *Keywords: A Vocabulary of Culture and Society*.[2] That is to say, my book is both a reference source and an extended argument. I have tried to assemble a coherent, accessible, and sophisticated conceptual system for the analysis of visual arts and visual cultural materials, while at the same time not minimising the intellectual tensions both inside art history *and* between art history and the nascent subject of visual culture. I would like to hear from any readers who think that I have missed anything vital to the terms I have included here, and welcome arguments and suggestions for further terms to be included in the future. Languages and disciplines are always spoken collectively, not by individuals – my hope is that this book will enable younger people to begin to speak and help those who have already mastered the basics (and far beyond, of course) to think through change and find the means to generate positive meanings for the future.

<div style="text-align: right">

Jonathan Harris
Congleton, Cheshire, March 2006

</div>

2 Published originally by Fontana Press, 1976; revised and expanded by Flamingo, 1983.

ART HISTORY

The Key Concepts

ABSTRACT EXPRESSIONISM *ABSTRACT EXPRESSION, AMERICAN ABSTRACT EXPRESSIONIST*

This composite term was one of several coined to **identify** the work of a number of fairly loosely-associated **artists** based in the US and active from the late 1940s. It is important to note, however, that this, the most successful – that is, used – name (coined by the critic Robert Coates in 1946) was *not* the invention of any of the artists themselves, nor did they endorse it as an accurate description of their activities and interests. Five of the key artists identified as American **abstract^ expressionists** – Jackson Pollock, Mark Rothko, Barnett Newman, Robert Motherwell, and Willem de Kooning – were resident in New York, a **metropolitan** centre that had become home to many European **modernist** artists in the 1930s who had gone there to escape the nazis and coming war in Europe. **Surrealist** artists in particular, such as Joan Miró and André Masson, are credited with **influencing** in a number of important ways the chief ideas, **technical** procedures, and **stylistic** concerns of some of the abstract expressionists, though a very much wider range of **artistic** and **socio^-cultural** sources may be detected in the **development** of these artists' work, including **psychoanalytic^ theories**, Greek and Roman **myths**, Jewish theology, anthropological **discourse**, Native American totemic **sculpture** and religion, as well as **art** by 'the European Greats' of the inter-war period – particularly Henri Matisse, Pablo Picasso, and the aforementioned abstract (that is, non-**figurative**) surrealist **painters**.

Most artists identified as abstract expressionists after 1945 had been committed to **forms** of **social^ realism** or **socialist realism** in the 1930s during the Depression and New Deal **period** in the US, having then embraced liberal-left or communist political beliefs associated with varying degrees of support for the USSR. With the revelations of Joseph Stalin's purges of his opposition there in the later 1930s, the rise of anti-communism in the US, and the ending of the New Deal's radical economic and social reform programme in the early 1940s, artists generally became disillusioned and individualistic, seeking to find modes of expression that they thought could transcend the horrors of world war, the failure of radical political beliefs, and the growing alienation they felt in 1950s American **consumer^-capitalist** society. As the two elements of the term suggest, paintings by these artists brought together abstract (and non-**narrative**) **pictorial^ conventions** with expressive, non-**illusionistic** devices for conveying feeling, though there was a wide variety of both, and the

3

extent of contrast can be seen by comparing, for instance, a Pollock 'drip-painting', such as *Number One 1948* (1948), with the 'colour-field' effect of Rothko's *Light Red over Black* (1957). Works by other abstract expressionists, such as Adolph Gottlieb and Clyfford Still clearly fall between the 'drip' and the 'field' categories, combining elements of both in various ways.

Since the 1970s art **critics** and **historians** have reappraised the **movement** in a number of ways: for instance, looking at the manipulation of abstract expressionism 'as a weapon of the cold war' during the 1950s and 1960s – the main interest of **social historians of art**. In a different direction, more recent scholarship has examined how the 'Americanness' of this art actually concerned much more than simply the US government's post-1945 cold war political-**ideological** agenda. Questions of **gender, feminism**, and the relationship between expressiveness, action, **aesthetics**, and **sexuality** have been raised, though the phase 'women abstract expressionist' still seems an unlikely combination (like 'women surrealist'), despite the fact that, for instance, Grace Hartigan, Lee Krasner, and Helen Frankenthaler have long been identified as – marginal – members of the overall grouping. Recent research has stressed the importance of African-American abstract expressionists, such as Norman Lewis, and investigated the reasons why, despite accusations of its Cold War imperialist character, some Latin American critics and artists positively embraced abstract expressionism as a model of artistic freedom.

Further Reading

Craven, David *Abstract Expressionism as Cultural Critique: Dissent during the McCarthy Period* (Cambridge University Press: 1999).

Frascina, Francis (ed.) *Pollock and After: The Critical Debate* (Routledge: 2000).

Guilbaut, Serge *How New York Stole the Idea of Modern Art: Abstract Expressionism, Freedom, and the Cold War* (University of Chicago Press: 1983).

Leja, Michael *Reframing Abstract Expressionism: Subjectivity and Painting in the 1940s* (Yale University Press: 1993).

ABSTRACTION *ABSTRACT, ABSTRACTED, ABSTRACTING, ABSTRACTIONIST*

In perhaps its two most familiar uses – that is, as a noun (*abstraction*) and an adjective (*abstract*) – this term denotes **artworks** that appear *not* to depict or include reference to objects (and **figures**) or events in the **real** world. Recognising this definition as negative is important

because it indicates how **theories** and **histories** of abstraction in **modern**^ **art**^ **developed** in the early twentieth century partly as **critiques** of traditional^ naturalistic or realist **representational**^ **pictorial**^ **conventions**. Wassily Kandinsky is often credited with the title of being the first abstract **painter**, with works such as *With the Black Arch* (1913).

However, in **western**^ **art history** concerned with pre-modern painting and **sculpture** (in this **epochal** sense modern is opposed to the general category of ancient art, that is, works **produced** before the birth of Christ), abstraction and naturalism are **concepts** used to **identify** a range of **stylistic** characteristics seen as at either ends of a continuum of representational **forms**, with the more abstract examples considered to be highly *stylised*. Such works include, for example, the marble *Kouros*, a sculpture of a man, dedicated to Poseidon at Sunium (about 590 BCE).

In relation to twentieth-century art, **architecture**, and **design**, however, theories and **practices** of abstraction are modernist in **origin**, and relate to the development of **avant-garde** painting and sculpture in particular. In whatever context of usage, though, the term *abstraction* has important art historical and philosophical dimensions, the latter particularly connected to accounts of the kind of knowledge or insights that art has been claimed to produce. In one of its simplest art historical uses the term functions descriptively: for example, 'Morris Louis was an abstract painter'. That is, Louis's painting, such as *Blue Veil* (1958–59), **expresses** – that is, **communicates** ideas and feelings – through the use of colour, pattern, and facture (the character of the painted **surface**) alone. Louis's paintings have been closely related to the work of earlier, **abstract expressionist**, **artists**. On the other hand, Piet Mondrian's paintings, such as *Composition with Red, Yellow, and Blue* (1921), have sometimes been described as examples of geometric, or 'cool' (suggesting highly controlled), abstraction. Many other twentieth-century modernist **movements** have been associated with abstraction, or the 'abstracting of **content**', including **futurism**, **cubism**, and some aspects of **surrealism**. In architecture, Le Corbusier, and in design those associated with De Stijl and the Bauhaus have also been seen as particularly interested in abstraction and its use in the **creation** of objects for practical rather than for **aesthetic** contemplation.

These factual examples, however, entail a wide range of theoretical **complexities** and problems that attend on the notion of abstraction. While a contrast with naturalistic conventions in nineteenth-century **academic** painting (e.g.: William Frith's *Derby Day* (1858)) emphasises that abstraction in modernist art avoids depicting the literal appearance

of the world, all so-called abstract paintings and sculptures necessarily communicate **meanings** through some kind of formal **compositional** means and in that process create **symbols** referring to the world (including the 'world' of **subjective** feelings and experiences).

Further Reading

Art & Language 'Abstract Expression' (1982), in Charles Harrison and Fred Orton (eds.) *Modernism, Criticism, Realism: Alternative Contexts for Art* (Harper and Row: 1994).

Cheetham, Mark A. *The Rhetoric of Purity: Essentialist Theory and the Advent of Abstract Painting* (Cambridge University Press: 1991).

Greenberg, Clement 'Abstract, Representational, and So Forth' (1974), in Robert C. Morgan (ed.) *Clement Greenberg: Late Writings* (University of Minnesota Press: 2003).

Osborne, Harold *Abstraction and Artifice in Twentieth-Century Art* (Oxford University Press: 1979).

ACADEMY *ACADEMIC, ACADEMICISE*

The inauguration of **artistic** education within officially recognised *academies* was one of the most significant **institutional^ developments** in the **social^ history** of **renaissance^ art**. Academic qualification and subsequent life-membership – for instance, being able to use the initials R.A. (Royal Academician) after one's name – led to the professionalisation of artists and the elevation of their status to a category far beyond that of **contemporary^ artisans** and **craft**-workers. Though **western** artists had been trained and accredited with technical and social standing in some earlier kinds of **organisation**, such as monasteries, workshops, and guilds, the opening of the first academies, or art **schools**, for **painters** and **sculptors** in the city-**states** of southern Europe (Vatican, 1531; Florence, 1563; Rome 1593; Bologna, 1598), and in France (1648), and England (1768), generated a wholly new understanding of the **meaning** and **value** of art and the role of artists in those societies. The academies also importantly contributed to, and were themselves part **product** of, a newly-forged **social order** in western and southern Europe based on mercantile **capitalism** and the rise to power of a wealthy new middle **class**. In addition, however, these first academies were usually also closely related to, and in some cases dependent upon, the support of monarchies – particularly in France and Britain – and to that extent they were the institutional creatures of **emerging^ nation^-states**,

reflecting in their organisation and activities the **complex** political forces attempting to lead these rapidly transforming societies.

Academies sought to select, train, educate, **commission**, and accredit artists and in doing so **produced** an elite group of workers whose skills and intellectual abilities were put to work making paintings and sculptures to adorn and embellish **public** buildings of many kinds, including palaces, parliaments, churches, and the newly **created** state art **museums**, such as the Louvre in Paris which became an art gallery after the French Revolution of 1789. Accredited artists (known as 'Royal Academicians' in England) also worked for private **patrons** in many countries throughout the world by the nineteenth century. Contemporary art schools, colleges, and departments of art in universities in Europe and North America owe their existence, via a complicated history, to the founding of academies in the renaissance and enlightenment **epochs** (*c.* 1500–1800) and the processes of qualification and professional accreditation have their roots in the social division of labour developing in the societies that inaugurated the first academies.

By the mid to late nineteenth century in Europe many societies with official academies of art had entered a **period** of sustained economic, social and political crisis – the latter related to the growth in popular **movements** for democratic and then socialist **revolution**. Under these conditions the terms *academy* and *academic* began to generate *negative* connotations, as these institutions were increasingly **identified** as part of a conservative state attempting to prevent change in the nation's **cultural**, as well as social, order. National academies of art lost power, status, and **influence** as **modern** or, more strongly, **avant-garde** artists (e.g.: the **impressionists**), by the 1860s, 1870s, and 1880s, particularly in France, began to produce works appealing to a new middle class itself **critical** of, or at least increasingly indifferent to, established **taste** and artistic **tradition**^ **symbolised** by an old-**fashioned** academic – academicising – focus on life-drawing, and the rote production of preparatory sketches and models for **history paintings** and large-scale monumental sculptures.

Further Reading

Boime, Albert *The Academy and French Painting in the Nineteenth Century* (Phaidon: 1971).

Hoock, Holger *The King's Artists: The Royal Academy of Arts and the Politics of British Culture: 1760–1840* (Clarendon Press: 2003).

Pointon, Marcia (ed.) *Art Apart: Artifacts, Institutions, and Ideology in England and North America from 1800 to the Present* (Manchester University Press: 1994).

Singerman, Howard *Art Subjects: Making Artists in the American University* (University of California Press: 1999).

ADVERTISING *AD, ADVERTISEMENT*

Graphic **representations** combining the use of **visual** and **textual** (sometimes, in addition, recorded spoken) **materials** in the effort to sell **products**, services, **images** of life-**styles**, and brand **identities** in, for example, newspapers, magazines, and on billboards, **television**, and the internet. The **origins** of *advertising* lie in eighteenth-century print **media** – principally the then newly **developing** newspaper or 'broadsheet' and journal **forms** – and consisted in 'classified notices' (that is, classed or boxed according to various categories) informing **readers** that certain goods or services were available for their purchase. These referred to, for instance, accommodation, food and dining, transport, and legal advice. In this early and comparatively straightforward example 'information' is perhaps a more accurate term than 'advertisement' for a simple and obviously useful kind of notification. However, these **origins** led to a profound, even transforming, **cultural** development in **modern**^ **societies** that now includes the **complex** and expensive **forms** of the television ad, large-scale billboard images (sometimes the size of the sides of entire buildings), **film** (movie) 'trailers', and the use of rapidly innovating internet computer formats. Advertising in these **contemporary** examples refers to a sophisticated, continual, and systematic effort to convince **viewers** or readers – now **abstractly** referred to by advertising executives as **consumers** – that they would be much better off if they wore Levi's jeans, or ate Domino pizzas, or drove Ford cars.

The combination of visual and textual/spoken elements within magazine or television advertising constitutes an effective system of rhetorical selling devices designed to persuade. For instance, adverts typically draw attention to, play on, and even attempt to manufacture, the psychological weaknesses of their 'target-audience' (for example, the dire threats of baldness or ageing skin quality), habitually use both explicit and subtle forms of **sexual** imagery (linking products to sexual success), engage the '**identificatory** processes' of viewer-recognition (by paying celebrities or trusted **public**^ **figures** huge sums to endorse **products** and services), and insist that their products

can bestow clear advantage on those who purchase and continue to use them.

By the 1970s it had become clear that a considerable part of what one **critic** (Peter Fuller) called 'the mega-visual' **tradition** – large-scale graphic art, in the nineteenth century exemplified by **history paintings** – was now devoted to advertising and that the public **culture** of **western** societies as a whole was being transformed by innovations in advertising and the consumer-**capitalist** system driving its development.

Numerous critiques of this 'advertising culture', founded on the priority accorded to selling and persuasion **techniques**, claimed that a wholesale corruption of the **social order** of western democratic societies was taking place: that national political life in particular, through the use of 'sound-bites' and 'spin', had become simply another form of clever advertising equated with a deceitful manipulation and misleading of the public. Political advertising **techniques** using sophisticated **narrative** and dramatic devices developed in television and film drama contributed to the development of what the **revolutionary^ marxist^** theorist Guy Debord, writing in the late 1960s, called the 'society of the spectacle'.

Further Reading

Barthes, Roland *Mythologies* (Jonathan Cape: 1972).
Debord, Guy *The Society of the Spectacle* (Zone Books: 1994).
Williams, Raymond 'Advertising: The Magic System', in Williams, *Problems in Materialism and Culture* (Verso, 1980).
Williamson, Judith *Decoding Advertisements: Ideology and Meaning in Advertising* (Marion Boyars: 1978).

AESTHETIC *AESTHESIS, AESTHETE, AESTHETICISE, AESTHETICISM, AESTHETICS, AESTHETIC EFFECT*

One of the most important **concepts** in **art^** history, art **criticism**, and the philosophical study of the arts, referring both to those **artefacts** thought of as intrinsically **artistic** (aesthetic by **nature**), but also, by extension, to some of the properties of a much wider range of **humanly^ designed** objects in the world. Thus it would be acknowledged that, for example, within the **visual** arts, **paintings**, drawings, prints, and **sculptures** are *aesthetic* objects – this term effectively having the same **meaning** as **artworks** – being the result of ideas, **materials**, and **techniques** of construction focused specifically

9

on the **creation** and combination of aesthetic **qualities** and properties (e.g.: Anne-Louis Girodet's painting *The Burial at Atala* (1808) and Edgar Degas's painting *Young Spartans* (1860)). These two paintings, that is, have been created as aesthetic objects first and foremost, and their **exhibition** in art **museums** and galleries (rather than churches or palaces) indicates this primary function. However it would generally be conceded that, for example, such ordinary items as pizza boxes, shoes, and CD cartridge designs also have aesthetic properties (shape, colour, pattern, texture, etc.), though the primary **function** of these artefacts is not aesthetic, but utilitarian – that is, to contain and preserve food, to cover and protect their owners' feet, and to **identify** and preserve the discs inside. It might be said that this second (and vast) range of artefacts, existing in order to fulfil a non-artistic function, sometimes express an 'aesthetic effect' – to use a term **developed** by **semiologists** and dramatists, such as Bertolt Brecht, who believed that **signs** and **symbols** in everyday life, as well as in the theatre, could draw valuable attention to the **nature** of the world and ways to **interpret** it.

This notion of the active **production** of **meaning** through everyday signs and symbols is conveyed by one of the older **forms** of the concept of *aesthetic*, closely related to its Greek **origins**: *aesthesis*, or the transmission and **communication** of sense and feeling. In its earliest uses, and, in fact, up to the time of the philosopher Immanuel Kant, *aesthetic* and *aesthesis* did not have a meaning limited specifically to artworks or artistic activity narrowly defined in terms of **media** such as painting or sculpture. *Aesthesis*, rather, meant the transmission and communication of *feeling* through the **body's** senses: touch, hearing, sight, smell, and taste. In this usage, the natural world of skies, **landscapes**, and seas, communicated to people through their bodily faculties, was as much a vehicle for aesthesis, or the cause of 'aesthetic effect', as the look or touch of paintings and sculptures.

By the early twentieth century, however, *aesthetic* became applied, particularly within **modernist** criticism and **theory**, *only* to recognised and distinct art forms. This radical reduction and narrowing in the meaning of the concept went hand in hand with the contentious claim that there was a specific, singular, and **autonomous** kind of 'experiencing' and 'knowing' peculiarly associated with contact with artworks. The late-nineteenth-century notion of a type of person known as an aesthete (such as Oscar Wilde), living a life obsessed with artistic feeling – aestheticism – anticipated the modernist sensibility exemplified in the twentieth-century critics Clive Bell and Clement Greenberg.

Further Reading

Bloch, Ernst, Georg Lukács, Bertolt Brecht, Walter Benjamin and Theodor Adorno *Aesthetics and Politics: Debates between Bloch, Lukacs, Brecht, Benjamin, Adorno* (Verso: 1980).

Eagleton, Terry *The Ideology of the Aesthetic* (Blackwell: 1991).

Lake, Beryl 'A Study of the Irrefutability of Two Aesthetic Theories', in Charles Harrison and Fred Orton (eds) *Modernism, Criticism, Realism: Alternative Contexts for Art* (Harper and Row: 1984).

Osborne, Harold *Aesthetics and Art Theory: An Historical Introduction* (Longmans: 1968).

AGENCY *AGENT*

In its most familiar **art^ historical^ form**, *agency* or *agent* has virtually the same **meaning** as **artist** and artistic labour – two notions (themselves surprisingly unexplored as **concepts**) indispensable to practically all accounts of artistic **production**. *Agency* may be said to refer in general to the force active in making actual **artworks**, though many other features of the **art world** – such as **museums**, legal contracts between artists and dealers, and artists' **materials** – have been similarly manufactured by agents and agencies of various kinds. The term's important **theoretical** insight however, **originating** in **sociology** and social **theory**, was that of **identifying** the active element (or person or group) capable of bringing about change in a particular situation. In many of these accounts, however, agency was set in opposition to, or at least in contrast with, the concept of **structure**. This complicated term, which might in art history refer to the physical entity that is a **sculpture**, or a building, or an art **installation**, may also refer to a range of non-physical things: for example: the *social structure* of an art college's staff and students, or the structure of economic and social relationships between artists, **designers**, **architects** and their **patrons**.

Agency, and its **complex** relationship to structure, then, raises a rich and interesting set of problems to do with what **explanation** in art history, or art **criticism**, might actually mean. Agency understood simply as artistic intention, for example, seems usually to be reduced to the artist's aims: those meanings or feelings or **values** claimed to be **communicated** through the form of the artwork. The formulation 'agency = artist = communicated intention', though, is crude as an explanation for a number of reasons. It contains, for example, a simplistic idea (or mere assumption) of what the artist 'is' or 'was'. **Human** agents, including artists, are not *only*

11

'intending' beings with self-conscious aims: they are also motivated, **influenced**, and limited by a variety of forces and conditions of which the agents themselves may not be fully aware. These factors may include, for example, competition with others, **traditions** of making associated with training and **national^ cultures**, and the perhaps unacknowledged desire to **express** aspects of their relationships to parents or partners.

Agency refers, then, not just to the isolated artist and the practical fabrication of artworks, but to a wide range of factors and events that constitute the 'active forces' at work in *all* human production: shaping traditions of **composition** and **narrative**, the intervention of patrons and other intermediaries, the informing role of ideas, **ideals**, and **ideologies** affecting choice of **subject^ matter**, the decisive power of **institutions** such as museums and galleries in selecting artists for shows, etc. The concept of agency, when expanded to include the **significance** of all these active elements – a clear emphasis within the **social history of art** – begins in fact to merge with the often opposed idea of structure (defined in its most orthodox sense as simply inert 'background' or 'context'), suggesting that an entirely new explanatory formulation is required, able to reconcile and interconnect agency and structure.

Further Reading

Barringer, Tim *Men at Work: Art and Labour in Victorian Britain* (Yale University Press: 2005).

Giddens, Anthony *Central Problems in Social Theory* (Macmillan: 1979).

Harris, Jonathan 'Radical Art History: Back to Its Future?', in Harris, *The New Art History: A Critical Introduction* (Routledge: 2001).

Wolff, Janet *The Social Production of Art* (Macmillan: 1981).

ALLEGORY *ALLEGORICAL*

Deriving from a Greek word **meaning** 'to speak otherwise', *allegory* or *allegorical* devices in **artworks^ communicate** through **symbolic** means, suggesting a *coding* of meanings – though not necessarily the communication of a coherent or singular message. Allegory, however, is often used as if it simply meant the same as **narrative** or story. Thus it might be said that a seventeenth-century Dutch oil painting, such as Pieter Claesz's *Vanitas* (1621) depicting a variety of objects – a skull, two smoking pipes, some over-ripe fruit, sunlight through a window reflected on a glass lamp – communicates the story or

meaning, allegorically, that in time all **human** beings die, that **material** possessions are ultimately worthless, and that the **viewer** of the **painting** should prepare him or herself for the moment of their impending death. This example also indicates how allegory is often conceived of as essentially profound: communicating, that is, *important* meanings. The idea of an in**significant** or everyday allegory generally remains unfamiliar.

But much **art** made since at least the later nineteenth century that qualifies as allegorical – containing coded meaning – cannot be said to communicate definite meanings either clearly or coherently, instead leaving much to be **subjectively^ read** into the artwork by the viewer.

For example, though it would probably easily be agreed that this 'openness' of meaning is manifestly true of, say, Henri Matisse's decorative painting *La Desserte* (1908) or Paul Klee's **abstract** canvas *A Young Lady's Adventure* (1922), it is arguably *also* true of much apparently **realist** or narrative painting. For example, though it is fairly obvious that Gustave Courbet's painting *Burial at Ornans* (1850) depicts a funeral, it is not at all clear what we should think the significance or meaning of this depiction is – either to the **artist** who painted it, or to particular viewers who have seen it as certain moments in **history** and inevitably brought their own, and always different, experiences, knowledge, and expectations to their understanding of it. The notion of allegory understood as a matter of subjective **interpretation** bound up with artistic **intention** raises a series of very fundamental problems within **art history** and **criticism**.

Though allegory as a **form** in **western** art is particularly associated with high **renaissance** painting and **sculpture** – with sophisticated, deliberately overlaid meanings and systems of **metaphorical** reference, exemplified in paintings such as *Birth of Venus* (1483) by Sandro Botticelli and Michelangelo's 1508–12 *Sistine Chapel* ceiling frescoes – its meaning and **value** as a critical term in the twentieth century, and as a means to explain **developments** in **modern** art, is beset with difficulties. The relationship (and difference) between mere reference to something and the thing's significance (meaning and interpretation) is at the centre of this issue. If, in the **epoch** of the renaissance and subsequent art up to the nineteenth century, it may be said that artistic meanings continued to be based on relatively shared and agreed – if increasingly shifting and diverging – ideas and **ideals** of the purpose of art, by the birth of **modernism** and **avant-garde^ culture** this commonality had begun to disintegrate.

Further Reading

Clark, T. J. *Image of the People: Gustave Courbet and the 1848 Revolution* (Thames and Hudson: 1973).

de Man, Paul *Allegories of Reading: Figural Language in Rousseau, Nietzsche, Rilke, and Proust* (Yale University Press: 1979).

Jencks, Charles *The Language of Postmodern Architecture* (Rizzoli: 1977).

Rowland, Ingrid D. *The Culture of the High Renaissance: Ancients and Moderns in Sixteenth-century Rome* (Cambridge University Press: 1998).

ALTERNATIVE

One important **theoretical** category in a set of three – the others being **oppositional** and **specialist** – that seeks to **identify** and **explain** the **significance** of **modern** and **avant-garde^ artistic^ forms** and **movements** within the **historical^ development** of **culture** and **society**, particularly since the later nineteenth century. This group of terms (or taxonomy) was proposed by the literary **critic** and historian Raymond Williams and constitutes part of his outline of a comprehensive historical **sociology** of culture. Williams's starting point was the recognition that, given the decline in the social and artistic **dominance** of **academic^ art** and the **institutional** role of **state** art schools during the second half of the nineteenth century, a wide range of new artists' groups, or **formations** (for instance, the **impressionists**, the pointillists, *Die Brücke*, the **cubists**, the **futurists**, and **dadaists**) – internally very diverse but generally united in a rejection of **traditional** art and its institutional power – had emerged by the 1910s.

Alternative groups amongst these (e.g.: the impressionists, *Die Brücke*, and the cubists) definitely positioned themselves in contrast to academic art's **genres**, **materials**, and **values**, but didn't set out directly to *oppose* or attack traditional art and its support from the state and conservative sections of society (as the oppositional futurists in Italy before the First World War, and dadaists throughout Europe and in New York before and during the war did). Specialist groups developed a particular focus on a new **medium**, or type of **subject^ matter**, or **technique** – such as the pointillist interest in scientific theories of colour which led to their use of **painted** dots to **create^ imagery**. Even given this very brief suggestion of examples it is easy to see that these three categories are not wholly separable: some oppositional formations, for instance the dadaists, included elements that were also specialist, such as the development of **photographic**

and photomontage techniques by John Heartfield and Hannah Höch, for instance in her *Cut with the Cake-Knife* (*c.* 1919).

Beyond the 1910s, these terms remain valuable – when used cautiously, in a trial and error, or heuristic, way – to begin to account for the importance of avant-garde art and artists *throughout* the twentieth century, when modernist art itself becomes in some ways traditional.

For instance, new post-1945 formations (such as the **abstract^ expressionists**) established themselves as an alternative to the 'School of Paris' painting of Pablo Picasso and Henri Matisse, in their choice of **means of production** (such as Jackson Pollock's use of aluminium car paint and 'drip' technique), though their rejection of American **consumer^-capitalist** society wavered between alternative and opposed positions. Barnett Newman, for instance, once claimed his abstract paintings, if understood properly, **symbolised** the 'end of all state capitalism and totalitarianism' (e.g.: *The Promise* (1949)). As always, theoretical terms, such as alternative/oppositional/specialist, if they are to be useful, have to be brought into relation to **art historical** examples, within an ongoing investigation and testing process that can throw light on these examples, but which might also lead to a modification of the theoretical terms themselves.

see also: **oppositional, specialist**

Further Reading

Newman, Barnett 'Interview with Emile de Antonio' (1970), in John O'Neil (ed.) *Barnett Newman: Selected Writings and Interviews* (University of California Press: 1992).

Pointon, Marcia (ed.) *The Pre-Raphaelites Reviewed* (Manchester University Press: 1989).

Williams, Raymond 'The Bloomsbury Group', in Williams, *Problems in Materialism and Culture* (Verso: 1980).

—— 'Formations', in Williams, *Culture* (Fontana: 1981).

ANALYSIS *ANALYTIC, ANALYTICAL*

The systematic, self-conscious investigation of an object of study – be it, for example, a particular **artist** or other kind of **producer**, an **artwork** or other **visual^-cultural** product, an **institution**, or an **art^ historical** or **critical^** text. *Analysis*, in this definition, therefore, is clearly distinguishable from a range of other responses and reactions, some of which, however, constitute very important components of

analysis. For instance, simply looking at certain objects – be it an eighteenth-century estate such as the grounds at Stourhead, Wiltshire (laid out from 1741 onwards) or John Portman's Hyatt Regency Hotel in San Francisco (1974) – or attempting verbally either to describe them, or describe the feelings or attitudes one **develops** in relation to looking at them, are instances of such response and reaction. For these activities to become part of an *analytical procedure*, however, they must be integrated into a defined process of **explanation**.

Analysis, therefore, involves the self-conscious (and self-critical) use of **concepts** brought to bear upon a specified object of study. In analysis, it should be clear that the object of study does not, and cannot, simply present itself for study (though buildings, in particular, may appear just to be simply *there*). The analyst must select and isolate this or that object for analysis, thereby giving it **significance** and **value** – although it may have already been studied by others. Buildings, like all other visual/physical **artefacts**, may be analysed **formally** (in terms of types and **styles**), **technically** (in terms of **materials** and construction methods), and in terms of their **social** use and importance. Description is an essential stage in all kinds of visual analysis, rooted in both looking and finding words and concepts able to convey that experience. However, *evaluation* – that is, saying what is good or bad, and why – is not simply a stage beyond, or concluding, description: all **language** arguably combines both descriptive and value-laden elements.

Analysis, then, is a radical activity in the basic sense that it requires the simultaneous use and questioning of explanatory (descriptive and evaluative) concepts. For example: to investigate whether an English country estate or a **modern** hotel may legitimately be considered **artworks** involves the reconsideration of a range of relevant, operative **art historical** concepts, including **design, function, art, author, consumption, effects, intention**, form, **meaning, new media, originality, quality, subjectivity, taste, theory**, value, and **visual pleasure** (and many others). The question of whether buildings of any kinds are *themselves* artworks – rather than repositories for them, as many clearly are – may be judged by some to be a marginal or absurd issue for analysis. But to see it as either marginal or absurd involves already holding some basic assumptions about the **nature** of art, and the purpose and value of art historical inquiry. If these assumptions are not systematically and self-consciously questioned then they remain 'pre-analytic', or to put it another way, simply instances of prejudice (pre-judging) or unexamined 'common sense'.

Further Reading

Barthes, Roland 'Introduction to the Structural Analysis of Narratives', *Image, Music, Text* (Fontana: 1977).

Baxandall, Michael *Patterns of Intention: On the Historical Experience of Pictures* (Yale University Press: 1985).

Harris, Jonathan 'Introduction', *Writing Back to Modern Art: After Greenberg, Fried, and Clark* (Routledge: 2005).

Kuhn, Thomas S. *The Structure of Scientific Revolutions* (University of Chicago Press: 1970).

APPROPRIATION *APPROPRIATE,* *APPROPRIATION ART*

A term with particular **significance** in relation to **art^ produced** after about 1970 that reflects novel **postmodernist** artistic and **critical^ conceptions** of **influence, meaning**, and the changed status of the **artist** as **producer**. Sherrie Levine, for example, has re-**photographed** photographs of **landscapes** and **nudes** taken by earlier artists, such as Edward Weston, and then **exhibited** her photographs of these photographs (e.g.: *Untitled (After Edward Weston no. 5)*, (1980)). In some cases it is impossible to know simply from **looking** at these **artworks** that they are in fact **representations** of existing representations – though in this case the title makes the *appropriation* fairly clear. This example suggests that postmodernist 'appropriation artists' such as Levine have a particular interest in highlighting the characteristic **conventions** and **compositional** devices found in **modernist** art made earlier in the twentieth century. Appropriation art in some respects is similar to 'sampling' conventions in **contemporary** music, though both **practices** contain a wide range (from faithful, edited **reproductions** of existing music and **visual** representations to highly modified and reshaped examples – in each case the purpose of the sample/appropriation is specific and may differ considerably from others).

The term *appropriation* – one of whose meanings is to 'steal' or 'take without asking' – seems specifically apt in the case of Levine's photograph, which, in effect, disguises the **nature** of her artistic practice (leaving aside for a moment the title). Once one is aware that she has 'lifted' an earlier representation, her own art takes on a conceptual or **theoretical** dimension that contrasts with usual accounts of modern art's intrinsic and authentic meaning and **value**, seen as directly **expressive** of its **creators'** personalities. Challenging as this insight may be it does not necessarily lead to the conclusion that such

appropriation art is good – indeed the obvious **criticism** has been that Levine's works demonstrate little skill of their own. She might reply, however, that their value precisely lies in *questioning* notions of skill, expression, and **quality**. Andy Warhol's soup cans and brillo boxes, appropriated from **mass culture** in the 1960s, provoked the same kind of debate.

Appropriation differs from the **traditional** art historical notion of influence in an important respect: though it retains the sense that artistic elements may have been either 'borrowed' or 'stolen' from earlier sources – say, Robert Rauschenberg's use of an **old master^ painted** nude motif in his oil and silkscreen on canvas work *Tracer* (1963) – they can't easily be said to *belong* to their current owner. Rauschenberg's **picture** seems intentionally flat and inexpressive, a rather listless compendium of sources. Conventional notions of influence and tradition, in contrast, tend to carry with them the sense that the latest artist to make use of a source somehow manages to make it uniquely his or her own, as part of the evolution of an invigorating **original** visual **style**. This is the way that the mature Raphael, for example, is always claimed to have adapted or 'been influenced by' the paintings of his teacher Perugino. Artists after 1970 – about the time when modernism is usually claimed to have ended or at least shaded into a range of other practices and attendant theories – do not, on the whole, retain the sense of continuity to earlier artists that conventional art historical (and modernist-critical) notions of style, influence, and tradition convey.

Further Reading

Crimp, Douglas *On the Museum's Ruins* (MIT Press: 1993).
Mitchell, W. J. T. *What Do Pictures Want?: The Lives and Loves of Images* (University of Chicago Press: 2005).
Nelson, Robert S. 'Appropriation', in Robert S. Nelson and Richard Shiff (eds) *Critical Terms for Art History* (University of Chicago Press: 2003).
Wallis, Brian (ed.) *Art After Modernism: Rethinking Representation* (New Museum of Contemporary Art: 1984).

ARCHITECTURE/ARCHITECT *ARCHITECTONIC, ARCHITECTURAL*

Like the term **art**, *architecture* has both neutral and clearly **evaluative** senses: within the former it **means** a building with an accessible inside and an outside – a **material^ structure** made by **humans** for

habitation. Within the evaluative sense it refers only to those build-ings considered to **exhibit** the highest **qualities**: the *best* or *most important*. The architectural **historian** Nicolaus Pevsner famously once remarked 'a bicycle shed is a building; a cathedral is a piece of architecture'. Note here the association of status and **value** with the intended **social** use of the structure. Cathedrals, like royal palaces and houses of parliament, are, or were, places built (financed and over-seen) by, and for, the most powerful and richest groups in society. In the **medieval^** period cathedrals **symbolised** the political, social, and economic power of the Christian church **dominant** within the **social order** of European regions prior to the rise of monarchies, **nation^-states**, and the later **development** of commercial and industrial **capitalist** societies.

Taking many decades to build to completion – if that point was ever reached, or indeed anticipated by those in charge of construction – cathedrals (such as Notre Dame in Paris, built from 1163 to 1250) in their massive size, technical sophistication, and ornament have come to symbolise the growing scale, **complexity**, and achievements of the societies that were able to plan and build them. The sheer human **organisation** involved in their fabrication, in terms of the social and **technical** divisions of labour, carried on sometimes over many generations, may be seen as a kind of **meta-phor** for the evaluative meaning to architecture. Or, to reverse this observation: architecture as an evaluative term symbolises the idea, and **ideal**, of the complex organisation and orchestration of intellectual, technical, physical, spatial, social, and spiritual resources. Interestingly, the example of cathedrals as instances of 'best architecture' does *not* include the **explanatory** element central to **traditional^ art his-torical** accounts of great **paintings** and **sculptures**: the singular, dominating **agency** or force of the **artist**, thought to be uniquely responsible for **designing**, and conceiving, in advance, the **art-work's^ form** and meaning. (Michelangelo and Pablo Picasso are the two artists probably most celebrated in art history as semi-divine **creators**.) By the twentieth century, however, **modern** architects had begun to be seen as similar kinds of individual **geniuses** – for example, Le Corbusier, Ludwig Mies van der Rohe, and, more recently, Daniel Libeskind, have attained this status.

Karl Marx famously took the example of architecture to illustrate his notion of the essential difference between human labour and that carried out by animals in the construction of their habitat. The architect – as designer, pre-conceiving his/her **artefact** – **theorises** the finished object, whilst the bee, building a honey-coned nest, acts

merely instinctively. The social and technical division of labour, however, within what is usually an inherently *collective* process distances architecture, and accounts of the creativity within its **production**, from the different, and still dominant, notions of art and artist centred on the **ideology** of individualism.

Further Reading

Curtis, W. J. R. *Modern Architecture Since 1900* (Phaidon: 1996).
Frankl, Paul *Principles of Architectural History: The Four Phases of Architectural Style, 1420–1900* (Harvard University Press: 1968).
Lotz, W. *Studies in Renaissance Architecture* (Harvard University Press: 1977).
Trachtenberg, Marvin 'Some Observations on Recent Architectural History', *Art Bulletin* June 1988: 208–41.

ART *ARTISTIC, ARTS, ARTY*

Both a descriptive term and an evaluative **concept**, *art* refers to **artefacts**, processes, skills, and **effects** entailed in the **production** of **visual^ representations** within a wide variety of **media** and **materials**. The latter category – effects – interestingly includes the **critical** label 'arty', suggesting a too-obvious playing with, or showy use, of artistic means (as in 'special effects'). With a highly complicated **historical** and **contemporary** relationship to many other terms used in **art^ history** – that composite term itself, along with, for example, **design, craft, artisan**, labour, **theory**, and science – *art* remains one of the most problematic and confusing, yet indispensable terms in **cultural** history and **analysis**. Its **complexity** and **significance** is partly a result of its centrality within both the **development** of visual-representational **practices** *and* cultural theory since the **renaissance**. For example, the evolution of the idea and self-presentation of the **artist** as a special kind of **creative** producer (individual **genius**) is a key aspect to the history of the concept of art.

Art, by the fifteenth century in Europe, had started to become a specialised name for an increasingly limited number of practices and artefacts – certainly *not* at that stage, however, limited only to **painting** and **sculpture** – selected and regarded as 'liberal' in their **nature**. This designation (e.g.: in Leon Baptista Alberti's *Della Pittura* [On Painting] (1435)) was used to indicate that a theoretical understanding *preceded* and guided the practice of the activity, in accordance with established, though evolving, rules and precepts. These 'liberal

arts', then, were separated from, and elevated in status above, other activities seen as essentially practical – such as stone-masonry or stained-glass work – which later became understood as **crafts**, and the work, not of especially creative artists such as Leonardo da Vinci, Raphael, or Michelangelo, but rather of (certainly skilled) artisans or craftspeople whose individual names and lives were not regarded as crucial in accounts of the **value** of their work.

In contemporary historical, critical, and **popular** usage, art retains a wide range of overlapping and sometimes contradictory **meanings** and **values**. For instance, it is still used generally to designate a plurality of cultural activities and products: the arts – with an additional 's', that is – generally refers to, for example, painting, dance, literature, music, **architecture**, and **cinema**. Note, however, that although this list *seems* inclusive, in actual critical and historical accounts radical selection is typical and excludes certain kinds of work. Disputes continue over whether, for example, pop or rock music, or comic books, are *really* art. Evaluative distinctions between **high art** and 'low' or **mass culture** have characterised **academic** and critical analysis over many decades now, creating categorical divisions and entrenched positions. While **conventionally** agreed art objects, such as paintings and 'fine art' prints, have in all cases been designed (that is, planned and executed according to rules and **compositional** conventions), the category of design in the twentieth century has become established partly *in contrast* to art. Printed **advertisements** and product packaging, for example, are not accorded art status, although these two **forms** and sets of artefacts are clearly visual, fabricated from printed media materials, and have, in some cases, very sophisticated composition and **stylistic** histories. And while some artefacts are awarded high status as design objects (sometimes with 'designer' or even '**classic** design' status: e.g. haute couture dresses by Christian Lacroix and Charles Eames's moulded plywood chair from 1948) rather than craft items – often, but not always, due to their mass production and **reproducible** character – they exemplify the way art as a term, like design, may be used in one sense in an apparently neutral classificatory sense and then in a clearly evaluative sense in order specifically to select or reject, and to judge the value and meaning of certain objects.

Further Reading

Collingwood, R. *The Principles of Art* (Oxford University Press: 1938).
Fischer, Ernst *The Necessity of Art* (Penguin: 1963).

Hall, Stuart and Paddy Whannel *The Popular Arts* (1964).
Taylor, Roger *Art, An Enemy of the People* (Harvester: 1978).

ART-FOR-ART'S-SAKE

A phrase, or slogan, or 'battle-cry' **originating** in the early nine-
teenth century in France, which claims and celebrates the
distinctness – in some versions, the actual separateness, or
autonomy – of **modern^** **art's** concerns from **social** and political
interests and **values**. The term is particularly associated with the
writer Théophile Gautier, who gathered around him a group of
artists and **authors** after the restoration of the monarchy in France
in 1815. Though *art-for-art's-sake* attitudes are **popularly** linked to
interpretations of **impressionist^** **paintings** in the last third of the
nineteenth century – with, say, Auguste Renoir's **pictures** of the
bourgeoisie at play (e.g.: *La Grenouillere* (1869)) and Claude Monet's
near-**abstractions** (e.g.: *Rouen Cathedral* (1894)) – it is very impor-
tant to note that the term's earlier moment of **emergence** implicated
attitudes toward the socio-political situation in France after Napoleon
Bonaparte's final defeat and exile.

As a demand **intended** to antagonise **traditional** artists and others
committed to the conservative and patriotic values of the **Académie
des Beaux-Arts** in France, art-for-art's-sake paradoxically was itself a
kind of political claim or demand: implicitly, or more openly, refer-
ence to it by **critics** such as Stéphane Mallarmé was an attack on a
corrupt society which they – the bohemians, as they became known –
believed was **symbolised** by the authoritarianism of the Academy
and its annual Salon **exhibitions**. Impressionist and post-impressionist
paintings of modern life, painted in a **technically** radical **style** reject-
ing the **narrative^** conventions, **compositional^** **ideals**, and
'finish' of traditional **history painting** taught by the Academy, (e.g.:
Édouard Manet's *Dejéuner sur l'herbe* (1863); Georges Seurat's *Sunday
Afternoon on the Island of La Grande Jatte*, (1884–86)) symbolised the
rejection of this system of artistic **production** and the **social order**
in France that had maintained it for around two hundred years.

With the radical decline in the power and **influence** of the
Academy and Salon exhibitions in France by the end of the nine-
teenth century – brought about partly by the rise in a commercial
'free market' for art that made **state^** **patronage** far less significant
to the **careers** of modern artists – it became established (and, indeed,
in time another kind of 'establishment thinking') that artists did not

produce according to anyone's interests except their own, and produced works that were **expressive** only of their personal experiences of the **contemporary** world. **Aestheticism** was the term coined for this bohemian revelling in **subjective** feeling, and Oscar Wilde exemplified its lifestyle and anti-bourgeois philosophy. By the mid twentieth century, a version of art-for-art's-sake (sometimes called **formalism**) **developed** by American critic Clement Greenberg rescued the paradoxically political anti-political strand originating in Gautier's circle over a hundred years earlier. **Abstract^ expressionist** painting, as part of modernism, Greenberg believed, rejected **capitalist** society and **culture** in favour of a 'purified' expression purged of narrative and symbolic references to the world outside. **Avant-garde** groups, after the **surrealists**, mostly gave up any kind of orthodox political or **ideological** beliefs, retreating to 'art itself' – art-for-art's-sake – as the last bastion of value and authenticity in contemporary society.

Further Reading

Boime, Albert *Art in an Age of Counterrevolution 1815–1848* (University of Chicago Press, 2004).

Bürger, Peter *Theory of the Avant-garde* (University of Minnesota Press: 1984).

Greenberg, Clement 'Avant-garde and Kitsch' (1984) in John O'Brian (ed.) *Clement Greenberg: The Collected Essays and Criticism*, vol. 1 (University of Chicago Press: 1988).

Orton, Fred and Griselda Pollock *Avant-Gardes and Partisans Reviewed* (Manchester University Press: 1996).

ART HISTORY *ART HISTORIAN, ART HISTORICAL, ART HISTORIOGRAPHICAL*

Name given to the **historical** study of **art** – involving such **practices** as **curation** and research, teaching, and the preparation for publication of essays, books, and catalogues – work often carried out, though not exclusively, in scholarly or higher education **institutional** contexts, such as universities and **museums**. Since the early twentieth century, though particularly after the Second World War, *art history* in this broad sense became an **academic** *discipline* (equipped with established curriculum and standard aims and objectives), taught at undergraduate and postgraduate levels, **producing^ specialists** and experts working in a variety of locations including teaching in schools and universities, buying and selling art in auction houses and

dealing galleries, curation and conservation in museums, and, more recently, broadcasting on radio and television. Art history's disciplinary status consists, too, in sets of **concepts** and principles, objects and methods of study – along with some foundational arguments and **values** claimed to underpin and guide the general inquiry. Since the early days of the discipline's **development** in universities in Europe in the early years of the twentieth century, however, these basic elements have evolved and multiplied almost beyond recognition and it is extremely doubtful now that any consensus exists over the key concerns of the field of study as a whole.

Early disciplinary emphases – for instance, on establishing the **authorial^** origins of **artworks** (*who* **produced** *what*, *when*, *how*, and usually to a lesser extent, *why*) – was supplemented, and in some cases entirely transformed, by the development of other interests. These have included, for example, the study of **symbolism** in artworks (**iconography**); **social history of art^** **analyses** of the **socio^-cultural** circumstances in which art is produced and **consumed**; **feminist** interest in the status of women in the development of art, art **institutions**, and in culture and society as a whole; the **psychology** and psychoanalysis of art and artists; and **semiological theories** of how artworks contain and **express^** **meanings** through specific kinds of **signs** and **communication** systems.

Serious disputes, for example over the selection of objects of study for art history, have persisted for many decades now, and suggest how art historical and art **critical** concerns, particularly in the era of **modernism**, both overlap and divide at various points. These arguments over the **formation** of a **canon** of artworks and **artists** – that is, those items and producers deemed worthy of study as the 'best' and the 'highest', according to certain criteria and values – indicate how the apparently simple idea of a factual history of art contrasts with the actual selections and accompanying claims articulated within particular art historical accounts. The study of the development of the discipline, which is often said to have begun with the *Lives of the Artists*, first published in 1550, by Giorgio Vasari – sometimes called the first art historian – is called *art historiography*. Since at least the 1970s, however, it has become clear that art history grew up as a **western**, and specifically European/North American, **subject** though some of its most **influential** scholars and institutions claim to be able to encompass the study of **visual representations** from all around the world. The very terms *art* and *history*, however – European in intellectual **origins** themselves – arguably lock such 'world art' studies closely into the interests and values of a narrow **metro-**

politan elite (white, middle **class**, predominantly male) based in the cities and cultures of the northern and western hemisphere.

Further Reading

Belting, Hans *The End of the History of Art?* (University of Chicago Press: 1987).
Fernie, Eric (ed.) *Art History and its Methods: A Critical Anthology* (Phaidon: 1995).
Nelson, Robert S. 'The Map of Art History', *Art Bulletin* March 1997: 28–40.
Vasari, Giorgio *Lives of the Artists* (1550) (Oxford World Classics: 1998).

ART WORLD

Mid-twentieth-century term denoting the entirety, interconnectedness, and distinctiveness of *all* the elements and relationships within **visual^ art's^ production**, its commercial exchange, **exhibition** (more broadly, its use, or **consumption** of all kinds), and **critical^ interpretation**. 'World' in the sense of *art world* is both a **metaphor** and a description: visual art's activities and **practices** take place now all over the world, between cities and continents, in **real** (physical) and electronic **forms** of exchange, yet **artists** and other members of the art world still live in (though, again, increasingly move between) particular places. In a narrower sense, art world is now used typically to refer to those **agents** and **institutions** making up the **contemporary** *economic market* for art: artists, dealers, auctioneers, accountants and lawyers, critics, buyers, and **museum** and gallery professionals. Note that this usage usually excludes those who simply visit galleries or museums but have no financial, business, or other professional interest (stake) in art. In the broader sense, however, the art world also includes, for instance, academics teaching and researching art and **art history** – both recent and past – in the universities and art colleges. What all *these* agents and institutions share, then, is an interest, in the different sense of 'intellectual concern for', the **history**, **meanings**, and **values** of art and its shaping conditions and circumstances. Such intellectual concern, however, has never been, and is not now, incompatible with a financial interest in art: many art historians and critics (e.g.: Charles Baudelaire, Roger Fry, Nicholas Penny), have bought and sold **artworks**, or been paid to advise others to do so.

The idea that there was a discrete art world began to form by the end of the nineteenth century in France and was associated then

particularly with the rise of **impressionism** (particular parts of the city of Paris favoured by these artists), the rapid **emergence** of dealers and private galleries selling non-**commissioned** works to new middle class buyers in a 'free market', within a **society** whose **state** art **academy** and other institutions quite quickly lost power and control over **modern** art and artists forming and **painting** their own social units (e.g.: Claude Monet's *Bathing at La Grenouillère* (1869); Édouard Manet's *Luncheon in the Studio* (1868)). This wider social framework provides a clue to the sense in which those in the contemporary art world *wanted* to project themselves as separate from – and some as increasingly opposed to – a society they saw as corrupt and authoritarian, and hence a danger to contemporary artists committed to **art-for-art's-sake** or **avant-garde** values and practices. A term for this particular social grouping or **formation** in mid- to late-nineteenth-century Paris was 'bohemia', and behaviour called 'bohemian': reference both to a real and supposedly wild place (actually in eastern Europe) *and* to a state of mind, life**style**, and set of values held by its members. The art world in New York in the 1940s, 1950s, and 1960s, from the time of the **abstract expressionists** through to Andy Warhol and **pop**, was probably the most recent, and perhaps last, really believed-in as well as actual place in this bohemian sense.

Further Reading

Baines, Sally *Greenwich Village 1963: Avant-garde Performance and the Efferves-cent Body* (Duke University Press: 1993).

Becker, Howard S. *Art Worlds* (University of California Press: 1982).

Crane, Diane *The Transformation of the Avant-garde: The New York Art World 1940–1985* (University of Chicago Press: 1987).

Harris, Jonathan (ed.) *Art, Money, Parties: New Institutions in the Political Economy of Contemporary Art* (Liverpool University Press/Tate Liverpool: 2004).

ARTEFACT

Term used to **identify** a **humanly** *constructed* object and to distinguish such objects in fundamental ways from all other phenomena found in the **natural** world. Its etymological connection to the word *artifice* indicates its important **analytic^ value** within **art^ history**. *Artifice*, once actually meaning **artwork** (in the seventeenth century), now means something 'false' or 'cunning', but the underlying recognition in the **original** usage was that of an object's *manufacture*: an existence

brought into being through work combining and transforming physical **materials**. A variety of complications certainly attend upon the term, but its chief value is that it differentiates between objects made by human beings in **societies** at particular **historical** moments – objects including artworks, such as **paintings**, **sculptures**, drawings, as well as **architecture** and **design**, **television** programmes and **films** – and a vast range of non-humanly made physical things, such as trees, mountains, sky, and the stars. (Even in these cases, however, there are analytic difficulties: horti**culture**, for example, is the ancient human **practice** of controlling and breeding new kinds of crops, plants, and trees, most recently through sophisticated **forms** of genetic manipulation. While not usually regarded as artworks, then, laboratory-produced **hybrid** varieties of rose or apples *are* clearly artefacts.)

Artefacts range from the crude items made in very early small-scale 'pre-historic' human communities – such as blades for arrow heads and other tools – to the highly elaborate **contemporary** physical **structures** (and amalgamations of structures) such as engines, buildings, roads, cities, and international **communications** systems. All, however, are evidence of human social and cultural life in its **development** thousands of years ago up to the present day. Artefacts may be viewed as documents therefore – as in archaeology – of the purpose, **organisation**, and values of actual human societies as they have evolved, and coexisted alongside each other, for many hundreds of generations.

In the teaching of art history an important distinction should be made between the study of two-dimensional **representations** of artefacts, such as **photographs**, slide projections, and digital data projections (all artefacts themselves), and the study of the artefacts represented within these forms of recording. For instance, a painting, such as Hans the Younger Holbein's *The Ambassadors* (1533), though in one usual sense regarded as a 'two-dimensional' image (a reference to its flat, limited **surface** area containing painted marks – notice the distorted **image** of the skull, visible only when **viewing** the painting from the side, alluding to the flatness of the **picture** as a whole) is clearly actually a physical, three-dimensional artefact, whose size, scale, frame, history of place of **exhibition**, and many other factors relating to its existence, can never be conveyed accurately – if at all – in its photographic representation. Such forms of documentation, while necessary when access to the artefacts in question is not possible, are themselves therefore potentially seriously misleading.

Art history may itself be understood as an artefact, though it is not simply a set of **texts**, or university departments, or **museum** buildings (though these are all part of it). In the broadest **perspective** 'art

history as artefact' has a sense similar to the term **discourse**: a set of activities and meanings adhering in the relationships between objects and people, bound up with ideas, **ideologies**, perceptions, and values.

Further Reading

Baxandall, Michael *The Limewood Sculptors of Renaissance Germany* (Yale University Press: 1982).

Bentmann, R. and M. Muller *The Villa as Hegemonic Architecture* (Humanities Press: 1992).

[multiple authors] 'The Problematics of Collecting and Display', Parts 1 and 2, *Art Bulletin* March 1995: 6–24 and June 1995: 166–85.

Orton, Fred *Figuring Jasper Johns* (Reaktion: 1994).

ARTISAN *ARTISANAL, ARTISANSHIP*

Term for a skilled manual worker and one of a number of both descriptive and **evaluative** words used to **identify** the **producer** of **art, design**, and **craft**^ **artefacts** – the other principal names include **artist, architect**, and craftsman/woman. While these terms still have a place in common usage, along with *artisan* (itself more rarely used now), all four share a **complex**, interconnected **history** and, in **contemporary**^ **society**, retain multiple **meanings** and **values**. *Artisan*, or *artisanal* production, is particularly associated with the social **organisation** of work in **medieval** society, before the **development** of the **renaissance** idea, and **ideal**, of the highly **creative** and individualistic artist. Artisans were highly proficient labourers, trained and accredited collectively within guild **institutions**, who served apprenticeships and could become, in time, **masters** themselves of certain crafts and skilled trades. In the collective production of the great medieval monasteries, castles, and cathedrals (e.g.: the Krak des Chevaliers inland fort in Syria, built by the Knights Hospitallers, 1150–1200), artisans worked in many capacities, including stone-masonry, stained-glass blowing and colouring, plumbing, carpentry, fresco-**painting**, wood and stone bas-relief **sculpting**, brass, silver, and gold masonry, and fabric weaving. Some of these trades – for example, painting and some sculpture practices – were later to become absorbed into the category of art and artistic **practice**.

Artisan, when used today, retains the strong sense of a highly skilled and subtle *maker* – but trained in a workshop, not educated in an **academy**; working alongside others, but not according to a grand **vision** – capable of extremely sophisticated **design** and realising ideas

and values in certain chosen physical **materials**. The distinction between *artisan* and *artist* is sometimes extremely small and disputed: contemporary carvers in clay may produce objects much closer formally to 'fine art' sculpture than to utilitarian (**functional**) or decorative artefacts (e.g.: Halima Cassell's *Celestial Star* (2004)) and sometimes their point is precisely to challenge the distinction itself. The positive use of the term *artisan* indeed has occasionally been intended to offer a contrast to some **modern** and contemporary examples of artists who are clearly **conceivers** or planners of **artworks** (e.g.: works by Joseph Beuys, Richard Serra, and Jeff Koons), rather than themselves the actual *makers* of artefacts with a vocation deeply rooted in their own physical use and transformation of artistic materials. However, it has been the case for hundreds of years that artists have employed artisans, and other artists for that matter, as co-makers within a complex division of artistic labour involving both **conceptual** and material elements – Raphael's studio of painters collaborating on large **commissions** (within a strict hierarchy of jobs according to status) is a particularly well-known case. Within this division and order of labour Raphael clearly remains the **author** (**originator**) of the work in art historical accounts.

Since the **emergence** of **conceptual art** in the twentieth century – including famous examples where *no* physical artefact at all seems to have been fabricated for orthodox **public^** **exhibition** (e.g.: Robert Smithson's 1970 Utah-located rock sculpture *Spiral Jetty*) – important questions have been raised concerning value, meaning, and the transformed purposes of contemporary art.

Further Reading

Buskirk, Martha *The Contingent Object of Contemporary Art* (MIT Press: 2003).
Hauser, Arnold 'Lodge and Guild', in *The Social History of Art*, vol. 1 (Routledge: 1999).
Leach, Bernard 'The Artist Craftsman and Machine Production', in Paul Greenhalgh *Quotations and Sources: On Design and the Decorative Arts* (Manchester University Press: 1993).
Winter, R. (ed.) *Towards a Simple Way of Life: The Arts and Crafts Architects of California* (University of California Press: 1997).

ARTIST *ARTISTIC, ARTISTRY*

Indispensable term in **art historical** and **critical** writing with two separable **meanings**: the first is *descriptive* (e.g.: 'an artist is someone

who makes **paintings** or drawings') and the second heavily-laden with a range of evaluations accrued over centuries of usage (e.g.: when the **abstract expressionist** Barnett Newman said 'the first man was an artist', what he meant was that **humans** were intrinsically **creative** beings). In this second sense, it might be generally agreed, for example, that both Michelangelo and Michael Jordan were *artists* in their own chosen field, however artist in this sense refers *not* to any specific activity but rather to the assurance and excellence (artistry) with which the activity is carried out – be it painting **murals** or playing basketball. An artist in this usage, then, is an excellent performer: the best, the highest achiever, the greatest exponent. This sense indicates very clearly the judgement of **quality** built into the art historical meaning of the term, present since at least Giorgio Vasari's account of the *Lives of the Artists* (1550), written – not coincidentally – in that **epoch** of greatness in **western^ art identified** as the high **renaissance**.

Artist, as the term for the best or greatest, can be clearly differentiated from, and elevated above, at least two others used to describe kinds of **producers** (and people) in **visual^ media**: **artisans** and **craftspeople**. A more recent word – **designer** – interestingly confuses this hierarchy of terms. *Designer* is used, for example, to identify those gifted individuals who conceive, and sometimes themselves fabricate, successful clothes **styles** (e.g.: Alexander McQueen, appointed head designer at Givenchy in 1996), or cars (e.g.: Bruno Sacco, responsible for the 1971 Mercedes 280 SE Cabriolet), or furniture (e.g.: innovative plywood chair designer Ernest Race). *Designer*, then, is used on occasion both to mean the same as 'excellent artist' – as in these examples – but *also* in the descriptive sense to refer simply to someone who works with particular **materials**. In this latter usage it would be possible to say that a particular example was 'a bad artist' or 'a bad designer'.

Artist is also often used as an **abstraction**, after the definite article – as in the phrases '*the* artist in **society**', or '*the* artist is against social conformity'. These usages indicate again the strong evaluative, judgemental, meaning many writers have tried to attach to the term at particular moments in **history**. These have included, for instance, times when certain societies have become highly authoritarian (e.g.: Jacques-Louis David's role as **state** director of the arts in France after the 1789 **revolution**), or, by contrast, transformed by liberatory forces seeking to harness **cultural** intellectuals (e.g.: Kasimir Malevich in Russia after the 1917 Bolshevik revolution). In the **period** of **modernity** and **emergence** of abstract art created by **avant-**

gardes since about 1910 (e.g.: the **cubists)**, the term *artist* has been **subject** to intense rhetorical, socio-political, and philosophical debate. Consequently, it remains confusingly both deeply **ideological** as well as the chief descriptive term for the manufacturers of **artefacts** such as paintings and **sculptures**.

Further Reading

Baxandall, Lee *Radical Perspectives in the Arts* (Penguin: 1972).
Lipton, Eunice *Picasso Criticism 1910–1939: The Making of an Artist Hero* (Garland: 1976).
Williams, Raymond 'Instituted Artists', in Williams, *Culture* (Fontana: 1981).
Witzling, M. A. (ed.) *Voicing Today's Visions: Writings by Contemporary Women Artists*, 2 vols (Women's Press: 1995).

ARTWORK *WORK OF ART*

Term for the **artistic^ artefact**, either in its *finished* **form** (e.g.: John Constable's **painting** *The Haywain* (1821)), or, more complicatedly, for the *process* of its making (work used as a verb). The two elements of this idea, overlapping in **meaning**, raise very **significant** issues and problems in the **historical** study of **art**. In the simpler sense 'work' refers straightforwardly to the thing **created** by the artist, whether it be, for example, a painting, **sculpture**, or drawing. Work functions in this sense as a noun, a fixed thing. In the second sense, however, work – though retaining its meaning as an entity **created** – refers also to the **practices**, skills, ideas, and decisions involved in its **production**. There is a more familiar usage that reflects this second sense when, for instance, a magazine editor might ask 'What stage is the artwork at for the cover story?' This is a reference both to one or more illustrations in preparation, but also to the ongoing range of activities that will result in these finished illustrations becoming the magazine cover.

However, definitions of the process and activities involved in, and claimed to be *relevant* to, the production of *artworks*, are **complex** and sometimes disputed. More **traditional^ art historians** and **critics** might argue that this is simply a matter of the artist's use of certain physical **materials, techniques**, and **compositional** formats: the choice and application of, for example, oil paint using sable brushes on a primed and stretched canvas **surface**. In a **landscape** painting the artist would decide on a scene or motif, perhaps make preparatory pencil sketches, and finally complete the full-scale work of art in the

studio, painting over a lightly drawn outline of the projected scene. A full **analysis** of the artwork here should surely refer to *all* these decisions, preferences, and activities – including drawing outside and moving to the studio – as well as to the actual artefact finally produced by an artist such as Constable.

It is possible to see now how complex 'work of art' as an idea might be: for to account fully for these decisions and preferences would also include understanding and **explaining** *why* they were made by *that* particular person, at *that* historical moment, given the particular set of wider **social** circumstances or conditions *then* in place. For instance, what kind of art **academy** or educational **institution**, if any, did the artist attend? Was the artist a professional – attempting to make a living out of the activity and therefore trying to reach a market of buyers – or an amateur, perhaps with no interest in the preferences of others? Is it possible, or relevant, to know how an artist's **class** and **gender** background, his or her **views** on the English countryside and the people who live there, may have **influenced** their painting? Once these kinds of questions become admitted as relevant and important to understanding the processes and activities involved in the production of artworks – questions that are central to the **social history of art** – then it is possible to see how even the apparently most straightforward art historical ideas and terms pose difficulties and challenges that cannot be avoided by serious scholars.

Further Reading

Barrell, John 'John Constable', in Barrell *The Dark Side of the Landscape* (Cambridge University Press: 1980).

Benjamin, Walter 'The Work of Art in the Age of Mechanical Reproduction', in Benjamin *Illuminations* (Harcourt Brace Jovanovich: 1968).

Harrison, Charles *Essays on Art and Language*, vol. 2 (MIT Press: 2003).

Mainz, Valerie and Griselda Pollock *Work and the Image*, 2 vols (Ashgate: 2000).

AUTHOR *AUTEUR, AUTHORIAL, AUTHORITARIAN, AUTHORITATIVE, AUTHORITY, AUTHORSHIP*

Term designating the person **identified** as responsible for the **production** of a written **text**, with a **meaning** virtually interchangeable with the descriptive sense of **artist** – for example, in the statement: 'The artist [author] Jan Van Eyck **painted** *The Righteous Judges and the*

Knights of Christ scene on the wings of the Ghent altarpiece, completed in 1432'. However, *author* also **signifies** important assumptions about the **nature** and **value** of this responsibility. Though the term *authority* has a range of meanings, its links to *author* and *authorship* are instructive: authors (and artists) are believed to operate control and power in their productions; that is, they have 'authority' over them as their **creations**. Over the centuries since the **renaissance**, however, the *kinds* of authority associated with artists as authors have changed and varied fundamentally.

Artists, as authors of, say, paintings and **sculptures** in the **period** leading up to the renaissance, had control over many **compositional** and technical decisions but usually had to work in accordance with the strict terms set down in their **commissions** by Church and aristocratic **patrons**. These contracts set out the work to be done in great detail, for example, stipulating the scene to be depicted (for instance, a Biblical or **mythological^ narrative**, usually related to the **symbolic** place where the **artwork** would be sited), the **materials** to be used (for instance, specifying kinds and amounts of paint to be used, depending on cost), and the physical location for the work (for instance, a fresco in a particular chapel in a church, painted directly onto the wet plaster of the wall; or onto the ceiling in the chief bedroom of a private house). Donatello's *Herod's Feast*, a gilt bronze relief sculpture on a baptism font in the church of San Giovanni in Siena completed in 1427 indicates how the scene depicted – from the life of John the Baptist – corresponds appropriately with its physical location and theological function.

Authorship in the **modern** sense – control, that is, over the entire creative process – is an idea (and an **ideology**) that emerged in the high renaissance within the first written accounts of Michelangelo, Leonardo da Vinci, and Raphael. Yet these artists were still, on virtually all occasions, working according to contracts. It is true, though, that their fame had spread during their own lifetimes and that their patrons began to give them much more freedom (authority, even perhaps **autonomy**) to work in their own ways. The nineteenth-century **romantic^ ideal** of the unfettered creative artist – lone individual **genius** inspired by an internal **vision** – is partly indebted to such early **art historical** accounts of the greatest renaissance artists. *All* artists as authors, though, have worked (and continue to work) under specific **social^ relations of production and consumption^**, **influenced** by other artists, by **institutions**, and broader societal circumstances. The French word for author, *auteur*, used to describe great movie directors such as Alfred Hitchcock or

Jean-Luc Godard, is intended to signal this individual vision present within what is the collective work process of **film**-making. However, social and historical factors inevitably set limits on all artists' and authors' individual authority and power, as does the activity of those **reading** or **viewing** artworks, who produce **interpretations** according to their own experiences, knowledge, and values.

Further Reading

Benjamin, Walter 'The Author as Producer' (1937), in A. Arato and E. Gebhardt (eds) *The Essential Frankfurt School Reader* (Blackwell: 1978).
Barthes, Roland 'The Death of the Author', in Barthes *Image, Music, Text* (Fontana: 1977).
Christie, J. R. R. and Fred Oron 'Writing on a Text of the Life', in Fred Orton and Griselda Pollock (eds) *Avant-Gardes and Partisans Reviewed* (Manchester University Press: 1996).
Holt, E. G. (ed.) *A Documentary History of Art*, 2 vols (Princeton University Press: 1958).

AUTONOMY *AUTONOMOUS, RELATIVE AUTONOMY*

In **theoretical** accounts of **modern^** art, particularly **abstract^** **painting** and **sculpture** in the twentieth century, *autonomy* designates the separation or distance or freedom from **society** that certain **artworks** have been claimed, by **critics** such as Clive Bell and Clement Greenberg, to have achieved. In some respects autonomy is close to that of the (**originally** early nineteenth century) term **art–for–art's–sake**: the belief or doctrine that modern, and particularly, **avant-garde^** **artists**, in escaping the restricting, old-fashioned **conventions** and limits of **traditional^** **academic** art and its **institutions**, could and should assert a 'freedom to **create**' without reference to the wider society, often perceived as corrupt and decadent. In logical terms, however, it is much more sensible to talk of actual artists – as **human^** **agents** – having autonomy (free will to decide what to do) rather than inanimate **artefacts** such as paintings. In political or philosophical theory (where the term originates), autonomy usually refers to individuals, groups of people, or **nation^-states** – for example, the 'semi-autonomous region' of north-west Spain, home of the Basque people, or the Welsh Assembly in Cardiff, a parliament granted some autonomy from the UK government in Westminster, London.

Paradoxically, the credibility of the notion of the autonomy, or radical separateness, of abstract painting – seen as a source of **aesthetic^ value** set against a corrupt and limiting society (e.g.: **abstract^ expressionist** Barnett Newman's *Ulysses* (1952)) – depends upon the **authority** of a critical claim conferred on particular artworks by interlocutors 'speaking for the work'. In the 1960s modernist critics, such as Greenberg and Michael Fried, for a while achieved this **dominance** over other **interpretations** of artworks by painters Barnett Newman, Kenneth Noland, and Frank Stella. As the examples of Basque and Welsh people suggest, however, autonomy is always a *relative* state and many recent interpretations of abstract painting (some closely relating these artworks to their **social relations of production^ and consumption^**) have since come to argue against the 1960s modernist emphasis on their apparent autonomy, or separateness, from the **culture** and society in which they were **produced**.

One of the **concept's** near-synonyms – distance – clearly suggests the **metaphoric^ quality** always present in the term *autonomy* when used about abstract art. 'Distance' has both spatial and temporal senses and both have an evaluative element: the quality, that is, of being *distant* or 'far away' in place and time. By virtue of appearing not to refer to objects in the real world – objects and people **represented^ naturalistically** and through **narrative^ conventions** in most nineteenth-century art – abstract paintings are claimed to achieve this distance. Rejecting naturalism and narration, many artists in the twentieth century *did* seek radically to question the world, how it looked, how it might be represented, and what it might be said to **mean** (e.g.: Alberto Giacometti's boldly abstract sculpture *Head* (*c.* 1928)). But in each and every case this was a decision made by artists located in specific social and **historical** circumstances, often acting according to an acute sense of how their societies were **organised**, and with a **desire** – sometimes utopian – to see them changed for the better.

Further Reading

Clark, T. J. 'Jackson Pollock's Abstraction', in Serge Guilbaut (ed.) *Reconstructing Modernism: Art in New York, Paris, and Montreal 1945–1964* (MIT Press: 1990).

Frascina, Francis *Art, Politics, and Dissent* (Manchester University Press: 1999).

Harris, Jonathan 'Abstract Expressionism and the Politics of Criticism', in Jonathan Harris, Francis Fascina, Charles Harrison and Paul Wood *Modernism in Dispute: Art Since the Forties* (Yale University Press: 1993).

Schapiro, Meyer 'The Social Bases of Art' (1937), in Mathew Baigell and Julia Williams (eds) *Artists Against War and Fascism: Papers of the First American Artists' Congress* (Rutgers University Press: 1986).

AVANT-GARDE *AVANT-GARDISM, AVANT-GARDIST*

Previously a French military term referring to the outriders who would scout ahead of the main troop of soldiers, *avant-garde* became applied to the **formation** of **artists, critics, patrons**, collectors, and other members of the late-nineteenth-century French **art^ world** thought of as advanced or radical in **aesthetic, social**, and political ways. Some of its **meanings** are close to 'bohemian' (an older term, in use in relation to art in the early nineteenth century). Both words refer to a life**style, symbolised** sometimes by the reputedly eccentric or dishevelled appearance of artists, as well as to their **artworks**, attitudes, and beliefs. The term has changed and broadened from containing a specific and limited **historical** reference – that is, to *some* artists and writers active in a certain time and place (Paris in the *c.* 1850–1900 **period**: e.g.: artist Gustave Courbet, critic and poet Stéphane Mallarmé, writer and **painter** Maurice Denis, art dealer Daniel Kahnweiler) – to being used now in a general and trans-historical manner. In one current usage, for example, virtually all **contemporary** artists – or to qualify this, artists thought to be making art about life now using new **materials, media**, and **techniques** such as **installation art** or DVD – are referred to as avant-garde.

The term in this sense has come to mean the same virtually as 'contemporary art' – with the oddity that **modern** art has increasingly become an historical term, referring to artists and works in the period *c.* 1860–1960. Given that there is no **academic** art now – that is, no art sponsored or championed by a single **state**-run **institutional** authority guarding a notion of **practice** or the purpose of art – *avant-garde* has actually lost its fundamental **original** sense, which implied a challenge posed to **traditional** artists and official art **institutions** such as the Académie des Beaux-Arts and the annual Salon **exhibitions** in Paris. Nineteenth-century avant-garde painters, such as Courbet and Camille Pissarro, set out to oppose – in artistic and political terms – the **social order** in France, dominated in this period (*c.* 1850–1900) by the conjoined powers of the monarchy and the Catholic church, subsequent republican government administrations, and the commercial bourgeoisie. Both were **revolutionary** socialists and their paintings of workers on the land were intended as

what might be called **visual** criticisms of the **capitalist^ social order** in France (e.g.: Courbet's *The Stonebreakers* (1849) and Pissarro's *The Apple Eaters* (1886)).

By the 1960s modernist critics had begun to attack the continued use of the term *avant-garde* to refer to contemporary art, while, at the same time, they reconfirmed its specific historical **value** in relation to French art in the later nineteenth century. Clement Greenberg, for example, wrote of the shallow 'avant-gard**ism**' or 'avant-gardist' **manners**, **fashions**, and pretensions of some abstract artists, in a time when the impetus for genuine aesthetic innovation in modernist art, at least as far as Greenberg himself was concerned, had waned. He attacked, particularly, what was called the 'second generation' of **abstract expressionist** artists – painters, Greenberg believed, who slavishly adopted the **conventions** of earlier artists, such as Jackson Pollock and Willem de Kooning.

Further Reading

Clark, T. J. 'We Field-Women', in Clark, *Farewell to an Idea: Episodes from a History of Modernism* (Yale University Press: 1999).

Greenberg, Clement 'The Avant-Garde and Modernism', in Robert C. Morgan (ed.) *Clement Greenberg: Late Writings* (University of Minnesota Press: 2003).

Harris, Jonathan *Writing Back to Modern Art: After Greenberg, Fried, and Clark* (Routledge: 2005).

Orton, Fred and Griselda Pollock 'Avant-Gardes and Partisans Reviewed', in Orton and Pollock *Avant-Gardes and Partisans Reviewed* (Manchester University Press: 1996).

BAROQUE *NEO-BAROQUE*

One of the great **epochal^ concepts** in **western^ art history** concerned with the post-**medieval^ period** in Europe, containing interconnected **stylistic** and **socio**-political **meanings**, and part of the sequence spanning about four hundred years that runs **renaissance → mannerism →** *baroque* **→ rococo → neoclassicism → romanticism → realism**. Possibly from the Portuguese word *barroco*, meaning a misshapen pearl, the term, **originally** used with derogatory overtones, is applied to **architecture** (particularly that of Gianlorenzo Bernini and Francesco Borromini), **sculpture**, and **painting** – often containing dramatic architecture **imagery** – **produced** between *c.* 1575–1750. Bernini and Borromini were almost

exact **contemporaries** and rivals, **designing** buildings for both Church and **state**, and based in Rome – the centre of Catholicism and the political hub of what eventually became the nation-state of Italy. Bernini's Santa Andrea at Quirinale in Rome (1658-70) is regarded as a perfectly unified architectural setting for the religious experiences intended to be **created** by the sculptural decoration inside the church. Borromini, who worked for a time under Bernini, loved **technical** perfection and the use of startling **perspectival** devices, such as the **illusionistic** *trompe l'oeil* (literally 'deceive the eye') elements in the arcade he built at Palazzo Spada near Rome (after 1647).

The reference to a 'misshapen pearl' suggests the view that baroque art **forms** – highly geometrically-ordered, using **real** and **pictorial** space in **complexly** combined decorative, dramatic, and **symbolic** ways – relied upon the technical innovations of renaissance art yet increasingly tended to use these resources in a showy and exploitative manner (e.g.: Giacomo della Porta's early baroque church Il Gesu in Rome (*c.* 1575); Peter Paul Rubens' painting *The Betrothal of St. Catherine* (1628)). Another suggested origin for the word, given this brief stylistic description, is that *baroque* comes from the **medieval** Italian word *barocco*, meaning a convoluted argument or thought. Baroque orchestrations of space, those both architectural and illusionistic, are often highly theatrical and emotive, **designed** literally and **metaphorically** to 'transport' the **viewer** to what seems like a perfectly harmonious physical realm – the spatial geometry of circles, squares, ellipses – evoking Christian spiritual connotations.

Baroque art and architecture, at least in its earlier phase, is closely associated with the events of the counter-reformation in the western Christian church. This **development**, symbolised by the declarations of the 'Council of Trent' in 1545–63, attempted to re-impose the power of the Roman Catholic popes over the church as a whole. Earlier 'Protestant' attacks on the spiritual and political corruptions of the Roman church – most famously those of Luther – had called for simple devotion to a personal God, freed from **institutional** dogma and mystifying religious art. Baroque art, in opposition to this, and **influenced** particularly by the Catholic Jesuit order, sought to evangelise (preach the gospels to) the laity and reconnect ordinary people spiritually and **ideologically** to Rome. In that sense early baroque art was a kind of ecclesiastical propaganda, though it found diverse forms and specific socio-political connotations across the many Catholic European countries and regions that supported its development – though all shared autocratic political systems.

Further Reading

Hauser, Arnold 'The Concept of the Baroque', 'The Baroque of the Catholic Courts', and 'The Baroque of the Protestant Bourgeoisie', in Hauser, *The Social History of Art*, vol. 3 (Routledge: 1999).

Hempel, E. *Baroque Art and Architecture in Central Europe* (Penguin: 1965).

Varriano, J. *Italian Baroque and Rococo Architecture* (Oxford University Press: 1986).

Wölfflin, Heinrich *Renaissance and Baroque* (Cornell University Press: 1966).

BAUHAUS

An amalgamation of the Weimar **Academy** of Fine **Arts** and the Weimar School of Arts and **Crafts**, *bauhaus* was the name for a teaching **institution** set up in 1919 in Weimar, Germany, by the **architect** Walter Gropius. His aim was to **create** an art school that would unify the full range of artistic disciplines, particularly bringing together the **visual** arts and architecture. The bauhaus's ethos and working methods were **modernist**, and closely linked to **avant-garde^** **developments** in **painting**, **sculpture**, and building construction. In one sense, Gropius's aim was to do away with the distinction between art and craft, or, to put it another way, between the **symbolic** and decorative (**functional**) use of **materials** and **production** processes. All of these important **concepts** were undergoing radical review, challenge, and change: exploration of the then **emergent** concept of **design** – with its radical political and **social**, as well as **compositional** and artistic **meanings** – was the bauhaus's real legacy to art and **art history** in **theoretical** terms. Design, in bauhaus thinking, meant a systematic process of planning at a theoretical-philosophical level, yet this ambitious conceptualisation was intimately tied to experimentation with the use of **modern** materials and production methods.

The bauhaus also sought to introduce design principles and methods suitable for machine **mass**-production, an aim underpinning its clearly radical ambitions. In this sense the bauhaus embraced industrialisation and the rapid **development** of new materials and **technologies** for construction in building and product design. Its two principle courses – one studying materials and techniques of fabrication, the other an intellectual **analysis** of **formal** innovation in **contemporary** art and design – became the basis for modernist arts and crafts teaching in the visual arts throughout the world. This **influence** is retained within the majority of 'foundation' courses

taught in art and design today. The ethos of these programmes emphasises that students should initially encounter a wide range of arts and crafts **practices**, learn skills and aptitudes across several disciplines, and be able to understand and **value** all stages of work in design development and production.

It is perhaps not surprising that the bauhaus became associated with left-wing political **ideology**, and was closed down by the nazis when they came to power in Germany in 1933, eight years after the school had moved to Dessau and another architect, Ludwig Mies van der Rohe, had replaced Gropius as its director. Many of its most famous teachers (often Jewish) had earlier been supporters of communist **ideals** as well as makers of avant-garde art – including Wassily Kandinsky, Lyonel Feininger, Josef Albers, Paul Klee, and Oskar Schlemmer. The painter, sculptor, **photographer**, and metalworker László Moholy-Nagy headed a reformed bauhaus established on the other side of the Atlantic Ocean in Chicago, USA, in 1937, as many thousands of modernist artists and designers moved to that country to escape nazi Germany and the coming war in Europe.

Further Reading

Franciscono, M. *Walter Gropius and the Creation of the Bauhaus in Weimar German* (University of Illinois Press: 1971).

Naylor, Gillian *The Bauhaus Reassessed: Sources and Design Theory* (Herbert Press: 1985).

Weltge, S. W. *Bauhaus Textiles: Women Artists and the Weaving Workshops* (Thames and Hudson: 1993).

Wingler, H. M. *The Bauhaus – Weimar, Dessau, Berlin, Chicago* (MIT Press: 1977).

BEAUTY/UGLINESS *BEAUTIFUL/UGLY*

The term *beauty*, central to accounts of the **meaning** and purpose of **western^** art since the **renaissance,** and closely related to a number of terms include harmony and **compositional^ order**, became, by the mid twentieth century, virtually redundant – at least in its inherited, recognisable **forms**. While a Piet Mondrian **abstract^ painting** such as *Composition with Red, Black, Blue, Yellow, and Grey* (1920) could still be called beautiful in its subtle combination of pattern and colours, it's hard to use the term instinctively about, say, a Henry Moore **sculpture** (e.g.: *Recumbent Figure* (1938)), Jean Dubuffet's *Corps de Dames* series of crude paint/collage **images** (1950–1), or

Francis Bacon's (perhaps deliberately repellent) oil *Portrait of Isabel Rawsthorne* (1966). The rejection of **conventional** senses of beauty in **modern^** art is unintelligible without an understanding of the shift that **avant-garde^** **artists** and modernist **criticism** brought about – though earlier **developments** in **realism** in nineteenth-century French painting, particularly that of Gustave Courbet, are also important. In contrast, much amateur recent and **contemporary** art – that is, made by artists *not* trained in art **institutions** over the past fifty years – is still **produced** according to principles of beauty based on **ideals** and **values** traceable back to the renaissance. **Landscapes, portraits,** and **nudes** – all genres with long **histories** – tend to **dominate** within this kind of art.

Beauty in **traditional** terms was a matter of rational **design** and the *appropriateness* of this design to the **subject matter** being depicted. Leon Baptista Alberti's treatise on painting *Della Pittura* [*On Painting*] (1435), usually regarded as the first such setting down of rules, argues that the making of a **picture** is a matter of orchestrating all the elements together: the **creation** of an 'istoria' or **narrative** that perfectly combines **figurative** (pictorial) and **symbolic** features. In a religious scene, for example, the depicted gestures of a particular character – for example, the serenity and modesty of the mother of the Virgin Mary, in Domenico Ghirlandajo's wall-painting *Birth of the Virgin* (in the church of Santa Maria Novella in Florence, 1491) – were to be in keeping with her role within the Holy Family. Beauty, or harmony and compositional order (and their opposites: ugliness, disharmony and compositional disorder), were matters of the fit, or the lack of it, between form and **subject**. This fittingness was a **social** and institutional, as well as an **aesthetic**, matter: knowledge of the meaning of symbols and characters in religious painting, or in **mythology**, was in large part **public** and agreed. Art institutions up until the late nineteenth century conserved, transmitted, and defended the value of such knowledge.

Modern art broke with this conventional understanding of the purpose of art. Its typical subjects – contemporary, secular, ordinary life – rejected both the **technical** means of production and the religious, historical, and propagandistic themes of **academic** art. **Impressionist** painting provides many examples (e.g.: Gustave Caillebotte's *Le Pont de l' Europe* (1876)). Some of Honoré Daumier's earlier realist **pictures** (e.g.: *Washerwoman* (1863)) indicate this development presciently. Though many avant-garde pictures made in the twentieth century may certainly be described as beautiful, they were usually not produced with the **intention** of exemplifying some

preordained notion of beauty. Many others, of course, were intended to be seen as shocking, or even actually ugly (e.g.: Pablo Picasso's *Les Demoiselles d'Avignon* (1907)).

Further Reading

Bull, Malcolm 'The Ectsasy of Philistinism', in Dave Beech and John Roberts (eds.) *The Philistine Controversy* (Verso: 2002).
Richter, Hans *Dada: Art and Anti-Art* (Oxford University Press: 1965).
Thompson, M. *Rubbish Theory* (Clarendon Press: 1972).
Winckelmann, Johann Joachim *The History of Ancient Art* (1880), extracts in David Irwin (ed.) *Winckelmann, Writings on Art* (Phaidon: 1972).

BODY *BODILY, EMBODY, EMBODIMENT*

In both literal and **metaphoric** ways, *body* (that is, the **material^ human** body, alive and dead) has a range of highly important **subjective** and objective **meanings** in **art**, as well as in **art history**. In its *literal* sense, the body has, since the ancient **origins** of human **visual^ representation**, been both the resource that **produced** such **artefacts** and **images** – through hand-tool **sculpting^ techniques** and hand-inscribed **pictorial^ imagery** – and their chief **subject matter** (e.g.: sculpted **portrait** head of limestone, found in a tomb at Gizeh, Egypt, *c.* 2700 BCE; two bronze warrior statues of Riace, near Reggio, in southern Italy, *c.* 460–450 BCE; after Ku K'ai-Chi, *Husband Reproving His Wife*, silk scroll drawing, CE 406). Even when apparently absent entirely, in, for example, **modern^ abstract^ painting** and sculpture, these non-**figurative^ forms** and **signs** have come to signal, amongst other things, the body's necessary role in the human capacity, through the senses, to experience space (e.g.: Mark Rothko's *Violet, Black, Orange, Yellow on White and Red* (1949)). Figurative means 'of the figure' and figure – though in one sense referring to *any* isolated mark or element – is another key metaphor for the human body. In a Jackson Pollock drip-painting, for example, though *no* body is depicted illusionistically, the method of applying paint – via pourings, splatterings, and flickings – tells us much, indexically (see **semiology**), about the placement and movement of Pollock's own body around the canvas located on the ground as he marked its **surface** with paint (e.g.: *Autumn Rhythm* (1950)).

In one of its *metaphorical* senses, *body* has a crucial art historical meaning: the organised – ordered – entity of the **composition** itself,

whether this is, for example, the body of a sculpture, or drawing, or a building. Body in this sense means articulated, coherent, and balanced. It is possible to see the links, then, from **ideal** notions of the body to **traditional^ theories** of beauty and composition. In ancient art, and in the **renaissance's** adaptation and **development** of these forms, the human body was thought of as the measure and map of harmony in sculptures and pictures. **Narrative** actions and **symbolic** meanings of all kinds in art from the renaissance up to the beginnings of modernism (and beyond in many cases) have been conveyed principally through depictions of human bodies, both in isolation and in relation to each other.

The body has gone on being a central theme in **postmodernist** art, in terms of techniques of mark-making, philosophical themes, and symbolic treatments. Women's bodies, in particular, became the subject for much work – including **performance art**, some of which rejected traditional media altogether – providing both a **critique** of the representation of perfect bodies in earlier art and, often with the use of written **text**, showing **contemporary** bodies de-idealised in various ways (e.g.: Barbara Kruger's **photographic** silkscreen *Untitled* ('Your Body is a Battleground') (1989)).

Further Reading

Adler, Kathleen and Marcia Pointon (eds.) *The Body Imagined: The Human Form and Visual Culture Since the Renaissance* (Cambridge University Press: 1993).

Jones, Amelia (ed.) *Body Art/Performing the Subject* (University of Minnesota Press: 1998).

Heathfield, Adrian (ed.) *Live: Art and Performance* (Tate Publishing: 2004).

Potts, Alex *Flesh and the Ideal: Winckelmann and the Origins of Art History* (Yale University Press: 1994).

BYZANTINE

One of **art^ history's** great **epochal^ concepts** – within the broad and **conventional** chronological sequence that includes **renaissance** and **baroque** –referring to art **produced** in the Roman and *byzantine* empires, in the **period** *c.* CE 330–1450. The mosaic from the Basilica of S. Apollinare Nuovo, in Ravenna, depicting 'The Miracle of the Loaves and Fishes' (*c.* CE 520), exemplifies the highly schematic, doll-like **imagery** of men and physiognomic (**bodily**) gestures associated with byzantine **visual^ culture**. *Byzantine* has a second,

now fairly rare, adjectival **meaning** when the term is used across a much broader span of time to **identify** various types of unchanging, very **stylised**, or 'hieratic' **visual^ representations**, usually of religious themes. In both kinds of usage, however, it is often the case that the term denotes stylistic elements *and* the kind of **society** in which this art was produced.

For instance, in some **sociological** studies of art – including simplistic **marxist** accounts – it has been claimed that the former (the schematic, stylised visual character) is a direct reflection, and consequence, of the latter (the frozen **social order**): that a hieratic, 'flat' representational idiom, apparently showing little or no **development** over many centuries, demonstrates the suffocating **nature** of the immobile, socially-fixed, and autocratic **social order** responsible for it.

Byzantine art, in its strict period meaning, includes buildings and **sculptures**, along with wall-**paintings**, illuminated manuscripts, panel-paintings, and, above all, mosaics, within all of which was preserved aspects of formal **composition** and **mythological^ narrative** from the arts of **classical** antiquity (consider, for example, the 'Great Trajanic Frieze' battle scene incorporated in the Arch of Constantine at Rome in CE 312). These **artworks** are to be found in regions over a wide area in greater Europe and Asia Minor, including those that are now part of Italy, the Balkan states, and southern Russia. Art historians now believe that quite a high degree of innovation and change actually can be discerned in the development of byzantine art, particularly in its phases in the twelfth and thirteenth centuries. Talk of a 'renaissance' in late-byzantine art reflects the **traditional** art historical **perspective** – similar to claims made about later Italian and northern European art – that it, too, began to become more **naturalistic**, and correspondingly less decorative, both in aim and **formal** character. Art historical epochal terms, as this qualification implies, are necessarily **abstract** and rather fluid – as byzantine passes to romanesque and **gothic**, and from the latter to the so-called 'early' renaissance of the fifteenth century.

In its second sense, identifying various styles through **history** that included highly fixed formal compositional features, *byzantine* came to mean almost the same as **primitive** – a term given positive meanings by **avant-garde** artists and **modernist^ critics** around 1900. For them, such art, along with what they took to be its powerful mystical religiosity, **symbolised^ emergent^ expressionistic** notions of visual and emotional truth, freed from the constraints and conservatism of **academic** dogma. There is, then, it could be said, a byzantine element to modern *primitivist* art (e.g.: Émile Bernard's

painting *Breton Women in A Meadow* or *Le Pardon* (1888) and Ernst Ludwig Kirchner's *Bathers in a Room* (1909–10)).

Further Reading

Beckworth, J. *Early Christian and Byzantine Art* (Penguin: 1970).
Cormack, R. *Byzantine Art* (Oxford University Press: 2000).
Kitzinger, E. (ed.) *The Art of Byzantium and the Medieval West* (University of Indiana Press: 1976).
Nelson, R. S. 'The Discourse of Icons: Then and Now', *Art History* June 1989: 144–57.

CANON *CANONICAL*

Term **originally** within fourth-century Christian **discourse** referring to written **texts** given **authoritative** theological status (that is, Truths from God), the *canon*, or *canonical*, as **art^ historical** terms, refer to the group of **artefacts** awarded especial importance or **value**. As a noun the term is used to **identify** specific items (usually **paintings**, drawings, prints, and **sculptures**) claimed to **embody** the highest possible **artistic** achievement. Though *canon*, in this sense, has been adapted in the twentieth century for use in relation potentially to virtually all other kinds of **visual^-cultural** artefact (e.g.: canonical or **classic, films, designer** cars and items of furniture, etc.), the original art historical use (probably in the seventeenth century) – limited to **traditional** artistic media – implied that an artefact, such as an oil painting, placed within the canon was unique, original, inimitable, and unrepeatable. Leonardo da Vinci's painting of the *Mona Lisa* (1503) has come to **symbolise** the canon of great visual art.

Canon has close affinity to the terms **genius** and *classical* which offer, respectively, the categorical name for the **producer** of such exceptional artefacts and the set of extraordinary **qualities** that such an artefact must possess to merit inclusion in the canon. (Canon had another **meaning** in relation to Egyptian art where it referred to the system of **conventions** established for deciding proportion, scale, and decorum.) When used as an adjective – to describe actual features of an artefact – canonical refers explicitly to evaluative criteria and their actual application in art historical accounts: for example, 'canonically beautiful' or 'canonically well-proportioned'. Interestingly, while traditional art historians often claimed that the **artworks** of geniuses were self-evidently great, or **masterpieces** (virtually the

same as saying 'belonging to the canon'), canonical at the same time draws attention to the *process* of identifying the qualities that canonical artefacts must exhibit – skill, **beauty**, inspiration, **vision**, **complexity**, etc. This work of identification – both of qualities and artefacts – is always done by **influential^ mediators** and mediating **institutions** in the **art world**: for example, **critics**, **curators**, and the fields of expert knowledge involved in the purchase and **exhibition** of such artefacts by **museums** and galleries. All these **agents** and institutions are involved, then, in the active process of **interpretation** and evaluation. Artworks, that is, can't get to be canonical *by themselves*.

While **critiques** of the process of canon **formation** are correct in establishing that all canons are the result of an evaluative interpretation necessarily based on the interests, values, **desires**, and beliefs of those making judgements, they have been less concerned, to deal with several questions raised by those who support the upholding of canons – or, at least, believe that questions to do with value, **taste**, and **civilisation** (however defined) should be asked and answered. For instance, is the process of evaluating artefacts itself wrong? If the answer to this question is 'yes' then it is difficult to see how any kind of intellectual or educational work can be justified, as the selection of things to study already implies some prior judgements have been made about which artefacts, producers, **movements**, authors, etc., are worthy of attention in the first place. If the answer is 'no', then the challenging and important task of exploring different and sometimes clashing criteria of judgement can begin.

Further Reading

Brettel, Richard (ed.) 'Rethinking the Canon: A Range of Critical Perspectives', *Art Bulletin* June 1996: 198–217.
Kermode, Frank *The Classic* (Faber and Faber: 1975).
Leaman, Michael R. 'Cultural Value and the Aesthetics of Publishing' in 'Money, Power, and the History of Art: A Range of Critical Perspectives', *Art Bulletin* March 1997: 11–14.
Pollock, Griselda *Differencing the Canon: Feminist Desire and the Writing of Art's Histories* (Routledge: 1999).

CAPITALISM *CAPITALIST, CAPITALIST SYSTEM, CAPITAL MODE OF PRODUCTION*

Term for the overall system, or **structure**, of economic, **social**, and political relationships derived from the private ownership and control

of financial and material wealth – a system **dominant** within **western** societies in Europe and North America since the mid nineteenth century. **Modern^ art** has been **produced**, exchanged, and **consumed** within, and as part of, *capitalist* society since the 1860s. In the early-nineteenth-century *capitalism* promoted an industrial **revolution** based on factory **mass** production, the exploitation of a huge impoverished working **class**, and the construction of a permanent **state** apparatus to regulate the system as a whole. In its earlier, commercial mode – the exchange of goods for financial profit, or what Karl Marx called 'surplus **value**' – capitalism has been in existence for a much longer **historical^ period**.

The **renaissance** is, in part, the name for the social **development** that sees the **emergence** of movable, sellable, *commodified* easel-**paintings** as part of the rise of secular, as **opposed** to religious, art. Capitalism as a mode of **cultural** production – that is, as a set of relationships between independent makers and buyers of art objects (commodities), later involving various intermediaries such as dealers – became increasingly powerful in the **epoch** from the sixteenth to the nineteenth centuries, though other **social relations of production and consumption** (for instance, those involving **traditional** forms of direct **patronage** by the Church and aristocracy) coexisted along with them. By the mid nineteenth century some European societies as a whole – England above all – had evolved **social orders** that were decisively shaped by the needs of capitalist accumulation (for example, the **creation** and maintenance of foreign empires in order to extract raw **materials** for goods produced and sold in northern Europe).

While it is a commonplace, then, straightforwardly to call these societies – and later the US – capitalist, it is clear that *other* social and political relationships, **institutions**, and forces remain **influential** within these social orders. This is evident in the situation and development of the **visual** arts over the last five hundred years. The Christian Church and the civic institutions of **nation**-states (e.g.: monarchies and parliaments) persisted throughout the sixteenth to the nineteenth centuries in western Europe – though the Church's power became increasingly **residual**, and secular state institutions much more significant. The influence of art **academies** established in Italy, France, and England from the renaissance onwards indicate growing state control: the genre of **history painting** is, amongst other things, a propagandistic celebration of monarchies, a championing of subsequent revolutions against autocracy, and, later, the commemoration of parliamentary democratic institutions and causes (e.g.: Diego Velazquez, *Prince Philip Prosper of Spain* (*c.* 1660); Jacques-Louis

David, *Oath of the Horatii* (1784); and Benjamin Robert Haydon, *The Anti-Slavery Society Convention 1840* (1841)).

However, by the third quarter of the nineteenth century some **artists** began to turn against what they saw as their own corrupt and corrupting societies. **Avant-garde** painters of the time, anti-academic and some socio-politically radical, attempted to reject the **conventions** and values of the capitalist, imperial nation-states of western Europe, but found themselves enmeshed – socially marginal and isolated – within the 'free market' that capitalism had, by then, made general (see e.g.: Gustave Courbet's *The Stonebreakers* (1849); Jean-François Millet's *Man with a Hoe* (1862); Paul Gauguin's *Seaweed Gatherers* (1889)).

Further Reading

Clark, T. J. *The Painting of Modern Life: Paris in the Art of Manet and His Followers* (Princeton University Press: 1984).

Harris, Jonathan 'Capitalist Modernity, the Nation-state and Visual Representation', in Harris *The New Art History: A Critical Introduction* (Routledge: 2001).

Marx, Karl *Wage Labour and Capital* (1891) (Progress Publishers: 1978).

Miliband, Ralph *Marxism and Politics* (Oxford University Press: 1977).

CAREER *CAREERISM, CAREERIST*

Simply factual, as the notion of 'a career as an **artist**' sounds, the **concept** of *career* – involving the professionalisation of an activity – became applied to those who **produce^ art** only in the later nineteenth century. The term's early-nineteenth-century **meaning** of a 'course or **progress** through life or **history**' implied neither of the two elements that now **dominate** its **meaning**: that the career is (1) a means of attaining a sufficient financial income; and (2) a commitment to a single lifelong pursuit. To have a career, in *this* sense, as an **artist**, meant to be able to work, continuously, producing and selling **artworks**, and not to have to rely on other **forms** of income. It is likely that, since the 1880s, only a tiny proportion of those called or calling themselves artists have ever managed to secure these conditions. Even many artists subsequently accorded very high status by **critics** and **historians** failed in their own lifetimes to make art their career in this professional sense.

In fact, the term *artist* presents some serious **theoretical** problems of its own. Unlike **painter** or **sculptor**, it specifies *not* a **practical** activity (thought it implies one or more), but rather suggests a kind of voca-

tion or calling. Some of the roots of this **ideal** lie in the **renaissance**, and in nineteenth-century **romantic^ interpretations** of artworks produced by acclaimed **geniuses** such as Leonardo da Vinci or Michelangelo – for instance, the latter's emotional intensity (*terribilità*) and striving for absolute perfection held to characterise his sculptural and **architectural** projects, such as the Medici Chapel and the Laurenziana Library in Florence (begun in 1520). Of course, **myths** and idealisations surround many jobs in **society** – such as those of airline pilot and heart-surgeon – but the difference is that, in economic terms, artists have *not* typically worked under continuous contractual or wage-labour conditions, receiving weekly or monthly salary payments. When these arrangements *have*, quite rarely, been imposed on those producing paintings, sculptures, and prints – for instance, under the New Deal Federal Art Project in the US in the 1930s, during the Great Depression – many **contemporary** art critics and other commentators claimed this invalidated their status precisely as artists in the idealised vocational sense. The **modern** myth, or **ideology**, of the artist, that is, is that he (and usually the mythic artist *is* a man) works not – *never* – for profit, or even simply for an income to live on, but for the intrinsic **aesthetic** and spiritual **value** of **creative** activity itself.

Since the heyday of such idealism (probably ending in the very early 1960s), a new generation of **avant-garde** artists – associated with **pop** – reversed this direction and made sustained attempts to emphasise that, at least in some respects, their work was similar, if not **identical**, to all others in modern **capitalist** societies. Andy Warhol's silkscreen prints of Coke bottles and *brillo* soap boxes, using some newly available **reproduction^ techniques** to **represent** industrially **mass**-produced commodities – fabricated in the studio he pointedly renamed a 'factory' – are an obvious case in point (e.g.: *Soup Cans* (1962–65), *Coca-cola Bottles* (1962), and *Dollar Bills* (1962–63)).

Further Reading

Greer, Germaine *The Obstacle Race: The Fortunes of Women Painters and their Work* (Farrar Straus Giroux: 1979).

Harris, Jonathan 'The Depression and the New Deal', in Harris *Federal Art and National Culture: The Politics of Identity in New Deal America* (Cambridge University Press: 1995).

Orton, Fred and Griselda Pollock 'Rooted in the Earth: A van Gogh Primer', in Orton and Pollock *Avant-Gardes and Partisans Reviewed* (Manchester University Press: 1996).

White, Harrison and Cynthia White *Canvases and Careers: Institutional Change in the French Painting World* (University of Chicago Press: 1993).

CINEMA *CINEMATIC, CINEMATOGRAPHER, CINEMATOGRAPHY*

A French word, anglicised in the early twentieth century, and used – particularly in Britain – to designate both moving **films** *and* the whole network of **institutions** and **agents** involved in film **production**. *Cinema* exists in an interesting contrast to the American term *movies* which is generally limited only to actual films (though it also implies the *venue* in which the film is to be viewed – as in 'going to the movies'). In Britain, cinema, in a very restricted sense referring to an actual building in which films are shown, has the same **meaning** as the American 'movie house'. The phrases 'French cinema' or 'Spanish cinema', however, indicate the broader British usage: they refer, that is, to a **culture** of film-making. This includes: actual films; the **styles**, **techniques**, and **conventions** of their production; the **significance** of particular directors and camera-operators (or 'cinematographers', to use the **original** technical and professional designation); and, beyond these elements, a range of **socio^-historical** characteristics believed to have **influenced** a particular cinematic culture. Generally such cultures of cinema are given **national^ identities**. However, there are some, at least partial, exceptions – for instance 'New Wave' or 'Neo-realist' cinema, though these tend, too, to be qualified via national **identifications**, for example, *French* new wave, *Italian* neo-realism.

Cinematic, in one of its current **specialised** senses, refers not to *actual* films or filmic techniques, but rather to the appearance or **look** of a particular **visual representation** or style of visual representation. For instance, it is routinely claimed that the **paintings** of Edward Hopper have something of a cinematic – or filmic – **quality** to them, though it is in the character of such claims that the details of this look usually remain both elusive (hard to specify) and allusive (open to multiple **interpretation**). In Hopper's **pictures** (e.g.: *House by the Railroad* (1925)), the perceived qualities of depicted light or sense of stillness are often referred to as in some way cinematic. These perceptions are, in general terms, reference to how time and movement appear to be represented – or *not* represented – in various kinds of static visual **art^ forms**. Cindy Sherman's **photographs**, for example showing models posing in windows or on beds, have also been called cinematic (e.g.: *Film Stills, No. 6* (1977)). This time, however, the suggestion is that some, again elusive and allusive, **narrative** moment is conveyed reminiscent of certain **genres** in Hollywood film – rather than that these photographs are clearly based upon *particular* still **images** from actual films.

50

Interestingly, the notion of 'Hollywood film' or 'Hollywood cinema' refers, again, to a culture of cinema located in a particular nation (actually in the area of Los Angeles, in California, USA). However, because Hollywood films, in terms of distribution as well as quantity of production, have become massively *inter*-nationally **dominant** – large corporate-**capitalist^ organisations** own the production facilities, the technology for their **mass^-reproduction**, distribution agencies, *and* the cinemas around the world in which they will be **viewed** – it is, in one sense, understandable that their character and impact cannot be restricted to, or seen in terms only of, a specifically American culture or **society**. Hollywood cinema, then, is clearly an example of **cultural imperialism** and as such has come to **symbolise** both the best and worst aspects of American society in the twentieth century.

Further Reading

Bazin, A. *What Is Cinema?*, vol. 1 (University of California Press: 1967).
de Lauretis, T. and S. Heath (eds) *The Cinematic Apparatus* (St. Martin's Press: 1980).
Hayward, Susan *Cinema Studies: The Key Concepts* (Routledge: 2000).
Ort, J. *Cinema and Modernity* (Polity Press: 1993).

CIVILISATION *CIVILISED, CIVILISING, CIVIL, CIVILIAN, UNCIVIL*

Mahatma Ghandi, leader of the Indian Independence movement in the 1940s, when asked what he thought about western *civilisation*, famously replied 'it would be a good idea'. This clever riposte indicates the central importance of, and problem with, this **concept**: it is often *proposed* as an achieved state, **embodying** some **ideal^ values**, and yet – as a claim about an actual place where the situation is said to exist – remains intrinsically questionable. Civilisation, then, is really always an assertion, rather than a matter of agreed fact: the term rhetorically and **subjectively** *claims* a state of affairs (in ancient Greece or Rome, or Britain or the US?), rather than refers to one that could ever be shown to be undeniably true. As such, the notion has profound implications, because, in the **west** since at least the **renaissance**, **visual^ art** has been claimed as one of civilisation's chief **cultural** manifestations.

There is, however, a more neutral-sounding and relative **meaning** for *civilisation* that complicates the issue. Civilisation in this **alternative**

sense refers instead to the actual **human**, **material** world of both **historical** and **contemporary**^ **societies**. This would include, for example: cities, transport and **communications** systems; **institutions**, laws and **social order**; available resources, **technology**, and skills; cultural **forms** and **practices** of all kinds, including family and kinship **structures**. In this admittedly limited sense, civilisation can be agreed to have negative as well as positive properties. For example, in this kind of civilisation – **meaning** almost the same as **modern** society – you will probably be able to find the highly skilled heart-surgeon you need to deal with your coronary attack, but you may well get mugged on the way to the hospital (or die when the ambulance gets stuck in a traffic jam or a power cut halts your operation).

The composite term 'western civilisation' – as proposed within **traditional**^ **art historical** accounts, such as Kenneth Clark's famous study – firmly places great art, typically made by lone artistic **geniuses**, at the top of an entire civilisation. Their **artworks**, such accounts assert, achieved **canonical** status, and, though **created** within specific historical societies, managed to rise above these contingent conditions and become trans-historical, ideal, and universal in value. In fact, this kind of judgement was made by art historians only comparatively recently – probably in the period from about 1930–70 – and itself reflected the power that some middle **class**, usually white, male **academics** in certain societies (western European and the US, in particular) had themselves achieved in being able to assert the economic, political, and military supremacy of their own *particular* civilisations/societies. They then traced what they believed were the roots of these modern empires back through history, as far as the European renaissance, and, in some cases, even further.

Since the 1970s, **postmodernist** art, art history, and cultural **theory** – within a broader intellectual framework called **postcolonial studies** – has set about attacking this implicitly imperialist notion of civilisation, working in association with people outside **academic**^ **institutions**, like Ghandi and his followers, who had fought for the end of the *uncivil* British empire in India after the Second World War.

Further Reading

Araeen, Rasheed, Shaun Cubitt, and Ziauddin Sardar (eds) *Third Text Reader on Art, Culture, and Theory* (Continuum: 2002).

Clark, Kenneth *Civilisation: A Personal View* (Harper and Row: 1969).

Fox, R. G. (ed.) *Nationalist Ideologies and the Production of National Cultures* (American Anthropological Association: 1990).

Freud, Sigmund *Civilisation and its Discontents* (1930) (Norton and Co.: 1961).

CLASSICAL/CLASS *CLASSIC, CLASSY*

Having senses that are apparently both neutral *and* highly laden with judgemental **meanings**, *classical* is a confusing **concept** that appears, nevertheless, to remain indispensable to **art** and **design^ history**. In its seemingly neutral use, classical refers simply to **artworks** (and many other **artefacts**) that **represent** a particular kind or type of **production**, following and exemplifying particular codes and **conventions**. Thus, for example, it is possible to speak of a classic cubist **painting** (such as Pablo Picasso's *Woman with a Zither* (1911–12)), or a classic piece of **modernist** furniture (for instance Le Corbusier's *Grand Comfort Armchair* (1928)). It might be countered, however, that these usages also imply a **value** judgement: that the cubist painting or the stainless steel and leather armchair are simultaneously classic in the sense of 'great' – extremely important objects. However, classic in the neutral sense can *also* be used of items thought to be poor or even absolutely worthless in evaluative terms: 'classic **socialist realist** paintings', for example, or 'classic kitsch wallpaper'. (Always a consideration, as these two examples indicate, is the question of *who* makes the judgement and from what **perspective**.)

In its straightforwardly evaluative sense, by contrast, classic is a term of extremely high praise: as in a classic (or classy) sports car such as the 1947 Pininfarina *Cisitalia Coupé*, or the classic 'calypso' black satin sling-back sandal with brass 'cage' high stiletto from 1955–56. Classic in this sense manages to negotiate the tensions inherent in the term: a class is a group of things (e.g.: a **social** class), yet this *particular* item in the group is able to rise above the rest – though it remains dependent upon the group or type as a whole for at least some of the properties constituting its **identity**. In both the neutral and evaluative senses, then, the dual meaning of classic in relation to 'group/'specified item in the group' remains present, though in the former, neutral, sense the group element **dominates**; while in the latter, manifest judgement, the individual example itself is highlighted.

Within art history more narrowly conceived, classical and **neoclassical** – with or without capital 'c's or 'n's – are mostly weak in **theoretical** terms. The first is simply a **period** or **epochal** term for art produced in what are usually called the ancient Greek and Roman **civilisations** (the three or four centuries of Roman **culture**

after the birth of Christ often get assimilated to the **modern, byzantine**, era). The latter composite notion – neoclassicism – is a term referring to painting, **sculpture**, and **architecture** in **western** Europe from about the 1760s to 1810 that self-consciously adopted and adapted what were believed then to be some of the aims and conventions of classic (ancient) art as well as the **myths** and **narratives** of Greece and Rome, whose ruins and surviving relics had begun to be systematically excavated during the eighteenth century. Jacques-Louis David's paintings are the best known examples of this instance of a deliberate **appropriation** of earlier art, along with the moral and patriotic **public** (civic) values Greek and Roman art was believed to **embody**. However, the neoclassicists **intentionally** used their sources **allegorically**, as in David's *Lictors Returning to Brutus the Bodies of his Sons* (1789), to make points about their own **contemporary** society, then in the throes of the French Revolution.

Further Reading

Bennett, Tony (ed.) *Culture, Ideology, and Social Process* (Batsford: 1981).

Lawrence, A. W. *Greek Architecture* (Yale University Press: 1996).

MacDonald, W. L. *The Architecture of the Roman Empire*, 2 vols (Yale University Press: 1965 and 1986).

Wölfflin, Heinrich *Classic Art: An Introduction to the Italian Renaissance* (1899) (Phaidon: 1994).

COMMISSION

Term for an order, issued by a **patron**, instructing an **artist** to **produce** an **artefact** in exchange for financial and/or other kinds of payment. Although such patronal *commissions* have been common for many centuries (and still occur) – constituting a characteristic type of **social** relationship within **cultural** production – the commission was **dominant** during the **medieval, renaissance**, and subsequent **epoch** prior to the **emergence** of the 'free market' in **art** in the mid nineteenth century, particularly in France. The main contrast here is between (a) producers entering into contractual obligations with patrons, who stipulated in advance, with varying degrees of detail, the **nature** of the **artefact** *subsequently* to be made; and (b) those producing their works in relative independence/isolation who then sought, through various means, to find potential buyers in an open market for these unsolicited commodities. The latter social relation of market cultural production is characteristic of a commercial-capitalist

system, which became effectively dominant in the **western** European societies of France and England by about the 1880s.

This shift from commission mode to free-market mode was profoundly important for the lives and work of all artists and **artisans**, but also indicated societal transformation in terms of the power and **influence** of key **institutions**, socio-political forces, **ideologies**, and **values**. The commission is associated particularly with religious patronage: with a patron (such as the merchant Enrico Scrovegni) instructing an artist (Giotto di Bondone) to paint a fresco series (the *Lives of the Sts. Joachim and Anne and the Virgin*) in a particular place (the Arena Chapel in Padua, between 1303–6). During the medieval and renaissance **periods**, patrons and commissioned artists may have been members of the same ecclesiastical (religious) order, working together to embellish their church or monastery. Later, secular patrons, sometimes landowners, bankers, or traders – such as Scrovegni – commissioned artists to paint devotional scenes in their own chapels of worship, partly to show the patron's fervour for God but also to do penance for committing what was then the sin of usury (moneylending with interest charged). At this time, the contract for the commission might have included extensive details of the **narrative** scenes to be depicted, the inclusion of likenesses of the patron and his family, and the use of stipulated amounts of expensive pigment – such as gold or azure blue – to show the seriousness of the patron's holiness.

It is easy to see why it might be thought that artists were 'freed' from these conditions when they began to produce art to be sold in the 'free market' of commodities. By the later nineteenth century artists were no longer required, nor necessarily wanted, to produce art with religious, **historical**, or **mythological** themes, commissioned by either the Church, **organisations** of the **nation^-state**, or private corporations (though instances of these commissions continue to the present). The power of **traditional** institutions and their ideological value-systems – in society at large and in terms of art **academies** – declined rapidly towards the end of that century as the size and power of the capitalist market increased. **Forms** of *indirect* patronage through commission survive into the present through the activities of state-funded arts organisations, such as the Arts Councils in the UK and the National Endowment for the Arts in the US.

Further Reading

Baxandall, Michael *Painting and Experience in Fifteenth-Century Italy: A Primer in the Social History of Pictorial Style* (Oxford University Press: 1972).

Berlowitz, Jo-Anne 'The Museum of Contemporary Art, Los Angeles: An Account of Collaboration between Artists, Trustees and an Architect', in Marcia Pointon (ed.) *Art Apart: Artifacts, Institutions and Ideology Across England and North America* (Manchester University Press: 1994).

Gilbert, Felix *The Pope, His Banker, and Venice* (Harvard University Press: 1980).

Lytle, Guy Fitch and Stephen Orgel (eds) *Patronage in the Renaissance* (Princeton University Press: 1981).

COMMUNICATION *COMMUNICATE,* *COMMUNICATIONS, COMMUNICATIVE*

General term referring to both the **form** and **content** of information transmitted between people – a process also implying the reception, **interpretation**, and use of such information. 'Information' itself, interestingly, *sounds* neutral and **value**-free. 'Communications', a term used in military and emergency planning activities, suggests simply a practical operation. Yet the 'information' and 'communications' people and **organisations^ produce**, transmit, receive, and use are always bound up with **social** interests and value judgements. This is true in the obvious cases, for instance, of broadcast **television** and radio communications, whose programmes and content are produced by particular **institutions**, financed and controlled in most countries around the world by a mixture of private commercial-**capitalist** and **publicly** owned **state** organisations. In a broader sense, such institutions are part of the **social order** of a society as a whole, and can play a decisive role in **influencing** that society's **national^ culture**: the predominance of commercial television (**advertisement**-financed) stations in the US since the 1950s, based on 'the imperative to sell', is a case in point.

In contrast, the powerful British Broadcasting Corporation (BBC), a state or 'public service' provider, carrying no advertisements, operated a restraining **influence** on commercial culture in Britain for many decades. However, it too has been **subject** to serious **criticism** particularly over the last thirty years: that its communications were similarly highly partial, interest-led, and only **represented**, it was claimed, the snobby middle-**class** values of a small and unrepresentative group of people constituting what is often called the London or south-east England 'establishment'. More recently, from another direction, it has been attacked for becoming *too* commercial in providing programmes designed to be highly competitive with those produced by private stations. The claim here is that the BBC

has reneged on its **historical** role of providing high **quality**, cultivated, programmes for distinct groups of people and now sees its audience cynically in commercial terms (like all other ad-driven channels) simply as a 'market' to be exploited.

Far more attention, however, has always been paid to the constitution and function of communications institutions than to the **real** ways in which their transmitted content is received, interpreted, and actually (rather than apparently) used by people. The sheer scale, and **theoretical** difficulties, of understanding the process of reception has been a barrier to this vital work: for example, unexamined assumptions of 'the masses' and **mass culture** still undermine serious **analyses** of audience response and use. Problems of survey and research method in this kind of – inevitably partly statistical – study should not be underestimated. The basic question, though, is *why* this kind of work remains necessary, and in *whose* interests it is worth carrying out. Advertisers and marketing consultants are one group in society particularly anxious to know what people are **really** thinking and doing when they watch TV because they want to influence their **consumption** decisions. This commercial motivation underlines one kind of social interestedness in communications, and begs the question of what, in contrast to private enterprise, 'public service' and 'public interest' really means now.

Further Reading

Golding, P. and G. Murdock 'Culture, Communications and Political Economy', in J. Curran and M. Gurevitch (eds) *Mass Media and Society* (Arnold: 1991).
Habermas, Jürgen *Communication and the Evolution of Society* (Beacon Press: 1979).
Simmel, Georg 'How is Society Possible?', in *Georg Simmel 1858–1918: A Collection of Essays with Translations and a Bibliography* (Ohio University Press: 1959).
Williams, Raymond *Communications* (Penguin: 1962).

COMPLEXITY *COMPLEX*

Largely unexamined term, used habitually in **art^ history** and **criticism** in two distinct ways: (a) by writers wishing to confer high **value** on **artworks** (as in such a claim that 'Anthony Caro's **abstract^ sculpture** *Midday* (1960) is a marvellously *complex* articulation of **forms**'); and (b) to suggest, less judgmentally, the presence

and interaction of a range of elements within an object under **analysis**, whether this be, for instance, an **artefact**, a **style**, a written **text**, or even a **historical** moment. These two usages are not necessarily related, though it is quite unusual for critical praise to be couched solely in terms of an artefact's undiluted *simplicity*, especially in the **period** of **modernist** and **postmodernist**^ **art** (*c.* 1860–2000). For instance, though it is a staple of critical reviews to admire the **primitive** 'directness', even 'crudity', of, say, Paul Gauguin's **paintings** done in Brittany or Tahiti (e.g.: *Eve – Don't Listen to the Liar* (1889)), qualification of this observation routinely involves **identifying** the variety of sources, subtleties of form, and decorative nuances also present in these **pictures**. These comments add up effectively to a statement of the artefacts' complexity and value under definitions (a) and (b) given above.

The assumption remains prevalent, that is – though **developed** in a number of very different ways – that important, or **canonical**, artworks intrinsically contain 'depths' of **meaning** and **significance**, some levels of which are not immediately or literally **visible** (as the **metaphor** of 'depths' suggests). This idea of 'depths' is fairly close to the notions of ambiguity and ambivalence of meaning – two highly **influential** critical **concepts** developed within literary **theory, structuralism**, and **poststructuralism** in the mid decades of the twentieth century. Often, what are proposed as the complex ambiguities of serious (good) art have been opposed to the vulgarity of items said to belong to (bad) **popular** or **mass culture** – the latter term itself suggesting an undifferentiated entity lacking strands of richness.

Complexity as a concept, then, has two broad ranges of usage in art history and criticism. These might be called (1) **real**, or grounded in hard **looking** at an object, and (2) **ideological**, or fantasised. In the former, the term designates the authentic sense held by a **viewer** that a particular artwork or artefact presents profound challenges to understanding and, in a sense, 'refuses' to give up its whole meaning – that, indeed, a complete or exhaustive analysis of it may *never* be possible (for instance, the philosopher G. W. F. Hegel commented upon what he thought of as the enduringly enigmatic **quality** to the Egyptian pyramids). In the second sense, the term operates merely as a 'code-word' for its user, who, by it, is **expressing** profound pleasure in, or self-**identification** with, the object of his or her **analysis**. This usage is ideological because the meanings of complexity are neither examined nor articulated – rather the term is used rhetorically, largely as a means to **authorise** and confirm a simple value-judgement.

Further Reading

Empson, William *Seven Types of Ambiguity* (Chatto and Windus: 1953).
Harris, Jonathan *Writing Back to Modern Art: After Greenberg, Fried, and Clark* (Routledge: 2005).
Podro, Michael *The Critical Historians of Art* (Yale University Press: 1982).
Williams, Raymond *The Year 2000* (Pantheon: New York: 1985).

COMPOSITION *COMPOSED, COMPOSING, COMPOSITE*

Central **concept** in **art^ history** and **criticism** which designates both the *process* of **formal** ordering involved in making an **artwork** (say, a **painting, sculpture**, print, or **photograph**) and the *completed* order present in the **artefact^ produced**. The sense to the adjectival term *composed* **meaning** 'settled and relaxed' – used, for example, to describe a person – persists, then, in the use of the term as a noun in relation to art. A *good* or *successful* composition, that is, has the look of, or displays, its completeness and 'rightness' as an apparently necessary order – it *has* to be that way. The French critical term *tableau*, meaning something akin to a **pictorial** 'scene' or composition in English, **developed** in eighteenth-century writing on art by Denis Diderot and others, contains this **evaluative** sense – though through to the use of the term in the mid nineteenth century there was the suggestion that quite *how* such a completeness and rightness was achieved was not entirely understood. A successful *tableau* – such as Jean Baptiste Greuze's *The Son Punished* (1778) – was much more than merely the sum of its parts.

Composition in the sense of a successful tableau included the implication that the **artist** had followed a set of principles or guidelines. In this way, producing a *good* painting or sculpture was bound up with – inseparable from, though not reducible to – the set of operative **conventions** taught in the **academies**, observed by those **authorities** selecting artworks for official **exhibition**, and codified in the **discourses** of the first art critics and **theorists**. When this system of **values** began to break down, by the mid nineteenth century in France – for instance, within the works of Gustave Courbet and, later, Édouard Manet – it was because these artists no longer considered themselves bound by such **institutional** norms and the values they **represented**. Having said that, both Courbet and Manet greatly respected aspects of academic art and its achievements, though their playing with or overturning of academic conventions had clear

social and political connotations. Manet's *Olympia* (1863), a picture of a naked woman recognisable as a working-**class** prostitute – neither **idealised** nor simply based on **old master** prototypes of **nudes** – brought **contemporary** life into art in what was perceived as a threatening and shocking way. For Manet, orthodox rules of compositional decorum – *this* motif ordered in *that* formal **manner** – had become constraints.

However, it is not true to say that these and later **avant-garde** artists brought about the downfall of the system, any more than that the decay of institutions and their system of rules was the precondition for their rise. The *actions and effects* of individuals and groups and the *actions and effects* of institutions are bound up together in any, and all, **historical** moments. **Agents** and **structures** mutually condition each other and are most intelligible when seen as interdependent. Composition in the very broadest sense, then, is a social phenomenon – an order, and process of ordering, which is at once artistic *and* social in character – though particular individuals within the **period** of **modernism** in the arts have been singled out as leaders and transformers.

Further Reading

Alberti, Leon Baptista *On Painting (1435)* (Penguin: 1991).
Clark, T. J. 'Olympia's Choice', in Clark *The Painting of Modern Life: Paris in the Art of Manet and his Followers* (Princeton University Press: 1984).
Fried, Michael *Absorption and Theatricality: Painting and Beholder in the Age of Diderot* (University of California Press: 1980).
Gombrich, Ernst *Symbolic Images* (Phaidon: 1972).

CONCEPT *CONCEPTUAL, CONCEPTUALISATION, CONCEIVABLE, CONCEIVE*

Though apparently straightforward – a *concept* is simply an idea, isn't it? – the term actually has a range of descriptive, **theoretical**, and **evaluative**^ **meanings** and uses within **art**^ **history**. Usually these are overlaid and interact to the point where separating the different senses out (**analysing** them) becomes difficult. For example, take the concept of the **renaissance**. It functions, in one way, simply to name a claimed *factual* entity; as in this typical definition: 'the **development**, in the fourteenth and fifteenth centuries in Italy of **artists'**, **patrons'**, and scholars' interest in antique **art**, combined with the **desire** to **produce**^ **naturalistic**^ **representations** of the world

increasingly based on observation and scientific procedures'. This sort of account is often still presented as uncomplicatedly *descriptive*, though all the key terms (concepts) in it – antique, desire, naturalistic, representation, observation, and scientific – themselves present considerable problems and **complexities** of definition.

In a second sense, then, the factual or **narrative** role of the concept 'renaissance' is made marginal and emphasis placed on these, and other, problems of **historical** assertion and proof. *When*, for instance, did the renaissance happen? When did it *end*? To what extent was the term, perhaps, really a later invention (the word is French, and came into English only in the nineteenth century), introduced to make sense of an **epoch** that otherwise can be shown to contain a bewilderingly chaotic range of developments and features, in **social, cultural**, and artistic terms? This explicit questioning of ideas is what is usually recognised as conceptual (or theoretical) analysis.

In a third kind of usage the concept of the renaissance is either openly or covertly evaluative: that is, used to confer **value** and **significance** on the lineage of artists and **artefacts** it incorporates and/ or on the wider socio-cultural process of which they are a part. This was the intention, for instance, of Jacob Burckhardt, a nineteenth-century German cultural historian whose **influential** use of the term is partly responsible for its core meanings still current today. He used the then relatively new idea of the renaissance as a means to suggest that a powerful continuity of development – a **civilising** drive – existed in European history and culture that culminated, he believed, in his own **contemporary** German nation, unified as a **state** in 1870. 'The truest study of our **national** history,' Burckhardt wrote, 'will be that which considers our own country in parallels and in relation to world history and its laws ... one day to be engulfed in the same eternal night and perpetuated in the same great universal **tradition**' (*Reflections on History* (*c.* 1872)). Concepts, then, are also the record of the self-interest and values of those who use them.

In these three ways then, *all* terms in art history are conceptual – that is, they carry descriptive, theoretical, and evaluative weight. In *particular* **discourses** (essays, **texts**, arguments, etc.) however, one or other of these registers tends to be stressed, and the others underplayed. Then it becomes possible to say, and believe, that a certain term is merely descriptive or factual. Indeed, the word 'term', literally meaning simply a word, suggests itself the absence of *manifest* conceptual meaning. *All* terms, or words when examined, however, can be shown to have a range of conceptual meanings and implications.

Further Reading

Barnes, Barry 'Conceptions of Knowledge', in Charles Harrison and Fred Orton (eds) *Modernism, Criticism, Realism: Alternative Contexts for Art* (Harper and Row: 1984).

Pateman, Trevor *Language, Truth, and Politics* (Jean Stroud: 1980).

Skinner, Q. 'Language and Social Change' in B. Michaels and S. Ricks (eds) *The State of the Language* (University of California Press: 1980).

Williams, Raymond *Keywords; A Vocabulary of Culture and Society* (Fontana: 1988).

CONCEPTUAL ART *CONCEPTUALISM, CONCEPTUALIST*

Term given to a range of **artists** and artists' **formations** – those mainly active in the US and Europe in the late 1960s – whose interests lay in drawing particular attention to the function of ideas and **language** within the **production** and **interpretation** of art. Highly sophisticated **theoretically** and aware that their own **representations** of **concepts** must necessarily take *some* kind of **material** and **visual^ form**, artists such as Joseph Kosuth and the group 'Art and Language' believed that **modern** art's characteristic **practices** had reached an end by *c*. 1966. That is, the *conceptualists* concluded that the innovative formal **development** of particular art forms, such as **painting** and **sculpture**, appeared to have run their course. The slightly earlier **minimalist** artists of the time – such as Carl Andre and Donald Judd – had themselves registered this state of affairs by starting to produce **artworks** (though that term began to seem inappropriate) that no longer resembled nor represented, in recognisable ways, the **artefacts** and themes of modernism. Their constructions – such as Andre's **compositions** made from house bricks (e.g.: *Equivalent VIII*, 1966) – resisted definition as **abstract** sculpture and instead, according to the **contemporary^ critic** Michael Fried, simply exemplified and dramatised their own literal status as *non-art* objects.

The conceptualists – like the minimalists – began to cast radical doubt on art's usual **meanings**, contexts, and experiences, given that it seemed to them that the century-old modernist critical **tradition** was exhausted. Judd's painted metal and wood objects, as much as Art and Language's **exhibited** filing cabinets containing multiple cross references between entries and files, or Kosuth's written statements displayed on gallery walls (e.g.: Judd, *Untitled* (1963–75); Art and Language, *Index 01* (1972); Kosuth, *Titled (Art as Idea as Idea) (Uni-*

versal) (1967)) all directly reject modernism's orthodox **media, conventions,** and **expressive** devices. In that sense both minimalism and conceptual art have been **interpreted** as indebted to the 'ready-mades' fabricated by Marcel Duchamp in the early years of the twentieth century. Conceptual**ism**, however – in distinction to conceptual art – a general term for much work produced since the 1970s, has been even more thorough-going than minimalism in its questioning of the notions of **visual** and 'visuality', using and combining a variety of new representational **technologies** – such as **photographs**, documents, charts, maps, **film**, and video – to further this critique (e.g.: Victor Burgin's photolithographic print, *What Does Possession Mean To You?* (1974); Barbara Kruger's photograph with text, *Your Comfort Is My Silence* (1981); Mona Hatoum's video **installation**, *Corps Etranger* (1994)).

Much of the **postmodernist** art produced in the **period** since the mid 1980s owes an intellectual debt to the work of the first conceptual artists – not necessarily in terms of the detailed philosophical arguments mounted by, for example, Kosuth, but rather in terms of the focus on language and acknowledgement of the role of **ideology** within art production, exhibition, and **criticism**. Late-1960s conceptual art in that sense contained an implicit political dimension, based on a critique of **institutional** power, which contributed to the development of, for example, 1970s **feminist** art and the 'Land-' or 'Ecological artists' – such as Robert Smithson and Richard Long – who attempted, through their earthworks and country walks, to resist the powerful processes of **capitalist** commercialisation and commodification endemic to the **art world**.

Further Reading

Harrison, Charles *Essays on Art and Language* (Blackwell: 1991).
Kosuth, Joseph *Art After Philosophy and After: Collected Writing 1966–1990* (MIT Press: 1991).
Lippard, Lucy *Six Years: The Dematerialisation of the Art Object 1966–1972* (University of California Press: 1973).
Stimson, Blake and Alexander Alberro (eds) *Conceptual Art: An Anthology of Critical Writings and Documents* (MIT Press: 2000).

CONNOISSEURSHIP CONNOISSEUR, CONNOISSEURIAL

Name given to an early, though still active, field of **traditional^ art^ historical** research concerned with **identifying** the **authorship**,

provenance (**history** of ownership), and **stylistic** character of **artworks**, through a forensic examination of the **surface** and all other **material qualities** of the **artefact** in question. *Connoisseurship*, in a more general (though still often dismissive) sense, is a term applied to those whose interests in **art** *appear* not to extend beyond the immediate material **reality** of artworks – for instance, **paintings** – and the way in which this material reality is considered principally to reveal the stylistic 'signature' of its **creator**. One of connoisseurship's founding **practitioners**, the **critic** Giovanni Morelli, claimed to be able to attribute a painting or drawing to an **artist** on the basis of his scrupulous **analysis** of how *minor* details – such as ears, noses, and hands in a portrait – were **represented**. These elements, because they appeared subsidiary or marginal within the painting as a whole, were held to contain the true, that is 'unconscious', key to the artist's **manner**. As this belief indicates, connoisseurship had something importantly in common with the **emergent** late-nineteenth-century sciences of forensic medicine, crime detection, and **psychoanalysis**: they all sought what were conceived as *hidden* truths lying beneath the appearance of things.

Connoisseurship has had, and continues to have, two important roles in the **institutional^ organisation** of the **art world**. First, the forensic examination of artworks is a crucial authenticating practice within the operation of the art market, as attributions of authorship are key to the confidence buyers must have in the genuine status of the artefacts they are prepared to purchase through auction houses such as Sotheby's and Christie's. Connoisseurship is thus a type of **art history** directly linked to the economics of the world art market, with its practitioners in the pay of a whole range of **agencies** and intermediaries, including those wishing to sell art, the dealers, prospective buyers, legal experts, and accountants.

Second, art appraisal and **criticism** in its most traditional senses involves the careful **formal^ analysis** and **evaluation** of artworks and makes use of many of the skills and insights learnt within connoisseurial practice. When this type of criticism (found in journals such as *Apollo* and *The Burlington* (both UK)) has been thought to descend into mere descriptive exercise or to become obsessed with questions of authenticity and personal style – appraisal deliberately sealed off from, or oblivious to, broader kinds of art historical **explanation** – these faults have routinely been laid at the doors of art market connoisseurship. Sharp attacks on such apparently **formalist** appraisal and criticism from those representing, for example, **feminist** and **social history of art^ perspectives** in the 1970s and

1980s, also tended to portray **conventional** art history as itself little more than a lightly historicised type of connoisseurship short of worthwhile insights.

Further Reading

Gibson-Wood, C. *Studies in the Theory of Connoisseurship from Vasari to Morelli* (New York: 1988).

Ginsburg, Carlo 'Morelli, Freud, and Sherlock Holmes', *History Workshop*, 9 (1980): 5–36.

Morelli, Giovanni *Italian Painters: Critical Studies of their Works* (1890) (John Murray: 1890).

Wollheim, Richard 'Giovanni Morelli and the Origins of Scientific Connoisseurship', in *On Art and the Mind: Essays and Lectures* (Allen Lane: 1973).

CONSUMPTION *CONSUME, CONSUMER, CONSUMERISM, CONSUMER-CAPITALISM*

If the study of the **production** of **artworks** – and all other items of **visual^ culture** – is the **analysis** of *how, when, why,* and *with what* **materials** *and resources* **artefacts**, such as **paintings**, **sculptures**, jewellery, and clothes, get made (and by *whom*), then the study of their *consumption* is the analysis of the circumstances of *how, when,* and *for what purposes* these artefacts are used, **interpreted**, and seen as **meaningful** (and by *whom*).

One familiar sense, 'to consume', implies the 'using up' (destruction) of that which is consumed – say, a pizza or a tank of petrol – and it is probable, therefore, that in adapting the **concept** for **art history** some **development** of, and change in, its meaning is necessary. This is because the vast majority of artworks are *not* destroyed in their consumption (though occasionally **contemporary^ artists^ create** edible artefacts that **naturally** decay rapidly, such as Janine Antoni's sculptured chocolate in her piece *Lick and Lather* (1993–94)). Consumption, therefore, is perhaps best understood art historically as the activity through which particular artefacts are interpreted and given meanings – used, but not actually 'used up' – in particular contexts by particular people. Consider, for example, how the eighteenth-century painting *Blue Boy* (1770) by Thomas Gainsborough is used in a professor's lecture, or in a student's essay, or in a **curator's^ exhibition**. This very simple example, however, already presumes a lot: that an actual artefact – in this case,

a painting – rather than a slide or **photograph** or digital **image** of the painting, has been consumed. (*Slides* of artworks often *are* eventually destroyed through their use.) Perhaps there is another sense, too, in which actual artworks *are* in effect 'used up', when, for example, they are bought or sold, and stop belonging in one (**public**) place to a **national^ institution** and begin to belong in another (private) place to one person or privately owned institution. The threat often hangs over highly prized artworks located in Britain that their purchase by the Getty Museum in California will constitute what is called a 'loss to the **nation**'.

Indeed, fully to investigate the term *consumption* in the sense of 'using up', consider the pizza box as well as the pizza. This *is* lost and destroyed at the end of its process of consumption – for the box disappears into a trashcan, or is recycled, or finds its way onto a landfill site. Most ephemeral visual-cultural material, this example suggests, *is* deliberately destroyed in the process of its consumption – packaging directly and quickly, on the opening of goods; or more slowly through the gradual obsolescence of various consumer commodities themselves, such as TV sets and computers. This term – consumer commodity – is only rarely related to the **traditional** artefacts studied in art history: old paintings (or new ones for that matter) are not typically thought of as consumer items in this way at all. Consumption, then, in one of its most important visual-cultural senses, is a term for the *process of the use (sometimes including the actual 'using up') of* **mass**-*produced goods manufactured in factories, within a* **society** *that has made mass consumption a continuous mass activity.* The key 1960s terms *consumer* and *consumer society* – partly coined by **advertisers** and marketing executives in that decade – indicate how a whole **social order** was transformed in the development of a 'consumer-**capitalist**' economy. As such, consumption, on a mass and continuous scale, itself became a very powerful productive activity, producing not only huge numbers of goods and services, but producing people themselves now as consumers first and foremost, in the way that they had once been encouraged to think of themselves primarily as citizens.

Further Reading

Bocock, R. *Consumption* (Routledge: 1993).
Corrigan, P. *The Sociology of Consumption* (Sage: 1997).
Falk, P. and C. Campbell (eds) *The Shopping Experience* (Sage: 1997).
Grunenberg, Christoph and Max Hollein (eds) *Shopping: A Century of Art and Consumer Culture* (Tate Publications: 2002).

CONTEMPORARY *CONTEMPORANEOUS*

In its **dominant** sense, *contemporary* refers to now – in strong opposition to a moment in some recognised past (which is over) or future (yet to come) time – but the term also contains within it the undertow of a late-nineteenth-century usage **meaning^ modern** or ultramodern. This inheritance is at the root of the difficulty with the term: it has come to mean, confusingly, both now *and* modern, even though in **art history** modern has become, in some important ways, a distinctly **historical** notion. 'Modern **art**' usually refers to art from the time of Édouard Manet (the 1860s) to the 'end of modernism', a point located in the later 1960s – just prior to, that is, the **emergence** of **postmodernism**. Difficulties, however, equally plague the term 'now': it cannot mean simply the 'immediate present' (literally this second) and therefore is ambiguously open itself – perhaps meaning anything from 'this year' to 'the last ten years'.

Several further elements of confusion over *contemporary* involve **significant** issues to do with the **nature** of art historical research, and the relations between this activity and the study of art and art **institutions** *in the present*. In one way, the resort to this phrase – 'in the present' – valuably indicates that the term actually has no neutral or clear meaning though it is often used precisely with that intention. For instance, it became common about thirty years ago for new galleries and **museums** of art, wishing to show **artworks** made 'now' or 'in the present', to call themselves 'Museums of Contemporary Art' (e.g.: the Los Angeles Museum of Contemporary Art). This usage **created** a deliberate contrast with 'museums of *modern* art', whose collections were clearly associated with what was believed now to be an *ended* past history: the modernist art, that is, of the twentieth century (roughly from, say, **cubism** up to the work of the **pop^ artists** of the early 1960s). The exemplary **curatorial institution** concerned with this history is the Museum of Modern Art, New York, whose nickname 'MoMA' indicates its founding – **metaphorically** maternal – status, as the first such named museum, established in 1929.

Contemporary in this recent usage – since the 1970s – means more or less the same as 'now' or 'in the present', and, although the contrast with a past (completed, finished) modern moment is clear, the term remains itself ambiguous. In this ambiguity contemporary shares a vagueness with that other term mentioned above and used to describe art 'after modernism': postmodernism. The 'after' certainly suggests the 'overness', but also the **influence** or legacy, of *that which*

came before. For example, a drawing or **painting** or **sculpture**^ **identified** in **conventional** art historical terms as 'after' an earlier artist is believed to demonstrate some observable connection to a work, or works, by that former artist. In the same way, contemporary art, though clearly different from past modernist art, will be, in virtually all cases, shown to bear some important relation to preceding works. A good example is the bronze sculpture *Fountain (after Marcel Duchamp)* (1991), by Sherrie Levine, a postmodernist artist known for her systematic and highly self-conscious **appropriations** of earlier works – in this case Duchamp's readymade *Urinal* (1917).

Further Reading

Bois, Yves-Alain *Endgame: Reference and Simulation in Recent Painting and Sculpture* (MIT Press: 1986).

Foster, Hal 'Postmodernism: A Preface', in Foster (ed.) *Postmodern Culture* (Pluto Press: 1983).

Harris, Jonathan 'Elements Toward a Historical Sociology of Contemporary Art', in Harris (ed.) *Art, Money, Parties: New Institutions in the Political Economy of Contemporary Art* (Liverpool University Press/Tate Liverpool: 2004).

Williams, Raymond 'When Was Modernism?', *New Left Review* (May/June: 1989) 48–52.

CONTENT *CONTENTS ANALYSIS*

One of the most important and yet difficult **concepts** within **art**^ **history** and the study of all items of **visual**^ **culture**: the matter of what a given **artefact** may be said both to be 'about' and 'for'. *Content* refers (a) to the **materials**, processes, **conventions**, and codes from and out of which any given item is fabricated, and (b) to the **meanings** and **values** given to the work as an **intended** and **signifying**^ **human** artefact. To that far-reaching extent, then, and couched in general terms such as these, it would not be surprising if 'contents analysis' *seemed* to be the only really necessary **explanatory** tool.

The difficulties arise however when considering very different kinds of broadly visual-cultural artefact – say, a **fashion** artefact such as Emanuel's 1984 version of the sailor collar (reversed on the back, extra long, and finished with a bow), a late-twelfth-century stone-built shrine at Phra Prang Sam Yot, Lopburi (**modern** Cambodia), and Adrian Piper's 1970 **performance** entitled *Catalysis III*, in New

York (now surviving in documentary **photographs** only) – as no *single* notion of meaning, material, **intention**, context, and **function** seems possible in order to make sense of such diverse examples. The significance of *content*, therefore, is **historically** and culturally/geographically specific: reliant upon assumptions and knowledge about, for instance, individually **produced** artefacts, precisely knowable contracts and conditions of work, the **social** and **symbolic** worlds in which the artefact becomes operative, and the likely audience or **consumers** for whom a particular artefact was meant and attains its intelligibility.

Complications also arise because *content* is often discussed along with two other key terms whose own interrelationship is **complex**: **form** and **subject^ matter**. These terms *appear* to divide the content of an **artwork** into separable quantities and **qualities**. First, the form, or physical fabrication and **design** of the artefact (say, a **painting's^ surface**, the 'working' of this with paint, the construction of a **composition** of colours and lines) and second, the subject matter, or theme and reference of the artefact (say, a **landscape** showing a town in the middle distance, some trees, and a clear sky; e.g.: Jean Baptiste Camille Corot's *View of Genoa from the Promenade of Acqua Sole* (1834)). However, dealing with such a nineteenth-century European painting's content is very different from, say, attempting to describe the content of an episode of the **TV** cartoon show *The Simpsons* – or the continuous broadcast output ('flow') of television as a specific **medium**. Symbolic meanings in examples of fashion and **architecture** may be shown to bear little or no relation at all to such electronic **image^ media**. Beyond dealing with European and American culture since the **renaissance, western** scholars who attempt to make sense of artefacts made thousands of years ago in places completely unconnected to Euro-American culture and **civilisation** must search for usable notions of content dependent upon an understanding of radically different ways of life, in which visual artefacts might be shown to have played a **functional** part. Art history in this sense is necessarily related to, and dependent upon, anthropological and archaeological investigation, as well as part of the **emergent** field of **postcolonial studies**.

Further Reading

McLuhan, M. *Understanding Media: The Extension of Man* (Routledge: 1994).
Strathern, M. (ed.) *Shifting Contexts: Transformations in Anthropological Knowledge* (Routledge: 1995).

Weber, R. P. *Basic Content Analysis* (Sage: 1990).
White, Hayden *The Content of the Form: Narrative Discourse and Historical Representation* (Johns Hopkins University Press: 1987).

CONVENTION *CONVENE, CONVENTIONAL*

Term used in **art^ history** to denote an agreement, or rule, governing how elements *within* an **artwork**, or those actually *defining* an artwork, should be ordered. For instance, within **medieval** and **renaissance** Christian religious **painting** it was *conventional* for the Virgin to be depicted wearing a blue cloak (e.g.: Simone Martini and Lippo Memmi's *The Annunciation* (1333)). The ordinary **meaning** to *convention* contains several important features relevant to the **specialised** art historical sense. A convention is a social meeting: the bringing together of a group of people sharing common interests – though there may be serious disagreements between them, and sometimes these can lead to the convention breaking apart (e.g.: splits in a political party leading to the **formation** of a new one).

There are many kinds of conventions in art: both in terms of the **material^ composition** of particular kinds of artworks (such as paintings and **sculptures**), and in terms of the agreements or rules establishing the place and meaning of art in **society**. It is common to refer to the former kinds of conventions as **aesthetic** or **stylistic**. These would include, for example, the very basic convention that a painting consists of a piece of canvas stretched over a wooden frame. A **picture** is then painted onto the canvas, which, for the purpose, is conventionally placed upright on an easel, using brushes and paints made from pigments mixed with oil or water. These primary conventions (or 'norms') **produce** the material conditions for the **practice** of painting. There are, though, numerous counter-examples: for instance, Jackson Pollock painted his 'drip paintings' on unstretched canvas (not attached to a frame) placed on the floor, abandoning brushes and instead finding ways to flick and drip the paint – including some made with industrial aluminium normally used to spray cars – onto the **surface**: for example, *One: Number 31* (1950).

The derogatory sense to the use of *convention* – in phrases such as 'merely conventional', or 'highly conventional' – indicates the way in which an agreement or rule may become a stifling orthodoxy: a tired or clichéd way of doing something, often backed up by **institutional** power rather than compelling justification. **Complex** debate has

taken place, too, about **visual^ representational** conventions that appear to be *innate* rather than learned; the ways in which children, for instance, depict a **human** face simply as a circle with dots and a line for the mouth. These sorts of conventions (if that is what they are) seem far away from, for example, the use of sophisticated **perspective** systems in paintings, the selection of poses found in **classical** sculptures of the human **body**, or the agreement to **symbolise** mortality through pictorial depictions of rotting fruit and old wine (e.g.: Andrea Mantegna, *St. James on the Way to His Execution* (1455); the north-wing frieze showing the battle of gods and giants, Great Altar of Zeus at Pergamum (180 BCE); Willem Kalf, *Still Life with the Drinking Horn of the St. Sebastian Archers' Guild, Lobster and Glasses* (*c.* 1643)). These are all examples of conventions. Rules about *where* art is shown, about the **architectural^ design** and decoration of **museums** and galleries, are equally conventional. And while some types of rules apparently work *unconsciously* (like human **language**-use) – or *become observed unconsciously* (like not eating with your mouth open), which is a very different thing – the vast majority of conventions have within them the trace of agreed collective meanings and **values**. In that sense, then, though certainly *analytically separable*, there can be no strict separation, finally, between aesthetic and social conventions **historically^ developed** and transformed over time.

Further Reading

Panofsky, Erwin *Perspective as Symbolic Form* (1927) (Zone Books: 1991).
Schapiro, Meyer 'Style', in Morris Philipson (ed.) *Aesthetics Today: Selected Writings* (World Publishing Co.: 1961).
White, John *The Birth and Rebirth of Pictorial Space* (Faber and Faber: 1972).
Williams, Raymond 'Aesthetic and Other Situations' and 'Conventions', in Williams, *Marxism and Literature* (Oxford University Press: 1977).

CRAFT *CRAFTSMAN/CRAFTSPERSON,* *CRAFTWORK, CRAFTY*

Though in some cases simply used as a **contemporary** – and neutral – **alternative** term for skill, *craft* as an **art^ historical** term refers to certain kinds of **material^ practices** and occupations distinguished from those **identified** as **artistic**, often with the implication that, of the two, art is (or at least should be) the more important activity. While one might still hear a particular **artist** – say, a **painter** – referred to as 'a **real** craftsman', the **evaluative** distinction

between art and craft *presented as radically different sorts of activities* remains strong, if now fairly rare. Craft understood as labour, though, means a **technique** of making involving the use of materials and tools to **create**^ **functional** or decorative **artefacts**: for instance, stone and brick work, glass and stained-glass windows, wood-carving, and gold and silverware. This situation is complicated, however, because both many **historical** craft items and some contemporary crafts artefacts are **exhibited** *as if they were* **artworks** – that is, as if they had been **produced** in order primarily to be admired for their **aesthetic**^ **qualities**, rather than to serve a practical or decorative function (e.g.: ceremonial wooden chairs from BaMileke, Cameroun, West Africa (late nineteenth century); tables **designed** by the sculptor/designer Isamu Noguchi in the late 1940s)).

Historically, the prevalence of craftwork in Europe is associated with the period *before* the **renaissance**, when evaluative notions of *art* and *artist* began to **emerge**, and hierarchies of production and occupation were first established in **theoretical**^ **texts** and within the training and accreditation offered by **institutions** such as guilds and, later, **academies**. The **medieval** craftsman is a highly-skilled **artisan** – guild-trained and likely to have served an apprenticeship in the workshop of a **master** of a particular trade. When at the top of his craft the artisan is certainly recognised as a gifted worker – but remains **classed** as a material labourer, not an artistic thinker or intellectual. The names of many thousands of medieval artisans are known, but their personalities are not thought of as somehow importantly **embodied** within their productions (for example, consider the anonymous highly ornate gilt bell metal candlesticks made for Gloucester Cathedral, *c.* 1104–13).

In the twentieth century, when **modern** artists, for instance, began to produce apparently very simple **abstract**^ **paintings** not thought by many to demonstrate much **traditional** skill or craft – or, more radically, when they began to **conceive** artworks made out of industrial materials fabricated by other workers following the artist's designs – a partial revaluation of craft meaning skill and practice took place. Consider, for example, Jeff Koons' *String of Puppies* (1988), a multi-coloured wood **sculpture** made by craft workers under the artist's guidance. Whose skills and conceptual insights are deposited here? Have they, in effect, been separated out entirely in the division of labour? Has the conceptual aspect (Koons' idea for the piece) become a kind of skill in itself, though it is unrelated to any kind of material dexterity? This kind of recent art entailing a conceptualist legacy has sometimes been **represented** by sceptics, in highly

derogative terms, as 'crafty' in one of its oldest senses, meaning deceptive and unreliable.

Further Reading

Crane, Walter 'The Claims of Decorative Art' (1892).
Gropius, Walter 'The Bauhaus and Hand-made Products' (1935).
Harvey, Charles and Jon Press *William Morris: Design and Enterprise in Victorian Britain* (Manchester University Press: 1991).
Mainardi, Patricia 'Quilts: the Great American Art' (1982), all in Paul Greenhalgh (ed.) *Quotations and Sources on Design and the Decorative Arts* (Manchester University Press: 1993).

CREATIVITY/CREATOR *CREATION, CREATIVE*

One of the most **complex** and important ideas in **art^ history**. Though much more often *implied* than **explained**, the belief in **artistic** *creativity* – that is, **qualities** that are innovative, inspirational, and visionary – nevertheless underpins many facets of the discipline as well as the world of **contemporary** art and **design** beyond it. In one common usage, the term *creation* means simply and neutrally the same thing as **product** – a thing made out of certain pre-existing **materials** that its producer transforms and presents. Every product, however – be it a **painting** or a portable cassette player – implies materials that are not just physical: the *idea*, for instance, of what a superb eighteenth-century **portrait** of a race-horse by George Stubbs, such as *Hambletonian* (1800) should include; or how a high quality mobile music player, such as the **classic** Sony *Walkman* (1978), should sound and look. The term *creativity* has come to emphasise, and stand for, this visionary flash believed to inspire – literally 'to give breath to' – certain **artefacts** held to be extremely, even uniquely, creative. For this reason, creativity is often **represented** in art history as the property of particularly gifted, innovative individuals: the **geniuses** or **old masters**, such as Michelangelo, J. M. W. Turner, or Pablo Picasso.

For this reason, it is not surprising that art history has concentrated much of its efforts on the study of individual artists and their **stylistic^ development** and **influences** (within the monographic study and *oeuvre* catalogue **genres** of art historical writing). Yet at the same time it is recognised – implicitly, if not openly – that all artists inevitably create and live *in* **societies** and that the **meanings** of their **artworks** relate to the **aesthetic** and social **conventions** and **traditions** active at particular times. This is the case, indeed, even if –

perhaps particularly when – certain artists turn against such conventions and produce a different kind of artwork, and in turn, establish what may become new conventions. This was the case, for instance, with the French anti-**academic**^ **avant-garde**^ **artists** of the 1880s and 1890s, such as Henri Toulouse-Lautrec and Paul Gauguin, who introduced new kinds of contemporary **subject matter** and **forms** of **pictorial**^ **composition**, colouring, and patterning to represent their own sense of place – and actual social *dis*placement – in **modern** society (e.g.: Lautrec's fascination with the music hall in *Jane Avril Entering the Moulin Rouge* (1892) and Gauguin's **idealisation** of Tahitian society in *Faa Iheihe* (1898)).

In the twentieth century, however, **theories** of creativity became the province of art **criticism** and studies in the **psychology** and psychoanalysis of art, rather than that of art history proper. Indeed, over the last third of the twentieth century sustained attacks on the idea (and **ideology**) of individual artistic creativity preoccupied particular groups of politicised art historians, such as **feminists** who claimed that the **traditional** notion – *male artistic creative genius* – was really an instance of sexist and patriarchal ideology, while **marxist**^ **social historians of art** wished to counter what they saw as bourgeois-idealist accounts of art, artistic production, and society. It remains to be seen if feminists and marxists can, or even wish to, reconstruct a notion of artistic creativity which recognises both social **structure** and individual innovation. Whether, that is, a **materialist** account is possible that understands innovation in art as fully **human** and social, rather than pseudo-divine and **ahistorical**.

Further Reading

Clark, T. J. 'The Conditions of Artistic Creativity', *Times Literary Supplement* 24 May 1974: 561–62.

Ehrenzweig, Anton *The Hidden Order of Art: A Study in the Psychology of Artistic Imagination* (Orion: 1967).

Fuller, Peter *Art and Psychoanalysis* (Writers and Readers: 1980).

Pollock, Griselda 'Vision, Voice, and Power: Feminist Art Histories and Marxism', in *Vision and Difference: Femininity, Feminism and the Histories of Art* (Routledge: 1988).

CRITIC CRITICAL, CRITICISE

Name given to those who write and publish **evaluations** of **contemporary**^ **art** and **artists**, usually based on their experience of

visiting an art gallery or other **public^ institution** in which art is **exhibited**. **Criticism**, then, is a public activity and **modern** *critics* **emerged** when **state-**supported art exhibitions, such as the annual Salon in Paris, were opened in the mid nineteenth century to everyone who could afford the entrance fee. The term, however, is deceptively simple: most people who visit an art gallery probably formulate opinions, if not necessarily judgements, on the **meaning** or **value** of the **artworks** they have seen. They are, in that sense, critical and able to criticise. But the critic as an institutional and **authoritative** intellectual is a person who goes two steps further than this – (1) writing down an account of what they have seen and thought, and (2) finding a newspaper, journal, or other outlet in which to **communicate** the account to a public **readership**. **Historically**, the **development** of criticism in this occupational or professional sense (though many received, and still receive, little or no payment), began in the mid eighteenth century in France, with Denis Diderot's writings on the art he saw in the, then, irregular Salon exhibitions (his reviews were not all published regularly either). By the mid nineteenth century, however, critics such as Charles Baudelaire and Stéphane Mallarmé *were* publishing regularly in journals that were disseminated and read more or less contemporaneously.

The emergence of modern critics depended, then, upon an apparatus of fast, mechanised publishing and mass printing, and the generation and retention of a readership interested in critical opinion and able to compare these accounts to their own experience of visiting exhibitions. By the 1880s a variety of different venues had opened in Paris and control of these shows slipped away from the **state**. The critic became, by the late nineteenth century, an important intermediary in the modern art world; his or her judgements (though women critics were rare until the mid twentieth century) as to which art was good or bad could powerfully **influence** the financial value of artworks for sale and affect, over a longer **period** of time, the reputation and **careers** of contemporary artists. Émile Zola, critic and novelist, mockingly described critics as 'policemen' in an 1867 essay, implying that their role had become controlling and moralistic.

By the twentieth century critics had begun to attempt to influence the *future* direction of contemporary art, partly by developing close professional and personal relationships with certain artists: for instance, Clement Greenberg's with Jackson Pollock in the 1940s and 1950s. By this time there is a sense in which **modernist** criticism had begun to assume **theoretical** as well as critical authority, blending historical **analysis**, **subjective** judgements, and philosophical

pronouncements – such as in Greenberg's influential 1960 essay 'Modernist Painting'. While it is often claimed that criticism in the **traditional** sense was replaced after about 1970 by something called art theory – a term which attests to the prominent intellectual interests of many **postmodernist** artists, such as Martha Rosler – aspects of this theoretical character to art writing were salient, though understated, in earlier examples of criticism, such as essays by Roger Fry and Clive Bell in England before the Second World War.

Further Reading

Heard, George Hamilton (ed.) *Manet and his Critics* (Norton: 1969).
Hughes, Robert *Nothing if Not Critical: Selected Essays on Art and Artists* (Penguin: 1992).
McWilliam, Neil (ed.) *A Bibliography of Salon Criticism in Paris from the Ancien Regime to the Restoration* (Cambridge University Press: 1991).
Zola, Émile 'Édouard Manet' (1867), in Charles Harrison and Francis Frascina (eds) *Modern Art and Modernism: A Critical Anthology* (Harper and Row: 1982).

CRITICAL THEORY

Though *not* a recognised **academic** discipline in itself, the now diverse group of intellectual **traditions**, **texts**, **concepts**, methods of **analysis**, and **socio**-political **perspectives** that together constitute the **discourse** of *critical theory* had a profound effect upon **art^ history** in the last third of the twentieth century. In the mid twentieth century the term acted largely as a codeword for **marxism**: that is, as the theoretical **explanation** for the **development** and broad impact of **capitalism** upon **modern** society and **culture**, based upon a philosophical position known as **historical^ materialism**, and intimately connected to a belief in the necessity of bringing about a political revolution that would lead to communism throughout the world.

By the 1950s critical theory-as-marxism had generated a number of highly important problems, issues, and themes for art history. These included: (1) **analyses** of the relationship between social **class**, **ideologies**, and artistic **styles** (those both of individual **artists** and **epochal^ forms** and **movements**, such as **mannerism** and **romanticism**); (2) study of economic modes of **production** – such as those **identified** as feudal or capitalist – and their **complex** relationship to societies and **cultural** life; and (3) examination of the propagandistic

and **revolutionary^** **function** of art, artists, and intellectuals in twentieth-century societies whose **social orders** were **dominated** by religious, monarchical, and **nation^-state^** **institutions**. By the late 1960s and 1970s, however, critical theory had expanded to include several other currents of thought with distinct political perspectives (some connected to marxism; others in fact hostile to it – at least in its Bolshevik or Stalinist forms).

These new political-intellectual **formations** were **feminist** and anti-racist, or **postcolonial**, studies; gay and lesbian **history**, **theory**, and cultural analysis; the philosophical and historical critiques of **modernity** and the **human^** subject particularly associated with Michel Foucault, Jacques Derrida, Jürgen Habermas, Jean-Francois Lyotard, and Jean Baudrillard (also identified as **poststructuralist** or **postmodernist** discourse); and **psychoanalytic** accounts of subjectivity, culture, and art offered, for instance, by Jacques Lacan, Julia Kristeva, and Luce Irigaray.

As this long list suggests, critical theory had become, by the 1980s, a multi-vocal, highly complex, and often very difficult-to-understand set of concepts and arguments and, though amorphously 'left wing', was no longer clearly marxist or even socialist in its political orientation. Its dense terminologies also combined oddly with art history's own, by comparison, fairly straightforward **languages**. Critical theorists hostile to art history's traditional notions of **meaning, intention, author, originality**, and style believed that the **critiques** of these concepts developed by Foucault, Derrida, Lacan, and others constituted a devastating intellectual demolition of art history's core explanatory principles. In turn critical theorists were attacked and mocked for their theoretical unintelligibility by those who defended their own sense of art history's legitimate disciplinary ground, expertise, and power. This intellectual stand-off continues though the political activism (and relative social optimism) that underpinned critical theory's expanded radicalisms in the 1970s and 1980s – including that of those who remained committed to some version of marxism – has clearly dissipated.

Further Reading

Abercrombie, N., S. Hill and B. S. Turner *The Dominant Ideology Thesis* (Allen and Unwin: 1980).

Belsey, Catherine *Critical Practice* (Methuen: 1980).

Bourdieu, Pierre *Outline of a Theory of Practice* (Cambridge University Press: 1977).

Held, David *Introduction to Critical Theory: Horkheimer to Habermas* (Hutchinson: 1980).

CRITICISM *CRITIC, CRITICAL, CRITIQUE*

Term given to writing focused on the **appreciation, analysis,** and judgement of the **value** of **artworks.** In this respect, the **production** of art *criticism* – while certainly overlapping with some of the concerns of **art history** – involves a **specialised** concern and set of interests. Before the twentieth century, however, art criticism and art history did not exist as clearly separate **practices** (much less as discrete disciplines or fields taught in universities). The notion of any *professional* distinction between being an art critic and an art **historian** was not possible either until probably the early to mid twentieth century. Since the 1960s, however, criticism has been joined by other kinds of writing about **postmodernist** and **contemporary** art not focused on evaluative judgements of **aesthetic^** quality: political criticism, **cultural** commentary, and art **theory** have been some of the names given to this much broader area of **discourse.**

The **emergence** of the **modern** art critic, and of criticism as a particular **practice** of thinking and writing, was closely related to the **development** of art in France in the *c.* 1850–90s. These first critics – in the sense recognisable to us – wanted to find ways to emphasise the differences between contemporary artworks and those in the **museums** that had begun to seem to them locked into a definitely concluded past. So the stress in the writings of, for example, Charles Baudelaire, the Goncourt brothers, and Stéphane Mallarmé, is on how the newly produced **paintings** of **artists** such as Édouard Manet and the **impressionists** highlight the characteristic and yet fleeting experiences and **meanings** of Parisian modernity. Manet **represents**, for example, his own (but typical) experiences of the contemporary city – its urban bustle, commercial encounters with strangers, his own friends and social occasions (see e.g.: *Portrait of Émile Zola (1867)*; *The Railway* (1873), *Boating* (1874), *The Bar at the Folies-Bergère* (1882)). These works constitute, Mallarmé remarks, 'an **original** and exact perception which distinguishes for itself the things it perceives with the steadfast gaze of a **vision** restored to its simplest perfection'.

This type of criticism, however, certainly had a historical **perspective** – as many painters of the '1863 generation' had been trained in a **traditional**, if by then **residual^ academic^ manner** often including references to the art of the past in their works – but the primary purpose of their writing was to account for the **look**, meaning, and importance of the new art that they saw in the Salon **exhibitions,** and in the other, recently established, places that displayed

paintings by Manet and the impressionist artists with whom he became associated by the mid 1860s. Since then, and for the next century, orthodox art criticism centred on the critic's personal experience and response to seeing artworks: attempting to (1) describe and analyse their **formal** attributes; (2) relate them to their producers' lives and to the wider world; and (3) say whether, and why, these works were good or bad. Notions of **beauty, convention**, morality, **creativity, influence**, modernity and **social^ function** – amongst others – have been closely bound up with these judgements made by the mainstream critics in the twentieth century who descend from Mallarmé, Baudelaire, and their contemporaries.

Further Reading

Frascina, Francis and Charles Harrison (eds) *Modern Art and Modernism: A Critical Anthology* (Harper and Row: 1982).

Fried, Michael *Manet's Modernism, or the Face of Painting in the 1860s* (University of Chicago Press: 1998).

Gee, Malcolm (ed.) *Art Criticism since 1900* (Manchester University Press: 1993).

Wallis, Brian (ed.) *Art After Modernism: Rethinking Representation* (New Museum of Contemporary Art: 1984).

CUBISM *CUBIST*

Name given to a **style** of **painting** invented and **practised** by Pablo Picasso and Georges Braque at the beginning of the twentieth century (*c.* 1907–16), which, by the 1930s, had come to **symbolise^ modernism** in the **visual^** arts. The **technique**, in what is generally regarded as its first phase (called '**analytic** cubism', 1908–11), *appeared* to break down **illusionistic^ representational^ images** – typically those of **human^ figures, still lifes**, and **landscapes** – and partially reconstruct them in *fragmented* or *facetted* sections, some of which resembled cubes: hence the style's name, coined by the **critic** Louis Vauxcelles, after a remark by the painter Henri Matisse about 'Braque's little cubes' (see e.g.: Picasso's *Seated Woman* (1909), *Reservoir, Horta da Eloro* (1909)).

It is necessary here to insert the qualifier 'apparently' because cubist **pictures**, above all others within modernist visual art, have been claimed to undertake (a) a kind of systematic, if not 'scientific', analysis of visual **form**, and (b) **develop** from that analysis a new kind of formal **language** given great philosophical **significance** by numerous **critics** and **historians. Art historical** accounts of cubism,

characteristically, **identify** 'phases' or 'stages' in its 'evolution' – all loaded Darwinian terms – suggesting this experimental and **developmental** character ('analytic', followed by 'synthetic', or 'late cubism', 1911–16; e.g.: Braque's *Woman Reading* (1911); Picasso's *Woman with a Mandolin* (1912); and Picasso's *Dice, Wineglass, Bottle of Bass, Ace of Clubs and Visiting Card* (1914?)). Recently more sceptical scholars have responded that cubism merely has the deceptive **look** – a beguiling visual appearance, or rhetoric – of such a rigorous investigation but should more **realistically** be seen as a series of clever visual games that Picasso and Braque played in their paintings.

Cubism understood as a fairly open-ended pictorial and **compositional** style, however, profoundly **influenced** many later **artists** active in a variety of **movements** over the **period** *c.* 1917–50. Its basic 'faceting' and 'fragmenting' look – along with the addition of collage **materials** by 1913 – proved to be susceptible to many different **readings** and **evaluations**. Artists and artists' **formations** claiming (or claimed by others) to have adapted cubism to their own ends include Juan Gris, Fernand Léger, Albert Gleizes, Jean Metzinger, André Derain, Robert Delaunay and the Orphists, the 'section d'or' (Jacques Villon, Raymond Duchamp-Villon, Marcel Duchamp), the **futurists** in Italy and vorticists in Britain, some of the German **expressionists**, the constructivists and suprematists in Russia, and the *De Stijl* group in the Netherlands.

Beyond these instances, cubism understood as a **theoretical** category played an important part in the modernist criticism of Clement Greenberg and Michael Fried written during the *c.* 1940–65 period. Both argued that the emptying out of 'deep' illusionistic pictorial space in cubist works and the use of seemingly banal **subject matter** (flower vases, **portraits**, still life items) indicated its real interest lay in visual composition itself as an **autonomous** self-critical practice. Versions of this type of reading **dominated** accounts of the impact of cubism upon **abstract expressionism** after the Second World War. Some recent historical studies, however, have attempted to emphasise **social-historical^ subject matter** in cubism – concentrating, for example, on collages including fragments of newspaper stories dealing with the events of the Balkan Wars and political anarchism in France (as in Picasso's *Table with Bottle, Wineglass and Newspaper* (1912)).

Further Reading

Berger, John *The Success and Failure of Picasso* (Writers and Readers, London: 1980).

Clark, T. J. 'Cubism's Collectivity', in Clark *Farewell To An Idea: Episodes from a History of Modernism* (Yale University Press: 1999).

Krauss, Rosalind 'In the Name of Picasso', in Krauss *The Originality of the Avant-Garde and Other Modernist Myths* (MIT Press: 1985).

Leighton, Patricia *Reordering the Universe: Picasso and Anarchism 1897–1914* (Princeton University Press: 1989).

CULTURAL IMPERIALISM *CULTURAL IMPERIALIST*

Term given to the process through which a corporation or **nation^- state** extends its economic, **cultural**, and **ideological** power and **influence** beyond its area of **origin** into external territory and **societies**. Often corporations and nation-states collaborate in order to propagate *cultural imperialism* and the US is by far the most successful example in the **period** from *c.* 1945 to the present. US-based or owned **capitalist^ organisations** such as **media** combines (controlling, for instance, **film** and **TV production**, distribution and broadcast networks, and **cinema** chains, e.g.: Warner Brothers and Twentieth Century Fox) and 'life**style**' product brand-leaders (such as Levi's jeans, Coca-Cola, and Ford) have penetrated the markets and cultures of most societies around the world for many decades, producing and selling films, TV programmes, clothes, soft drinks, cars, and many other commodities recognisable virtually everywhere. Cultural imperialism, however, is *not* only an activity carried out by capitalist economy-**dominated^ social orders**: during the Cold War the Soviet Union (and China to a lesser extent) carried out similar policies of attempted cultural domination upon their respective 'spheres of influence' – bolstering their own economies by flooding those of their client-states with products and **images** of Russian and Chinese power and success.

Imperialism, **historically**, had been a process of both direct *military* domination and subsequent *political-economic* control, the latter carried out through a number of different strategies – but all of these, arguably, involved attempts to **influence** how people think and act. If thinking and acting (and the things they think and act with) constitute a large part of what is **identified** as **human** culture, then there is a sense in which political-economic imperialism since its **modern** origins (say, since the establishment of the British empire in India in the seventeenth century) has always involved a cultural imperialist element. Since the mid twentieth century, however, with 'decolonisation' – the ending of formal political control of colonies by the **western**

European imperial powers – economic domination has been very closely linked to cultural imperialism. The US, in fact, has rarely operated any direct or declared political sovereignty over any other country. Economic penetration, by the 1960s **symbolised** by the **consumption** of **visual**-cultural commodities – film, TV, **fashion**, and product **design** – has been the chief means to influence the actions of people in other nation-states. 'Americanisation' was the term coined during the Cold War to define this process of 'winning the hearts and minds' of those in Europe and Asia who had been drawn to the **ideals** of socialism.

It has been countered that the people of countries around the world have really always *wanted* to be able to buy American goods and see Hollywood films, and that to call this process of economic and cultural domination 'imperialism' is entirely misleading. The problem with this claim, however, is that there was never an initial moment – or subsequent one – when any actual consultation or debate took place dealing with the social and cultural implications of what is interestingly called 'market penetration'. Enticing incentives were also offered, such as the **creation** of new jobs in poor countries when companies like Coca-Cola opened up production facilities and bottling plants. The governments of the penetrated societies generally acquiesced and focused only on what they saw as the immediate benefits. France, an important exception for a time in Europe, imposed (and continues to impose) import restrictions on American films. Significantly, France has always also rejected the location of US military bases on its territory.

Further Reading

Bhabha, H. K. *The Location of Culture* (Routledge: 1994).

Clifford, J. *The Predicament of Culture* (Harvard University Press: 1988).

King, A. (ed.) *Culture, Globalisation and the World System* (Macmillan: 1991).

Mattelart, Armand *Multinational Corporations and the Control of Culture: The Ideological Apparatus of Imperialism* (Harvester: 1979).

Wallerstein, I. *The Capitalist World Economy* (Cambridge University Press: 1980).

CULTURAL POLICY

Relatively new **concept**, in **historical** terms, that designates the motivations, principles, and **practices** guiding **state** involvement in the **development** of the **arts** and **culture** broadly. It has close relations

to **traditional** government cultural **patronage** – various **forms** of which have existed for hundreds of years in Europe and the US – but *cultural policy* is the term for a more **abstract**, systematic, and pervasive process: governments deciding that they can **influence** long-term **social** and political **organisation** within their own territory *and in other countries and regions* through sponsorship of, for instance, sports, the arts, journalism, and intellectual debate. Before the 1930s, however, it would have seemed quite odd to argue that cultural **production** might, or could, be 'led' through policy and deliberate planning – or that it was even an important or legitimate concern of state **institutions**.

Though the Bolsheviks in Russia had attempted to support what they thought of as sympathetic **revolutionary** art and **artists** during the **period** immediately after they took power in 1917, the *relative* liberalism of this attempt – in which a phase of experimentation in the **visual** arts was tolerated if not officially encouraged – quite quickly degenerated into **authoritarian** censorship. Dictatorial control characterised the propagandistic use of art in fascist Italy and nazi Germany in the following decades. In important contrast, under President Roosevelt's New Deal administration in the US from 1933–39, a form of genuinely decentralised state-funding of the visual arts took place – providing artists with a regular income and shaping, in a variety of ways, the kinds of art produced across the **nation**.

By 1945, after the end of the Second World War, governments in **western** Europe set about attempting to reconstruct their shattered economies and societies. The war against fascism had included the use of increasingly sophisticated **visual–cultural** propaganda: notably and innovatively, in **film** and radio production. It was believed that post-war 'social reconstruction' should involve an effort to democratise and improve *all* aspects of life for people – in Britain, after the landslide election in 1945 of a Labour government committed to the creation of a 'welfare state' the Arts Council of Great Britain was established to fund the development of the arts. Though this was organised on an 'arm's length' principle – funds would be allocated through intermediate **agencies** *not* controlled directly by the government of the day – the Arts Council had a clear educational mission connected to the rhetoric of the Labour government then *promising* dramatic democratic, even socialist, transformation.

Since the 1950s, in most western European countries (the situation in the US was different, distorted by deeply institutionalised anti-communism), it has been accepted that the state could and should use

83

cultural production and the arts to further a range of economic and social aims: redevelopment and regeneration in particular regions, support for robust national cultural institutions, and the strengthening of citizenship and cultural **identity**. Not surprisingly, there have been many disputes within particular countries about what these aims might really achieve, how selections and definitions of art, artists, and culture have been arrived at, and whose interests might actually be made marginal or excluded altogether in pursuit of these policies. Cultural conservatives have continued to argue that authentic art and artists cannot flourish under *any* sort of intervention from the state.

Further Reading

Eliot, T. S. *Notes Toward the Definition of Culture* (Faber and Faber: 1948).
Fitzpatrick, S. *The Commissariat of Enlightenment* (Cambridge University Press: 1970).
Institute of Contemporary Arts *Culture and the State* (ICA: 1984).
Rosenzweig, Roy (ed.) *Government and the Arts in Thirties America: A Guide to Oral Histories and Other Research Materials* (George Mason University Press: 1986).

CULTURAL STUDIES

Name given to the inter-disciplinary study of **modern^ social** life bound up with **visual** and other kinds of **representations**: principally the twentieth-century mechanical, broadcast, electronic, and digital **media**; and **forms** of **human** presentation and self-presentation in, for example, **fashion, popular** music, dance, and other types of **subcultural** behaviour. *Cultural studies* – with capitalised initial letters indicating its **academic** status; taught, researched, and **reproduced** as a **subject** in higher education **institutions** since the late 1960s – thus overlaps to an extent with **traditional^ art history** but has also been cast as **alternative**, or even **opposed**, to it in important ways. This contrast is usually posed in terms of a clearly different – sometimes actually antagonistic – set of **explanatory** principles and **concepts**, methods of **analysis**, and socio-political **perspectives**.

Cultural studies is typically described as concerned with study of all the elements that make up *the way of life* of a people – or of distinct groups of people (subcultures) within a particular society. In its earliest phase cultural studies analysed the rise of youth cultures in the late 1950s and 1960s, charting their interaction with particular kinds

of music (such as rock'n'roll) and forms of dress (e.g.: the English 'Teddy boy' look). In this emphasis on collective, dynamic 'way of life' or life**style** culture, its proponents paid far less attention to the study of isolated **artefacts**. Though such items are always **produced** and used by people within particular **historical** and social circumstances, they are usually – at least in traditional art history's concern with, for example, **paintings** and **sculptures** – accorded separate, and sometimes even **autonomous**, status and **value**. However, it may be incautious to generalise and there are some important 'anthropological' studies in art history that attempt to make sense of artefacts principally in terms of their social circulation and **function**. In addition, art historians over many decades have sometimes been prepared to leave objects aside altogether and study the social institutions (e.g.: the Church, academies, galleries, and **museums**) implicated in art production and **consumption** – in this way anticipating an important focus of research in cultural studies on interaction between groups, **ideologies**, **organisations**, and power in society.

The differences between art history and cultural studies as forms of academic scholarship and teaching are clearly political-institutional and social, as well as intellectual and analytical. Cultural studies developed in Britain partly as a radical **critique** of the **consumer^-capitalist** society **emergent** in the 1960s. Its non-academic roots lay in trades union, workers' education, and socialist discussion groups – and only migrated into the universities as an academic subject during the 1970s. When this occurred, some academics from the orthodox, established subjects (e.g.: English literature, sociology, and art history) attempted to join it, or attack it, usually for a mixture of political, professional, and intellectual reasons. Thirty years on, although these debates, acrimonious on occasion, continue, art history and cultural studies – as disciplines taught in universities and forms of still-evolving enquiry – in practice feed off each other, and co-exist, rather more than they compete. This is indicated, for example, by the title of a department at the University of Leeds: 'the School of Fine Art, History of Art, and Cultural Studies'. That is to say, there is no *necessary* conflict between the two areas of work.

Further Reading

Eisenman, Stephen F. *Gauguin's Skirt* (Longitude: 1999).
Hall, Stuart, Dorothy Hobson, Andy Lowe, and Paul Willis *Culture, Media, Language: Working Paper in Cultural Studies, 1972–79* (Hutchinson: 1992).

Williams, Raymond *Culture and Society 1780–1950* (Chatto and Windus: 1958).
—— *Culture* (Fontana: 1981).

CULTURE *CULTURAL, CULTURED*

The process and **product** of **human** collective life and primary evidence of the patterns of its **social** and **historical^** **organisation**. *Culture* has three interrelated aspects: (1) the particular, selected, **traditions** and **forms** of **art** held to **represent** the highest achievements and **values** in a particular society (e.g.: Michelangelo's 1508–12 *Sistine Chapel* frescoes in the Vatican); (2) *all* of the **artefacts**, **institutions**, and **practices** constituting the '**material** culture' of a particular society (e.g.: the Eliot Noyes 1961 electric typewriter for IBM); and (3) the 'lived' relationships between individuals and groups in a society representing their interconnected economic, political, generational (family), and **communications** systems (e.g.: the Inuit people's way of life in the sub-Arctic region of north America).

It is easy to see, given this definition, that culture overlaps with society in many respects: the two **concepts** are *not* exclusive. Historically, the earliest definitions of culture and cultural life were bound up with revisions to the definition of society in the late eighteenth and nineteenth centuries – particularly when the industrial **revolution** and the urbanisation that accompanied it in Britain was understood to be radically transforming the **nature** of all life and social organisation. So **modern** definitions of culture and society are part of a response to the change and crisis (as well as *part* of that change and crisis) in **western** societies brought on by the **development** of **capitalism**, the rise of democracy, and the beginnings of a 'world system' (or **globalisation** process) based on interaction between **nation^-states**, including phases of military imperialism and peaceful co-operation.

Culture, in the three senses defined above, obviously forms a major part of the object of study of **art history**. In its traditional emphases, however, art historical interest has focused on (1) the particular, selected, traditions and forms of art, sometimes to the virtual exclusion of the concerns of (2) and (3). **Cultural studies**, on the other hand, has tended to focus on (2) the full range of artefacts and institutions; and (3) 'lived relationships', making relatively marginal (1). It is not surprising, then, that conflict between the two **subjects** has often focused on sharp disagreement about questions of **canonical**

selection (*which* **artworks** and practices deserve to be studied); *how* values and judgements as to the worth of artefacts are established; and *what* notion of 'society as a whole' is assumed to provide the context within which isolated artefacts and **artists** are studied.

The evaluative **meaning** to *culture* – 'the best', 'the highest' (and the idea of a cultured person) – remains an important **symbolic** issue for all those who study culture. This is because both art history and cultural studies have always been driven by moral and political interests of one kind or another: these include, on the one hand, the idea (and **ideal**) that human society is really a forum in which only certain individuals, like great artists, excel and, on the other, the notion that authentic democratic social change would enable *all* people to act **creatively**, thereby doing away with the need for a **myth** of the 'lone artistic genius'.

Further Reading

Goffman, E. *The Presentation of Self in Everyday Life* (Penguin: 1959).
Hall, Stuart *Critical Dialogues in Cultural Studies* (Routledge: 1996).
Thompson, E. P. *The Making of the English Working Class* (Gollancz: 1963).
Willis, Paul *Common Culture* (Open University: 1990).

CURATION *CURATE, CURATORIAL*

Term for the selection, collection, care, **exhibition**, and **interpretation** of **artefacts** – a **practice** usually carried out in **institutions** such as **museums** and galleries. Interestingly, **historical** uses of the word include two **meanings** apparently unrelated to **art^ history** and the study of **culture** which, nevertheless, may add relevant senses and insight. First, and still in use, *curate* refers to an official of the church given the responsibility of a 'spiritual charge' – for instance, looking after a parish (and, for a time, in Ireland, it referred to a bartender in charge of strong alcoholic drinks: spirits!). Second, the term refers to someone appointed as guardian over a young person or child. Curators in art museums and institutions containing ethnographic artefacts might be said to have entrusted to them all these tasks – either literally or **metaphorically**.

The main practical tasks involved with *curation* are (1) deciding which artefacts *deserve* to be protected and preserved in an institution; (2) arranging their safe storage and appropriate display; and (3) **organising** ways to facilitate an interpretation of their meanings for

specific audiences. Though 'practical', of course, these activities are interdependent with a number of **theoretical**, political, and cultural policy processes that often include **national** government and now often international-level consultation. This is particularly the case with institutions that receive their funding from the **state** and **represent**, in effect, part of the **national** culture. Even most private institutions, free to spend their money as their owners see fit, are regulated by, and party to, many kinds of international **conventions** concerning, for example, the means through which acquisition of items occurs. Perhaps particularly in the case of ethnographic collections, ethical and political matters relating to the purchase and display of items from non-**western** countries and territories have become extremely prominent. Have the items acquired, for instance, been transferred directly from their makers' (or their makers' descendants) possession, or been bought and sold several times by other institutions over many years, in a process obscuring ownership rights and knowledge of the importance of these artefacts for the people for whom they were **originally** made? In the case of funerary practices and the embalming of **human** remains (e.g.: artefacts involving mummification processes) this matter is of extreme moral **significance**.

These issues *are* similar in kind to those that attend upon the guardianship of children and involve taking decisions that are claimed to be in their 'best interests'. Indeed, the **contemporary** institutional care and use of **artworks** and other cultural artefacts *does* invest them with an either direct or indirect spiritual significance: they are the **products** of actual people (living or dead) and represent traces of their life. Extremely bitter dispute surrounds some collections – such as the 'Elgin Marbles', or the 'Parthenon Frieze Sculptures' as the Greek government calls the antique statues sold by the Ottoman Turks to the British Museum in 1816. Thomas Bruce, the 7th Earl of Elgin, was the English aristocrat **mediator** who arranged the purchase. Possession and control *then* was a matter of unabashed national pride in Empire; in the **epoch** of decolonisation since 1945, however – and in the wake of **postcolonial studies** – institutions such as museums are understandably highly reticent to trumpet the honours of ownership that earlier imperial conquest bestowed.

Further Reading

Association of Museum Directors *Different Voices: A Social, Cultural and Historical Framework for Change in the American Art Museum* (Association of Art Museum Directors: 1992).

George, Adrian (ed.) *Art, Lies and Videotape: Exposing Performance* (Tate Publications: 2003).

Wallach, Alan 'The Battle over "The West as America",' and Ann Rorimer 'Questioning the Structure: The Museum Context as Content', both in Marcia Pointon (ed.) *Art Apart: Artifacts Institutions and Ideology Across England and North America* (Manchester University Press: 1994).

DADA *DADAISM, DADAIST,* NEO-*DADA*

Artists'^ movement established in Zurich, Switzerland, in 1916 in order to attack what its members saw as the decadence and corruption of **contemporary** bourgeois **society**, the power of the Church, and the forces of **nationalism, capitalism**, reaction, and militarism that had brought about the slaughter of the First World War. Though its members included **painters, sculptors, photographers**, and poets (principally Jean Arp, Hugo Ball, Marcel Janco, Richard Huelsenbeck, Francis Picabia, Hans Richter, and Tristan Tzara), the most startling and infamous manifestations of *dada* – a nonsense word **meaning** 'hobby horse' – were what would later in the 1960s be called *happenings*: the 'Cabaret Voltaire' raucous concerts and meetings, often ending in chaos and sometimes violence, involving deliberate acts of provocation and disruption.

Others associating themselves with the spirit of dada became active in a number of countries – Arp, for instance, went to Cologne and **organised** activities there with Max Ernst. After the end of the war, Berlin became the centre for a more politically radical dadaism, bound up with support for the newly-created German Communist Party. Those involved included the painter George Grosz, photomontage artist John Heartfield (a German who Anglicised his name as a **symbolic** rejection of German nationalism), his brother Wieland Herzfelde, and collage-maker Hannah Höch (see e.g.: Grosz's painting *Funeral Procession Dedicated to Oskar Panizza* (1917); Heartfield's photomontage *The Meaning of the Hitler Salute: Little Man Asks for Big Gifts. Motto: Millions Stand Behind Me!* (1932); and Höch's montage *Cut with the Cake Knife* (1919)).

In **art^ historical** terms the most **influential** dadaist was certainly Marcel Duchamp, a French national who moved to New York in 1915 to avoid military conscription. His 'ready-mades', constructed from non-art **materials** – most famously a urinal turned upside down, signed 'R. Mutt', and intended for display in an **exhibition** in New York in 1917 – became the key antecedents for a vast range of **artefacts^ produced** by later **artists** affiliated one way or another to

89

dada's **avant-garde** ambitions. The term *neo-dada* was coined in the 1960s to **identify** these highly diverse new artistic **formations**, their **artworks**, and **performances**. The term *happening* was also coined around this time to define a shift from the **production** and display of isolated objects to a concentration on staging events involving artists and their entourages – for instance, Andy Warhol's 'factory' and the various happenings associated with it during the period *c.* 1962–68, such as the 'Exploding Plastic Inevitable' multi-**media** show.

Neo-dada implies a retrospective **reading** of the **original** dadaist activities: a radical selection of **practices**, meanings, and **values**. Although the direct social and political intentions and contexts of *c.* 1916–19 dada have *not* been completely overlooked, post-1960s artists' and art historical **interpretations** have tended to focus on dada's place in a sequence of **art world** avant-gard**isms** (its relations with **surrealism**, for example), as part of the standard **history** of **modernism** in the **visual** arts. This has, inevitably, undermined recognition of the primarily disruptive and anarchic **qualities** to dada. Some recent accounts, for instance of the American dadaist Baroness Elsa von Freytag-Loringhoven, however, have made valuable attempts to redress this potentially depoliticising **perspective**.

Further Reading

Doherty, Brigid *Montage: The Body and the Work of Art in Dada, Brecht, and Benjamin* (University of California Press: 2004).

Jones, Amelia *Irrational Modernism: A Neurasthenic History of New York Dada* (MIT Press: 2004).

Motherwell, Robert (ed.) *The Dada Painters and Poets: An Anthology* (Wittenborn, Schultz: 1951).

Sheppard, Richard *Modernism – Dada – Postmodernism* (Northwestern University Press: 1999).

DECONSTRUCTION *DECONSTRUCT,*
DECONSTRUCTIONISM, DECONSTRUCTIONIST

Name given to (1) a type of intellectual **analysis**^ **developed** within **poststructuralism** and (2) a **practice** in **postmodernist**^ **visual**^ **arts** and **architecture** since the 1980s that attempted to undermine certainties about the **meanings** of, and relations between, **concepts**, **forms**, **traditions**, and **identities**. *Deconstruction's* **origins** lie in the writings of the French philosopher Jacques Derrida, who, in a series

of brilliant books published in the 1960s and 1970s argued that *all* **texts** contain within their **structure** the means for their apparently stable and clear meanings to come 'undone' and be made radically open to re-**interpretation**. This claim and insight had two main implications for **artists** (as well as **art historians** and **critics**). First, it emphasised the apparently absolute 'role of the **reader**' (rather than the **author** or artist) in *determining* the meaning of something – be it, for example, a written text, or **painting**, or **film**, or building. Second, and somewhat contradictorily – a contradiction, however, that Derrida revelled in – it stressed the apparently *inherent* ambiguities present in any kind of **significatory** practice or form. Any **cultural**^ **artefact** read as a kind of text, that is, could be shown to **exhibit** a range of meanings ('polyvalence').

Deconstruction was taken up by artists and critics partly because it **emerged** at a time when radical questioning of **modernist** art and its criticism was already underway. If modernist **theorists** such as Clement Greenberg and Michael Fried insisted in the 1960s that the best **artworks** *necessarily* contained their own significance and **value** – **art-for-art's-sake** as this idea had much earlier been known – then deconstruction bolstered the claims of the so-called 'critical postmodernists' that modernism's key interlocutors had really managed to *impose* an interpretation on past art that could no longer be justified intellectually or was relevant to **contemporary** art practices. Deconstruction therefore enabled a re-reading of modern (and earlier) art to become possible – and necessary – which fundamentally undermined the already shaky basis of modernist interpretations. T.J. Clark's neo-**marxist** deconstruction of Jackson Pollock's paintings and those of other **abstract expressionist** artists are a case in point.

Deconstruction, however, does not have a *single* aim or purpose: as a basic 'technique of reading' based on undermining established conceptual dualisms (binary divisions) – such as text/context; **agent/** structure; speech act/**language** system; male/female; heterosexual/ homosexual, etc. – it has been adopted and adapted by a wide range of artists and critics with different, and sometimes even opposed, motivations and interests. Deconstruction has been compatible with a number of **social** and political **perspectives** including **feminism**, **marxism**, gay and lesbian studies, and **postcolonial studies**. Artists with an equally wide range of concerns have made use of it, in for example, combining text, objects, and **images** in **complex** artefacts that seek to **create** new meanings and subvert old ones (e.g.: Fred Wilson's anti-colonialist **installation** concerned with ethnographic collections *Mining the Meaning* (1992); Rachel Whiteread's **material**

'inversion' of an East London working class home *House* (1993)). In addition, much art (and some postmodernist architecture) since the 1980s – based on one understanding of the significance of deconstruction – has been premised on the idea that visual **representations** cannot and should not have single meanings, or be interpreted on the basis of assumed or **intended** authorial meanings (e.g.: Renzo Piano and Richard Rogers' *Centre National d'Art et de Culture Georges Pompidou*, Paris, 1971–77).

Further Reading

Clark, T. J. 'The Unhappy Consciousness' and 'In Defense of Abstract Expressionism', in Clark *Farewell to an Idea: Episodes from a History of Modernism* (Yale University Press: 1999).

Derrida, Jacques *The Truth in Painting* (University of Chicago Press: 1987).

Norris, Christopher *Deconstruction: Theory and Practice* (Routledge: 1986).

Salingaros, Nikos *Anti-Architecture and Deconstruction* (Umbau-Verlag: 2004).

DESIGN *DESIGNER, DESIGNER-OBJECT*

In **art^ historical** and **visual^-cultural** terms, *design* refers to two separable but related things: (1) the conscious and systematic **development** of a *plan* intended to realise a **visible** physical-**structural** project in the world, and (2) particular, though broad, fields of twentieth-century and **contemporary material^**-visual **practices** (including, for example, **fashion**, the applied arts and decoration, **product** manufacture, print and **communication** graphics).

In the sense outlined in (1) above, *design* may be shown to have a **history** as a **theoretical** notion traceable back at least to the ancient Greeks and Romans, and was very important to the first attempts made in the **renaissance** to **conceptually** elaborate, and contrast, one area of **human^ production^** (called **art**) from another (called **craft**). For example, the *act of mental planning* fundamental to the successful production of **complex** building structures – such as the cupolas (domes) over large churches – was held to indicate the higher, **creative^ nature** of this design activity (e.g.: Filippo Brunelleschi's cupola for the cathedral in Florence (1420)). Leon Baptista Alberti's famous treatise *De re aedificatoria* ('On the Art of Building', 1452) was the first **text** to theorise rules and **conventions** for **contemporary** building and town-planning. As these plans began to require, for instance, sophisticated mathematical and engineering calculation, it was even more convincingly argued that the design task involved was

elevated categorically beyond work of mere physical labour. Related to this hierarchical distinction was the possibility – soon to become routine – of an important *intellectual and social division of labour*: the **architect** designs (plans) the building, working out, for example, load stresses for walls and appropriate materials to be used; the actual building can then be constructed, under supervision, by those able competently to follow the orders.

This elevation and distinction could be applied, with some qualification, to the renaissance arts of **painting** and **sculpture**. In the ambitious schemes for fresco decoration carried out by Raphael in the Vatican palace, for example, the **master^ artist** designed the **compositions** for these wall-**pictures**, then oversaw their actual painting carried out by a team of apprentices and more experienced workers – though Raphael would himself paint particularly important sections (the chief figures and faces, for example, in the *Stanza della Segnatura* (1509–11), a painting appropriately on the theme of the human intellect). Design in this sense, then, was an integral part of the *professionalisation* process for the **emergent^ modern** categories of **artist** and architect.

The second, contemporary, sense to design **identified** above interestingly *excludes* what are usually regarded as the most creative arts – or the **ideal** of **high art** in the categorical sense **traditionally** contrasted with craft. This exclusion persists despite the fact that design has, in the last twenty-five years or so, become a term of extremely high praise: exemplified within such notions as 'designer sunglasses' and 'designer couture'. Perhaps the distinction remains because high art **artefacts** – such as paintings and sculptures – are still thought of as in some essential way without practical purpose (designed specifically to be **looked** at and admired), while even the most exquisitely **beautiful** and well-made designer-objects came into existence in order (at least initially) to be used for some practical purpose (e.g.: Gerrit Rietveld's 1918 Red/Blue chair; Christian Dior's **classic** 1951–52 knife-pleated skirt).

Further Reading

Attfield, Judy and Pat Kirkham (eds) *A View from the Interior: Feminism, Women and Design* (Women's Press: 1989).

Margolin, Victor (ed.) *Design Discourse: History, Theory, Criticism* (University of Chicago Press: 1989).

Sparke, Penny *An Introduction to Design and Culture in the Twentieth Century* (Allen and Unwin: 1986).

Woodham, Jonathan M. *Twentieth-Century Design* (Oxford University Press: 1997).

DESIRE *DESIRING SUBJECT,* OBJECT OF DESIRE

Though only used quite recently in **art^ history** – probably since the later 1970s – *desire* is one of a series of **psychoanalytic** terms that has been adopted and adapted in order to account for some important aspects of the **production** and **interpretation** of **artworks**. In rarer cases, however, writers have attempted to understand artworks as *only and wholly* the result or **representation** of what is called the 'desiring **subject**' (the **artist**), and this desire is claimed to be exclusively **sexual** in character. Sigmund Freud's famous early-twentieth-century case-study essays on Leonardo da Vinci and Michelangelo, for example, assert that the extraordinary productivity and obsessiveness of these two artists was a relatively simple matter, finally, of their repression of homosexual desires – which, Freud argued, they 'sublimated' (redirected) into artistic **creativity**. The term *art historical* seems quite misleading as a characterisation of these accounts – in which human productive activity and **culture** are depicted as the representation/sublimation of an essentially **asocial**, *universal*, and *unchanging* sexual **nature** which is claimed to direct, shape, and fill up the artistic endeavour. While sometimes acknowledging other possible contexts, interests, and motivations, these psychoanalytic **explanations** of **art** tend to render all else peripheral to the main – actually itself obsessive – focus: the means and products of this 'externalisation' of primeval unconscious **human^ bodily** drives.

In many other studies, however, desire as an explanatory category has been given different, lesser (and more plausible) **meanings**. In its ordinary usage, for instance, its meaning is close to conscious intent and therefore raises all the issues and questions surrounding the idea of **intention** – and in this sense it belongs to an orthodox cluster of terms and problems long examined in **art history**, philosophical **aesthetics**, and the psychology of art. How are the ideas and meanings the artist desires or *wishes* to **communicate** actually 'put into' the artwork? Think, for instance, of a **photographic^ portrait** by Cindy Sherman where erotic **content** seems more implied than shown (e.g.: *Number 13* (1978)), or a painting by Edgar Degas where feeling and desire appear sinister and threatening (e.g.: *The Interior* (1869–70)). How can it be shown, if at all, that these meanings are

actually *there*? How does the role of the **critic** as intermediary between artwork and the wider **public** work to establish, or possibly, subvert these desired meanings? How do the various desires of the public – including those of critics – affect the kind of **readings** or interpretations that are made of all artworks?

Desire, in both its **specialised** psychoanalytic uses and in these familiar senses related to intention, is **significant** because it poses some serious challenges to the habitual rationalism that governs most art historical research: the belief, or assumption, for example, that conscious **design** or *planning* by the artist (depicted as a self-knowing and self-possessed **agent**) is the key to understanding the meaning, purpose, and **value** of their products. In this way, then, desire usefully stands **metaphorically** for a whole series of factors – to do with the body and sexuality, but also with social **organisation** through, for instance, **language** and **institutions** – that come to shape, as well as sometimes undermine, self-directed planned actions undertaken by individuals. Psychoanalysis, that is, presents one important instance of the '**structure**–agency' explanatory dilemma that always attends upon art historical accounts of artistic production and its wide range of conditions and circumstances.

Further Reading

Bryson, Norman *Tradition and Desire: From David to Delacroix* (Cambridge University Press: 1984).

Freud, Sigmund 'Leonardo da Vinci and a Memory of His Childhood', in Freud *Standard Edition of the Complete Psychological Works*, vol. xi (Hogarth Press: 1910).

Kristeva, Julia *Desire and Language* (Columbia University Press: 1980).

Lacan, Jacques *Four Fundamental Concepts of Psychoanalysis* (Hogarth: 1977).

DEVELOPMENT *DEVELOP, DEVELOPING*

Though apparently straightforward, when used in **art^ historical^ explanation**, *development* has two important senses that are separate but related: (1) when used *neutrally*, to mean 'a link between things' or 'interaction'; and (2) when used **evaluatively**, to mean 'an improvement, or deterioration, or later stage'. In much art history these two senses have become fused – or confused – and the differences between them are often unacknowledged. For instance, it is typically claimed, or implied, in **traditional** accounts that significant development occurs *between* the **epochal^ styles** of **western** art since the

fifteenth century: **renaissance** → **mannerism** → **baroque** → **rococo** → **neoclassicism** → **realism** → **modernism**. In the first *neutral* **meaning** given above the idea of 'linkage' makes obvious common sense: it would be absurd to claim that these style names are meant to stand for absolute divisions and distinctions between the range of phenomena to which they refer (for instance renaissance or mannerist **artworks, techniques** and resources, **artists,** particular **social** relationships involving **institutions,** the wider societies, etc.). In the second sense, however, *development* may be used *clearly* to suggest some **qualitative** change regarded as either good or bad, or to imply that a *single continuous process* consisting of a series of 'phases' or 'stages' – like those of a space rocket – is working its way through in art's **history.** It is this insidious use of the term that causes most of the problems: for it may smuggle in attitudes, **values** and judgements that are *not* declared, that may remain unconsciously present, and which may lead to faulty conclusions.

For instance, it is fairly standard *still,* for art historians of the whole post-renaissance **period** (*c.* 1500–1850), to argue that the central development, or impetus, in **western** art was towards an increasingly **naturalistic** depiction of the empirical, observable world, and that this occurrence (neutral) or development (value judgement) **represents** a profound achievement. As a claim it is possible to link this assertion to its proponents' views about the societies in which the artists thought responsible for this achievement worked: those constituting western **civilisation** and its mastery of the **natural** and **human** world in many other ways, including the inventions of technology and imperial conquest of other territories and **cultures.** At this point it should become clear that the **concept** of development *may* mask beliefs, values, and **ideologies** that are highly partial and questionable – that the western art tradition, for instance, is clearly superior to **visual^ representation^ produced** in other parts of the world by makers who did not attempt to **create** (what westerners think of as) naturalistic likenesses. Indeed, representation understood to mean naturalistic depiction – Ernst Gombrich's notion of 'schema and correction' set out in his **influential** study *Art and Illusion: A Study in the Psychology of Pictorial Representation* (1960) – itself smuggles in evaluations about *western* development, cultural maturity, and civilisation that are usually inapplicable to the **artefacts** and cultures of other peoples. **Primitivism,** a cult adopted by **avant-garde** artists (such as the **cubists** and **expressionists**) and art historians alike in the early twentieth century, valued visual **images** and

objects from non-European cultures precisely *because* they were thought – **idealistically** – to **exhibit** no development, to be in some important respects unchanging or timeless, and therefore to be uncorrupted by the descriptive, rationalising aims underpinning naturalism.

Further Reading

Albrow, M. and E. King (eds) *Globalization, Knowledge and Society* (Sage: 1990).
Blomstrom, M. and B. Hettne *Development Theory in Transition: The Dependency Debate and Beyond: Third World Responses* (Zed Books: 1984).
Gombrich, Ernst *The Story of Art* (Phaidon: 1950).
Rosenblum, Robert *Cubism and Twentieth-Century Art* (Harry N. Abrams: 1960).

DISCOURSE *DISCOURSE ANALYSIS, DISCURSIVE, DISCURSIVITY*

Importantly related to, yet distinct from, two other **theoretical** terms in **art^** history – **language** and **ideology** – *discourse* refers to the **historical^** structure of **meanings** in place at a particular time that fixes the **value** and sense given to a range of things. As this definition suggests, discourse is a **complex^** concept and its understanding requires the provision of illustrative examples. When someone talks, for instance, of '**modernist** discourse' or 'discourse on **feminist** art' some aspects of its meaning are familiar and straightforward. These facets relate to the use of language and **texts**: discourse *includes* both written and spoken language, and refers to distinct **bodies** of language – and a text (literally, a book) is a simple example of such a body (or grouping). Discourse in its traditional eighteenth-century meaning meant literally this: a lecture or essay on a particular **subject** (e.g.: Sir Joshua Reynolds's *Discourses Delivered to the Students of the Royal Academy* written as lectures when he was the president of that **institution** in London, between 1769–90). But discourse in its theoretical sense **developed** from the 1960s onwards, as part of **post-structuralist** philosophy, added several new elements to the definition.

First, it was **intended** to refer to an *active grouping* of meanings and values developed and used **socially** and institutionally to bring about certain **effects** in the world. So a discourse cannot be the property or **creation** of a single individual: it is **produced** between people, over time and in a variety of places, and constitutes a **form** of structuring *of consciousness* about the meaning of the phenomena to

which it refers. In this way it is possible, for instance, to talk about the discourse on **genius** and 'individual creativity' in art history – this discourse is a set of statements and texts, historically vast in their production, stretching back hundreds of years, and yet linked, through certain key ideas and terms, to **contemporary** enunciations. This notion of discourse has meanings close to those of ideology: that is, statements and values linked to social interests in the world that promote a certain **view** of *how* and *why* things are the way they are. **Feminists**, for instance, have claimed that **old master** discourse in art history is **patriarchal** and entrenches male power.

Another important sense to *discourse*, however – *unlike* most **marxist** accounts of ideology – emphasises how a set of structuring statements and values, using key concepts and terms (e.g.: '**origin-ality-authenticity**' discourse) *creates the world* rather than merely reflects it: that actual things, such as **paintings** and buildings, once understood by people within certain discourses, become 'discursive objects' in themselves. This radical sense to discourse – in some cases proposed as a deliberate attack on marxist 'reflectionism' accused of defining language/**culture**/ideology as passive elements *determined* by economic forces – does away with the distinction between 'consciousness' and 'social being' that marxism maintains, arguing instead that the world is altogether 'discursively produced' through the structuring activities of language and its social-institutional use to create certain effects. Although this notion of discourse, particularly in the writings of Michel Foucault, produced some extraordinarily important research into areas of **human** life hitherto relatively unexplored (e.g.: the discourses of human **sexual** activity, prison existence, and care of the 'mad'), marxists continue to argue that discourse theory offers no **real** account of 'determination' or causality, because effectively it has rendered *everything* equally discursive – no element, such as economic production, is given priority or an over-arching role in shaping and limiting, for example, the development of human consciousness or the **social order**.

Further Reading

Foucault, Michel *The Order of Things: An Archaeology of the Human Sciences* (Tavistock: 1970).
—— *Discipline and Punish: The Birth of the Prison* (Penguin: 1977).
Laclau, Ernesto *Politics and Ideology in Marxist Theory* (Verso: 1982).
Williams, Raymond 'Base and Superstructure' and 'Determination', in Williams *Marxism and Literature* (Oxford University Press: 1977).

DOMINANT *DOMINANCE, DOMINATE*

One of a set of three terms – along with **emergent** and **residual** – devised by the **cultural**^ **historian** and **theorist** Raymond Williams as a means of **identifying** the historical force, or **influence**, of specified cultural phenomena. In **art**^ **historical** terms, for instance, the *dominance* of, for example, a particular **style** (e.g.: **cubism**), or an **artist**, or an **institution**, or a **critical**^ **perspective** might be shown within a certain **socio**-historical moment – relative to the influence and status of *other* **contemporary** styles, artists, institutions, or critical perspectives. Williams suggested these terms as a means to attempt to account for **complex** cultural and artistic change in **modern** societies. In any given historical moment, he argued, different styles, artists, institutions, and critical perspectives could be seen as *dominant* (most influential), or residual (losing power), or emergent (coming to prominence). However, Williams envisaged these terms always being used flexibly and heuristically – that is, through **analytic** trial and error – rather than in a dogmatic **fashion**.

To give an example. By the mid 1960s the dominant critical account of the **origins** and **meanings** of modernism in the **visual** arts was that by Clement Greenberg and his followers in the US and **western** Europe. This account later became known as 'Greenbergian modernism'. Its dominance consisted in the pervasive **forms** of its influence: as a codified intellectual perspective and a habit of assumptions or 'common sense' that others active in the **art world** shared and **reproduced** in various ways. This happened, for example, (1) through institutionalised university and art school teaching programmes that encouraged artists to think along Greenberg's lines; (2) through the writing of criticism, catalogue, and art historical essays formulated in Greenbergian terms; and (3) through the **curatorial**^ **practices** of particular **museums** and galleries conforming to (or, at least, not challenging, Greenbergian precepts; e.g.: those of the Museum of Modern Art in New York). Together these practices constituted a consensus formed around Greenberg's particular version of **art-for-art's-sake**^ **discourse**, the importance of one **reading** of Kant's philosophical **aesthetics**, and the **value** of **abstract** art. These inter-linked notions were **produced**, within this account, as 'true' and formed the paradigmatic (i.e.: chosen, dominant) set of ideas, procedures, and methods for understanding what stood then as advanced, **avant-garde** art.

At the same time in the early 1960s, however, a number of other practices and critical perspectives were also present and active – some residual (for instance, the belief that a *moderate* abstraction, containing

some **naturalistic** elements, should characterise modern art: 'School of Paris', or Picasso and Matisse-led modernism); some emergent (for instance the sense that a new kind of art, concerned with aspects of **mass culture**, was important: **pop** art, as it would be termed).

As this simple example is **intended** to indicate, the term *dominant*, as part of the set Williams proposed, is an analytic and theoretical proposition or hypothesis – *useful* as a means to begin to 'think through' a particular historical situation, but *not* necessarily adequate to all of the empirical complexities one might find there. Its value lies in being a tool that can provide a schematisation – an outline – of the range of ideas, **artefacts**, practices, and values present, and always interacting dynamically, within any historical moment.

see also: **emergent**, **residual**

Further Reading

Duncan, Carol 'Virility and Domination in Early Twentieth Century Vanguard Painting', in N. Broude and M. Garrard (eds) *Feminism and Art History: Questioning the Litany* (Harper and Row: 1982).

Krauss, Rosalind 'Six', in Krauss *The Optical Unconscious* (MIT Press: 1994).

Reise, Barbara M. 'Greenberg and the Group: A Retrospective View', in Francis Frascina and Jonathan Harris (eds) *Art in Modern Culture: An Anthology of Critical Texts* (Phaidon: 1992).

Williams, Raymond 'Dominant, Residual, and Emergent', in Williams *Marxism and Literature* (Oxford University Press: 1977).

EFFECTS STUDIES/EFFECTS

Part of the work carried out in the **analysis** of **popular** or **mass culture**, *effects studies* is concerned with the ways in which **visual^-cultural^ representations** can be shown to modify the behaviour and attitudes of people in **desired** (and sometimes undesirable) ways. Effects studies *did not begin as, nor is it now, predominantly a* **form** *of* **academic** *research*: its **origins** lay rather in corporate **organisations** (those both commercial-capitalist and governmental in **nature**) in the early twentieth century attempting to find out if their new **advertising** and **public** awareness campaigns had the **intended** results. In the former case, the **emergent** branch of corporate activity concerned with 'marketing' and 'brand awareness' wanted to be able to monitor the success or failure of its strategies for **communicating** with people. Once advertising itself, as an economically important

form of corporate capitalist activity, became established – by the 1930s in its **modern** form – then effects studies **commissioned** by the industry began to receive considerable financial investment. It quickly became part of the advanced 'hard sell' of **consumer**-capitalist **society** and culture usually dated from the 1960s, associated particularly with **TV** advertising and telephone polling research.

Effects studies, perhaps somewhat ironically, became assimilated to some of the research aims of **cultural studies'** scholars in the 1970s. From a completely different, and sometimes even **opposing^ perspective** – intellectually and politically radical – academics establishing this new field also wanted to study the 'causes and effects' of mass cultural forms, such as print, **film**, TV, and radio. They had a particular interest in understanding how industrial capitalism – as both an economic system and as a set of social relationships – had already transformed, and continued to **revolutionise**, the broad patterns and **organisation** of life in **western^ societies** since the 1900s. In the 1960s and 1970s **academic** effects studies became preoccupied with certain issues then high on **national** moral agendas: for instance, the impact of TV and film depictions of violence and **sex** on younger **viewers**. To what extent did their exposure to graphically **represented** violence and sex **influence** the behaviour of this particularly impressionable group?

Effects studies has been faulted on many grounds – in, for example, isolating certain factors from others whose consideration might radically alter judgements about both 'cause' and 'effect' (in claiming, for example, that one presumed motivational cause can *ever* be held wholly or even largely responsible for a human action – e.g.: that the countless depictions of violent crime in TV shows actually *cause* young men to become violent). Despite the **complexities** and undoubted difficulties in **theorising** and carrying out this kind of analysis – usually based on questionnaires, statistical analysis, and laboratory-type experiments with volunteers – **art history** could valuably begin to consider the general area of popular **reading** and **interpretation**. This kind of research is un**developed** in most of its branches, partly because of the innate difficulties and problems of method such issues raise. The **discipline** could, however, learn from the interesting work of many case studies in the field of literary **hermeneutics,** and from similar research in cultural studies.

Further Reading

Frith, Simon *The Sociology of Youth* (Causeway Books: 1984).

101

Hall, Stuart 'Encoding and Decoding in Television Discourse', in Stuart
Hall, Dorothy Hobson, Andy Lowe, and Paul Willis *Culture, Media, Lan-
guage* (Hutchinson: 1980).
Hebdige, Dick *Subculture: The Meaning of Style* (Methuen: 1969).
Holub, R. C. *Crossing Borders: Reception Theory, Poststructuralism, Deconstruc-
tion* (University of Wisconsin Press: 1992).

EMERGENT *EMERGENCE*

One of a set of three terms coined by the **cultural^ historian** and
theorist Raymond Williams – the others being **dominant** and
residual – in order to attempt to calculate the **influence**, or force, of
specified cultural phenomena at a particular historical moment. These
would include, for example, **artistic^ styles**, or **institutions**, or
critical^ perspectives. As a theoretical category, *emergent* has a
relatively *fixed* **meaning**: that which may be said to be 'coming into
being', or 'becoming influential', with the implication that the thing
emerging has an independence or distinctness to it. When applied in
any particular historical and empirical study, however, the term may
or may not be shown to be useful or applicable to a range of **iden-
tified** phenomena.

It is now an **art^ historical** commonplace, for example, to argue
that **postmodernist** artistic **practices** were emergent in the later
1970s and early 1980s. That is, at this time, some artists (and critics)
were discarding what they saw as the exhausted **pictorial** and philo-
sophical **conventions** of 'late' **modernism** – for instance, the use of
oil **paints** on canvas, the attempt to **communicate** a unique,
authorial and purely **visual** style of **expression** (e.g.: Richard Die-
benkorn's *Ocean Park No. 60* (1973)) – and trying, instead, to
appropriate some of the effects of mass-**produced^ photo-
graphic^ imagery** which they overlaid with **text**, in order to subvert
the **ideologies** underpinning, for instance, commodity **consump-
tion** or **gender^ identity** (e.g.: Barbara Kruger's *All Violence is the
Illustration of a Pathetic Stereotype* **installation** at the Mary Boone
Gallery, New York (January 1991)). This transformation in practices –
as well as in **contemporary** critical anticipations and responses to
them – was a process that took place over a number of years and can
be shown to have been partly inspired by earlier precedents: for
instance silkscreen prints by Robert Rauschenberg and *some* of the
painting/prints of Andy Warhol **produced** in the **period** 1955–68.
But in the later 1970s postmodernism emerged and gradually over-
took **pop** (then in a position of relative dominance) as well as the

residual **forms** of **abstract expressionism** represented by Die-benkorn's painting.

As this simple example suggests, the term *emergent* is, **analytically** speaking, *retrospective*: it claims to identify a **development** that took place over a certain period in the past, in which some other practices could be said to have had dominance, and others to have been, or started to become, residual. 'Late modernism' is a general term used to identify a range of artistic practices still active in this period, drawing on both abstract expressionist and pop art legacies, although a range of others had emerged (began to become important) in a variety of ways since the later 1960s (e.g.: **feminist** art, land art, **minimalism**, and **conceptual art**). As theoretical categories, then, 'emergent-dominant-residual' may be used, and qualified in that usage, in subtle ways, or, in contrast, used to present a very crude kind of differentiation. Their meaning and **value**, however, depends *entirely* on the aims and interests of those seeking to put them to use in specific inquiries based on actual evidence and arguments. They all also have an important relationship to another **concept** developed in order to try to **explain** how all the forces and elements in a **social order** are **organised** and achieve meaning: the political and cultural notion of **hegemony**.

see also: **dominant, residual**

Further Reading

Buchloch, Benjamin, Donald B. Kuspit and Thomas Lawson 'Paroxysms of Painting', essays, in Brian Wallis (ed.) *Art after Modernism: Rethinking Representation* (New Museum for Contemporary Art: 1984).

Guilbaut, Serge *How New York Stole the Idea of Modern Art: Abstract Expressionism, Freedom and the Cold War* (University of Chicago Press: 1984).

Harrison, Charles and Paul Wood 'Modernity and Modernism Reconsidered', in Jonathan Harris, Francis Frascina, Charles Harrison, and Paul Wood *Modernism in Dispute: Art Since the Forties* (Yale University Press: 1993).

Williams, Raymond 'Dominant, Residual, and Emergent', in Williams *Marxism and Literature* (Oxford University Press: 1977).

EPOCH *EPOCHAL*

One of a series of terms used habitually in **art^ history** in order to designate a limited and distinct **historical^ period** or time and often

linked with a particular **style** of **artistic^ production** and/or phase of broad **social^ development**. Often the *epoch*, style, and social development are *conflated* (brought together): for example, in common uses of the terms **renaissance** and **baroque**. These names, that is, have come to stand both for an era of history and to characterise, at least in general terms, some broad stylistic and socio-**cultural** features. **Identified** epochs in the history of art since **medieval** times – a period of about twelve hundred years, from *c.* CE 200 to *c.* CE 1400 – interestingly tend to become shorter as they approach the present. The renaissance (including its 'high' and **mannerist** sub-phases) is usually dated from *c.* 1350 to 1550; the baroque from *c.* 1550 to 1740; the **rococo** from *c.* 1740 to 1790; and **neoclassicism** from *c.* 1790 to 1815.

Epochs are, in one sense, art historical constructions or projections; in this sense they are **discursive** inventions (and assumptions) telling us about the particular interests of historians who often lived, researched, and wrote many decades, and even hundreds of years, *after* the time in which they are interested. Period and style labels – such as mannerism, rococo, and **romanticism** – are often retrospectively applied to shore up a particular view about the long-term historical development of art and **human^ civilisation**. As 'macro'-**analytic** terms in art history (concerned, that is, with decades and centuries of development), they inevitably obscure many 'micro' phenomena (events in a year or month, or week, or a day), offering very broad – or, to put it another way, crude – generalisations, and radically selecting, for example, **artists**, **artworks**, and centres of development in art and society that fit in with the claimed epochal characteristics. For example, the two artists usually **represented** as working at the 'dawn' of the renaissance – Cimabue and Giotto – had died in 1302 and 1337 respectively, a full sixty years before even the birth of Masaccio, to whom the **metaphoric** baton of **naturalistic** rendering is passed according to the standard survey histories.

For this reason it is really impossible to say that the grand art historical epochs are either definitively 'true' or 'false' designations in any strict empirical sense – rather they represent, in one way, powerful **organising^ myths** about **western** art. These myths, however, certainly have tangible **effects**: they contribute, for instance, to the belief, or **ideology**, that western art had an internal dynamic (or *teleological* drive) towards the **production** of imitative likeness said to have been brought to perfection by the early part of the nineteenth century in the epoch of naturalism. After the mid nineteenth century these grand epochal characterisations quickly break down in both

historical and stylistic terms. Though it is true that the whole century since about 1860 to 1960 is known as the **modern** period, this term does not offer to define the nature of the highly diverse currents active over this time. Like its equally generic and hollowed-out immediate predecessor romanticism, the modern period is a more or less neutral container for a bewildering number of sometimes opposed sub-**classifications** including **realism** – which confusingly spans the romanticism-modern period divide (e.g.: some of the **paintings** produced by Eugène Delacroix, Gustave Courbet, and Édouard Manet between *c.* 1820-80) – and **abstraction**, as well as all the later **isms** associated with the much more **theorised^ concept** of modernism.

Further Reading

Focillon, Henri *The Life of Forms in Art* (1934) (Basic Books: 1976).
Onians, John '*Kunstgeschichte* and *Historia*', in *Art History* June 1978: 131–33.
White, Hayden *Metahistory: The Historical Imagination in Nineteenth Century Europe* (Johns Hopkins University Press: 1973).
Wölfflin, Heinrich *Principles of Art History: The Problem of the Development of Style in Later Art* (1915) (Dover: 1950).

ETHNICITY *ETHNIC, ETHNOCENTRICITY, ETHNOGRAPHIC*

Highly important **theoretical** term in several fields of the **new art^ history** since the 1980s, *ethnicity* is at once (1) centrally related to notions of **racial** and **social^ identity**; (2) bound up with an idea, and **ideal**, of **human** biological (**bodily**) **nature**; and yet (3) always inextricably connected to other, non-ethnic, factors within **historically** specific socio-**cultural** circumstances. Henri Matisse's 1907 **painting** *Blue Nude: Souvenir of Biskra* – a **representation** of a black woman prostitute from North Africa posed and **titled** as belonging to the **genre** of the **nude** in **western** art – manages to encapsulate all three of these definitions. Ethnicity, this painting suggests, is as much about **visual^ image** and appearance (and *who* **produces^/interprets** these) as it is to do with biological-physical **realities**.

In terms of one of the **traditional** concerns of art historians – that is, saying which **artefacts** and **artists** belong to the **canon** of great art, and why – **critical^ discourse** on ethnicity operated **originally** as a subversive political and intellectual critique of white, western **ideologies** and interests. The claimed universality to canonical great

art produced in Europe and the US in the **epoch** from the **renaissance** to the later twentieth century was judged by, for example, **emergent** black, Asian, and Latin American scholars actually to mask a highly selective and partial ethnocentricity. This canon, the radicals argued, reflected the extremely narrow interests and **values** of middle-**class** Anglo-American (and earlier European) scholars writing in the nineteenth and twentieth centuries rather more than it represented the tens of thousands of artists active since the 1500s. Ostensibly 'southern European' centres of artistic **production** in the renaissance, they pointed out, arguably owed more to *eastern* Roman, **byzantine** and Islamic culture and trade than they did to any others.

If the standard mid-twentieth-century art historical accounts of **civilisation** and culture were vehicles for **imperialising** western – that is, Anglo-American – power in the world, then it was radical black, middle-eastern, and Jewish scholars in those countries who led **developments** in **cultural studies** toward the **analysis** of how specific ethnic identities have both been **formed** and interacted. This process has been ongoing for many centuries, *in* the western societies as well as *outside* of them in what are now termed (by Euro/US-centric scholars) the 'second' and 'third worlds'. Many **specialised** areas of 'ethnicity studies' have emerged concerned with, for example: the forms of socio-cultural relation between **dominant** and subordinate (subaltern) ethnic groups in specific societies; the impact of imperialism and colonial rule upon colonised people and their cultures; the history of minority ethnic artistic production in the western 'host' societies; and the interaction of ethnicity with other kinds of group identity – for instance, **gender**, age, location, and social class understood in **marxist** terms.

In the past ten years or so some scholars, importantly, have drawn attention to the radically **hybrid,** or mixed, nature of ethnicity – casting doubt on the political and intellectual value and credence of arguments for *any* kind of 'pure' racial singularity. Can and should identity be re-thought, they have argued, as a matter of conscious choice and affiliation as much, or even more than, an indisputable fact of biology and innate destiny?

Further Reading

Fanon, Frantz *Black Skin, White Masks* (Pluto: 1986).
Gilroy, Paul *Against Race: Imagining Political Culture Beyond the Color Line* (Belknap Press: 2000).
Rose, Steven *Lifelines: Biology, Freedom, Determinism* (Penguin: 1977).

MacDougall, Hugh A. *Racial Myth in English History: Trojans, Teutons, and Anglo-Saxons* (University of New England Press: 1982).

EXHIBITION *EXHIBIT*

Apparently straightforward term for the display of **artistic^ arte-facts**, which, in the **western^ societies** since the eighteenth century, has been **organised** by and within **institutions** known as **museums** and **art** galleries. However, the complication comes immediately with questions about the purpose and character of the act of displaying. **Historical** studies show that there have been *many* **forms** of **public** exposition – before and since that century – indicating a wide diversity of aims.

For instance, in what senses would it be appropriate to say that the sixteenth-century fresco **painting** of Isaiah, painted by Raphael for the Goritz Chapel, Sant' Agostino, in Rome, is an artefact **produced** for *exhibition*? The picture *was* certainly painted in order to be seen and understood in a certain way by its **original^ viewers** – that is, **contemporary** church officials (including the wealthy Johann Goritz who **commissioned** the painting) and the laity (ordinary people). But these purposes were overwhelmingly religious-devotional in character. *Other* aims that the **artist** may have had (those that might be reconstructed or reasonably inferred) were secondary – for instance, to produce a convincing likeness of an old man, or to show him in what might have been thought of then as authentic 'ancient' (Old Testament) clothing. These secondary aims were subordinated to the first – the man shown **represented**, after all, an important **figure** from the Bible, and the purpose of showing him was to **impress** upon the viewers the **reality** and **significance** of Isaiah's prophecy of the coming of Christ – in order to aid worship and religious belief.

Exhibition in the **modern** sense, this example suggests, is a term with a specific and highly limited **meaning**. A Masaccio panel-painting of the *Madonna and Child* (1426) is currently exhibited in the **National** Gallery in London. Its viewers *in that context* see it first and foremost as an **artwork**, making sense in relation to all the other artworks – mostly paintings, **sculptures**, prints, and drawings – also exhibited in the gallery. Relatively few of these viewers over, say, the past century, are likely to have been devout Christians who saw the painting *primarily* as a religious-devotional **image**. They might have been able to **identify** the figures **represented** and to know

something of the **symbolic** importance of the scene (Jesus's mother is there at Christ's miraculous birth and death, as recounted in the New Testament). But the painting, hanging in the museum – *not* a church – signifies first and foremost as an artwork. It is a fabricated artefact regarded as **valuable** in specific **art historical** ways: as a product of its maker, Masaccio, who is regarded as one of the first **renaissance masters**; as a prized object with **beautiful^ composition** and colouring; and as documentary evidence, too, of a typical religious scene from the early fifteenth century.

But all these aims behind its modern exhibition in the gallery bear virtually no relation to its original purpose, meaning, and use. Exhibition in modern museums and galleries generates new meanings and values for pre-modern and non-western artefacts. Artworks made *after* the eighteenth century – those that were not religious commissions – were increasingly made in order to be exhibited as artworks first and foremost in a range of modern, new secular contexts. By the late nineteenth century, probably a majority were made to be seen and understood as modern art in specifically built art galleries and museums.

Further Reading

Brettel, Richard 'Modern French Painting and the Art Museum', in *Art Bulletin* June 1995: 166–69.

Cuno, James 'Museum Art History and Politics: Whose Money? Whose Power? Whose Art History?', in *Art Bulletin* March 1997: 6–10.

Daley, Michael and James Beck *Art Restoration: The Culture, the Business, the Scandal* (John Murray: 1993).

Trodd, Colin 'Culture, Class, City: The National Gallery, London and the Spaces of Education, 1822–57', in Marcia Pointon (ed.) *Art Apart: Artifacts Institutions and Ideology Across England and North America* (Manchester University Press: 1994).

EXPLANATION *EXPLAIN, EXPLANATORY*

In *any* **art^ historical** research project – ranging from undergraduate students writing essays based on questions set by tutors or instructors to the most ambitious books written by professional scholars working in universities and **museums** – the problem and definition of *explanation* is central: *what does the writer set out to achieve intellectually in his or her work?* Arguably, art historical explanation consists of (and should include) an amalgamation of three main tasks. These can be **identi-**

fied as those of (1) description: for instance, of **artworks, concepts, social** conditions; (2) **critical^ analysis** based on case-studies of, for instance, particular artworks, **artists**, or **authors**; and (3) evaluation (**value**-judgement) of the overall findings. Together these activities usually constitute what is offered, self-consciously or not, as explanation. Often, too, art historical writing includes some **narrative** element and the use of a conceptual framework – a set of key ideas and terms. This book is partly intended to help students and scholars become clear, or clearer, about what kinds of explanation they want to **produce** in response to art historical problems they either set themselves or have had set for them by someone else.

Explanation, to put it another way, is always best thought of as a *response* to a question or set of questions. This is made most obvious in the production of students' answers to essay questions. For instance, the question 'What role did competition play in the **development** of the sculpture of Donatello?' presumes, to begin with, that there *is* an answer, or that a number of answers are possible and can be judged to be right or wrong, according to some knowable criteria. The question also presumes the **meaning** and importance of some ideas and phenomena – for instance, that 'competition' (how ever defined) existed in the time of the Florentine **renaissance** artist Donatello; that some kind of change (how ever defined) occurred in the **sculptor's** work over the course of his life and in the work of his competitors; and, for that matter, that Donatello is an artist *worth* writing about for some reasons. So, couching any research project in terms of a question or set of questions is a good way to start – for it underlines how the most productive scholarly work sets itself specific aims and objectives that are valuable and realisable.

More elaborate research projects are often based on very closely defined **theoretical** and **historical** problems in which the purpose of the work is effectively to *test* and *assess* certain claims: for instance, that **paintings** showing social life on the land produced in England in the early and mid nineteenth century (such as Samuel Palmer's *Young Men Yoking an Ox* (1825)) contained important similarities to that produced in France (such as Gustave Courbet's *Peasants of Flagey Returning from the Fair* (1855)) at roughly the same time. But what might 'important' mean in this context? That the paintings looked **visually** similar? That they were produced by English artists working in similar kinds of places and ways, with similar interests and relationships to their counterparts over the Channel? That the two **societies** were, in important ways, becoming similarly **modern** and that their paintings were a considered response to these conditions?

As this simple example indicates, explanation is intimately related to the clarification and ongoing revision of the meaning of concepts and theoretical premises: a process bound up with the art historical clarification and continuing revision of the meaning of artworks and the **culture** and society in which they are both produced and **interpreted**.

Further Reading

Antal, Frederick *Florentine Renaissance Painting and its Social Background* (Routledge and Kegan Paul: 1948).

Bloor, D. *Knowledge and Social Imagery* (Routledge and Kegan Paul: 1976).

Harrison, Charles and Fred Orton 'Introduction: Modernism, Explanation and Knowledge', in Harrison and Orton *Modernism, Criticism, Realism: Alternative Contexts for Art* (Harper and Row: 1984).

Hemingway, Andrew *Landscape Imagery and Urban Culture in Early Nineteenth-Century Britain* (Cambridge University Press: 1992).

EXPRESSIONISM *EXPRESS, EXPRESSIONIST, EXPRESSIONISTIC, EXPRESSIVE*

One of the most important, and, as a result, over-used, terms in **art^ history** largely concerned with art **produced** since the late nineteenth century – in some cases the term is used to mean close to the same thing as **modernist** and **avant-garde**. Its basic sense is 'direct' or 'emotive': *expressionistic* art **communicates** strong feelings and **values**, and does so in a **manner** that *bends* all **compositional** and **conventional^ artistic** means to this end. (*Express*, however, has another, more or less neutral, meaning: 'to convey or communicate'. In this sense, then, *all* artistic **forms** may be said to be *expressive*, though the term used in this way says nothing about a particular **artist's** aims or the means used.)

In the former sense, however, within expressionistic painting the conventions of **naturalistic** likeness and **perspectival** space undergo distorting modification in order to communicate direct and strong feelings. Consider Edvard Munch's famous *The Scream* (1893), in which the wobbly contours of the **figure's^ body** find a sickly echo in the water and sky surrounding it. These **effects** manage to **create** an **impression** of severe mental disturbance, a condition in which the person **represented** (a **self-portrait**?) appears unable to distinguish between his bodily distemper and the state of the outside world. A similar kind of **pictorial** effect was created – this time

coloristically rather than predominantly through the use of line – in J.M.W. Turner's *Rain, Steam, Speed* (1844), though, interestingly, this is not normally read as **metaphorically** referring to the artist's own, or someone else's, psychic state (though the picture is thought to invoke the bodily experience of moving quickly through a **landscape** on an early steam train). Heightened expressiveness in art is also associated particularly with the use of certain **materials** – for example, oil **paint** placed upon canvas **surfaces** in ways that are often described as 'dramatic' or 'violent'. The method of application in this case (e.g.: **abstract^ expressionist** 'drip and splatter' **techniques**) takes on a metaphoric **meaning** and value, as if the painting as material **artefact** was a simple container for, or document of, the artist's agitated bodily and **psychological^ nature**.

The **origins** of the term *expressionism* in art **criticism** and art history are closely connected to the rejection of **traditional^ academic** techniques and values by the first groups of **modern** artists active in the **period** *c*. 1860–1910 in Europe. In this way, then, their artistic gestures were both formal – that is, to do with making paintings in a particular way – and political – turning against the art and academic **institutions** that **dominated** French and other European **societies** at the time. Conventional **subjects** as well as compositional means were rejected: modern artists chose to show, for example, in expressionistic ways, both the seamier **realities** of modernity (for example, the dancers and prostitutes pictured in Ernst Ludwig Kirchner's paintings, such as *Negro Dance* (1911)), but also deliberately selected apparently low-key or banal motifs (such as the **landscapes** and sunflowers painted by Paul Cézanne and Vincent van Gogh) as vehicles in order to communicate heightened subjective feeling. By the 1950s, however, it is arguable that the stock-in-trade conventions of being (or appearing spontaneously) expressive had themselves started to become clichéd: re-inventions of expressionism in 1980s painting, in 'neo-expressionist' pictures by Julian Schnabel (e.g.: *Exile* (1980)) now seem contrived and overly self-conscious.

Further Reading

Art and Language 'Abstract Expression', in Charles Harrison and Fred Orton (eds) *Modernism, Criticism, Realism: Alternative Contexts for Art* (Harper and Row: 1984).

Barron, Stephen *German Expressionism: Art and Society* (Rizzoli: 1997).

Goodman, Nelson *Languages of Art* (Hackett Publishing Company: 1976).

Szasz, Thomas S. 'Hysteria as Communication', in Szasz *The Myth of Mental Illness* (Harper and Row: 1961).

FASHION *FASHION VICTIM, FASHIONABLE*

An older **meaning** for the term – *making something* (e.g.: 'fashioning a sword') – has become all but forgotten now as *fashion* has taken on two **dominant^ contemporary** senses: (1) generally and neutrally, to mean a **style**, or a **form**, or a way of doing something; and (2) often with a negative implication, to mean **popular** or superficial and shallow (as in such put-down phrases as 'merely fashionable', or 'fashionable thinking'). The term, though, has another specific and familiar use within **visual^ culture**: the **design** and **production** of clothing and accessories, more or less meaning the same as what used to be called, following the French, *couture*. Given this range of meanings, with the negative sense often waiting in the wings, the term operates in a perpetually unstable **manner** – because the way it is articulated by one speaker may be very different from the way it is **interpreted** or used by another.

The slippage from *fashionable* simply meaning popular to fashionable meaning superficial or shallow, is an example of this: indeed, the term *popular* itself, along with its near-synonym mass (as in **mass culture**), is similarly ambiguous and open to a range of different meanings. This is a dispute, finally over the **value** of something – be it a certain cut in a *tailleur*, the women's tailored suit from the turn of the nineteenth century, or the use of 'serif' or 'sans serif' typefaces by newspapers, or, for that matter, a new cultural **theory**. The deeply derogatory connotation sometimes given to the term *fashion* is such that no one would probably admit to favouring any one of these things simply *because* it was popular – this sense finally implying that one had taken something up merely because everyone else had. (The 1960s British pop group the Kinks – leaders then in the **development** of **mod** (modern) style – sarcastically **identified** this conformist behaviour in their song 'A Dedicated Follower of Fashion'.)

Yet in terms of fashion meaning clothing there perhaps should be no shame in people acknowledging that their chief (even *only*) reason for buying an item of dress was indeed because it had become fashionable. Teenagers in particular often find themselves under strong pressure to wear certain kinds of clothing – for example, flared or bell-bottomed trousers (pants) during the second half of the 1970s –

simply because everyone else has begun to wear them. Fashion operates in an intimate relationship with **advertising**: the latter sells a particular fashion (e.g.: Levi's jeans) as individualistic, but this is always a part of **capitalist** mass-marketing strategy. Fashion in the modern sense of **consumption** patterns regulated by brand marketing produces what have come to be known as 'fashion victims'. The serious implication in this light-hearted phrase is that a duping or deception has taken place. But the same **ideological** contradiction envelops what is called consumer 'choice' as much as it does the notion of individual **taste**: a well-known French car manufacturer brought out a vehicle it called the 'Picasso Limited Edition', thereby directly linking what it hoped would be a fashionable mass-production model to the **myth** of individual **creativity^ symbolised** by this **artist**.

Further Reading

Attfield, Judy and Pat Kirkham (eds) *A View from the Interior: Women, Fashion and Design* (Women's Press: 1989).

Batterberry, Michael and Arianne *Mirror, Mirror: A Social History of Fashion* (Holt, Rinehart and Winston: 1979).

Konig, Rene *The Restless Image: A Sociology of Fashion* (Allen and Unwin: 1973).

Roach, Mary Ellen and Joanne B. Eicher *Dress, Adornment and the Social Order* (John Wiley and Sons: 1965).

FEMINISM *FEMINIST, FEMINIST ART, FEMINIST THEORY*

One of the most important political and intellectual forces in the twentieth century to enter into a sustained **productive^ critical** relationship with both the discipline of **art^ history** and, since the late 1960s, the **contemporary^ art world**. *Feminists* upheld the **social** and political rights of women, attacked all the **forms** of discrimination against them within what they **identified** as **patriarchal** society, and **organised** groups that began to fight for new laws and attitudes that would help to bring about a more egalitarian society. *Feminism* in *all* its manifestations – as a **movement** for social change; as a radical **analysis** of **human^ historical^ development**; and as a basis for **creative** work in the **visual** arts – became central to the **new art history** during the 1970s. Feminism's initial role in this **emergent** intellectual and **academic^ formation** was radically to critique the

interests and claims of **traditional** art history – claims that, for instance, 'great' art had only ever been produced by men; that artists were essentially 'lone individuals' whose creativity and creations were not socially explicable; and that there were **naturally** fixed male and female 'spheres of activity' in **public** and private life that precluded women from any important role in the production of art.

In its second phase feminism began to produce its own historical accounts and new **theoretical** frameworks for understanding **culture**, the **gendering** of artistic production, and the work of contemporary women artists – many of whom began to think of their art explicitly as feminist and underpinned by feminist theories (e.g.: Martha Rosler with *First Lady (Pat Nixon)* from *Bringing the War Home: House Beautiful* (1967–72); Judy Chicago's *The Dinner Party* (1974–79); Mary Kelly's *Post-Partum Document* (1978); Barbara Kruger's *We Won't Play Nature to Your Culture* (1983)). At the same time, feminist art historical and theoretical scholarship entered into productive relation with other kinds of radical political and social movements – those explicitly **marxist** and socialist, as well as those committed to **postcolonial** struggles against **racism** and **western^** **imperialism** (e.g.: criticism and historical studies by Lucy Lippard, Griselda Pollock, and bell hooks).

In its third phase (continuing to the present) feminism has consolidated its place in academic **institutions** and, to an extent, even become part of the establishment it **originally** attacked. Its 'interventions' into art history have themselves settled down into kinds of orthodoxy and feminist art history is now taught alongside other **specialist** studies in many universities throughout the world. A risk of depoliticisation inevitably follows this development. Feminist scholars have particularly interested themselves in the history of **psychoanalysis** and how psychoanalytic ideas linked to feminism – such as those of Luce Irigaray, Julia Kristeva, and Jacques Lacan – may help them to formulate accounts of visual **representation**, **meaning**, and **culture**. In particular feminists have focused on (1) processes of **viewer** identification and **subject**-formation; (2) scopophilia and voyeurism (the **pleasures** of **looking** and the experience of being looked at); and (3) relations between the sociocultural order and stages in becoming gendered (male or female). Feminism has, in addition, recently encouraged greater interest in the formation of male **identities** and been **influential** in inspiring the development of 'queer theory' concerned with homosexual life and cultures.

Further Reading

Baker, E. C. and T. B. Hess (eds) *Art and Sexual Politics* (McMillan: 1973).
Butler, J. *Gender Trouble: Feminism and the Subversion of Identity* (Routledge: 1990).
Gouma-Peterson, T. and P. Mathews 'The Feminist Critique of Art History', *Art Bulletin* September 1987: 327–57.
Parker, Roszika and Griselda Pollock (eds) *Framing Feminism: Art and the Women's Movement 1970–1985* (Pandora Press: 1987).

FIGURATIVE *FIGURAL, FIGURE, FIGURED*

Term with a range of **complex^ meanings** in the **art^ historical** and **critical^ analysis** of **visual** and **material^ forms**. In its simplest sense, the term is one of a pair – along with 'ground' – and denotes an **identifiable** shape or element within, for example, a **painting** or drawing. Thus it is common, for instance, to describe **abstract** paintings as containing *figures* or *figurative* detail, which may only be coloured marks or lines, that stand out from – and apparently 'above' – the **pictorial** field surrounding, or 'below', them (see for example Mark Rothko's *Number 22, 1949* (1949); Barnett Newman's *Tertia* (1964)).

Inverted commas around these terms 'above' and 'below' indicate something of the complexity to the term: for figure/ground relations are matters of both *literal* and *depicted* space or depth. That is, the bounded shape and size of a painting on a canvas is both an *actual* physical space – that is, a material **surface** upon which marks of various kinds are placed – and a matter of *perception*: where and how certain marks, seen as 'figure' or 'ground', appear to lie and relate to each other (e.g.: Kasimir Malevich's *Suprematist Composition* (1915)). Figure/ground relations, in this sense, are intrinsically **subjective-**perceptual as well as objective-physical **realities** and for this reason the **psychology** of art has made a particular study of how the **human** eye and brain sees and makes sense of shapes – and the shapes 'within' shapes that form the figure/ground distinction in paintings. The ambiguities of their relation are illustrated in the well-known experimental drawings that, **read** one way or another, reveal a man's face or a duck, and a woman's coat or a flock of swans.

The figure/ground phenomenon is important partly because it has been **interpreted** as demonstrating the potential openness of *all* aspects of human perception, seeing, and understanding. That is, seeing – literally and **metaphorically** (a 'figure of speech') – is

115

always a matter partly of making sense of something *through* imposing **meaning** and order upon the phenomenon. The human brain/eye works through what psychologists call the 'gestalt' principle: the ordering of **visual** phenomena through the immediate identification of pattern, or figure upon ground. It is a basic biological necessity to be able – instinctively – to make sense of things in the field of **vision** in case they, for instance, threaten survival or offer food. This example *may* seem a long way away from the study of **artworks** and the concerns of art historians. But the metaphoric meanings to the terms *seeing*, **looking**, and *figuring* (and 'figuring out') have many important implications for art history. Whole **critical^ theories** of meaning in **modern** art, for example, have been erected upon accounts of what **pictorial** space is and how it has been used by artists in both tacit and self-conscious ways (e.g.: Clement Greenberg's **influential** 1960 essay 'Modernist Painting'). *Any* kind of visual **representation** at all, indeed, depends upon the possibility of figure/ground differentiation and so mark-making of the simplest kinds to the most complex (cave paintings to internet websites) becomes, in part, **symbolic** of this human capacity for **communication** and meaning. Figure, too, is another term for human **form**, and so, in one sense, *all* marks may stand for the human subject. Rothko's famous statement that he could no longer 'use the figure' (that is, represent people **naturalistically** in his paintings) takes on profound **significance** in the light of this, prompting questions about the ultimate purposes and means of communication through abstract art.

Further Reading

Gombrich, E. H. *Art and Illusion: A Study in the Psychology of Pictorial Perception* (Princeton University Press: 2000).
Lyotard, Jean-François *Discourse, Figure* (Harvard University Press: 1998).
Orton, Fred *Figuring Jasper Johns* (Reaktion: 1994).
Schapiro, Meyer 'On Some Problems in the Semiotics of Visual Art: Field and Vehicle in Image-Signs', in Schapiro *Theory and Philosophy of Art: Style, Artist, and Society* (Braziller: 1994).

FILM *FILMIC*

Though with a **meaning** close in some ways to **cinema**, *film* has the **specialised^ art^ historical** sense of a **medium** of **expression** or **practice** – this definition then raising the same set of issues and problems that face discussion of all other media and practices (such as

painting or **sculpture**). A third sense uses the term in an adjectival and suggestive way: when it is claimed, for example, that a certain painting or **photograph** displays filmic **qualities**. Sometimes this analogy seems literally anachronistic ('out of time') when, for instance, it's remarked that a **picture** by Michelangelo Caravaggio displaying dramatic lighting effects and a heightened **naturalism** – such as his *Doubting Thomas* (*c.* 1600) – is called filmic in its intensity. It's as well to remember, however, that **influence** can work both ways and though Caravaggio could not have seen any films in his time, directors and camera-operators have certainly been inspired to attempt to recreate their sense of the **effects** of paintings in films (see for example Derek Jarman's *Caravaggio* (1986) and Peter Greenaway's *The Cook, The Thief, His Wife, and Her Lover* (1989)). This raises the complicated question of whether particular ways of **representing** are intrinsic (that is, proper, or necessarily 'belong') to certain media.

Film may be defined as a **material** practice and expressive resource for **creating** and **communicating** consecutive – moving – **visual-audio** representations. Film reel (celluloid) is a plastic, acetate-based, substance, which, when exposed to light via a camera lens, records a flow of single **images** that, when **developed** and projected onto a screen at a certain speed, appears to show continuous movement. Given this ability to record and show events occurring in, and over, time it is not surprising that **narrative** became film's chief expressive capacity, though many kinds of filmic story-telling have evolved. This **history** of the development of the medium involved many stages and innovations: perhaps most notably the shift from black and white to coloured imagery and the addition of synchronised sound. Both these innovations have been regarded as immensely important in the development of film's **realism**. Though **technical** innovation brought about the potential for these changes they were not immediately taken up equally across the industry – though silent movies became obsolete fairly quickly in the US during the very late 1920s and 1930s, black and white films continued to get made and still are today, now largely for what are **explained** as **aesthetic** reasons. A medium, that is, is *not* simply a technical capacity or set of material devices; it includes the **conventions** and assumptions behind their use as well as the **values** and attitudes of its practitioners, along with the conditioning **social relations of production and consumption** active at any given historical moment.

As a mechanical and later electronic medium – now processed through digital systems which can alter **image** and sound in radical ways – film has virtually always been **produced** collectively. That is,

the **modern** use of cameras, lighting, stage-sets, scripts, actors, music, and special effects necessitates the involvement of many people. Though there are some similarities here with the production of, for example, large-scale **mural paintings** and **history paintings**, film, based on photographic technology, developed as an *intrinsically* **reproducible^ form**, requiring **specialised** equipment for its editing, print production, distribution, and **viewing**. Highly **capitalised** at an early stage in its development – by corporations in Hollywood, California that still **dominate** world cinema – film has always been **identified** closely with commercial or **mass culture**, though 'art film' variants have remained tenaciously obscure. Like any other visual medium, film has been examined through a variety of familiar art historical **concepts**, methods, and themes: for instance, the **analysis** of particular directors (auteurs), or **genres** (such as **romance** or thrillers), or **styles** (such as realism or expressionism), or through claimed **national** characteristics (like French film noir, or Italian neo-realism).

Further Reading

Bordwell, D. *Narration in the Fictional Film* (Routledge: 1986).
Bordwell, D., J. Staiger, and K. Thompson *The Classical Hollywood Cinema: Film Style and Production to 1960* (Routledge: 1985).
Gidal, P. *Materialist Film* (Routledge: 1989).
King, J. *Magical Reels: A History of Cinema in Latin America* (Verso: 1990).

FORM FORMAL

One of the most indispensable **concepts** in **art^ history**, presenting a series of interesting yet vexing problems for its definition and use. The term, however, is often employed as though its sense was straightforward: *form* meaning simply the **visual** appearance of worked **artistic^ materials**. So, for example, **critics** and **historians** talk of the 'form of a **painting**', or the 'form of a **sculpture**' – how this or that particular **artefact** made up of **composed** physical substances appears to the **viewer**. E. H. Gombrich, for instance, notes that the anonymous sculptor **representing** two of the founders of Naumburg Cathedral, *Ekkehart and Uta* (*c.* 1260), **produced** 'statues of men and women ... ready at any moment to step down from the pedestals and ... join the company of ... vigorous knights and gracious ladies'. His statement, highlighting the **realism** of the stone statues located on the cathedral's facade, usefully illustrates several important issues bound up with formal **analysis**.

This term is the name given to the work of describing and assessing the visual and **material** appearance of **artworks**. Though formal analysis is one of the first activities taught to students – because it is regarded as so basic to the job, and self-**image**, of the art historian – it raises key problems. For instance, should the discussion of the formal appearance of an artefact initially involve a discussion of the things *depicted* in the representation (such as the self-evident 'men and women' Gombrich talks of)? Usually, the answer is 'no': form is restricted in definition to the **pictorial** (two-dimensional)/plastic (three-dimensional) material means of representation – **qualities**, for instance, of line, tone, colour, **composition**, modelling, and **surface** texture. Yet in the everyday viewing of artworks people clearly *do not* exclude their sense of immediate recognition of things depicted – or not depicted – in visual representations. Indeed, the concept of representation implies the depiction of things that can be, in ordinary terms, easily **identified** and understood.

Formal analysis, however, often has the unfortunate consequence of at least *appearing* to separate off a discussion of *what* is represented from *how* it is represented. Distinctions between form and **content**, or between form and **meaning** exacerbate this apparent division of interests and analytic activities. The term **formalist** is commonly used in a derogatory way in order to characterise **critics** and historians who appear to concentrate on – even become obsessed with – discussions of form to the apparent exclusion of questions of reference, meaning, and **symbolism** (e.g.: the late-nineteenth/early-twentieth-century scholars Heinrich Wölfflin and Alois Riegl). Most art historians and critics, however, have *not* sought to cancel the inquiry into the **social** meanings of representations – rather they have tried to stress that careful **looking** and the **development** of a **technical^** **language** for description of what is seen is the solid beginning of art historical inquiry, upon which analysis of the things depicted (why and when) can be addressed.

In the twentieth century, however, **modernist** art writing became associated with critics – such as Clive Bell and Roger Fry – who believed that the ultimate **value** and purpose of art *was* unrelated to its depictive and 'social-reference' capacities. To further complicate matters, by the 1960s some **abstract** paintings and sculptures had also earned the name formalist, suggesting that their **producers** were similarly no longer interested in **communicating** with the viewer in **traditional** ways (e.g.: Frank Stella's *Marquis de Portago* (1960); Kenneth Noland's *Via Blues* (1967); Anthony Caro's *Prairie* (1967)).

Further Reading

Bell, Clive 'The Aesthetic Hypothesis' (1914), in Francis Frascina and Charles Harrison (eds) *Modern Art and Modernism* (Harper and Row: 1982).

Iversen, Margaret *Alois Riegl: Art History and Theory* (Harvard University Press: 1993).

Podro, Michael *The Critical Historians of Art* (Yale University Press: 1982).

Riegl, Alois *Problems of Style* (1893) (Princeton University Press: 1992).

FORMALISM *FORMALIST ART, FORMALIST ART HISTORY, FORMALIST CRITICISM*

Though associated particularly with **developments** in **abstract^ art** and **modernist** art **criticism** and **history** in the twentieth century (principally the writings of Clive Bell, Roger Fry, Clement Greenberg, and Michael Fried), *formalism* is a term that has been used – mostly in a condemnatory way – to characterise accounts of art of *any* **period** that appear to separate **explanations** of its **nature**, **meaning**, and **value** from an understanding of the **socio**-historical **conditions** of its **production** and **interpretation**. Formalism used in this derogatory way is very different from the sense given to the term by some early-twentieth-century central European philosophers and **linguists** (e.g.: Roman Jakobson and Viktor Shklovsky) for whom formalism was the name they gave to a new kind of inquiry into how language, **artworks**, and other **communicative^ artefacts** worked to produce their various **effects** and meanings. Their concern with **form**, then, was about the mechanics of making meanings through **representation** and, although in some ways a complicated **technical** matter, this interest was definitely *not* held to be separate from the exploration of how these meanings also circulated socially and historically.

Some scholars within this **formation** known as 'Russian Formalism' actually had close links to **contemporary^ marxists** (e.g.: the linguist V. N. Volosinov, better known as Mikhail Bakhtin) developing accounts of art and **cultural** history. The Russian Formalists did not see their interest in the mechanics of meaning as necessarily either **alternative** to, or in **opposition** with, the concerns of the marxists (either intellectually or politically – much of this work took place in the years around the Russian Revolution in 1917 and involved the then especially pressing issue of the role of art as an **agent** of radical **social** and political change). However, though lit-

erary scholars such as Shklovsky – author of a famous essay called 'Art as a Technique' (1916) – may have seen their **analysis** of the formal properties of **artworks** as really an emphasis or special interest, and therefore *not* unrelated to, or incompatible with, other kinds of analysis, formalism has generally become a term of abuse hurled by one **author** or faction at another.

The German **art historians** of post-**renaissance** art Heinrich Wölfflin and Alois Riegl were both condemned as formalist by critics from various standpoints, including **social art historical** and **feminist^ perspectives**. Interestingly, both Wölfflin and Riegl held very clear **views** about the historical development (perhaps *evolution* is a better word for their view) of **western** art since the **middle ages**, though they saw this process in rather abstracted, asocial terms – as a matter of what Riegl called 'the will to form' (kunstwollen), with dynamics they claimed were somehow 'internal' to **visual** art itself (with long term **painterly** and linear phases, according to Wölfflin), rather than a matter of artists' conscious **intentions**.

Formal analysis is clearly not incompatible with social and historical investigation; in fact, the two need each other. Marxists in particular have struggled to bring the two kinds of attention into productive relation, not wishing to sacrifice either one wholly to the primacy of the other. While earlier twentieth-century marxist art historians such as Frederick Antal and Max Raphael tried to develop **concepts** of **style** linked to **theories** of **class** and social struggle, recent scholars such as T. J. Clark, John Tagg, and Fred Orton have concentrated on much closer analysis of the social **function** of artworks in particular historical moments – attempting to link their formal analysis to specific **interpretations** made by real individuals.

Further Reading

Bann, Stephen and John E. Bowlt (eds) *Russian Formalism: A Collection of Articles and Texts in Translation* (University of Edinburgh Press: 1972).

Raphael, Max *Proudhon, Marx, Picasso* (Humanities Press: 1980).

Volosinov, V. N. *Marxism and the Philosophy of Language* (MIT Press: 1988).

Williams, Raymond 'Language', in Williams *Marxism and Literature* (Oxford University Press: 1977).

FORMATION *FORMATIVE*

Though sometimes used to **mean** the same as 'grouping' or **movement** (in order to **identify**, for example, collective **avant-garde**

entities such as the **dadaists**, the **surrealists**, and **abstract expres-sionists**), *formation* was coined specifically by the Welsh **cultural^ historian** and **theorist** Raymond Williams for two reasons. First, simultaneously to accompany and question the **art^ historical** term **form**. Second, to re-address the meanings inherent in familiar notions of movement or grouping. If **artists^ produced^ paintings** and **sculptures** whose **material** and **visual** forms were held to be the obvious focus of **traditional^ analysis** and **evaluation**, then such artistic forms, in order to be properly understood had to be related, Williams insisted, to the social circumstances – the formation – in which their makers, both as individuals and as members of groups, always existed. (Artists' forms and formations are, then, *always* bound up together in actual social life, though art historians tend to concentrate on the former to the relative exclusion of the other.)

These circumstances include collective **identity** and social positioning of various kinds. An artist's formation, in the broadest sense, then, is the *totality of circumstances and conditions* that have shaped and limited his or her work, activities, and interests as an artist and as a **social^ agent**. This totality would include factors to do with, for example, **institutional** training, family background, social status, and political affiliations. Information about this 'macro' formation can be used valuably within an examination of any artist's life and work – though if the **period** under consideration is, say, the **renaissance** in Italy in the fifteenth century, then the range of empirical factors to take into account will be very different from those bearing on twentieth-century art and artists. Much more is known, too, about recent art and society – and the further back in history one searches the less (the 'thinner') the knowable 'macro' formation becomes. Studies of art forms and artists' formations in the **epochs** before the **western^ medieval** period tend to rely much more on assumptions, hypotheses, and educated guesses than on the extensive ('thick') historical evidence found in the later literate, documented, societies and **cultures**.

A much narrower – or sharper – sense to *formation*, however, is also important. This focus concerns the activity of self- and immediate social **organisation** that artists may be shown to have orchestrated at specific historical moments. For instance, from the early nineteenth century onwards, as **traditional** institutions for the training, **patronage**, and accreditation of artists begin to decline, artists began to organise for themselves novel independent corporate units and social identities through which to defend and **express** their related economic, vocational, **aesthetic** – and increasingly political – interests and **values** (some of the earliest of these were the *cenacles*, or

circles, in Paris after the fall of Napoleon Bonaparte in 1815: often these included **critics** as well as artists, such as the early bohemian **art-for-art's-sake** group formed around Théophile Gautier). There is, of course, great variation within these formations. They range in general type from (a) the highly ordered, official, and large-scale organisations such as trades unions set up by artists (e.g.: in the US during the 1930s when artists were employed as wage-labourers by the **state**); through to (b) formations based on written agreement with particular artistic and philosophical beliefs (e.g.: the dadaists, the surrealists), and (c) looser groupings based on occasional social, shared **exhibition**, or intellectual contact (e.g.: the **impressionists**; the **abstract expressionists**).

Further Reading

Blotkamp, C. (ed.) *De Stijl: The Formative Years* (MIT Press: 1982).

Boime, Albert 'Restoration Bliss: The Nazarenes', in Boime *Art in an Age of Counterrevolution 1815–1848* (University of Chicago Press: 2004).

Fry, N. *The IBM World* (Eyre Methuen: 1974).

Williams, Raymond 'Formations', in Williams *Culture* (Fontana: 1981).

FUNCTIONALISM/FUNCTION *FUNCTIONAL, FUNCTIONALIST*

Term **originating** within early-twentieth-century **modernist^ architectural** and **design^** theory designating the claim, belief, or **ideology**, that the construction and appearance of an **artefact** – for example, a building, a motor car, or chair – should **materially** and **visually embody** the object's **intended** practical purpose and use in the world. In the strongest versions of this doctrine (e.g.: Adolf Loos' 1908 essay 'Ornament and Crime') this notion of *functionalist* priority – **'form** follows function' – was entirely opposed to the use of decoration and embellishment in the design and construction of the built environment and included a number of important social and moral philosophical elements. It was believed, for example, that there was a vital honesty and truth within the use of **materials** towards strictly utilitarian ends – especially when compared with overtly decorative Victorian and Edwardian **styles** such as Art Nouveau. New building materials, such as concrete and steel, and new fabrication and engineering **technologies** – for example, glass 'curtain' walls – were declared to be the necessary materials and means for achieving this pristine 'functional clarity' and 'truth-to-materials' (see

for example Le Corbusier: villa at Vaucresson (1922), the Salvation Army Hostel in Paris (1929), United Nations Headquarters in New York (1947); and Ludwig Mies van der Rohe: Lake Shore Drive apartment buildings, Chicago (1951), Lafayette Towers, Detroit (1963)).

As a species of modernist thinking, *functionalism* has **historical** links to the **development** of both modern (particularly **abstract**) **art** and to modernist art **criticism**, though the connections are **complex** and merit careful empirical comparison rather than incautious theoretical generalisation. A stress on a kind of 'truthfulness' in the use of materials in the fabrication of **artworks** and buildings, for instance, can be found in the criticism of Clement Greenberg and the design philosophy of Le Corbusier – though the two were not quite **contemporaries**. Both rejected, too, what they saw as moribund **academic** and decadent pre-twentieth-century art and design. In that sense both became leaders of **avant-garde** activity (though Greenberg's own **paintings**, unlike Le Corbusier's building designs, have no place within that avant-garde's historical development or **canon** of great works.)

As an ideology or belief-system, functionalism in architecture and design had had its heyday by the 1960s, and by the end of that decade architects and critics were beginning to recognise and admit that functionalism – like any and all other theories of art or architecture – had been a rhetorical and polemical force reacting with, and against, other current and received notions of the **nature** and purpose of art and design. By then it had achieved **institutional** power and become an orthodoxy in itself. In the 1970s and 80s some of the ugly and decaying concrete tenement housing blocks built in functionalism's name around the world (e.g.: Ronan Point in East London) were dynamited to make way for new **structures** intended essentially to **humanise** the environment. Technology, modernity, and modernisation were being re-understood by this point as sometimes destructive and *inhuman* forces. The notion of **postmodernism** arose at this time – in design **practice** and in the philosophy of the **visual** arts – encapsulating this reaction against modernism and providing a name for some of the positive changes its critical proponents, such as Charles Jencks and Hal Foster, advocated.

Further Reading

Frampton, Kenneth 'Towards a Critical Regionalism: Six Points for an Architecture of Resistance', in Hal Foster (ed.) *Postmodern Culture* (Pluto: 1985).
Jencks, Charles *The Language of Post-Modern Architecture* (Rizzoli: 1977).

Léger, Fernand 'The Machine Aesthetic: The Manufactured Object, the Artisan and the Artist', in E. F. Fry (ed.) *Functions of Painting* (Thames and Hudson: 1973).

Venturi, Robert *Complexity and Contradiction in Architecture* (Museum of Modern Art: 1966).

FUTURISM *FUTURIST, FUTURISTIC*

One of the most important **avant-garde^ formations** of the early twentieth century, with a simultaneous presence in a number of European countries in the **period** preceding the First World War – though these activities declined rapidly once the war actually began in 1914. This **history** is a key to the **movement's** chief impetus and concern: *futurism* breathlessly **aestheticised** and **idealised** urban, industrial, and military **modernity**, linking them to a faith in the renewal of patriotic **national^ identity** through corporate political leadership and an aggressive rejection of the pre-modern past. These features, at least, were the basis for Italian futurism – the root of the pan-European manifestations that all adapted, in various ways, the sub-Alpine **origins** of this group.

Like **surrealism,** futurism had its chief spokesman not in a **visual^ artist** but in a philosopher-writer – Filippo Tommaso Marinetti, a poet and novelist whose 1909 Futurist Manifesto celebrated the exciting modernities of automobiles, machine-guns, and mechanised warfare. A friend of Benito Mussolini (fascist dictator in Italy between 1922–45), Marinetti's futurism was a political-**ideological**, as well as **social** and artistic, entity. It was possible to sift from Marinetti's bellicose and misogynistic polemic a delight in modern **forms** of power, **production**, and dynamism and it is these themes that found innovative **expressive** visual form in **paintings** and **sculptures** by, for instance, Giacomo Balla, Umberto Boccioni, Carlo Carrà, Luigi Russolo, and Gino Severini (who all signed the 1910 'Manifesto of Futuristic Painters'). The dissolution of **traditional^ perspectival^ design** and **naturalistic^ conventions** – in paintings such as Balla's *Dog on a Leash* (1912) – was the result of their common attempt to **represent** seen and felt experiences of motion and time. As this example shows, however, they didn't simply choose to depict **symbols** of macho urban modernity and many of these artists went on working after 1918, having discarded the futurist rhetoric. Boccioni's 1913 sculpture *Unique Forms of Continuity in Space*, however, **embodies** the combination of social, **aesthetic**, and martial **qualities** generally characteristic of pre-war futurism: the

work depicts what looks like a male soldier striding forward, his dynamic motion and power expressively rendered through the widening and billowing **nature** of his shoulders, torso and muscular thighs. This sculpture's formal similarity with **contemporary^ cubist** paintings by Picasso and Braque appears to suggest a unity – or at least overlap – of interests and Marcel Duchamp's earlier painting *Nude Descending a Staircase No.1* (1911) may be read as a formal bridge between the two avant-gardes, though **pictorial** analogies are, by definition, superficial.

In England the home-grown Vorticist group of painters and agitators, including C. R. W. Nevinson and Wyndham Lewis, from 1912 attempted to apply and **appropriate** what they took to be futurist insights and themes, in the context of an on-going contemporary vernacular rejection of British Victorian **culture** and **academic** traditionalism. Two editions of their typographically explosive magazine *BLAST* appeared in 1914 but the movement sank quickly. The political context of this English futurism bore no relation to the Italian situation, and with experience of the trenches and mass slaughter the Vorticists rapidly faded. Futurism was, in twentieth-century artistic terms, an interesting anomaly: a short-lived *right wing* avant-garde, though it produced some **influential** artworks whose makers generally outlived the nationalist polemic.

Further Reading

Celant, Germano *Futurism and the International Avant-Garde* (Philadelphia Museum of Art: 1980).

Hanson, Anne Coffin *The Futurist Imagination* (Yale University Press: 1983).

Perloff, Marjorie *The Futurist Moment: Avant-Garde, Avant Guerre, and the Languages of Rupture* (University of Chicago Press: 1986).

Umbro, Apollonio (ed.) *Futurist Manifestoes* (Thames and Hudson: 1973).

GAZE

To stare at someone or something – with an **expression** of either apparent blankness or intense curiosity. With its **modern^ origins** chiefly in **psychoanalytic^ theory**, *gaze* is a term relating to the kinds of **visual** and **sexual** attentions and implications contained within **embodied^/gendered^ human** perception, the dynamics of inter-personal relations, and the use of **images**. In the 1960–2000 **period**, the **concept** was adapted and **developed** as an **analytical** tool within some **forms** of **feminist** and psychoanalytic **art** theory

and **history** – though the **meanings** and references the term brings from psychoanalysis *do not* limit the definition of imagery to visual **representations** understood as physically fixed **artefacts** such as **paintings**, drawings, **photographs**, or **sculptures**. This is an important qualification: art theorists, **critics**, and historians have **appropriated** many terms from psychoanalytic therapeutic **discourse** that are actually concerned with **real** human beings and their forms of inter-personal life, usually then attempting to apply them to a narrow range of *inanimate* visual objects or representations. While people certainly do sometimes look at each other, and use each other, as though they were simply images (though this behaviour is not just connected to sexual activity) there is a world of difference between analysing an actual person, or a couple, and talking about visual representations – photographs, **films**, paintings, etc. – *as if* they were people.

Within psychoanalytic discourse, actual gazing is considered centrally bound up with sexual attraction and processes of both positive and negative **identification** – those characterised, for instance, as 'narcissistic' (loving/**productive**) and 'nihilistic' (hating/destructive). An older set of **metaphoric^ meanings** for the term comes from **classical^ mythology**, particularly from archetypal stories about the mystical power of certain characters able to use their appearance, or gaze, to entrap, enrapture, or otherwise control the behaviour of those who have looked upon them (see, for example, Anne-Louis Girodet's painting of the **narrative** of *The Sleep of Endymion* (1791)). The **allegorical^ nature** of these stories – that is, their multiple **interpretations** – appealed to some of the early-twentieth-century psychoanalysts who wished to stress the **complex** and dynamic **social** and sexual relations between members of families, in which dramas of identification and affiliation between children and parents strongly feature.

The **significance** of **looking** – its **visual pleasures** (scopophilia) and perversities (voyeurism) – has been valuably examined by many art historians, theorists, and critics. Feminists have been particularly interested in the relations between looking, imagery, and power in society. Laura Mulvey, for example, in an extremely **influential** 1975 essay considered the role of filmic imagery in **organising** and **reproducing** socio-sexual roles in society, while John Berger in his 1972 book *Ways of Seeing* examined connections between **advertising** rhetoric, possessions, and **visuality** in **capitalist** society. The notion of the 'male gaze' indicates how feminist arguments have come to **dominate** debate over visual representation and sexuality.

Two interesting and pressing questions, however, attend upon this situation: (1) is there such a thing as a 'female gaze' (a particular way in which women look – at men, and at other women, including themselves)?; (2) does not the use of the definite article ('*the* gaze') dangerously distract attention away from real *varieties and differences* in kinds of looking, in both historical and **contemporary** societies, making it less likely that **valuable** analyses of actual gazing (rather than 'theorizing the gaze' **abstractly**) will take place?

Further Reading

Bryson, Norman 'The Gaze in the Expanded Field', in Hal Foster (ed.) *Discussions in Contemporary Culture 2* (Bay Press: 1988).

Davis, Whitney 'The Renunciation of Reaction in Girodet's *Sleep of Endymion*', in Norman Bryson, Michael Ann Holly, and Keith Moxey (eds) *Visual Culture: Images and Interpretations* (Weslyan University Press/University Press of New England: 1994).

Freud, Sigmund *On Sexuality: Three Essays on the Theory of Sexuality and Other Works* (1905) (Penguin: 1977).

Stacey, J. *Star Gazing: Hollywood, Cinema and Female Spectatorship* (Routledge: 1994).

GENDER *ENGENDER, ENGENDERING, GENDERED, GENDER-RELATIONS, GENDER-SPECIFIC*

Referring **originally** to any **class** or group of things, *gender* had come to **mean** by the early nineteenth century only the **state** of being either masculine or feminine. In its uses in **art^ history** the term has become preferred to that of **sex**, although the two terms retain some common elements. Gender is intimately bound up with **socio**-sexual **identity** and the range of characteristics associated, at any particular time, with the states of being masculine or feminine (whereas the terms 'male' and 'female' are generally reserved for less-arguable biological classification). In another usage, in the study of grammar, a third category of **subject** also exists in some **languages**: 'neuter' – someone or thing that is neither masculine nor feminine (e.g.: *buch*: the German word for 'book' is of the neuter gender signalled by the definite article 'das' (the), in contrast to 'der' which is masculine, and 'die' which is feminine).

In the **development** of art history since the 1960s, gender became important in a wide variety of ways. For example, in relation to the

analysis of the **production** and **consumption** of art the question of the gender of the **artists** involved became crucial. Did women, for instance, have access to the **institutions**, **conventions**, and **forms** of training in the **visual** arts that were open to, and controlled by, men? How might these have developed and changed **historically**? It was pointed out, for example, that women were denied access to male nude life-drawing class in all the **academies** of Europe virtually until the end of the nineteenth century. Without **mastering** this skill it was impossible for women to become fully trained and accredited artists able to produce works in the most prestigious **history paint-ing^ genre** (a French term related to gender) which involved single or multiple **human^ body compositions**. Johann Zoffany's 1771 painting of the founders of the English Royal Academy attending a life-drawing class shows two women artist-founders (Angelica Kauff-mann and Mary Moser) shown within a **picture** in the painting because decorum dictated that they could not be depicted actually present in the room with the naked male model.

The term *mastering* in the last paragraph is an instance of another important meaning to *gender* developed in the last thirty years of art history: the claim that certain words (or stories, or **styles**, or **mate-rials**, or **artworks** – or **theories**, or political **perspectives,** for that matter) particularly **represent** a masculine or feminine viewpoint and can therefore be said to be gendered or gender-specific. This **iden-tification** could be argued to be a good *or* a bad thing – depending on the case and the speaker. For instance, some **feminist** art histor-ians claimed in the 1970s that visual arts **crafts** like needlework were in some way essentially feminine (positively womanly) in their **nature** and **significance** and should be defended as such. In con-trast, others argued that oil painting – of the 1950s **abstract expressionist** 'action painting' variety – was essentially masculine, meaning negatively macho, and therefore not available or suitable as a **medium** or **practice** for women and non-sexist men. The **marxist** and feminist claim that some visual representations effectively 'objectify' men and women – a common example is pornography – might be related to the third gender of 'neuter', in the sense that objectification is a process that effectively dehumanises people (i.e. removes their authentic identity). Theorists and historians interested in sexuality and representation *beyond* heterosexual and homosexual categories, however, might regard this idea as simplistic and reactionary – based on dividing up people, and **artefacts**, and lan-guage elements into 'binary oppositions' that suppress existing or potential multiple forms of being or representing.

129

Further Reading

Chave, Anna C. 'Minimalism and the Rhetoric of Power', in Francis Fras-
cina and Jonathan Harris (eds) *Art in Modern Culture: An Anthology of
Critical Texts* (Phaidon: 1992).
Grosz, E. *Volatile Bodies: Towards a Corporeal Feminism* (Indiana University
Press: 1994).
Irigaray, L. *This Sex Which Is Not One* (Cornell University Press: 1985).
Mulvey, Laura 'Visual Pleasure and Narrative Cinema', *Screen* 16: 3 (1975):
6–18.

GENIUS

Carrying with it a complicated **history** of connected **meanings**, this
term encapsulates the **traditional^ art^ historical** idea that the
greatest **artists** have inborn, instinctive abilities that are mysterious,
or, at any rate, hard to **explain**, and possibly divinely inspired.
Artistic *geniuses*, then, are set apart (genus means 'type' or 'kind'),
unlike other people – even most artists – and in some way appear to
be 'out of time,' **creating** extraordinary **artworks** that are claimed to
have a universal appeal and **value**. While Michelangelo remains the
archetypal genius – whose status as such is set out in Giorgio Vasari's
Lives of the Artists (1550, enlarged 1568: full title *The Lives of the Most
Excellent Italian Architects, Painters and Sculptors*), often called the first
work of art history – it was only in the twentieth century that a 'cult'
of genius in art historical thinking resulted in the notion becoming
an extremely tired cliché. Applied to dozens of **modern** artists,
amongst them Henri Matisse, Paul Cézanne, Pablo Picasso, Jackson
Pollock, and Andy Warhol – the term lost most of its credibility
which had depended upon it being used very sparingly. The increas-
ingly indiscriminate use of the term was partly a function of the role
art history had begun to play in the operation of the art market:
boosting (or, more cynically, hyping) the financial value of artworks
made by artists both living and dead.

Some of those scholars **critical** of traditional art history since the
1960s – **marxists, feminists**, and **semiologists**, amongst them –
stressed the **ideological** meaning of the term and what it revealed,
they believed, about the methods and values of many of those who
propagated the notion of genius. *All* artists, sceptics pointed out,
simply could not make art, or sell or **exhibit** it without living in
societies made up of specific kinds of economic, political, and
ideological conditions and relationships. The notion of genius
worked to eradicate acknowledgement and discussion of those **social**

relations of production^ and **consumption^**. These necessarily shaped and limited the artworks that artists produced ('production' was preferred over 'creation' which also sounded like a divine activity – making something from nothing). Feminists stressed, too, the **gendered^** nature of artistic genius, showing that the **institutions** that trained and accredited artists were **dominated** by men and had actually prohibited women from entry and equal status for many centuries. The idea and ideology of artistic genius was, then, *itself* a social category produced by individuals and groups selectively controlling access to the **academies** and **museums** that constituted the **modern^** art world.

However, since the 1990s critical art historians and **theorists** of various kinds have devoted a lot of attention to trying to argue over, and re-state, the importance and **quality** of particular artists and their work. They realised that condemning the notion of genius did not really deal with, or make irrelevant, the question of the ways in which certain artists' works *do* appear to be of superlative **quality**, historically massively **influential**, and to have enduring value. This task might be called the attempt to develop a *social theory and history of value in art* – though there are multiple and sometimes antagonistic directions within this work. It is not, however, a general goal in contradiction with the historical study of actual societies and the place of art within them – rather the two now **form** essential parts of the same, single, inquiry.

Further Reading

[multiple authors] 'Art History: A Range of Critical Perspectives', *Art Bulletin* September 1995: 367–71;

Nochlin, Linda 'Why Have There Been No Great Women Artists?', in Nochlin *Women, Art, and Power and Other Essays* (Thames and Hudson: 1988).

Shiff, Richard 'Originality', in Robert S. Nelson and Richard Shiff (eds) *Critical Terms for Art History* (University of Chicago: 2003).

Wagner, Anne Middleton *Three Artists (Three Women): Modernism and the Art of Hesse, Krasner, and O'Keeffe* (University of California Press: 1996).

GENRE

Term with two overlapping **meanings** within **art^** history: (1) it refers to recognised types or **classes** of **picture**, such as the *genres* of **landscape**, or **still life**, or **nude**, or **history^** painting; (2) it refers

specifically to pictures of 'ordinary' or 'everyday life' and in this usage is often a reference to pictures **produced** in the low countries of northern Europe (now Holland and Belgium) in the **period** from the **renaissance** to the nineteenth century. These inverted commas indicate that 'ordinary' and 'everyday' are terms over which there may be dispute: in **practice**, however, the terms were used to refer to depictions of the life of the servant or peasant class, in their kitchens or gardens, in work activities and sometimes at rest (e.g.: Diego Velazquez, *The Black Servant* (1615); *Woman Cooking Eggs* (1618)).

In the first sense outlined above *genre* has elements similar to those often designated under the terms **form**, or type, or kind. In their broadest and earliest meanings these terms share with *genre* what is, in one sense, intended to be a simple classificatory function. Within art historical **discourse**, however, these senses have become increasingly **specialised**, though they retain some common properties. For instance, it would be perfectly proper to say that certain paintings by, for example, Peter Paul Rubens (e.g.: *Landscape with Chateau de Steen* (1636)) and John Constable (e.g.: *Golding Constable's Kitchen Garden* (1815)) are both part of the landscape genre and a type of art. However, in another usage exploiting the nuances within these terms, one could say that 'pictures within the landscape painting genre have been **produced** in a range of different **styles** – for example, **naturalistic** and **symbolist**. Further, specific types of works within these styles of landscape genre display highly varied formal characteristics (compare, for example, Joseph Wright's *Ark-wright's Cotton Mills by Night* (1782–83); Caspar David Friedrich's *The Cross in the Pine Forest* (1808); Georges Seurat's *Bathers at Asnieres* (1884); and Paul Signac 's *Buoy, Port of St. Tropez* (1894)). These classificatory and descriptive terms then – for example, form, style, type, kind, genre – have a range of uses, rather than a single, correct meaning.

Genre became particularly important in the establishment of **institutional** priorities within the **academies** in the seventeenth and eighteenth century – the so-called 'hierarchy of genres' was a doc-trine that proclaimed the relative **value** of certain kinds of paintings (and, correspondingly, that of the **artists** who produced them). The most important scenes were the large-scale history painting pictures which included **narratives** drawn from classical **mythology**, the Bible, and – later – secular **modern** historical events. Sir Joshua Reynolds, the first President of the English Royal Academy, defen-ded this **art** as the noblest and most demanding. Its elevated status both reflected and helped to establish the reputation of the artists –

himself included – who could be selected, trained, and **commissioned** to paint these scenes for the glory of God, the **state**, and the monarchy in Britain in the late eighteenth century.

In its second sense – genre as the depiction specifically of ordinary life – the term carries still with it the evaluative element present in its classificatory meaning. 'Ordinary' suggests less important, and, perhaps, requiring less skill (or ambition) to produce. By the twentieth century, however, with the almost complete collapse of the regulatory power of the academies and belief in the 'hierarchy of genres', it became possible for scenes of, for example, work boots or peasants playing cards to become invested with the highest possible **aesthetic** evaluations relating to the **development** of **abstraction** and the celebration of the **genius** of the modern **masters** (as with for example Vincent van Gogh's *Pair of Shoes* (1886)) and Paul Cézanne's *The Cardplayers* (1890–92)). The artist, that is, became more important than the ostensible theme or **subject matter** of the **artwork**.

Further Reading

Alpers, Svetlana *The Art of Describing: Dutch Art in the Seventeenth Century* (University of Chicago: 1983).

Bakhtin, Mikhail *Speech Genres and Other Late Essays* (University of Texas Press: 1986).

Conisbee, Philip *Chardin* (Oxford University Press: 1986).

Cranston, Jodi *The Poetics of Portraiture in the Italian Renaissance* (Cambridge University Press: 2000).

GLOBALISATION/GLOBAL *GLOBALISED*

Though **originally** a **concept** formulated within **sociology** and political **history**, *globalisation* has become, in the last twenty years, an important and increasingly **influential** way of thinking about the **development** and **meaning** of **culture** and **art** particularly since the late nineteenth century. However, important distinctions, as well as similarities, should be acknowledged between the **concept** of globalisation and a number of other (more familiar and **traditional**) related notions, including colonisation, imperialism, and international history. Globalisation, that is, is one of a cluster of terms through which the attempt has been made to **theorise**, and historically demonstrate, the interconnectedness of the world and all its peoples. In broad terms globalisation concerns the impact that different parts

of the world have had on others within all areas of **human** life and activity. As such, it is clearly not a process that began merely, say, a hundred and fifty years or so ago. Distinct regions in the world developed particular **social** systems and cultures thousands of years ago and, through processes including trading, exploration, intermarriage, and military conquest, began to affect other – usually geographically adjacent – societies and cultures (e.g.: the influence of ancient Minoan (now Crete) **civilisation** upon the Middle East, the Magreb, and Southern Europe).

The rise of the **modern** European **nation^-states**, along with the disciplines of history and **art history**, did not really occur until the nineteenth century. These twin developments drastically altered how the past was seen and **evaluated**: art history became, in large part, a history of art within certain 'nations', although many of the nation-states that constitute Europe now did not exist at all in **formal** or political terms until the middle of the nineteenth century – for example Greece (1820), Italy (1860), and Germany (1870). The idea of the 'Italian **renaissance**', then, is, in this sense, a fiction **created** in the later nineteenth century. Globalising contacts – especially those based around the **commissioning** of **artists** in southern Europe during the fourteenth to seventeenth centuries – were usually **organised** between cities and towns, *not nation-states*, as these were the centres of competing economic, political, cultural, and military activity (Florence and Rome being two of the most prominent examples).

Globalisation became an important component of **postmodernist^ discourse** in the later 1980s and 1990s, attempting to theorise the implications of the spread around the world of various **technologies** for **visual^ representation** – TV, **film**, video, computers, and the internet. Were these forms, **conventions**, and technical means, along with their (usually European or North American) multinational **institutional** corporate sponsors, creating a homogenised 'world society' and a single culture? Was globalisation a process which, though spreading a homogeneous culture, at the same time confirmed and entrenched the power of particular nation-states and corporations – especially those of the US, northern Europe, China and Japan? It became clear, too, that the history of modern art – i.e., **painting** and **sculpture** – had important transnational dimensions (which cannot and should not be limited to an **ideal** of *national* development and interaction). **Avant-garde** artists such as Paul Gauguin, for example, had sought out places remote to Europeans such as Tahiti – a French island colonised by France in the

nineteenth century – in which to 'dream' a life and a world not contaminated by European urban-industrial **capitalist** society (e.g.: *Spirit of the Dead Keeps Watching* (1892)). The **ideological** contradiction is obvious: it was the already existing French colonial empire that provided the condition and possibility for Gauguin to idealise a place as somewhere apparently outside of the known (globalised) world **dominated** by the European nation-states.

Further Reading

Anderson, Benedict *Imagined Communities: Reflections on the Origin and Spread of Nationalism* (Verso: 1983).

Coombes, Annie E. *Reinventing Africa: Museums, Material Culture and Popular Imagination* (Yale University Press: 1994).

Kofman, E. and G. Young *Globalization: Theory and Practice* (Pinter: 1996).

Spybey, T. *Globalisation and World Society* (Polity: 1996).

GOTHIC *INTERNATIONAL GOTHIC, NEO-GOTHIC*

In its most **conventional** sense *gothic* remains the name for an **historical^ style** in **architecture** (applied to a lesser degree to **contemporaneous^ painting** and **sculpture**) produced in northern Europe between about the early twelfth until the sixteenth centuries – when the **renaissance** is deemed to have superseded it. Gothic architecture and **art**, however, do not disappear, as it were, on 1 January 1500 and **traditional^ art historical^ discourse** typically 'compares and contrasts' the two, drawing attention particularly to the claimed **primitivism** and spirituality of the gothic (sometimes qualified as 'late gothic') in relation to renaissance rationalism and **realism**. The earliest completely gothic building is the lower part of the east end of St Denis Abbey, in France (*c.* 1140–44). The high windows of Sainte Chapelle, Paris (completed 1250) and the ornate tracery (decoration) of its stained glass panels have come to **symbolise** the gothic sense of simple **beauty** and Christian piety. In **pictorial** art, gothic is associated particularly with thirteenth-century painting and Cimabue: an artist still working in the **byzantine** tradition whose religious paintings nevertheless indicate the beginnings of an interest in depictive **naturalism** (e.g.: *Sta Trinita Madonna* (*c.* 1270)).

The term itself, however, was coined in the seventeenth century with clear derogatory connotations: the 'goths' were amongst the barbarian ancestors of **medieval** Europe and to call gothic art and

architecture 'primitive' was clearly intended *then* as an insult. Many gothic *revivals* took place in Europe – from the early nineteenth century onwards – and it is these self-consciously historical **movements** that select, emphasise, and **idealise** elements proposed as authentically 'gothic'. These encompassed egg tempera painting **techniques**, fresco wall decoration, and ecclesiastical architecture thought to **represent** the stability and moral superiority of an earlier **social order** rooted in monastic Catholicism. The Brotherhood of St Luke, a group of artists active in Vienna and Rome between 1809–20, believed such a revival could reverse the chaos in Europe brought about by the French **Revolution**, the rise of secularism, and the beginnings of democratic politics.

Art historical accounts of an **original** gothic **style** involve considerable generalisation. In architecture, French twelfth-century gothic is typified by pointed arches, high walls, elaborate ceilings, extensive use of glass and complex sculptured tracery. Romanesque architecture, however, from the mid tenth to the late twelfth centuries, also contains pointed arches and rib-vaults. Gothic took these elements and combined them with the 'flying buttress', an external structural arch supporting the wall of a building (e.g.: the Cathedral of Notre Dame, in Paris). The high spires and dynamic lines of gothic churches that have come to suggest religious spirituality and mysticism were, in one sense, a nineteenth-century **interpretation** and evidence of a reaction, then, against secular industrial and technological **modernity**. The Houses of Parliament in London, completed in 1852 (designed by Charles Barry), built as part of an ongoing gothic revival in Europe, also symbolise this idealism. Interestingly, the contemporary use of gothic or 'goth' as a label for styles of dress, music, and fantasy **narratives** (e.g.: the *Lord of the Rings* films and 'Warhammer' games) draws attention to the 'dark', barbarian sense implied in the seventeenth-century coinage.

Further Reading

Camille, Michael *The Gothic Idol: Ideology and Image-Making in Medieval Art* (Cambridge University Press: 1989).

Clark, Kenneth *The Gothic Revival: An Essay on the History of Taste* (1928) (BIIK Press: 1950).

Panofsky, Erwin 'The First Page of Giorgio Vasari's "Libro": A Study on the Gothic Style in the Judgement of the Italian Renaissance', in Panofsky *Meaning in the Visual Arts* (Penguin: 1970).

Sauerländer, W. *Gothic Sculpture in France 1140–1275* (Thames and Hudson: 1972).

HEGEMONY *HEGEMONIC, HEGEMONISE*

Deriving from the Greek, **meaning** 'leadership' or 'to lead', *hegemony* is a term from political **history** and **marxist^** **theory** that has been adapted by **art^** **historians** attempting to **explain** how and why certain **styles** of **art**, or **institutions**, or **critical** theories (or kinds of art history, for that matter) become **dominant** at particular moments. In the 1920s the Italian marxist and founder of the Italian Communist Party, Antonio Gramsci, turned to the **concept** in order to explain the rise in the **popularity** of the fascists in his country at the time. It was because the fascists had offered the idea of a powerful **national^** **culture** (based on an **idealised** version of Roman history), Gramsci thought, that they had managed to convince the people that they could become as great again. Their leader, Benito Mussolini, aped the physical appearance of the Roman Caesars and in various ways the Italian **state** under his command deliberately used the **signs** and **symbols** of the imperial Roman past in order to **produce** the fascist hegemony. Instead of the working **class^** **developing** socialist political sympathies in line with their place in a **capitalist^** **social order**, as they should have done according to marxist expectations, they had become seduced, Gramsci believed, by Mussolini's rhetoric of patriotic nationalism and Italy's new imperial destiny.

Hegemony, then, is a **social** and cultural *process*: a selective and strategic **appropriation** of symbols and meanings current and past in a society, which are then linked to a set of **contemporary** political-**ideological** goals and **values** – though Gramsci had stressed that hegemony worked through coercion (state power and violence) as well as through convincing people. It is fairly easy to see how art and art history contain ideological hegemonic **materials**. **History painting** in the nineteenth century, for example, became a direct and powerful way to **narrate** and **visualise** a particular account of a ruler's power and his regime's legitimacy – for example, Jacques-Louis David's 1801 **picture** of *Napoleon Crossing the Saint Bernard Pass* depicts the French emperor as a **modern** Hannibal or Charlemagne crossing the Alps on his way to military victory over the Austro-Hungarian army at Marengo a year earlier. The **ideal** of a specifically national art or national culture – say, that of the nazis in the 1930s, based on their claim to 'Aryan **racial** purity' and a trans-historical, mystical 'Germannness' – became an ideological lynchpin for many states in the twentieth century, though *all*, in **reality**, had to select and reject cultural and artistic elements in order to **create** such a singular hegemonising **representation**.

Hegemony, however, is not *always* an obvious political process. For example, the modernist idea that **abstract** art is **autonomous** – free from social restriction and political values – became a hegemonically dominant claim during the 1950s and 1960s in the US, shored up partly and importantly by the power of certain cultural institutions, such as the **Museum** of Modern Art in New York, which organised **exhibitions** and published catalogues that supported this assertion. Art **critics**, such as Clement Greenberg, as well as art historians, such as William Rubin (**curator** of painting at the museum in the 1960s), became **significantly** involved in generally defending this critical **perspective**. Though it *claimed* to be apolitical, ironically the **discourse** which later became known as 'Greenbergian modernism' was actually deeply implicated in how the US government attempted to represent American **abstract expressionism** in the Cold War **period**: that is, as a free cultural **expression** unquestionably better – morally, philosophically, **aesthetically** – than the regimented **forms** and **artists** of contemporary Soviet **socialist^ realism**.

Further Reading

Berger, John *Art and Revolution* (Vintage: 1969).
Gramsci, Antonio *Selections from the Prison Notebooks 1929–1935* (Lawrence and Wishart: 1971).
—— *Selections from Cultural Writings* (Lawrence and Wishart: 1985).
Laclau, Ernesto and Chantal Mouffe *Hegemony and Socialist Strategy: Towards a Radical Democratic Politics* (Verso: 1985).

HERMENEUTICS

Study of the **meanings** and **interpretations** of **artworks**; closely linked within **art^ history** to **analyses** of **forms** of **visual^ signification**, and the activity of audiences, or **viewers**, or **publics**. Though **originally^ developed** within some branches of philosophy and literary **theory** in the early and mid twentieth century (particularly the work of the 'reception theorists' Wolfgang Iser, Hans-Georg Gadamer, and Hans Robert Jauss), *hermeneutics* became a serious aspect of art historical **discourse** only in the **period** since the 1970s. This was because at that time radical art historians and theorists with a variety of **perspectives** – including **feminists, marxists**, and those with particular interests in **psychoanalysis** and **semiology** – began to draw attention to the range and *disparity* of meanings that artworks could and had generated in particular **his-**

torical and **social** situations. (Leonardo da Vinci's famous **painting** of the *Mona Lisa*, for instance, has generated many different interpretations since its **production** in *c.* 1500.) These scholars were beginning to **identify**, in other words, the different groups and individuals in society who apparently experienced the 'same' **artefacts** (e.g.: paintings, **sculptures, films, television** programmes) and yet **produced** from these encounters very different **readings** of them.

For instance, how might a British or American working **class** (blue collar) woman and a middle class, university-educated man differently respond to – interpret and **value** – a film such as *Pretty Woman* (1990), starring Richard Gere and Julia Roberts? What aspects of these hypothetical viewers' backgrounds, education, work experiences, voting habits, etc., might **influence** their reading of this movie? With which characters in the filmic **narrative** might they identify (or the opposite: feel repulsion) and why? Scholars interested in these issues began to see the need for what might be called 'socio-historical hermeneutics': a way to research and gather information that could answer these kinds of empirical questions about actual people. Feminists, for instance, wished to understand how **gender^ identity** – being masculine or feminine – could thus come to **structure** and shape people's experiences (of films, and everything else in society). How might gender relate to, say, social class, and beyond that, to broader **cultural** and **ethnic** circumstances? How might *Pretty Woman* have been interpreted, say, in Mumbai or Jakarta?

Hermeneutics began, therefore, radically to shift the **nature** and purpose of art historical work – *away* from concentration on **artists' intentions** and the circumstances of production, toward questions around audience or viewer reception, interpretation, and **consumption**. Not that the two are ever finally separable: *all* meanings are someone's interpretations, though before the rise of socio-historical hermeneutics the interpretations of **critics** and art historians were usually presented and often accepted as objective, or at least held to be more important than anyone else's. Neither, though, does hermeneutics disregard these still privileged meanings – to the contrary: it asks how they came to be made out of the life experiences of those responsible for them, and how and why they were able to become so **significant**. Influential art historical interpretations are nearly always connected to the **hegemonic** status and power people secure in **institutions** such as universities, **museums**, broadcasting, and publishing.

Further Reading

Boas, George 'The Mona Lisa in the History of Taste', in *Journal of the History of Ideas* April 1940: 207–44.

Freud, Sigmund *The Interpretation of Dreams* (1900) (Penguin: 1991).

Gadamer, H. G. *Truth and Method* (Sheed and Ward: 1975).

Holub, Robert C. *Reception Theory: A Critical Introduction* (Methuen: 1984).

HIGH ART

A term used by some **art^ critics** and **historians** to categorise what they regard as the most **significant** and precious **creations^ produced** by **artists**. *High art* implies an **opposite**, or at least a sharply contrasting **alternative** category: this space has been filled by a number of derogatory terms, including the diametrically opposed 'low art', **mass^ culture**, and **popular^ culture**. 'Significant' and 'precious' are words of high praise, used to indicate a wide range of high art **qualities** believed to reside in the selected **artefacts**. Typically, the claim has been made by **traditional** scholars concerned with **western** art that such **canonical** objects (e.g.: in sculpture, *Laocoon and His Sons*, from the workshop of Hagesandros, Athenodoros and Polydoros of Rhodes (*c.* 25 BCE); and in paintings, Pablo Picasso's *Violin and Grapes* (1912), Nicolas Poussin's *Et in Arcadia Ego* (*c.* 1655), Jean August Dominique Ingres' *Bather* (1808), Vincent van Gogh's *Landscape with Cypresses near Arles* (*c.* 1889)) all have *universal* and *trans-historical* appeal based on their perfect combination of **material** (**compositional**) and intellectual qualities. Following only cursory examination, however, it is clear that these claims should be taken with extreme scepticism – though they *might* be true (however, this is extremely unlikely), they could never actually be *shown* or proved to be true.

For instance, the **modern** (in this sense, i.e., post-1500) **conventions** of western **painting** and **sculpture**, for example, are highly culturally- and **socially**-specific. Even if it were agreed for the sake of argument that *all* people, say, living now within greater Europe, western Asia, and Northern Africa could understand the historical bases of these conventions and therefore were able to **value** such artefacts according to an agreed *single* set of principles, then the vast majority of the **contemporary** world's population would be excluded. In historical terms this claimed 'universality' would continue to shrink dramatically. In 1848, for example, when western Europe's population was still about 80% rural and illiterate – leaving aside the

rest of the limited area suggested above – only a relatively tiny number (probably a matter of a few tens of thousands) of educated people would have been able to discern the supposedly universal qualities that bourgeois-**humanist** scholars, with their own partial interests, backgrounds, and values, have attributed to these artefacts. It is clear, then, that these kinds of judgements operate mostly at the level of rhetoric and **ideology** – though those making the judgements may well have *believed*, and continue to believe, them sincerely to be literally true. But these claims arguably tell us more about those responsible for them than about the art they categorise as 'high'! Notions of high art, too, are usually inseparable from a combined – if often only implied – judgement that the rest, or most, of other cultural items produced in urban, industrial society since the late nineteenth century, are worthless, or at least worth far less (mass culture refers to Hollywood **cinema**, **TV**, **photography**, pop videos, etc.). In this sense, high art or 'high culture' thinking is a distinctly modern invention – a product, too, of **capitalist** society – and would have been an alien notion to anyone living much before, say, the 1880s. However, to recognise this is not at all to ignore the importance of some of the issues raised by those proposing and championing the **concept** of a *single* high art: questions to do with ideas of artistic value, intellectual difficulty (**complexity**), and **aesthetic** judgement. More modest and **realistic** defences of high art have been produced by scholars active, for example, in the **social history of art**: attempting that is, to explain the importance and meaning of certain paintings or **films** *within* particular societies and cultures in times of crisis and transformation.

Further Reading

Adorno, T. *Aesthetic Theory* (Routledge and Kegan Paul: 1984).
Carrier, David *High Art: Charles Baudelaire and the Origins of Modernist Painting* (Penn State Press: 1996).
Marcuse, Herbert *The Aesthetic Dimension* (Macmillan: 1978).
Stallbrass, Julian *High Art Lit: British Art in the 1990s* (Verso: 2000).

HISTORY *AHISTORICAL, HISTORIC, HISTORICAL*

The gathering, selection, **organisation**, and presentation of documentary **materials** in the **form** of a **narrative** based upon the writer's declared or tacit **theories**, principles, and **values**. Confusion may arise in that *history*, in one of its senses, refers to that which is over,

finished: the concluded past (as in 'you're history!'); while in another it is the name for an investigation that seeks to **explain** the relationship between events and processes that have occurred in the past but which continue to **influence** the present. In this second **view**, the present is also necessarily *historical* and may be understood historically. This involves the perhaps confusing implication that **contemporary^ art** is therefore also historical and intelligible historically – confusing especially because the discussion of contemporary art is usually thought of as the province of the art **critic** not the **art historian**.

These two senses, though, are *not* finally separable. The Second World War, for instance, certainly is over, if 'the Second World War' refers to events in the first half of the 1940s such as the nazi invasion of France, the Battle of Britain, the Japanese bombing of Pearl Harbour, the D-Day landings, and the suicide of Adolf Hitler. These events – facts – are definitely *not* still happening now! However, the intellectual discipline of history is concerned with the **interpretation** of these events, how they formed a *process*, and how, since 1945, their consequences have continued to shape the course of **developments** in the world. In this latter sense, then, history is how the past continues to form the present, in **complex** ways. For instance, the nazi genocide of European Jews during that war hastened the decision of the United Nations to agree to the establishment of Israel as a **nation^-state** in 1948, an action that indirectly sanctioned the displacement of millions of Palestinians who lived on this land at the time Israel was **created**. Since then, this conflict over the Palestinian *nakbah* (Arabic word for this 'catastrophe' of population removal, including some episodes of mass murder carried out by the Israeli Defense Force) has exerted enormous influence on the history of that region, and the whole world beyond – during the Cold War **period** and continuing since, up to our own present, and for the foreseeable future.

Art history faces all the dilemmas and challenges that confront this kind of **social** or political history: establishing what can stand as facts, and explaining how these constitute part of an explanation for how a **society** and **culture** organises itself, changes, and develops certain values. Controversy over what is 'fact' and what is 'interpretation' – and arguments over how the two are bound up together – are as endemic to art history as they are to any other kind of historical study. The attribution of works to **artists** is an obvious example – since the 1970s scholars have radically reduced the number of oil **paintings** they are confident were painted by Jan Vermeer, with dramatic implications for the market value of these **artefacts**. History as a study of the past, and 'the past in the present', is also a matter of

deciding and saying what is good or bad and this exercise of judgement has certainly been key to the work of art historians since the founding of the discipline in the first decades of the twentieth century. By 2000, however, radical critiques of **traditional** art historical methods from, for example, **marxist**, **feminist**, and **postcolonial^** **perspectives**, had undermined many of the orthodoxies that **dominated** the **subject** for many decades. In this way the certainties of some facts (such as the existence of the **canon** or artistic **genius**) can, and have been, powerfully undermined – shown rather to be partial **ideological** values presented and **reproduced** as unassailable truth within **exhibition** and educational **institutions** such as **museums** and universities.

Further Reading

Duncan, Carol and Alan Wallach 'The Universal Survey Museum', in *Art History* December 1980: 447–69.

Edwards, S. (ed.) *Art and its Histories* (Yale University Press: 1998).

Hobsbawn, Eric *The Short Twentieth Century 1914–1991* (Abacus: 1994).

Werckmeister, O. K. 'Radical Art History', in *Art Journal* Winter 1982: 284–91.

HISTORY PAINTING

The highest **genre** in **pictorial^** **art** from the seventeenth up until the mid nineteenth centuries – primarily used to glorify those in power through **symbolic**, **narrative** depictions of the past and **contemporary** events that legitimised and celebrated their rule and the **states** they led. Taught in the **academic^** **institutions** established and financed by governments and monarchies in European city- and later **nation**-states, *history painting* evolved through a series of **ideological** and political adaptations. Part of the root of the term **history** came from the Latin *istoria*: meaning story or narrative **composition**. The Florentine scholar, **painter**, and **architect** Leon Baptista Alberti had **theorised** the **production** of a successful *istoria* – meaning then biblical or **mythological** composition – in his treatise *Della Pittura* [On Painting] (1435). His book set out to show the **developing^** **complexity** of art at that time and the ambitious **humanistic** – intellectual rather than simply practical – abilities of the artists who could produce successful *istorias*.

Over the next three centuries history painting became enshrined within the institutional systems for the training, accreditation, and

exhibition of painters in European **societies**. Reserved for what were thought the greatest artistic talents (often those connected to the powers that controlled particular courts and governments), history painting involved a lengthy process of skill acquisition and apprenticeship, partly served in the studios of established **artists** (for example, Édouard Manet had been a pupil in the *atelier* of Thomas Couture for six years in the mid nineteenth century). The profession was effectively limited to men – women were barred from drawing the live male **nude**, a compositional skill essential to the academic training of a history painter. The social and political status of history painters reached its height around the time of the French **Revolution** and the following Napoleonic empire when Jacques-Louis David became, in effect, a minister of state in the post-revolutionary regime of the 1790s, given responsibility for **organising^ public** 'pomp and ceremony' **visual** displays of state power and later producing monumentalised – indeed grossly sycophantic – **pictures** of Bonaparte as Emperor of France and her colonies (e.g.: *The Coronation of Napoleon* (1807) and *The Emperor Distributing Eagles* (1810)).

The **ideological** role of history painting, then, was something akin to that later accorded to **film** – it became the major propagandistic means for visualising/narrating a **social order** and **reproducing** (through painted and print copies of oil paintings distributed widely) that **imagery** within a nation. The economy of art production – chiefly painting and **sculpture** – became bound up with this ideological role as a vehicle for state policy. However, when a new, faster-produced, means of visual **representation** appeared in the mid nineteenth century – **photography** – the writing was on the wall for history painting. Its decline, certainly, took several decades, and occurred as part of a **complex** social and cultural process, but, by 1900, it was effectively obsolete as an official means to propagate state ideologies (though it was revived for a while under the guise of socialist realism in the USSR in the 1930s, 1940s, and 1950s). Twentieth-century **avant-garde** artists, however, no longer **valued** academic training and entered into new sets of social relations with **emergent^ mediators** (such as **critics** and dealers) whose importance – along with new galleries and later **museums** – within the economy of the **modern^ art world** rapidly increased.

Further Reading

Boime, Albert *The Academy and French Painting in the Nineteenth Century* (Phaidon: 1971).

Clark, T. J. 'Painting in the Year 2', in *Farewell to An Idea: Episodes from a History of Modernism* (Yale University Press: 1999).

Crow, Tom *Painters and Public Life in Eighteenth-Century Paris* (Yale University Press: 1985).

—— *Emulation: Making Artists for Revolutionary France* (Yale University Press: 1995).

HUMANISM/HUMAN *BOURGEOIS-HUMANISM, HUMAN, HUMANIST, HUMANITIES, HUMANITY*

In its current **art^** **historical** usage, *humanism* carries two very different senses: one still almost entirely positive and the other explicitly negative. In the case of the former – with **historical^ origins** traced back to the **renaissance** and the **emergence** then of a **class** of humanist intellectuals including Leon Baptista Alberti, Marsilio Ficino, and Desiderius Erasmus of Rotterdam – the term refers to a worldview centred on **human^ values** (rationality and freedom) *and* an acceptance of human limitations. The first humanists were committed teachers and scholars – drawing on recently discovered Greek and Roman philosophy, antique art, and **culture** – and generally optimistic about the capacity of *all* people to improve themselves through learning.

In **western^ painting** and **sculpture** the devices of linear **perspective** and **naturalistic** depiction have been ascribed to this increasingly human-, as opposed to God-centred, **view** of the world. In contrast, the worldview of the latter, seen as mystical and irrational in comparison, is associated with **byzantine** or **medieval^ visual^ representations** that show, for example, size and status in purely **symbolic** or *hieratic* ways: God (the Father or Jesus) always shown as the biggest **figure** in the centre of a **pictorial** scene; with the brightest colours or most expensive paint used to **identify** the most symbolically important characters, in particular in illustrations of Biblical **narratives** such as the Virgin Mary, or the acts of the apostles (contrast, for example: Masaccio's *The Holy Trinity, the Virgin, St John and Donors*, Santa Maria Novella, Florence (*c.* 1427); Leonardo da Vinci's *The Last Supper*, Santa Maria delle Grazie, Milan (*c.* 1495); and Giovanni Bellini's *Madonna and Saints*, San Zaccaria, Venice (*c.* 1505)).

When humanism has added to it the prefix 'bourgeois-', the term in effect becomes the name for an **ideology** claimed to be derived from, and to **represent**, the partial, privileged interests of white, western European/North American middle **class** professionals whose

actual **ethnocentric** prejudices regarding **history** and notions of **progress** in art, culture, and **civilisation** are falsely presented – for example, in much **traditional** art history – as objectively true. Since the 1970s **feminists** have argued, with good grounds, that *bourgeois-humanism* is also sexist and misogynistic. They pointed out, for example, that Ernst Gombrich's *The Story of Art* (first published in 1950), one of the most **influential^ texts** in art history, did not include the discussion of a single **artwork** by a woman.

These two **meanings** for humanism continue uneasily to coexist in art historical **discourse** and illustrate the sharp divisions that characterise the field intellectually. The divisions are also, necessarily, those between individuals and groups who teach, research, **curate**, and publish in the discipline. In recent years, however, though the political and ideological differences remain – in fact they have become exacerbated (over Islamic terrorism, the history of Western **cultural imperialism**, and related matters) – debate around definitions and defences of artistic **value**, notions of the **canon**, the purpose of education, etc., has become more considered and nuanced. This suggests that all accounts of culture and civilisation (western and otherwise), though certainly partly ideological, cannot and should not be *reduced* to ideology.

Further Reading

Althusser, Louis 'Marxism and Humanism', in Althusser *For Marx* (New Left Books: 1977).

Etlin, Richard A. *In Defense of Humanism: Value in the Arts and Letters* (Cambridge University Press: 1996).

Gombrich, Ernst *Art History and the Social Sciences: The Romanes Lecture for 1973* (Oxford University Press: 1973).

Panofsky, Erwin 'The History of Art as a Humanistic Discipline', in Panofsky *Meaning in the Visual Arts* (Penguin: 1970).

HYBRIDITY *HYBRID, HYBRIDIZATION*

In its **modern** sense the term entered **art^ historical^ discourse** from debates that took place within **postmodernist^ theory** in the 1980s: why and how, it was asked then, did **contemporary^ culture^ appropriate** and fuse elements from a wide variety of sources, **producing** new **forms** apparently without **historical** precedent? Though these questions were asked initially about non-**visual** arts phenomena – **developments** in **popular** music and related **sub-**

cultural^ **styles** of **fashion** were the concerns of, for example, cultural **sociologist** Dick Hebdige – it became apparent that these issues were highly relevant to the history of art in the post-1945 **period**, and much earlier too. Common now to both the sociology of culture and art history is the issue of **globalisation**, and *hybridity*, in its postmodernist theoretical uses, is closely related to the study of sociocultural interactions across borders, regions, **nations**, and continents.

Hybridity, in its pre-twentieth-century senses, was a horticultural (and later **ethnological**) term: it referred to the deliberate crossing of different plants and crops to **create** entirely new species within agriculture. Its later adaptation to describe **human^** **racial** intermixing remains very controversial, as this usage depends upon (a) the **assumption** that human beings are all part of **naturally** *separate* and pure racial 'streams' (Caucasian, black, etc.) and (b) that, implicitly or explicitly, their mixing or hybridisation created unnatural or even monstrous new categories of people. All these senses are carried over, if in implicit or obscure ways, within the use of hybridity to describe developments in contemporary visual art. The term has been used to describe, for example, **paintings** by the Brazilian **artist** Beatriz Milhazes, whose bright, swirling neo-**baroque abstract**, canvases **appropriate** and fuse stylistic and **conventional** elements from art from many sources (including US abstract painting from the 1960s, vernacular Brazilian folk art, and **pop art**: e.g.: *O Selvagem* (1999)). In another direction, hybridity could be used to describe the **artefacts** produced by the New York-based artist Fabian Marcaccio: combining elements of both painting and **sculpture**, these objects stand up by themselves in galleries away from the walls, offering a **surface**-side like an orthodox painting, yet are massively and oddly sculptural, built out of a range of **materials** including plastic and metal (e.g.: *Time Paintant: Image Addiction Paintant* (1999)). The new **form** of **installation art** – **creating** or adapting whole inhabitable spaces from a range of materials – is a hybrid innovation: the superlarge works that have filled London Tate **Modern's** turbine hall since 1999 are cases in point (e.g.: Anish Kapoor's *Marsyas* (2002–3) and Rachael Whiteread's *Embankment* (2005–6)).

Hybridity, however, for all its usefulness, overlaps with at least two **traditional** art historical terms – development and **influence** – and it is important that the relations between these **concepts** are explored and the **real** additional sense within the term *hybridity* **identified**. Though **western^** **avant-garde** or modernist art since the late nineteenth century has become increasingly globalised, cross-fertilisation in artistic terms is a process that has taken place for hundreds, and

probably thousands, of years – though perhaps the earlier **signs** of this have become so naturalised in western art as to be virtually hidden from **view**. In **architecture**, for example, the extraordinary palimpsest of **structures** making up the *Mezquita* (mosque) in Cordoba, Spain – inside of which a Christian church was built – indicates hybridization occurring over an **epoch** of a thousand years and more.

Further Reading

Bhabha, Homi 'Of Mimicry and Mean: The Ambivalence of Colonial Discourse', *October* Spring 1984: 125–33.

Harris, Jonathan (ed.) *Critical Perspectives on Contemporary Painting: Hybridity, Hegemony, Historicism* (Liverpool University Press/Tate Liverpool: 2003).

Hebdige, Dick *Subculture: The Meaning of Style* (Methuen: 1979).

Wallis, Simon and David Ryan *Hybrids: International Contemporary Painting* (Tate Publications: 2001).

ICONOGRAPHY/ICONIC *ICON, ICONOGRAPHIC, ICONOLOGY*

With its root in the term *icon*, **meaning^** **image** or likeness (and **originally**, from the Greek, a sacred **portrayal** of the face of God), *iconography* became the name in **art^** **history** for one of the discipline's central, and defining, activities: **identifying** the **formal** and **symbolic** elements in **visual^** **representation** and then elaborating upon their wider **social** and **cultural** importance. This **analysis** was proposed, **theorised**, and **developed** principally by the German scholar Erwin Panofsky in the mid-decades of the twentieth century who used it primarily to **explain** the **nature** and meaning of **renaissance^** **paintings**.

Taking **pictures** that represented **narratives** from the Bible or **classical^** **mythology** (e.g.: Benozzo Gozzoli's *The Journey of the Magi to Bethlehem*, Medici Palace chapel, Florence (1459–63); Sandro Botticelli's *The Birth of Venus* (1485)), Panofsky divided the study of these representations into three related phases. (1) The 'pre-iconographic', which meant description of the **formal** and physical elements of a **composition**; (2) the 'iconographic' which meant the identification of the symbolic and narrative meanings present in the picture – the recognition of which required knowledge of the development of art and its **socio^-historical** circumstances of **production**; and (3) the 'iconological', by which Panofsky meant the work of

elaborating – and thereby enriching – iconographic analysis through an understanding of the society as a whole in which the visual representations had been produced. A renaissance fresco painting series, such as Masaccio's *Life of St. Peter* (1425–28) in the church of Santa Maria del Carmine in Florence, for example, was **interpreted** (or **read**) in order to reveal effectively the whole basis of that city's **civilisation**. The frescoes offered a **perspectivally** rationalised, **naturalistic** rendering of the New Testament story, paid for by a pious secular **patron**-businessman who repented for his sin of usury (lending money at interest) by glorifying God with the **commission** and, at the same time, **publicly** demonstrating his wealth, learning, and power. Masaccio's work demonstrates how **visual** art's **technical** and intellectual achievements in the early renaissance were put to combined religious and social ends.

This very brief example suggests perhaps the limits and dangers of iconography, as well as its **value**. Iconography appears to work well as a method when used to account for visual representations that present identifiable narratives and known (social) symbolic conventions of various kinds. Iconography begins to founder, however, when it encounters art without – sometimes deliberately not using – these features (e.g.: **abstract** paintings from *c.* 1900 onwards, such as Kasimir Malevich's *Black Square* (1929)). Even on its chosen territory, however, there is a danger that iconography may render **artworks** *falsely* typical or illustrative of broad social and cultural features simply 'read off' from them. Though Panofsky himself was aware of these dangers, later scholars have sometimes used iconography as a crude sort of 'key' or 'code-breaker' to a whole society or historical moment, generalising dangerously from extremely partial and limited examples. Artworks may not be the most reliable documents of a **complex** society or culture – in fact no single group of **artefacts** *of any kind* can arguably carry this general **significance**. As a method of visual and historical analysis, however – and thought of as a 'trial and error' (heuristic) procedure, *not* a foolproof system – iconography remains an important way to learn about art and its interpretative possibilities.

Further Reading

Gombrich, Ernst *Ideals and Idols: Essays on Values in History and in Art* (Phaidon: 1994).
—— 'The Aims and Limits of Iconography', in Gombrich *Symbolic Images: Studies in the Art of the Renaissance* (Phaidon: 1993).

Pächt, Otto *The Practice of Art History: Reflections on Method* (Harvey Miller: 1999).

Panofsky, Erwin 'Iconography and Iconology: An Introduction to the Study of Renaissance Art', in Panofsky *Meaning in the Visual Arts* (Penguin: 1970).

IDEAL *IDEALISED, IDEALISM, IDEALIST*

One link in a chain of connected terms with a long record of use in **art^ history**, *ideal* has its **origins** in accounts of **classical** (ancient) art and in post-**renaissance^ academic^ discourse** on the purpose of art and the means to **create** its perfect **forms**. The term refers to both (a) the **representation** of perfect **human** forms: that is, idealised, *usually* **nude, bodies** of men and women (e.g.: the marble **sculpture** of *Venus de Milo* (second century BCE); the bronze sculpture of Hercules-Serapis, found at Begram (second century CE); Raphael's **painting** *The Nymph Galatea* (*c.* 1514); Diego Velazquez's painting *The Toilet of Venus* (1644–48); Antonio Canova's marble sculpture *Theseus Slaying the Minotaur* (1781–83)); and to (b) ideal **visual** forms rendered in **artistic^ materials**. Clearly there is much overlap between the two senses, though (b) is often used to describe visual representations that contain no depictions of ideal human forms. **Abstraction** in painting and sculpture since about 1900 has consistently attracted this sense, sometimes with the claim that its 'purity' (i.e., lack of depiction of recognisable objects in the world) has a philosophical confirmation in Platonic notions of the ideal as source of absolute **reality** (e.g.: Sonia Delaunay-Terk, *Contrastes Simultanes* (1912); Piet Mondrian, *Composition with Red, Yellow, and Blue* (*c.* 1937–42)).

The introduction of philosophical issues and **authorities** indicates the **complexities** attending upon the idea of the ideal and at least three of its related terms: idealist, idealistic, and **idealism**. These notions have their own long and elaborate **conceptual^ histories** which both predated and accompanied **developments** in art and art **theory**. The belief that certain pure forms **produced** in **artworks** chimed with, and represented, the basic **nature** of the universe understood as the work of a set of abstract forces and elements (or, later, of a deity) has continued powerfully to **influence** artists, **critics**, and historians over many hundreds of years. By the nineteenth century, however, idealism as both philosophical system and as a set of visual-representational **conventions** was radically challenged in both politics and art. Karl Marx saw philosophical idealism as an

ideological deceit, a mystifying misunderstanding of the true **nature** of the material world and the social condition of man. Gustave Courbet, Marx's artist and **socialist^ contemporary**, wished to produce paintings that showed the brute actuality and physicality of things, *not* what he thought of as the deluded and deluding mental constructs of men's brains (e.g.: *The Stonebreakers* (1849); *Burial at Ornans* (1850)).

Idealism in the ordinary sense of the term, of course, is not a bad thing in itself – on the contrary, optimistic belief in a better future, high **values** and standards, may be a basic psycho-biological attribute of being human. It is rather the ends to which idealism is put which can be suspect. Idealisations of human form in **academic** painting, and in twentieth-century nude **photography** and **advertising**, and in **TV** and **popular^ film**, have meant that certain kinds of bodies have not been shown and thus have become stigmatised as weak or monstrous or ugly. Cosmetic surgery **techniques** have now led people – mostly women – to actually have their bodies 'sculpted' into what they regard as the **desirable**, ideal shapes and **images** seen on TV and in movies. The French **performance** artist Orlan has drawn attention to this **state** of affairs in many of her disturbing video works over the last ten years (what the artist calls her 'theatre of the self', when she undergoes surgery while being filmed), while Marc Quinn produced a challenging marble sculpture of a pregnant and severely disabled woman – the artist Alison Lapper – for the empty fourth plinth in Trafalgar Square in London in 2005.

Further Reading

Crow, Thomas 'Observations on Style and History in French Painting of the Male Nude, 1785–94', in Norman Bryson (*et al.*) *Visual Culture: Images and Interpretations* (Weslyan University Press/University Press of New England: 1994).

Pointon, Marcia *Naked Authority: The Body in Western Painting 1830–1908* (Cambridge University Press: 1990).

Potts, Alex *Flesh and the Ideal: Winckelmann and the Origins of Art History* (Yale University Press: 1994).

Tickner, Lisa 'The Body-Politic: Female Sexuality and Women Artists Since 1970', *Art History* June 1978: 236–49.

IDENTIFICATION *IDENTIFICATORY, IDENTIFY*

In perhaps the most **traditional** and (literally) conservative fields of the discipline of **art^ history** – **artefact** preservation, restoration,

and conservation – *identification* is both the aim and process which attempts to establish what are held to be basic facts about the **nature** of certain artefacts: *who* physically **produced** the **artwork**, *when*, *where*, and with *what* **materials** and resources. A related task, particularly important within **connoisseurship** and the workings of the art market, is concerned with identifying the successive owners of an artefact: that is, its *provenance* (literally, from the French, **meaning** its **origin**). In these senses, then, identification had historically been thought of as a scientific task of verification carried out by experts working in **museums**, auction houses, and dealing galleries. By the 1970s, however, these aims and objectives came under fundamental attack from radical scholars of various kinds: **social art historians, feminists, semiologists,** and **structuralists.** They claimed – from a number of different **perspectives** – that these procedures (1) were actually based on dubious claims of objectivity and truth; (2) reduced art historical research to a mere hunt for facts and dates; and (3) all the while principally served the financial interests of those who controlled the process of buying and selling artworks.

Nevertheless, many of these **critical** scholars themselves had their own **theories** of identification, though these bore little or no relation to the senses outlined above – and their separateness (but *not* necessarily their incompatibility) underlines the divisions still deep and divisive across **contemporary** art historical **discourse.** Theories and accounts of identification from within the wings of **new art history** centre on **complex^** theoretical accounts of meaning, **subjectivity, ideology,** and **socio^-historical** context. In feminist **film** theory, for instance – an area that overlapped importantly with feminist art history particularly in the later 1970s and early 1980s – identification was the name for a socio-**sexual** process in which people (men and women, though feminists *tended* to concentrate on the latter) established and transformed their own subjective, **gender,** and sexual **identities** in relation to their **viewing** of, and identification with, visual **representations** of various kinds. These included, for instance, **advertising, romantic^** Hollywood **cinema,** the personas and **imagery** of **pop** stars, and depictions of men and women's social relations in both historical and contemporary artworks. The **visual pleasure** in such materials, theorised within **psychoanalytic** writings by Sigmund Freud, Jacques Lacan, Roland Barthes, Julia Kristeva, Luce Irigaray, and many others, became a particular interest – linked in many cases to a concern with how social ideologies of identity, image, and behaviour within **capitalist** society were produced and **reproduced** through such processes of

identification with character-types depicted in all kinds of visual **media**. It is not hard to see how scholars whose work exemplified these two very different kinds of attention – the traditional and the radical – might have come to understand, and represent, the activities and **values** of the other as a hackneyed and trivial pursuit, believed to be motivated more by personal obsessions, eccentricities, and political viewpoints (declared or not), than by a genuine interest in art. Yet, arguably, a concern with both the specificities of historical detail (the **practical** 'who', 'when', 'with what' questions) *and* with fundamental **explanatory** issues (the theoretical 'why', and 'in what social circumstances' questions) is necessary within *any* adequate art historical project. In fact, more than that, that these two sides are actually interdependent in any serious historical and **analytic** work on visual representation.

Further Reading

Berenson, Bernard *Aesthetics and History* (Berkeley Publishing Company: 1960).
Crowe, A. and G. B. Cavalcaselle *A History of Italian Painting* (1864) (AMS Press: 1909).
Irigaray, L. *Culture of Difference* (Routledge: 2000).
Mulvey, Laura 'Afterthoughts on "Visual Pleasure and Narrative Cinema," inspired by King Vidor's *Duel in the Sun* (1946)', in A. Easthope (ed.) *Contemporary Film Theory* (Longman: 1993).

IDENTITY

Though with close relation to the **concepts** of **identification** and **meaning**, *identity* retains its strong sense as a noun: that is, referring to a *fixed thing* with permanent, or at least, profoundly *continuing* **qualities** and attributes. For instance, it is common for **art^ historians** to offer definitions of **painting** and **sculpture** as fixed, stable, continuing **practices** 'within which' **artists** have worked for hundreds, if not thousands, of years. Attaching inverted commas to 'within which' draws attention to the quality of being a *fixed thing* that is associated, **traditionally**, with these **media** understood as particular, secure, art **forms** with clear identities. '**Modernist** art', Clement Greenberg famously claimed, for instance – meaning painting as a practice – 'takes its place in the intelligible continuity of **taste** and tradition.' It is from *within* these stable, **real** things, his statement implies, that many different **artists** working at many different **historical** moments have been able to **express** themselves.

Yet if *identity* is a noun illustrated by the apparently fixed practices of painting and sculpture (based, respectively, on artistic expression within the manipulation of two- and three-dimensional **materials**), it is also a noun of *process* encompassing a changing, and possibly **developing**, phenomenon. A person's identity is both: in one sense, a fixed or stable thing (someone's character or personality), but also a thing that has come into being (been formed) and that will, in certain ways, mutate in the future. The difficulties with concepts such as development, or evolution, or **progress**, are fairly easy to see: in art historical **discourse** they *tend* to suggest 'improvement' or 'positive change'. Sometimes this sense is clearly **intended** (e.g.: in phrases such as 'the development of the **renaissance**', or 'the development of **cubist** painting from **analytic** to synthetic phases'), while at other times the legacies within these powerful words operate unconsciously.

The media of painting and sculpture, in fact, can be shown to have changed – if not necessarily developed or progressed in any **evaluative** sense – in so many ways throughout history that the claim that they possess a *single* stable identity (or meaning or purpose) becomes, at best, highly implausible. Meyer Schapiro, for instance, pointed out that a fundamental change occurred many centuries ago when the **surface** upon which paint was applied became limited in area, increasingly *relatively* flat, and detached from the walls of caves or hillsides that had carried the earliest **pictures** (e.g.: **representations** of bison and other animals in caves in Altamira (Spain) and Lascaux (France) (15,000 BC)). Has cave-painting never, then, really been part of the identity of painting? Did its practice only really start *after* the point when the surface became clearly limited and detachable in the form of paintings on pieces of wood or cloth? To complicate the situation, for thousands of years painters worked on walls (**murals**) in buildings. Many later changes occurred in the history of the identity of painting – in terms of its physical materials and **technical** procedures, never mind its changing **social** use across different historical **periods**.

Identity, then, *remains* a highly important but potentially troubling idea and value: the stability of meaning for some unitary thing called painting in **western** art is key to many traditional scholars who defend notions of both **civilisation** and the **canon**. In the same way the identity of the category of the artist is problematic: claimed often to refer to a specific type (or **myth**) of person, with certain abilities and **perspectives**, fixed and continuing – despite the flux of history and the extraordinary diversities of place, community, **culture**, **social order**, and belief-system in which artists have worked and work now.

154

Further Reading

Martindale, D. *Social Life and Cultural Change* (Van Nostrand: 1962).
Schapiro, Meyer *Theory and Philosophy of Art: Style, Artist, and Society* (George Braziller: 1994).
Sousslof, Catherine M. *The Absolute Artist* (University of Minnesota Press, 1997).
Williams, Raymond 'Identifications', in Williams *Culture* (Fontana: 1981).

IDEOLOGY *IDEOLOGICAL, IDEOLOGUE*

Within **art history** *ideology* has become a **concept** used in close conjunction with the notion of **representation**. Though retaining a cluster of senses which precede Karl Marx's fundamental **appropriation** and **development** of the term in the mid nineteenth century, ideology has come to be associated specifically with **marxist^ analyses** of **society, history**, and **culture**. The link to **forms** of **visual** representation – those **produced** manually (e.g.: **painting**), mechanically (e.g.: **photography**), electronically (e.g.: **TV** and **film**), and digitally (e.g.: the internet, DVD) – concerns the definition of ideology as a set of ideas and **values**, related to the **material** interests of **social** groups, which claim the world is essentially *like that*. The *like that* might be the familiar assertion, for instance, that people are inherently competitive, narcissistic, and **naturally** seek their own individual, family, or company advantage, rather than broad social or international integration and responsibility. (This idea has been conveyed here through the **medium** of **language** – though it finds **expression** in visual **imagery** too.) Marxists **identify** instances of this statement, and others related to it, as elements constituting the ideology of bourgeois individualism: a **perspective** that promotes and reflects the **material** interests of the wealthy middle classes and corporations who have profited most from the **capitalist** economic and **social order**. Visual representations of many kinds – **advertisements** in print media and on TV particularly – tend to promote this ideology (e.g.: ad campaigns for Microsoft and IBM computer products for business over the last ten years, and those ads for cars that emphasise the claimed advantages of certain makes and models, such as BMWs and SUVs).

Since the 1930s, however, the **theory** of ideology elaborated by marxists – the claims, that is, that (1) ideology is rooted in objective economic **class** relations; (2) that such ideologies define and fix people's place in class struggle; (3) that socialism is the *intrinsic* and

necessary ideology of the working classes and would inevitably triumph over capitalist society following a **revolution** – have been **subject** to searching **criticism** and revision, as much by open-minded marxists as by, for instance, **feminists** interested, for example, in **psychoanalytic-** and **gender-**, rather than economic or social class, models of **human^** **identity** and relations. **Artists** have also sought to represent ideology as a multifaceted **structure** of **imagined** social relations, not reducible to a single element or dynamic (e.g.: James Rosenquist, *President Elect* (1960); Judy Chicago, Suzanne Lacey, Sandra Orgel, Aviva Ramani, *Ablutions* (1972); Martha Rosler, *The Bowery in Two Inadequate Descriptive Systems* (1974–75)).

Within this scholarship and related political activity since the 1960s, accounts of ideology and **meaning** have hinged on a view of subjectivity and personal identity as many-sided and mobile: people in late-capitalist, or **consumer** society, are addressed by many kinds of ideological 'apparatuses' – including advertisers, **institutions** of the **state**, and the organs of **popular^** **culture** – which appeal to people's **sexual**, social, gender, **ethnic**, age, **national**, and regional senses of identity. Visual representations **created** within novel advanced **technologies** (e.g.: the internet and digital TV) are clearly central to ideological production – to the extent that writers/activists such as Guy Debord and Jean Baudrillard have claimed that the **contemporary** world is a 'society of the spectacle', in which senses of **reality** and **illusion**, truth and falsity, ideology and reliable 'objective' knowledge, have become dangerously, and perhaps irredeemably, confused.

Further Reading

Baudrillard, Jean 'The Ecstasy of Communication', in Hal Foster (ed.) *Postmodern Culture* (Pluto Press: 1985).

Debord, Guy *The Society of the Spectacle* (Zone Books: 1994).

Larrain, J. *The Concept of Ideology* (Hutchinson: 1979).

Marx, Karl and Frederic Engels *The German Ideology* (1845–46) (Lawrence and Wishart: 1970).

ILLUSIONISM *ILLUSION, ILLUSIONISTIC, ILLUSIVE, ILLUSORY*

Within two-dimensional **media** particularly, **forms** and devices for imitating appearances in **western^** **art** have featured significantly – from the rediscoveries of **perspectival** drawing and **painting^** **techniques** in the **renaissance** to the **contemporary^** technologies

156

of 'virtual **reality**' found in computer video games and interactive live websites. Stories about the trickery of **pictorial^ representations** – birds mistaking painted **images** of grapes for real ones and the like – have come down to us from the Greeks. For many centuries **producing** convincing *illusions* of objects and space in paintings, prints, and drawings was seen as one of the **artist's** most important tasks and ways to demonstrate their abilities – though usually *illusionism* was combined in **compositions** with a range of **narrative** and **symbolic** functions (e.g.: Uccello, *The Rout of San Romano* (1450); Diego Velazquez, *Pope Innocent X* (*c.* 1650); Jacques-Louis David, *Death of Marat* (1793)).

To a lesser, though still important extent, illusionism has played its part in **sculpture** and **architectural^ design**: for example, when sculpted **figures** of saints placed high on a church's façade were manufactured in order to be seen as anatomically correct from the normal **viewing** position many metres below the statue's actual placement – demonstrated, for instance, by the statues with (actually) disproportionately large heads and arms placed high up on the walls of the cathedral and the adjoining bell tower in Florence. Related *trompe l'oeil* (literally: 'deceive the eye') painting decoration techniques, **mastered** in the sixteenth century, attempted to convince ground-level viewers that a building's ceiling was much higher than it actually was – continued, illusionistically, within the pictures painted in the roof arches that suggest either the closeness of the heavens themselves or the continuation of depicted (illusionistic) space in the actual **structure**, ornamentation, and sculpted figures in a building (e.g.: Andrea Pozzo's ceiling of the Jesuit church of San Ignazio (1791–94) and Giovanni Battista Gaulli's ceiling of the Gesu church, both in Rome (1672–83)).

By the late nineteenth century a profound reaction against illusionism had set in – though earlier realist painters such as Francisco de Goya and Gustave Courbet had understood that showing 'how things really are' had little to do simply with producing convincing optical illusions of three-dimensional objects. Consider, for instance, Goya's disturbing, **expressionistic** *Disasters of War* series (1810–13) and Courbet's *Return from the Conference* (1862), which depicts, in comic fashion, a group of drunken priests. Reality, that is, became understood as a **psychic** and somatic (**bodily**), as well as a **social** and phenomenal, thing: no longer only a matter of **naturalistically** depicting the physical appearances of objects in the world. **Modernist** painters and sculptors in the twentieth century, along with some of their most **influential^ critics**, rejected slavish illusionism as trivial trickery or deceitful misrepresentation (see, for example, Clement

Greenberg's 1939 essay 'Avant-Garde and Kitsch'). Depicting 'real' reality, in contrast, was increasingly seen as a matter of individual expressiveness and even a kind of knowing **primitivism**: the rejection, that is, of **academic** illusionistic **conventions** and the adoption of pictorial-spatial flatness and decorativeness in composition. It was these **qualities** which quite quickly became equated with the virtues and **values** of sincerity, spontaneity, openness, and even anti-establishment politics (e.g.: Pablo Picasso, *Seated Woman in a Chemise* (1923); and Henri Matisse, *Draped Nude* (1936)).

Further Reading

Bann, Stephen *The True Vine: On Visual Representation and the Western Tradition* (Cambridge University Press: 1989).
Barthes, Roland *Camera Lucida* (Hill and Wang: 1981).
Freedberg, David *The Power of Images: Studies in the History and Theory of Response* (University of Chicago Press: 1989).
Mitchell, W. J. T. *Picture Theory* (University of Chicago Press: 1994).

IMAGE *IMAGERY, IMAGINARY, IMAGINATION, IMAGINE, IMAGING TECHNIQUES*

Representation of the outward **form** of a person or thing, or a mental **picture**. *Image* remains one of the most basic **conceptual** 'building blocks' of **art^ historical discourse**, yet is fraught with a number of fundamental problems and confusions to do with both use and **theoretical^ value**. By the later 1970s the term was rejected more or less altogether by many radical art historians (**social historians, feminists**, those interested specifically in accounts of **visual^ meaning** and its relation to **psychic** processes) in favour of the term 'visual representation'. By using this **alternative** phrase they **intended** to indicate a clear, knowable process that fabricated **signs** from certain physical **materials** which then attained certain meanings in particular situations, due to **identifiable** factors involved in the circuit of **communication** (**production** → transmission → **consumption**). A **conventional^ photograph**, for instance, is produced by allowing light to fall on the **surface** of a portion of receptive **film** that, when **developed** using specific chemicals, projectors, and lenses in a darkroom, can be fixed on light-sensitive paper and printed at different sizes. This kind of visual representation – say the photograph of *Identical Twins, Rozel, New Jersey* by Diane Arbus (1967) – can be assessed as a recognisable type of **subject matter** (in this case, a **por-**

trait), treated in a certain way (as documentary **realist**), related to the **history** of photography and other visual **media**, and examined in terms of its appeal to certain groups of **viewers** for particular reasons. In contrast, the term *image* retains what seems like almost mystificatory properties – like a mirage (an optical **illusion** caused by atmospheric conditions), an image in one sense cannot be *real*: it is a mere projection, unstable, untrustworthy, and bound to disappear. Salvador Dali's and René Magritte's **surrealist^** **paintings** of **landscapes** and interiors deliberately sought to **create** this 'dream-like' feel associated with this sense of image (e.g.: Dali's *The Persistence of Memory* (1931) and Magritte's *Time Transfixed* (1938)). In one way, and perhaps ironically, this meaning *is* the **analytic** strength to the concept of image: it insists on an acknowledgement that appearances *are* flickering, insecure, and possibly deceptive. Image may refer to the objects in **human^ vision** (the image reversed on the retina surface of the eyeball and immediately turned round, made sense of, by the **interpreting** brain) as well as to *fixed* visual representations, such as paintings, drawings, and films. Within **subjective** human consciousness, we inevitably **look** and see images – of people, places, all things – *through* our own **identity**, place, and **perspective** in the world. Though 'seeing' is sometimes used to mean the same as understanding – for instance, when someone says 'I see, now, what you mean' – there is always the possibility that our sight (and our understanding) may be proved wrong, or misleading, as it is always partly dependent upon our subjective interests and **values**. Aeroplane pilots are taught to rely on their instruments for navigation because at certain dangerous moments the images they may see when they **look** out of the window – of land, or cloud, their visual sense of height from the ground or direction of movement – may be completely misleading.

Image, then, remains an important notion because it includes certain features of appearance and portrayal that 'visual representation' misses. There is a way, for example, in which Catherine Zeta Jones' forty-foot face on film screen close-ups in *The Legend of Zorro* (2005) *is* mostly image – experienced, that is, as a dream-like **cinematic** fantasy – though it is also a representation. Certain film-makers and painters, that is, have wanted and planned to fabricate visual representations that achieve this particular **quality** *as* image.

Further Reading

Barthes, Roland 'Rhetoric of the Image', in Barthes *Image, Music, Text* (Fontana: 1977).

Belting, Hans *Likeness and Presence: A History of the Image before the Era of Art* (University of Chicago Press: 1994).

Mitchell, W. J. T. *Iconology: Image, Text, Ideology* (University of Chicago Press: 1986).

Pächt, Otto 'The End of Image Theory', in Christopher S. Wood (ed.) *The Vienna School Reader: Politics and Art Historical Method in the 1930s* (Zone Books: 1930s).

IMPRESSIONISM *IMPRESS, IMPRESSION, IMPRESSIONISTIC*

So closely **identified** is *impressionism* with that **formation** of **artists** active in Paris and other parts of France (and beyond) in the **period** *c.* 1860s–80s (chiefly Claude Monet, Édouard Manet, Auguste Renoir, Alfred Sisley, Camille Pissarro, Paul Cézanne, Edgar Degas, Eùgene Boudin, Berthe Morisot, and Armand Guillaumin), that the term's adjectival (descriptive) basis, *impression*, has been converted, through many decades of mostly routine scholarship, into a kind of **invisibility**. Impression-ism, that is, has been frozen into an **art^ historical** noun or 'proper thing'. Rather than immediately relating the term, then, to this still extremely **popular** group of artists – or claiming that their **paintings**, drawings, and prints constitute a sin-gular or stable **style** – consider instead two dictionary definitions for the root-word of this art historical label. Impression: (1) 'a pressure applied by one thing on or into the **surface** of another ... the stamping of a **quality**'; and (2) 'an effect **produced** on the mind, conscience, or feelings'. Impressionist **pictures** (the artists made few **sculptures**) emphatically drew attention to their surface *facture* as painted objects – obviously marked and schematic, without the 'finish' and slick **illusionism** characterising most **contemporary** academic art (e.g.: Adolphe Bouguereau's *Birth of Venus* (1879)).

Both of these **meanings** to 'impression' speak directly to the experience of **looking** at impressionist **pictures** and, arguably, tell us about the experience of those who made these **representations** as well. The term *impressionism* came, initially, as a derisive **critical** riposte, from the title Monet gave to a **landscape** showing the play of sunlight on water (*An Impression, Sunrise* (1872)). Though the range of **subject matter** found in impressionist works is wide, including scenes of **nature**, the city, the suburbs, the leisure pursuits and work of Parisians, domestic interiors, family **portraits**, and self-portraits, all, in different ways, suggest a new kind of *self-consciousness* on the part of their producers. A self-consciousness, that is, about the

making of marks – including a common rejection, though in a variety of ways, of **academic^ idealist^ compositions** and **conventions** – and about their observations, and own place, within the recreated, **modernised**, Paris and the world beyond in the third quarter of the nineteenth century (e.g.: Monet, *La Grenouillère* (1869), Manet, *View of the International Exhibition* (1867), Renoir, *A Dance at the 'Moulin de la Galette'* (1876), Sisley, *The Flood* (1876), Pissarro, *Penge Station* (1871), Cézanne, *La Maison du Pendu* (1874), Degas, *Women Ironing* (1884), Boudin, *Women on the Beach at Berck* (1881), Morisot, *The Cradle* (1873), Guillaumin, *The Arcueil Aquaduct at Sceaux Railroad Crossing* (1874)).

Though the term *impressionism* may have been **intended^ originally** as an insult – suggesting fleetingness, insufficiency, and superficiality – one of the most **significant** critics of the time who championed the work of Manet in particular, Charles Baudelaire, suggested that these pictures faithfully showed the **reality** of the age: a reality which included a novel recognition, or impression, of this modernity's tentativeness *and* solidities, its disturbing undoing and reconstruction of physical, **social**, and **subjective^ identities** bound up with the **emergent** urban industrial-**capitalist^ social order** – and its debt to, but also far-distance from, both the artistic **imagery** and feudal stability of the pre-French Revolution (1789) *ancient regime* world.

Further Reading

Clark, T. J. *The Painting of Modern Life: Paris in the Age of Manet and His Followers* (Princeton University Press: 1984).
Herbert, R. *Impressionism* (Yale University Press: 1988).
Kendall, R. and G. Pollock (eds) *Dealing with Degas: Representations of Women and the Politics of Vision* (Pandora Press: 1992).
Rewald, J. *History of Impressionism* (Secker and Warburg: 1973).

INFLUENCE *INFLUENTIAL*

The power to **produce** an **effect** or bring about a change. Though probably as basic and indispensable a notion in **art^ historical** writing as **tradition** or **style**, *influence* – under examination – proves itself to be a complicated and sometimes confusing **concept**. Within standard disciplinary usage the term generally remains poorly **theorised**: that is to say, not **critically** thought-out or thought-through, but rather based on a set of stock assumptions. For example, in the

two simple statements 'Masaccio influenced Masolino' and 'Paul
Cézanne influenced Georges Braque' the common elements are (1)
the **artists**' names and (2) the idea of a *causal relation* between them
(though these kinds of statements are usually **intended** to refer to a
causal relation between their respective **artworks**, e.g.: 'Masaccio's
ground-breaking **naturalistic** depiction of the 'Expulsion of Adam
and Eve from the Garden of Eden' influenced Masolino's own ver-
sion of the biblical story, both **painted** in the same Church, Santa
Maria Novella, in Florence' (*c.* 1407–23)). Influence also, literally,
means 'the action of flowing in', but this sense then finds a variety of
necessarily **metaphoric** and *inferred* **meanings** when it is put to
actual use in art historical **discourse**.

In the simplest version – reducible to an equation for the sake of
clarity here – influence **means** something like 'artist A saw artist B's
painting C and adopted aspects of it for use in artist A's painting D'.
This is the way, for example, in which facets of Cézanne's **compo-
sitional^ design** are usually described as operating an influence
upon Braque's **cubist^ pictures** made between about 1908 and 1915
(consider Cézanne's *Mont St. Victoire* (1890) and Braque's *Landscape
with Houses* (1908–9)). Influence in this usage implies two – assumed,
rather than stated – things. First, that the causal relation between
artist A's and B's artwork is necessarily **visible**: a matter of visual
form. (It is unusual to find art historical uses of the term influence
not founded on the idea of a tangible visual relationship.) Second, that
the **identified** causal relation implies the assumption that works by
the artist claimed to have been influenced is recognised to have
inherent and **autonomous^ value** (i.e., that Braque is an **impor-
tant** artist besides the fact that – *not because* – he was influenced by
Cézanne). Influence, interestingly, actually means here virtually the
opposite to imitation. It might be said, in fact, that a rule in art historical
discourse is that the notion of influence can only be introduced into
explanation once it has been agreed that the artist said to 'have been
influenced' by another is credited with a **significant** place in the
canon. Artists without this standing are typically referred to dis-
missively as 'derivative' or 'slavishly imitative', rather than 'influ-
enced'. Successful artists and **authors**, however, can live in fear of
becoming merely derivative: what a **critic** once called 'the anxiety
of influence'.

The notion of influence, then, has a meaning directly **structured**
by, and dependent upon, its place in **narrative** accounts that order
and value artists and their **artworks**. Influence implies an object to
which the term is applied – be it artist or artwork – regarded as

autonomous and canonical. Griselda Pollock usefully aphorised this 'structuring relation' of meaning within **modernist** art historical discourse by remarking that successful **avant-garde** artists initially *referred* and *deferred* to their predecessors (processes that indicated how they were influenced), but then significantly *differed* from them, and in that difference produced their positive autonomy and value as artists in their own right.

Further Reading

Bloom, Harold *The Anxiety of Influence: A Theory of Poetry* (Oxford University Press: 1997).

Buskirk, Martha 'Authorship and Authority', in Buskirk *The Contingent Object of Art History* (MIT Press: 2003).

De Mann, Paul *Blindness and Insight: Essays on the Rhetoric of Contemporary Criticism* (Routledge: 1989).

Pollock, Griselda *Avant-Garde Gambits: Gender and the Colour of Art History* (Thames and Hudson: 1992).

INSTALLATION/INSTALLATION ART *INSTALL*

Over the past twenty-five years much of **contemporary^** art has been **identified** as *installation art*: that is, **artefacts^ commissioned** and **designed** to be located within a particular indoor or exterior place or space (often actually built within the space), and **intended** to generate their **meanings** and **value** from their relationship to – as part of – the chosen environment. The rise of installation art has coincided with the **production** of **hybrid** works *across* **traditional^ media** – such as **painting** and **sculpture** – also increasingly involving *new* **technologies** for producing and manifesting both two-dimensional **visual^ representations** and three-dimensional **structures** of many kinds (e.g.: Richard Serra's *Tilted Arc*, initially sited in Federal Plaza in New York (1982); Laurie Anderson's *United States*, multi-media **performance** (1978–82); James Luna's *Artefact Piece*, installation and performance at the San Diego Museum of Man (1987); and Barbara Bloom's *The Reign of Narcissism*, mixed media, dimensions depending on venue (1989)). An additional feature of a lot of installation art has been its producers' stated intention to **critique** – that is, question and challenge – the spaces in which the work is shown. This has meant, for example, an interrogation, through the installation piece, of the role and meaning of **exhibitions** and **institutions** that collect, **curate**, and **display** both **historical** and

contemporary art (e.g.: Fred Wilson's *Mining the Meaning*, installation concerned with slavery, **ethnicity**, and **artefacts** exhibited at the Maryland Historical Society (1992)).

Briefly considering the term *installation* in isolation, however, allows a reconsideration that places this new art **form** in a broader context. To install means 'to place' or 'to establish' (in one meaning it is similar to 'to invest', as in a royal investiture giving a prince a new title). In this general sense it is clear that visual art has, for many centuries – perhaps since its **origins** – always been 'installed'. As long as paintings, drawings, and **sculptures** have been made detachable from physical **structures** such as cave walls or built **surfaces**, upon completion they have always been *put* somewhere. Even in the case of **pictures** or sculpted artefacts made entirely for private use they will have been installed – if only, say, in a drawer or even under a bed!

Usually they have been placed in particular, chosen, spaces where their meaning and value has accorded with – rather than put into question – the **symbolic** and practical functions served by the place: this might have been a royal palace (e.g.: a **portrait**), or a church (e.g.: a devotional scene), or, since the eighteenth century more regularly, in an art gallery or **museum** (e.g.: a **landscape** or **mythological** picture). Many of these artefacts have subsequently been moved to other **public** places (town halls, corporate headquarters, banks, etc.) serving different **functions**. It has also been the case that pictures and sculptures originally intended for installation in religious **institutions** have subsequently been removed and placed in either *private* homes or art galleries (e.g.: **renaissance** devotional paintings exhibited in the Frick Collection town-house in New York, in the **National** Gallery in London, or the Getty Museum near Los Angeles).

It is clear, then, that *all* art has always been, and remains, in some sense installation art – though the sense of the purpose of the installation, the **materials** out of which it is made, and the meaning of the artefact when installed, has changed and will, no doubt, continue to change. Contemporary installation art, then, *continues* rather than detours this long history of art – now drawing particular, and often questioning, attention to its spatial and social situations.

Further Reading

Haacke, Hans *Unfinished Business* (MIT Press: 1986).
O'Doherty, Brian *Inside the White Cube: The Ideology of the Gallery Space* (University of California Press: 1999).

Suderburg, Eric (ed.) *Space, Site, Intervention: Situating Installation Art* (University of Minnesota Press: 2000).

Wilson, Fred *Mining the Museum* (Baltimore Museum of Contemporary Art: 1994).

INSTITUTION *INSTITUTE,*
INSTITUTIONALISATION, INSTITUTIONALISED

Referring both to actual buildings and to kinds of **organisation** (such as the **Museum** of **Modern^ Art** in Manhattan, New York, or the Victoria and Albert Museum in South Kensington, London), *institution* has a range of active positive, neutral, and negative **meanings** in **art historical^ discourse**. The term became particularly important within some aspects of **social^ history of art** research in the 1970s and 80s. At one level these scholars were concerned with the role and power of institutions in the ordering of the **art world**: for instance, art schools, **academies**, galleries and museums, government departments for art **patronage**, and the treatment of art by broadcast **media** such as the BBC in Britain. **Feminists**, in addition, wanted to know what **forms** of *social control* these institutions had exerted **historically** and in **contemporary** society: Did academies allow women to train alongside men? How many **artworks** by women did the **national** galleries own and how did **curators** justify their accession policies? What treatment of women students characterised teaching arrangements in modern art schools and universities?

If these questions (and the answers they **produced**) often seemed to **identify** institutions as essentially *constraining* or even *repressive* organisations, then subsequent research and debate – particularly indebted to the French historian and philosopher Michel Foucault – has stressed the **social ordering** and control exerted by institutions: actually making society and its groups and individuals. While it might be regarded as self-evident, for example, that galleries and museums help to **create** meanings and **values** for the **artefacts** they **exhibit** – one of their self-declared tasks is that of celebrating art – it was less usual to acknowledge that institutions such as art schools and universities help to produce the senses of **identity** (and *personas*) that artists (and art historians) acquire and come to experience as their intrinsic character-type. However, the processes of institutionalisation are still often regarded as essentially negative, though without them a large part of the meanings of art and artistic production would be subtracted. Indeed, even – perhaps especially – the refusal of the

status and values of **traditional** academic institutions by **avant-garde** artists since the late nineteenth century depended for its effect on the continuing, if **residual, images** these conservative, bureaucratic organisations managed to conjure up. (By the 1960s being thrown out of art school or not receiving a degree had almost become a staple of street credibility in some **pop** circles.) *Avoiding* becoming, or appearing, institutionalised, that is, became, in itself, in time, a new form of institution.

This situation suggests something of the **complex^** conceptual difficulties attending upon both the terms *institution* and *organisation*. While many **significant^ cultural** institutions *are* actual buildings and places (where people go and are aware that important things happen), other forms of artistic organisation and collective relationship *appear* far less tangible, but are nevertheless still **real** and have important effects. Avant-garde artists in the early and mid twentieth century, for example, began to create their *own* more unofficial groups or **formations**, often in conscious **opposition** to traditional, formal institutions, and thus found ways to institute more of their own meanings and values (e.g.: the events organised by the **surrealists** and situationists that deliberately mixed together **aesthetic**, social, and radical political concerns). On the other hand, the ongoing integration of artists and their artworks into **global** corporate **capitalist** relations of production, exchange, and **consumption** since the 1970s constitutes another form of institutionalisation threatening some extremely negative consequences.

Further Reading

Duncan, Carol and Alan Wallach 'The Museum of Modern Art as Late Capitalist Ritual', *Marxist Perspectives* Winter 1978: 28–51.
Harris, Jonathan (ed.) *Art, Money, Parties: New Institutions in the Political Economy of Contemporary Art* (Liverpool University Press: 2004).
Mannheim, K. *Ideology and Utopia: An Introduction to the Sociology of Knowledge* (Routledge and Kegan Paul: 1960).
Pevsner, N. *Academies of Art, Past and Present* (Cambridge University Press: 1940).
Williams, Raymond 'Institutions', in Williams *Culture* (Fontana: 1981).

INTENTION *INTEND*

Intentions are the **meanings^** artists *put into* their **products** and which **viewers** grasp – or fail to grasp – through their experience of

the **artworks**. What could be simpler? This remains the **popular** (and a **traditional**^ **art**^ **historical**) sense of what meaning in art amounts to. Many problems and questions arise, however, as soon as this claim is examined.

What exactly *is* an intention? Is it the thought in the head of the artist as she/he works? If so, then the thought of what? Does the artist think, as she/he stands there with brush, or chisel, or cursor in hand: 'this bit means X and that bit means Y' (reflecting a standard notion of what meaning is: a rational, one-to-one correspondence of thing to idea)? Often, in fact, what are called artists' 'intentions' are actually their *retrospective* statements elicited in interviews, in response to specific questions. This puts the artist, in one sense at least, in the same position as any other spectator of their artwork: what, when asked, would you say it 'was about' or 'meant'? Intention here slides into justification or defence: and artists, as much as anyone else, change their minds about what things mean or don't have a single sense of what the meaning might be. **Artefacts** may, in fact, come simultaneously to mean *contradictory* things to people. Artists may also *refuse* to suggest either intention or to offer retrospective justification for their works. An artwork, in this case, might be said to have no **authorial** meaning – and it may have been meant not to in the first place! Andy Warhol certainly attempted to mislead **critics** searching for his intentions 'behind' works such as *White Burning Car III* (1963).

This brief discussion only begins to scratch the **surface** of the problem of the equation 'intention = meaning'. How, for example, does one begin to answer the questions above (however right or wrong they may be as places to start with the problem of meaning) in relation to art produced by now *dead* artists, or by artists who *made no recorded comments*? The **metaphor** of meanings being 'placed' – **installed** – 'in' artworks should also ring some warning bells: it *is* only a metaphor, never literally true, though many art critics and **historians** have written about artworks as if their meanings are *physically inscribed* on/into the surface – so confident (or perhaps anxious) the commentators are about the truth of their own **interpretations**.

Despite the difficulties alluded to here over the formula 'intention = meaning', it is still commonly – and reasonably, within the terms of the thinking upon which it is based – held that artists, as the producers of their works, retain overall *responsibility* for them (responsibility, that is, for their meaning). This, however, has never been true and never can be: artworks are always produced within historical moments and, as time passes, inevitably slip away from their producers and that moment in which they were made and **originally**

understood. And even within that original moment of production and interpretation different viewers had already come to different conclusions about their **value** and meaning. This is not to deny that certain artists, viewers, and **institutions** have tried to make their own meanings into *agreed* meanings. Art critics and historians have always done this. But once in historical and **social** play – as all **human** artefacts become – the meanings they might evoke are necessarily generated by others, in a spiral becoming ever-distant from the realm (or **myth**) of their producers' intentions.

Further Reading

Baxandall, Michael *Patterns of Intention: On the Historical Investigation of Pictures* (Yale University Press: 1985).

Goodman, Nelson *Ways of Worldmaking* (Hackett: 1978).

Lipton, P. *Inference to the Best Explanation* (Routledge: 1991).

MacIntyre, Alasdair 'The Idea of a Social Science', in Charles Harrison and Fred Orton (eds) *Modernism, Criticism, Realism: Alternative Contexts for Art* (Harper and Row: 1984).

INTERPRETATION *INTERPRET, INTERPRETER*

Within **art^** **history** *interpretation* has come to mean, in general terms, the **significance** or **meaning** of something – an account or **explanation** based upon **materials** and evidence of various kinds, put into a **form** of argument. However, there are two additional definitions to the **concept** that are worth considering and which may offer a fresh **perspective** on art historical interpretation. One is its meaning used in relation to **language**, which is close to though not quite the same as the concept of translation.

Though interpretation and translation are subtly different from each other, it is interesting that the terms interpreter and translator *are* fully synonymous. People employed at these tasks take the language – in broader terms, the **communicative** form – of another speaker and render it intelligible within a different language, in order to make the **original** speaker's speech meaningful to others who cannot understand the language. The task is **specialised** and **complex**. It is acknowledged that literal translation (that is, word for word) is usually *not* the way to convey the actual significance of what is said: interpreters rather have to examine **creatively** the meaning **intended** and find ways to render it as accurately as possible within a different language, often **composed** of dissimilar systems of word combination,

tenses, **genders**, and **metaphors**. There is actually no final way to confirm the accuracy of an interpretation. By definition, the original speaker *cannot* speak the language that his/her words are translated into well enough to see if the true sense of what was originally said was actually conveyed. By definition too, the audience listening to the translation *cannot* compare the meanings conveyed through it with those of the original language which they cannot understand. The interpretation can simply be believed or not believed (and introducing a second or an infinite number of other translators will never provide a conclusive guide to accuracy.)

The second **alternative** definition to *interpretation* consists in its common use to describe how **artists** come to make their **artworks**: they may be said, for example, to 'interpret **nature**' in a certain way (the remark was made about Paul Cézanne's **landscape^ paintings**, e.g.: *The Grounds of the Chateau Noir* (1900–1906)). This phrase is used, it is true, much more about **modern** artists – after, say, 1848 – than about those working earlier. This is because it has become a commonplace that modern art is *about*, in a primary sense, the self-**expression** of artists, who use their **medium** to express their feelings and attitudes about their chosen **subject matter**. There is the similar sense here, then, that the artist, like the interpreter, is converting one thing into another (in Cézanne's case, **subjective^ vision** into painted visual form) and that though one might say the two things enter into a kind of equivalence, they remain profoundly different things. The term 'medium' also refers to a person claiming, or thought by others, to be able to speak for the dead – those not able to speak for themselves directly. Visual media are similarly thought of as vessels or 'conduits' through which other things speak: the spirit or **genius** of dead artists, or the sensibility and intentions of those living. Art history and **criticism**, whatever their claims to objectivity or **authority** in interpretation, remain at heart speculative and questionable **practices** – though this is not to say that certain **views** or principles have not solidified into agreed truths within **historical** and critical **discourse**. It *is* to say, however, that their truth status is a matter of continuing consensus or habit rather than of definitive scientific proof.

Further Reading

Geertz, C. *The Interpretation of Cultures* (Basic Books: 1973).
Hernadi, P. *Cultural Transactions: Nature, Self, Society* (Cornell University Press: 1995).

Richards, I. A. *Interpretation in Teaching* (Harcourt Brace: 1938).
Young, R. E. (ed.) *Untying the Text: A Post-Structuralist Reader* (Routledge and Kegan Paul: 1981).

INTERTEXTUALITY *INTERTEXTUAL, INTERTEXTUAL ART*

Intertextuality entered the **theoretical** discussion of **culture** in the 1980s, partly in response to the **emergence** then of **post-modernist^ artistic^ practices** that drew attention to, or actually combined, different **forms** of **language** and **signifying^ materials**. **Photo^-text**, **installation art**, and **performance** were three such practices – though there were important antecedents in the **modern^ period**, one of the earliest being **cubist** collage which combined, for instance, cut-out newspaper headlines with **painted** and drawn elements (e.g.: Pablo Picasso's collage *Guitar, Sheet Music and Glass* (1912); Victor Burgin's photo-text piece *Today Is The Tomorrow You Were Promised Yesterday* (1977); Mike Kelly's installation *Dialogue No.1 (An Excerpt from "Theory, Garbage, Stuffed Animals, Christ")* (1991); Carolee Schneeman's performance *Interior Scroll* (1975)).

Like the term text, language and signification have a wide range of **meanings** – some very precise and others suggestively open. Within **poststructuralist** philosophy of the 1960s and 1970s (particularly the writings of Jacques Derrida), *text* had come to mean something close to a 'field of signs capable of being **read** in a number of ways'. This plurality of **interpretation** undermined – and was usually **intended** to undermine – belief both in (a) the priority of an **author's**/artist's intended meanings and (b) the belief that a particular text (say, an essay or a painting or **film**) could 'itself' somehow manage to control or manifest its own meaning. Reading became seen as a radically *active* process that could overturn established meanings for texts, sometimes to the point of even turning a text (that is, the **dominant** interpretation of a text) apparently 'against itself' by suggesting that contrary meanings could be found (read) within it.

By the 1980s **visual** artists had begun experimenting with this idea of multiple readings, or 'polyvalence', in a variety of ways – combining visual-**representational** elements with actual words and font-types within, for example, photographs and posters by Martha Rosler and Barbara Kruger (e.g.: Rosler, *It Lingers* (1993) and Kruger, *Untitled (It's A Small World But Not If You Have To Clean It)* (1999)). This

work was by no means without precedent (though many of its intellectual **influences** were new): in the 1950s and 1960s artists such as Robert Rauschenberg, Jasper Johns, and Andy Warhol had produced paintings, prints, drawings, and **hybrid^ artefacts** utilising text and **image** – often based on **mass culture** sources such as bottle labels and soap boxes (e.g.: Rauschenberg's cardboard/plywood construction *Cardbird [Plain Salt]* (1971); Johns's painting *O Through 9* (1961); Warhol's stencilled box *Brillo* (1964)).

In another sense, **contemporary** artists were **identifying** and extending a much longer **historical** relationship or interplay between visual representation and language: **pictures** and **sculptures**, after all, have **conventionally** been given **titles** for hundreds of years, though these might not appear physically within, or upon, the artefacts themselves (as artists' written signatures often do). Illustrated manuscripts have also existed for thousands of years. Contemporary intertextual artists wish to make clear, then, how meanings are **produced** through particular systems of **signs** and conventions, and, going further, attempt to **create** new meanings by combining different sign systems. Often placing their artefacts in non-**traditional** contexts (not in **museums** and galleries), these artists are also experimenting with the **function** and status of art and the expectations of its **viewers**.

Further Reading

Ades, Dawn *Photomontage* (Thames and Hudson: 1976).
Buchloh, Benjamin H. D. 'Allegorical Procedures: Appropriation and Montage in Contemporary Art', *Artforum* September 1982: 45–56.
Kelly, Mary *Imaging Desire* (MIT Press: 1997).
Lippard, Lucy *The Pink Glass Swan: Selected Essays in Feminist Art* (New Press: 1995).

ISM *IST*

By no means limited to use within **art^ history**, the invention of proper nouns containing the suffix *ism* **signals** and **produces** a series of important **meanings** and **effects**. The most common of these is to convert what might otherwise be thought of as relatively indistinct and fluid phenomena into definite and known things. Art historical scholarship concerned with the twentieth century is full of these: for example, **dada**-ism, **surreal**-ism, **futur**-ism, **cub**-ism, constructivism, supremat-ism, and **abstract expression**-ism. The ism also

transforms these phenomena consisting of highly diverse **materials** into art historical equivalents: succeeding **avant-garde** groups, or **styles**, within a **perspective** of artistic **development** projecting an inherently **progressive** and unilinear dynamic. Alfred H. Barr's 1936 flow-chart diagram of **modern** art is the clearest indication of this view (Barr was **curator** of **painting** at the **Museum** of Modern Art, New York, at the time – diagrammatic **classification** of **artefacts** by museums is another likely product of this ism-labelling behaviour.) However, **criticism** of classifying avant-garde **formations** requires careful qualification: in some cases – for example, surrealism and futurism – the **artists** themselves chose the **identifying** term, including the *ism*, for their activities. In other cases, though, the name, and the ism, was the invention of others, as was the case with abstract expressionism.

Another set of art historical ism **concepts**, however, can *never* be tied down narrowly to specific **artists**, or groups, or even **periods**, and these float vaguely between **historical** and **theoretical** senses and applications: for instance, **realism**, **naturalism**, modernism, and **postmodernism**. In these cases the ism, though **functioning** again apparently to give solidity and coherence to the **concept** (helped in this task by often awarding the terms an initial capitalised letter), produces paradoxically what might be called a 'generalisation effect'. Ism covers an enormously large range of things in this kind of usage: it might be agreed, for instance, that Eugène Delacroix, Jean-Francois Millet, Gustave Courbet, *but also* Édouard Manet, Paul Cézanne, and Pablo Picasso manage equally to be – though in markedly different, even antagonistic, ways – exponents of realism. (The terms **social realism** and **socialist realism** produce a whole further set of complications and confusions, in historical, theoretical, and political terms.) In yet another, wider art historical framework or perspective, terms such as realism and naturalism – in this usage not usually capitalised – refer to **epochal^ forms** or idioms of **visual representation**, covering many centuries, even thousands of years of history (similar to some uses of the term 'ancient art', meaning all art made in Greece and Rome before the birth of Christ, though 'Greece' and 'Rome' are also potentially misleading terms, referring much more to geographical territory than to any homogeneous political **nationality** or **socio^-cultural** order).

Ism, then, **institutionalises** *official* categories, or orthodoxies, of art historical discussion – which does not necessarily mean that the terms containing the suffix are not useful or can be done without. On the contrary, notions such as realism and naturalism remain crucial,

though disputed. Their **value** stems, too, partly from their meanings *outside* art history, in, for example, philosophy and scientific **discourse**. A third set of meanings for ism lies in this broader intellectual discussion, when ism is sometimes used in a derogatory, and highly critical, **fashion** – for example: historic-ism, objective-ism, and theoretic-ism – to suggest purely **ideological** (deluding) modes of thought.

Further Reading

Brooker, Peter (ed.) *Modernism/Postmodernism* (Longman: 1992).
Little, Stephen *Isms: Understanding Art* (Herbert Press: 2004).
Shiff, Richard 'Figuration', in Robert S. Nelson and Richard Shiff (ed.) *Critical Terms for Art History* (University of Chicago Press: 2003).
Steiner, George *In Bluebeard's Castle: Some Notes Towards the Redefinition of Culture* (Yale University Press: 1971).

KUNSTWOLLEN

Usually translated from the **original** German as 'the will to **form**', *kunstwollen* (literally 'art-will') was a term coined by the scholar Alois Riegl and used to **explain** general **stylistic^ developments** in **art** from ancient to **modern** times. In common with much philosophy-**influenced** middle-European **art historical^** writing from the later nineteenth and early twentieth centuries, *kunstwollen* is an **abstract** and obtuse **concept** basically **meant** to suggest that there is an *internal drive* or *urge* or *logic* somehow propelling the formal evolution of **visual** art over many hundreds, even thousands, of years. It is perhaps not surprising, then, that Riegl's ideas and writings on ancient and **renaissance** art (e.g.: *Problems of Style* (1893) and *Late Roman Art Industry* (1901)) gained popularity in the mid twentieth century, when US **critics** such as Clement Greenberg and Michael Fried offered **formalist** accounts of the **progressive** development and impetus they saw in modern **painting** since Édouard Manet (e.g.: Greenberg, 'Modernist Painting' (1960) and Fried, 'Three American Painters: Kenneth Noland, Jules Olitski, and Frank Stella' (1965)).

In retrospect it is possible to see how Riegl's idea of an internal dynamic to art attempted to offer a solution to an intolerable **historical** dilemma (and anxiety). If it was to be accepted that art had a truly *continuous* history, *an authentic pattern of continuity* in visual-formal terms that stretched from, say, the Greeks and Romans up to modern (i.e. renaissance and post-renaissance) times, then it could not convincingly be based on a simplistic, aggregating notion of 'artist X

influencing Y influencing Z' from the third century BCE all the way to the 1800s! Riegl recognised that important art had been **produced** over many disparate and unconnected geographical and **socio^-cultural** regions throughout this **epoch** and that its essential unity could never be a matter of direct, continuous relation or influence. But to believe that this **ideal** art from Greek to modern times had *no* unity, or essential **identity** as confirmation of **humanity's** achievements and artistic greatness, was much more unthinkable.

The explanatory weakness – again recognisable, and highly **significant**, in historical retrospect – is that *kunstwollen* is an example of a 'self-grounding' belief or axiom: one either believes in the truth of it, or not (like the notion of inalienable human rights). Nineteenth-century philosophy and social sciences were characteristically 'self-grounding' in this sense (unlike the then-developing **natural** sciences): G. W. F. Hegel's account of history as the 'unfolding of God's will in the world' was the master-version of this kind of thought and utterly pervasive in its influence on European scholars working in the arts and humanities in the second half of the nineteenth century. In contrast, actually, Riegl's notion of *kunstwollen* was tinged with scepticism: though he claimed that art demonstrated a continuous dialectical – i.e. 'conversational' – passage between ornamental and **figurative** urges and idioms (e.g.: Egyptian decorative wall-painting, Necropolis, Thebes; decorative band frieze on Greek vase from Kameiros; theatre scene from the Casa di Casca, Pompeii (CE 79)), he made no arrogant 'histori**cist**' suggestion that some final culmination or state of artistic perfection lay ahead. Greenberg and Fried arguably hinted more at such an inevitability in their mid 1960s essays on the future of abstract painting since cubism.

Further Reading

Pächt, Otto 'Art Historians and Critics, VI: Alois Riegl', *Burlington Magazine* 105 (1963): 188–93.
Riegl, Alois *Late Roman Art Industry* (1901) (G. Bretscheider: 1985).
—— *Problems of Style* (1893) (Princeton University Press: 1992).
—— *The Group Portrait in Holland* (1902) (Getty Research Institute: 1999).

LANDSCAPE *LANDSCAPE PAINTING*

Importantly, the term *landscape* has entered **art^ historical** and **popular** usage in such a way that its two separable senses are often

combined and sometimes confused. While landscape **painting**^ **emerged** and **developed** as an independent **genre** in **academic** art in the **period** between the seventeenth and nineteenth centuries, initially being given a marginal place in relation to both **history painting** and **portraiture**, by the eighteenth century it had become elevated into an art **form** regarded as capable of conveying, **symbolically**, important religious beliefs, **social**^ **ideologies**, and **aesthetic**^ **values** (see e.g.: Thomas Gainsborough, *Mr. and Mrs. Andrews* (*c.* 1750); Caspar David Friedrich, *Landscape in the Silesian Mountains* (*c.* 1815–20); Jean-Francois Millet, *The Gleaners* (1857); Samuel Palmer, *Sleeping Shepherd Morning* (*c.* 1857)). The philosophical **idealism** inherent in this redefinition of landscape painting's **significance** – part of its **romantic** legacy – has carried over into the term's currency in ordinary **language**. We can look at a **real** landscape – say, a **view** out of the window of a train passing between towns, or from the front door of a house in the country – and see the scene partly in terms of our knowledge of landscape **imagery**. Windows, indeed, frame the view like a **picture**, **creating** the sense contained in the related term *picturesque*.

Landscape, then, has come to imply some selected view and usually, within that, a kind of idealisation – making that which is shown (or seen) fit an idea of what *should* be shown, and *how* it should be shown. By the mid nineteenth century, however, the **history** of landscape painting extended beyond an impulse to idealise, to other aims and concerns: to show the ground, and water, and sky as **realistically** as possible, often for mapping or other scientific purposes (e.g.: John Constable, *Study of Tree Trunks* (*c.* 1821); J. M. W. Turner, *Petworth: A Stag Drinking* (*c.* 1830)). Or, for example, deliberately to show the new spectacular ugliness and destruction of the **natural** world due to processes of urban and industrial development (e.g.: Philipp de Loutherbourg, *Coalbrookdale by Night* (1801)). Or even to act as mere 'backdrop' to other **subject matter** and aesthetic purposes – though in some examples of this, landscape again functioned symbolically as a reference to its status as a relatively lowly genre in the history of art (e.g.: Édouard Manet, *Le Dejeuner sur l'herbe* 1863).

In the twentieth century landscape grew another life for itself when it became conjoined with processes of **abstraction** and **subjective**^ **expressiveness** in **modern** art. In Mark Rothko's very late pink paintings, for example, suggestive of moonscapes, the flat broad bands of colour have been **read** as symbols for Rothko's interior 'mental landscape' (e.g.: *Untitled* (1969)). Recent landscape imagery

made with new **technologies** of **visual**^ **representation** – **photography**, video, computer-based simulation – has produced additional sense and **critical**^ **values**, and also worked to combine **traditionally** separated genres. For instance, Jeff Wall's large light-box photographs of soldiers dying on blasted battlefields splice a modern form of history painting with representations of ugly landscapes reminiscent of those found, for instance, in **contemporary** landfill sites, or on the dreary suburban fringes of cities (e.g.: *Dead Troops Talk (A Vision after an Ambush of a Red Army Patrol, Near Moqor, Afghanistan, Winter, 1986)* (1992); *The Storyteller* (1986)).

Further Reading

Andrews, Malcolm *The Search for the Picturesque: Landscape Aesthetics and Tourism in Britain* (Stanford University Press: 1989).
Barrell, John *The Dark Side of the Landscape: The Rural Poor in English Painting 1730–1840* (Cambridge University Press: 1980).
Bermingham, Ann *Landscape and Ideology: The English Rustic Tradition, 1740–1860* (University of California Press: 1986).
Green, Nicholas *The Spectacle of Nature* (Manchester University Press: 1990).

LANGUAGE/LINGUISTICS

System of words, **signs**, and **symbols**. *Language*, as such, plays an indispensable role in **art**^ **history** – a role that has been actively **theorised**, radically re-thought, and argued over within the discipline especially since the 1970s. After this, **new art historical** currents related to **semiology** and **structuralism** began to propose and examine the claim that (1) **visual** art *itself* was a language (or shared defining properties with language) and (2) the dissenting counter-argument that, even if seeing visual art *as if it was a* language might be inappropriate theoretically, then visual art was, in any case, always to be understood *through* other languages – **meaning**^ **explanatory**^ **discourse** in the **form** of words spoken and written down.

Two theorists have **valuably** attempted to characterise the relationship between actual words (those spoken or written language) and visual **imagery**. They made the following assertions. (A): **Pictures** are the victims of the ways we have of talking about them (Victor Burgin) and (B): We do not explain pictures: we explain remarks about pictures (Michael Baxandall). The first claim suggests that visual **representations** are in a crucial sense 'mute' and contain no inherent meanings *of their own at all* – they rather present visual

forms of various kinds which are then somehow 'filled up' with semantic, verbal, and cognitive meaning (commonly known as **content** or **subject matter**) when people begin to articulate their encounter with these forms. Though this idea may seem plausible when considering, for example, some comparatively rare kinds of 'fine art' **photographs** and **abstract^ paintings** (e.g.: Paul Strand's photograph *Abstraction, Porch Shadows, Twin Lakes, Connecticut* (1916); Aleksandr Rodchenko's painting *Pure Red Colour* (1921)), it seems less satisfactory when one considers how many apparently 'visual' forms actually have words *already directly written onto or placed in close physical proximity to them* (e.g.: most **advertising**, poster art, comics, paintings given **titles** – including 'Untitled' – and other words inscribed within them). The notion, therefore, of a *purely* visual form is problematic in both **historical** and theoretical terms: visual representations under examination have often – perhaps even usually – been **artefacts** that themselves combine, or entail, visual and written linguistic elements.

In the second claim, Baxandall is suggesting that the discipline of art history is what **structuralists** call 'a second order' system of meanings. This amounts to the **view** that: yes, there is visual art (though in all its **complex** combining of visual and written elements), yet what art historians really do is construct grandiose explanations for the purpose and meaning of art which are *far more dependent* on the layers of this explanatory system itself – the **specialisms** of **analysis** within the discipline – than on the visual art objects that are the ostensible **origin**, and focus, of the enquiry. Needless to say, this claim seems to marginalise art in a way that many art historians would find completely unacceptable. Surely, they would argue, there is a much more active relationship *between* visual **materials** and the languages used by scholars to describe, analyse, and **evaluate** them? They might add that the experience of art *cannot* be reduced to its intellectual explanation: that **aesthetic** engagement is, by definition, a *somatic* (**bodily** and sense) experience as well as a cognitive process. Though this is true, arguably the **institutionalised** study and teaching of art now relies heavily on the belief that its intelligibility – art's meaning and value – *can* be wholly articulated, and **communicated**, via the standard languages of the lecture and the book.

Further Reading

Bal, Mieke *'Rembrandt': Beyond the Word-Image Opposition* (Cambridge University Press: 1991).

Bryson, Norman *Word and Image: French Painting in the Ancien Regime* (Cambridge University Press: 1981).

Burgin, Victor *The End of Art Theory: Criticism and Postmodernity* (Macmillan: 1986).

Preziosi, Donald *Rethinking Art History: Meditations on a Coy Science* (Yale University Press: 1989).

LOOK *LOOKER*

Along with several other monosyllabic, though actually highly complicated terms – including *see* and **view** – *look* has a range of important **meanings** and **values** within **art^ history**. At the simplest level, it names an action (a key part of the procedure of **visual^ analysis**). One looks, for example, at a **painting** – or, more often in the seminar room, at a slide or **photograph** of a painting. However, while this sense of looking certainly refers to an event – an actual act, that is, carried out by a person at a particular time and place – there is a **complex** relationship between this physical-attention-using-the-eyes and the procedure called visual analysis. One looks; but then acts of description (for example, writing down what one sees) or attempts to draw that which is seen with a pencil (turning the seen into a scene) necessarily involve other abilities and skills. No two people will ever draw the same scene – say, a cat on a chair – in the same way. Have they, therefore, really seen the same thing? Although looking carefully and repeatedly is stressed as one of the most basic and **significant** art historical tasks (given a very high value), no one can really finally know how anyone else looks or sees!

Look is also used to describe *the object that is seen*, rather than the **agent** *doing the looking*. This is evident in common phrases such as 'wearing the latest look', or 'good-looking'. These phrases indicate that someone has been **identified** in terms of their **visual** appearance or **image**. Superficiality is usually associated with shallowness, being 'only interested in **surface** appearances'. This definition converts 'look' into a potentially unreliable and changing thing – though it's often offered as a compliment. These two meanings to *look* interact with each other: looking and being-looked-at are intrinsically **subjective** or affective processes. The person looking may be changed – stimulated in different ways (emotionally, intellectually) by the impact of the thing perceived, which, if it is a person, may also be changed by the experience of having been looked at. Édouard Manet's painting *The Bar at the Folies-Bergère* (1881) plays a complex game with both **real** and depicted appearances: those viewers looking at the

picture and those who appear to be pictured. Looking, therefore, is always an active **social** and inter-personal process, whether this means looking at art, or the looking-at and dressing-up of appearances that people habitually do in daily life.

Psychoanalytic accounts of looking emphasise its vital role in subject-**formation**, **identity**, and **identification**: processes of attraction and repulsion (in socio-**sexual** behaviour and in the engagement with visual art) are bound up with the categories of **visibility** and **visuality**. **Feminist^** **theories** of 'narcissistic identification' (with **origins** in the relationship of mothers and babies), sexual **desire**, and role-play stress the crucial importance of visual **representation** within the **production** and maintenance of **gender** distinctions and the **social order** of society as a whole. Theories of **visual pleasure**, such as those proposed by Laura Mulvey, particularly focus on analyses of **mass culture**, such as Hollywood **film^** **imagery** and **narratives**. Though scopophilia (pleasure in looking) is arguably a **human** biological constant (basic to species **reproduction**), Mulvey and other feminists claimed in the 1970s, pessimistically, that men – particularly within the **capitalist** commodification of society embodied in **modern^** **culture** – have become subject to corrupting **forms** of dehumanised looking, turning women into ossified images of sexual objects. And, moreover, that many women themselves have adopted this form of alienated looking, though it is against their real social interests.

Further Reading

Bryson, Norman (ed.) *Calligram: Essays in New Art History from France* (Cambridge University Press: 1988).

Mulvey, Laura *Visual and Other Pleasures* (Indiana University Press: 1989).

Robinson, H. (ed.) *Visibly Female: Feminism and Art Today: An Anthology* (Camden Press: 1987).

Rose, Jacqueline *Sexuality in the Field of Vision* (Verso: 1986).

MANNERISM *MANNER, MANNERED, MANNERIST, MANNERS*

Retrospective term for a relatively short **historical^** **period** and **style** in the **development** of **western^** **art**, **forming** part of the discipline's **epochal** post-**medieval^** **narrative**. This roll-call runs: **renaissance** → *mannerism* → **baroque** → **rococo** → **neoclassicism** → **romanticism** → **realism**. Beyond this specific use, however,

there is another more familiar sense to the term which is general in **art history**: *manner* meaning a 'way' of doing something and in this usage it is quite close to style. Sometimes, however, *manner* is used derogatively to refer to an **artwork** that too-obviously accentuates a certain formal trait or element, perhaps borrowed from an earlier **artist**, artwork, or style.

The historically-specific use of *mannerism* also contains (or, at least, initially was **intended** to contain) such a **criticism** too – of art judged to be slavishly dependent upon Michelangelo's monumental **painted** and **sculpted^ figures** of men and women – though this **evaluation** was mostly lost in the conversion of the term into an **epochal** style label in art historical **discourse**. Mannered in the second, general and judgemental, sense, meaning the same as 'very derivative', has been applied to many artworks by critics over the decades – for instance, to Pablo Picasso's apparent return to **conventional^ naturalism** soon after 1916, after he seemed to 'give up' **cubism** (e.g.: *Portrait of Olga in the Armchair* (1917)) and, much more recently, to the erotic scenes of 1920s/1930s couples in rooms painted by the Scottish artist Jack Vettriano (compared very unfavourably to works by Edward Hopper, e.g. *Only the Deepest Red* (1992)).

In its **original^ period**-specific sense, to reiterate, the term referred to **artists** and their artworks thought of as excessively dependent upon, and in a way, *contaminated* by, the overwhelming **influence** of Michelangelo. Artists such as Giulio Romano, Pellegrino Tibaldi, Agnolo Bronzino, Taddeo Zuccari, and Giorgio Vasari **produced** works that depicted the male **human^ figure** in overtly strained, dramatically distorted, and theatrical poses. These works were, at once, a 'homage' to Michelangelo's own paintings and sculptures (e.g. the Sistine Chapel ceiling and *Last Judgement* scenes, Rome (1508–12), and his **allegorical** figures of *Day* and *Night* and *Dawn* and *Evening* in the Medici Chapel, Florence (1520–29)) and yet at the same time self-condemning essays on their producers' egregious lack of originality. See Zuccari's sycophantic drawing of himself at work on the scaffolding of a palace, pictured being watched with admiration by the ageing Michelangelo (*c.* 1590)!

It is perhaps not surprising that the **marxist** art historian Arnold Hauser wrote a study associating mannerist style – usually dated *c.* 1520–1600 – with the decline in Florentine city-**state** democracy into a corrupt autocracy controlled by the Medici family. The term *mannerist* came from the Italian *maniera* and was used by Vasari – known much more as the first art historian than as a painter or as a sycophantic supporter of Michelangelo – to describe the generalised

character to much of the work produced in this time, rooted more in **visual^ idealisations** of strength and beauty than in a hard look at things in the **real** world. Its **aesthetic** corruption, then, was due to its parasitic reliance on the **abstracted** and ossified ideals drawn from the most favoured artist of the politically corrupt Medici regime – a world away from the rosy **view** of the high renaissance as an enlightened balance in art and **society** between rules of **composition** (and good government) and a healthy engagement with the empirical **visual** (and civic) world. Hauser extended the scope of the term to include the strange elongated **bodies** depicted in religious paintings and **portraits** by El Greco (e.g. *The Disrobing of Christ* (1577–79)), suggesting that mannerism was a courtly art phenomenon suiting dictatorial rulers detached from the ordinary world.

Further Reading

Hauser, Arnold *Mannerism: The Crisis of the Renaissance and the Origin of Modern Art* (Routledge and Kegan Paul: 1965).
Shearman, John *Mannerism* (Penguin: 1967).
Smart, A. *The Renaissance and Mannerism in Italy* (Harcourt, Brace: 1971).
—— *The Renaissance and Mannerism outside Italy* (Thames and Hudson: 1972).

MARXISM *MARXIST, MARXIST-LENINISM*

Philosophy of **history** and **social^ development** intimately linked in the twentieth century to successful **revolutionary^ organisations** in a number of European and Asian countries (principally Russia, China, Korea, and Vietnam). Although Karl Marx himself wrote on a number of occasions about the implications of his ideas for culture and art, the beginnings to what might be called a *marxist* **art history** occurred only in the 1930s, partly as a reaction to the rise of fascism in Italy and Germany. Though the Cold War (1945–91) saw the spread of anti-communism across the world – particularly in the US, but also in many European countries with hitherto strong revolutionary parties – *marxism* as a **conceptual**-political framework for the historical and **theoretical^ analysis** of culture actually flourished in the 1950s, 1960s, and 1970s (as part of the then **emergent** 'New Left' incorporating **feminism**, minority civil rights, and gay rights **movements**). By this time, the marxist parties in the **west** still affiliated to the USSR and China (chief defenders of

the **state^-ideological** orthodoxy called marxist-leninism, after the Russian Revolutionary leader Vladimir I. Lenin), had entered what was to be a phase of terminal stagnation.

Marxist histories of art began with the emphasis that defined marxism itself as a conjoined socio-historical theory and revolutionary **practice**: *a concern, that is, with how culture and* **visual** *art were intelligible as elements within the development of* **class** *struggle*. While this was projected as a macro-historical (**epochal**) process, traceable back to ancient and then feudal antagonisms between ruling and subordinate classes – **producing**, for instance, sacred (religious) **artefacts** in varieties of geometric-**abstract** and **naturalistic^ styles^ symbolising** actual power relations, dynamics of social change, and the **dominance** of ruling class groups in particular societies – particular focus was directed towards the place of art within the development of urban **capitalism** since the **renaissance**, especially from the mid nineteenth century onwards. This concentration was based upon serious interest in the idea of a **progressive** or revolutionary art: with *who* might make such an art, under *what* socio-political conditions, along with the attempt to characterise its likely, and in some versions, necessary, **visual^ forms** and **conventions**. Not surprisingly, Soviet historians praised the **socialist realist** artists in the USSR, though marxists **critical** of that regime by the 1950s condemned such art as **romantically^ idealistic**, ideologically bankrupt, and tediously based on derivative **academic** conventions.

Since the 1970s, scholars including John Berger, Albert Boime, T. J. Clark, Fred Orton, Alan Wallach, and O. K. Werckmeister – all of whom embraced the name *marxist*, though they also attempted radically to redefine its meaning in various ways – continued, in their own empirical studies, this earlier marxist concern with core concepts such as **realism**, style, class, **culture**, ideology, and social **formation**. But, as **critics** themselves of marxism as a theory rooted in an earlier highly dogmatic **explanation** of class understood as the basis and guarantee of revolutionary politics (marxist-leninism), they also sought to complicate their analyses by introducing, for example, notions of **signification** and **meaning** in art based upon **contemporary** theoretical developments in **linguistics, psychoanalytic** writing, and **poststructuralist** philosophy. This sophisticated elaboration and enrichment of marxism – *in no sense* an abandonment of its basic critique of the **modern** capitalist **social order** and belief in its overthrow for the good of all – recognised new forms of cultural-political **identity** and struggle, based upon, for example, **gender**,

postcolonial, and **racial^** **identities** produced within a **globalised** world of interdependent societies.

Further Reading

Attali, Jacques *Karl Marx ou L'Esprit du Monde* ('Karl Marx and the Spirit of the World'; English language edition pending) (Fayard: 2005).
Engels, Frederick *The Condition of the Working Class in England* (1844) (Electric Book Company: 2001).
Marx, Karl *The Communist Manifesto* (1848) (World Classics: 1996).
Marx, Karl 'A Contribution to a Critique of Political Economy' (1859), in Emile Burns (ed.) *The Marxist Reader* (Avenel: 1982).

MASS CULTURE

Used either in an apparently neutral **manner** (often by **sociologists**), or, by contrast, in a clearly **evaluative** and usually derogatory way (by **critical^** **theorists**), *mass culture* refers to **visual^-cultural^** **products** and **forms** of production based on industrial, **reproductive^** **technologies** that are **consumed** in a correspondingly collective manner. **TV** programmes and most kinds of **film** are standard examples of mass culture, a **concept^** **developed** within the twentieth century and used in relation to products, technologies, and manufacturing modes belonging to the **period** after 1900. Within standard **marxist^** **analysis** mass culture is a symptom of advanced post-Second World War **capitalist** society in the US, a product exported successfully to Europe and the world beyond in the decades since then. The 'Frankfurt School' marxists, for instance, a group of thinkers and activists who left Germany for the US in order to escape the fascists in Europe in the late 1930s, saw US culture and society at very close quarters – partly forming their account of mass culture after personal experience of, for example, Hollywood's **cinema** and its studio production methods.

The term's two conceptual elements are themselves products of **modern** society, and **emerged** in relation/reaction to the socio-political upheavals and changes that characterised the onset of industrial and then consumer capitalism in **western** Europe and the US in the **epoch** since the late nineteenth century. 'Mass' suggests an anonymous collective entity of people in some ways acting as a single unit. The term has links to the much earlier (eighteenth-century) notion of 'mob' and to varying extents, depending on usage, retains its sense that this collective entity, unruly yet somehow organised – or

organisable – is likely to act irrationally or destructively. Interestingly, 'mass' was given positive **meanings** within socialist political theory and rhetoric in the early twentieth century (e.g.: in Russia after 1917), meaning more or less the same as 'the working **classes**': the groups in capitalist society who were believed by socialists and communists to be capable of bringing **revolutionary** change. This marginal positive usage importantly includes the sense that those it designates are *various* – acting together yet, to an extent, internally differentiated. The socialist masses, for example, included those middle class people who *adopted* socialist beliefs, unlike the working class or 'proletariat' whose **material** interests were thought by most marxists actually to pre-determine their political and **ideological** affiliations. That is, the working class by its **nature** *should* have been socialist: the fact that in Italy and Germany under the fascists, parts of it swung to the far right indicated – for instance to Antonio Gramsci, thinker in the Italian Communist Party – that elements within the emergent mass culture of the later 1920s and 1930s could be **appropriated** to serve ultra-**nationalistic** ends.

The term *culture* had developed as a set of interconnected ideas and ideologies in the later nineteenth century, in response to the increasing fragmentation of the existing **social order**. While the term remained in most usages evaluative – related to definitions of **art** (and **high art**), **civilisation**, **genius**, and **taste** – anthropological definitions also began to emerge, **identifying** culture as a specific 'way of life' related to certain material and **social** conditions. When brought together into a single notion, however, mass culture in most respects *lost* these complicated and separable meanings, although interestingly it can still be compared and contrasted with the generally positive term **popular culture**. Disputes over, for example, whether pop music is better thought of as popular culture or mass culture usually hinge on what the speaker thinks about the **value** of the example in question: be it Britney Spears or Bruce Springsteen.

Further Reading

Adorno, T. *The Culture Industry: Selected Essays on Mass Culture* (Routledge: 1991).

Buchloh, Benjamin H. D. *Neo-Avantgarde and Culture Industry: Essays on European and American Art from 1955 to 1975* (MIT Press: 2000).

Held, David (ed.) *Introduction to Critical Theory: Horkheimer to Habermas* (Hutchinson: 1980).

Horkheimer, M. 'Art and Mass Culture', in Horkheimer *Critical Theory: Selected Essays* (Herder and Herder: 1972).

MASTERPIECE/OLD MASTER *MASTER*

Habitual term of highest praise reserved for what are regarded as the greatest **artworks**. Now, however, the term is often used with an ironic intent because *masterpiece* reveals – according to **feminist^ critics** – the reactionary **values** and assumptions of a **traditional^ art^ history** obsessed with (1) establishing the **authorship** of artworks and (2) pronouncing upon their relative degrees of **aesthetic^ quality**. The term *masterpiece*, along with others closely related to it – such as *old master* – became **subject** to intense attack ('critique' cannot really do justice to the hostility sometimes involved) particularly from feminist scholars and some women **artists** during the 1970s and 1980s. For instance, it was pointed out, in the title of a book by Griselda Pollock and Rozsika Parker called *Old Mistresses: Women, Art, and Ideology* (1981), that the terms *masterpiece* and *old master* had no **meaningful** equivalent when the feminine **gender** was introduced: there could be no (serious) 'mistress-piece' or 'old mistress'. These terms were simply absurd. 'Mistress', in fact, specifies in its commonest sense a woman 'attending upon a man **sexually**'. The term 'mistress' therefore was simply not available, **historically**, as a positive adjective – and there had been no tradition in art history of valuing artistic work by women in this way.

Pollock and Parker's aim, however, was *not* to suggest that a feminist history of art should merely go on to introduce this, or another term, and then find artworks to which it could reasonably be applied. Instead, they set about attacking the variety of ways in which men *and* women art historians had focused their interest on what Pollock and Parker claimed were purely **ideological** (in this sense, *spurious*) notions of **artistic^ creativity**, individuality, authorship, and meaning. To attempt merely to steal these categories from traditional art history and art historians in order to apply them to their own **canon** of women artists and artworks would simply be to **reproduce** the orthodox **discourse** and thereby perpetuate what they argued were these highly dubious founding principles. However, many other women art historians, some also calling themselves feminist – such as Linda Nochlin – did just that in books and catalogues published in the 1970s and 80s, and Pollock and Parker entered into sometimes acrimonious exchanges with them too. This debate, however, usually took place within and between different feminist camps rather than between feminists and traditional scholars: **productive** dialogue was virtually impossible between these groups given the huge **social**, political, and intellectual differences between them.

Since the 1990s however, feminist scholars – including Pollock – have revisited and reconsidered the questions of value and greatness in art and attempted to argue for their **significance** (as **concepts** and **practices** of judgements) in sometimes wholly transformed terms. This partly reflected the sense that many feminists had by then that their attack on traditional art history had been successful and that they could move on to less combative **forms** of scholarship and exchange. More recent feminist art historical research, for example, has moved its attention away from **conventional** artefacts such as **paintings** and **sculptures** and concerned itself with the ever-widening range of mixed **media**, **performance**, and other **hybrid** forms **developed** in **contemporary** art over the last fifteen years or so – diverse work that itself demonstrates the opening up of the **art world** to women and other hitherto marginal social groups.

Further Reading

Battersby, C. *Gender and Genius* (Women's Press: 1989).
Nochlin, L. and A. S. Harris *Women Artists 1550–1950* (Alfred Knopf: 1976).
Parker, Roszika and Griselda Pollock *Old Mistresses: Women, Art, and Ideology* (Pandora Press: 1981).
Petersen, K. and J. J. Wilson *Women Artists: Recognition and Re-Appraisal from the Early Middle Ages to the Twentieth Century* (Harper and Row: 1976).

MATERIALS/MATTER *MATERIALISM, MATERIALIST, MATERIALITY*

Term with two related, but separable, senses in its usual **art^ historical** applications. These refer to: (1) the physical substances deployed and **created** in the **production** of **artworks** – for example, **paint**, brushes and canvas; clay and modelling tools; celluloid and **filming** equipment – and (2) the whole range of **human**, **social**, and intellectual resources, including the immediate substances of fabrication, involved in artistic production (and in the production of art historical **discourse** too). It is in relation to this latter broad sense that philosophical **traditions** of thought **identified** as material**ist** have a bearing on the **meaning** of the term in its art historical usage – *historical-materialism* (closely related to **marxism**) being perhaps the most common example and sharing many of the concerns entailed in sense (2).

The difference between these two senses outlined above, though also the **significance** of their relation, is as follows. *Material* in sense

(1) refers narrowly to the fabrication of **artefacts** understood as physical **structures** with **visual**, tactile, spatial, and other **qualities** and characteristics. That materiality includes the physical resources required for the production of the artefact (e.g.: an oil painting): not just the existence, for example, of paints, support, and tools (brushes, palette knives, etc.) used in its production, but also, in effect, the whole physical environment in which this work is done. Such a (**modern**) environment might minimally include: a studio, electricity for lighting, heating and cooling systems. Beyond those immediate resources and conditions for production many other material elements will probably have been necessary – such as a training facility for the producer (in an **institution** such as an art **school**), **exhibition** spaces for the display of the artefacts, **photographic^ media** for their **reproduction** in illustrations enabling **critical** discussion in magazine reviews, and much else beyond. In short, more or less a whole material *world* quickly becomes understood as the necessary condition within which material fabrication takes place. Extrapolation from any example of any artefact produced at any moment in history would generate a list of these necessary material conditions (and the worlds to which they belonged), though their description in many cases would differ substantially. Compare, for example, the material worlds out of which were produced a twelfth-century Belgium brass font **sculpture** by Reiner van Huy, a Rembrandt self-**portrait** from *c.* 1658, or an Art Nouveau cup and saucer **designed** by Henry van de Velde (1904).

Materialism in the expanded sense (2) becomes **valuable** in understanding the production of such a world in which artistic production may take place. At one level this is what has been called 'biological-materialism': for the physical production and maintenance (**reproduction**) of the producers themselves as a group within a society is a further necessary condition for the production of artistic artefacts. Beyond that, and since the seventeenth century, the professionalisation of artistic production as a **career** within societies with a **complex** division of labour presupposes – is dependent upon – the **organisation** of the **social order** as a whole, with an allocation of resources beyond subsistence needs sufficiently large enough to permit and support a range of activities identifiable as cultural production. Though producers of visual arts artefacts existed in pre-modern societies, the category of the **artist** is a comparatively very recent **development**, dating in Europe from about the fifteenth century, coinciding with the rapid growth of urban societies within mercantile capitalism.

Further Reading

Bambach, Carmen C. *Drawing and Painting in the Italian Renaissance Workshop* (Cambridge University Press: 1999).

Boime, Albert *A Social History of Modern Art: Art in an Age of Revolution 1750–1800* (University of Chicago Press: 1988).

Callen, Anthea *Techniques of the Impressionists* (Chartwell Books: 1986).

Timpanaro, Sebastiano *On Materialism* (New Left Books: 1975).

MEANING *MEANINGFUL*

One of the most difficult to define yet indispensable **concepts** in **art^ history**. Often its senses are implied, or taken for granted, rather than spelt out in any detail. Only in certain **specialist** fields, relatively peripheral to the discipline as a whole – for instance, in philosophical **aesthetics**, **semiology**, and the **psychology** of **visual** perception – have some of the term's **theoretical** difficulties been dealt with directly. In general, within art historical **discourse^ produced** within the **western^ tradition**, *meaning* has been assumed, or understood, to be a matter of accurately 'de-coding' the **symbols**, **sign** systems, and **narratives** present and **represented** in all the diverse **forms** of visual art, **architecture**, **design**, and **visual culture**. It is necessary to acknowledge, though, that the protocols of art historical **analysis** – that is, its stated aims, methods, and theoretical terms – are *not* neutral tools simply brought to bear upon its objects: rather they contain shaping assumptions, **values**, and **perspectives** that inevitably themselves partly **create** the meaning of the entities they are used to examine.

This unavoidable epistemological ('how do we know?') dilemma – the inextricability of forms of analysis from the objects of their attention, the fusion of the two experientially for the art historian – is, however, one faced by *all* disciplines and, in fact, by all **humans** in their interaction with the world. Philosophy has called this '**subject**-object inter-relation' the realm of the *phenomenological*, meaning the experience of things in the world only knowable through human senses and consciousness and the **ideas** and **values** people hold at particular historical moments in specific **societies**. In art history, for example, it is still customary to use the term **artist** to refer to **producers** of visual representations made hundreds of years before this term and its current meanings came into existence (and for it to be used about producers living in **contemporary** societies that do not themselves have this **concept** with its **western** senses). The use of the term *artist* in these cases inevitably powerfully **influences**

assumptions about these producers and their products – for instance, introducing implicit value-judgements about individuality, these producers' aims and **intentions**, and the **significance** of **originality** in understanding their **artefacts**. Raymond Williams called the term *artist* used in this generalising and inappropriate manner a 'pre-sociological category', meaning that it was used without analytic discrimination by scholars prepared to impose it on producers, products, and societies for whom the idea was non-existent.

The belief that art history is essentially a task of 'de-coding' signs and symbols in visual representation also *falsely generalises* a method of analysis – **iconography**, elaborated by the German scholar Erwin Panofsky in the first decades of the twentieth century. Devised as a method of **interpretation** suitable for use in the study of **renaissance** narrative **paintings** laden with Christian and **mythological** symbolism, iconography becomes increasingly redundant when relied upon to explain later art – especially from the mid nineteenth century onwards, when an explicit *refusal* by artists of **traditional** narrative and symbolism **conventions** took place. Meanings, however, are not just produced; they are also **reproduced** within **institutions** such as art **academies** and universities. While art historians have worked extremely tenaciously to devise new analytic strategies fit for the ever-widening range of objects that interest them – at the same time challenging the meanings and values of previous scholarship, in political as well as academic ways, especially since the rise of the **new art history** in the late 1960s – meaning understood simply as 'information' or 'data' reproduced in educational **organisations** and presented as unassailable 'fact', becomes especially vulnerable to **ideological** manipulation.

Further Reading

Lavin, Irving 'The Crisis of "Art History"', *Art Bulletin* March 1996: 13–15.
Merleau-Ponty, M. *Phenomenology of Perception* (Routledge and Kegan Paul: 1962).
Preziosi, Donald (ed.) *The Art of Art History: A Critical Anthology* (Oxford University Press: 1997).
Ryle, G. *The Concept of Mind* (Hutchinson: 1949).

MEANS OF PRODUCTION

Term central to **marxist** accounts of the **organisation** of **human** labour, and a key component within its **materialist^** **theory** of

human^ history and **social^ development**. Even detached from these fundamental intellectual and political roots, the notion of *means of production* remains an important **analytic** tool within **art^ historical** thinking. In contrast, **traditional^ popular** preconceptions of **creativity** in art suggest that its **expressive** power and **value** is a simple and direct emanation of the great *individual* **artist's** will and **genius**. Creativity in this mystifying sense is **represented** as an ability, like God's, to apparently *make something from nothing* – to make something **real** simply from one's mental **image** or thought. Within such highly **ideological** accounts the physical, material processes of making often seem marginal – necessary, certainly (for how else would this great mental image or thought be available to us?), but essentially secondary to the story of the artist's creative will. The artists who, above all, have received this kind of judgement include Michelangelo, Vincent van Gogh, and Pablo Picasso. Though this tradition of hagiography (writing of the lives of great artists as if they were saints) may have started with Giorgio Vasari in the sixteenth century and reached its height by the mid twentieth century, art history has not generally connected its now many detailed accounts of artists' actual working lives and social circumstances to a **critique** of these **ideals** of creativity and individualism that have underpinned the discipline in its Anglo-American **form^ dominant** since the 1950s.

In contrast, thinking in terms of means of production draws attention to the whole range of materials – physical *and* mental, or intellectual – required for actual production to be possible at all. Products – for example washing machines, pizza boxes, oil **paintings**, books, buildings, **films** – are made from other things: preexisting components from various sources that are combined and transformed in the production process and then in their actual productive use when **consumed**. Means of production are intrinsically social, not individual – which is *not* to say, however, that individuals don't make washing machines and paint **pictures**. But the conditions necessary for means of production to exist are also social and always historically specific: involving the existence, at certain moments, of organised relationships between *stratified* groups and **classes** of people engaged in productive activity. These include, for example, (1) the people who produce the materials and tools that artists then go on to use; and (2) the people who build the studios and factories within which artists work and within which their materials are fabricated. Beyond those fairly *immediate* conditions are (3) the people who organise and teach in the art **academies**, universities, and **museums**

within which artists are trained and in which they **exhibit** their works and have it discussed – and whose financial payment for doing so enables them to rent their studios and living accommodation. *Means of production*, then, encompasses *all* these factors, materials, and conditions – amounting, finally, to a whole society in a definite stage of historical development.

Further Reading

Braverman, H. *Labour and Monopoly Capitalism: The Degradation of Work in the Twentieth Century* (Monthly Review Press: 1974).
Macherey, P. *A Theory of Literary Production* (Routledge: 1978).
Williams, Raymond 'Base and Superstructure' and 'Productive Forces', in Williams *Marxism and Literature* (Oxford University Press: 1977).
Wolff, Janet *The Social Production of Art* (Macmillan 1981).

MEDIA *MASS MEDIA, MEDIUM, MIXED MEDIA*

Plural of medium – **meaning**, in the most general terms, an **agency**, instrument, or channel – *media* in **art^ historical^ discourse** refers (a) to a group of **communicative^ forms** and **practices** (e.g.: **painting** and **sculpture**, or to the '**mass** media' of **TV** and **film**); and (b) to the physical **materials** which constitute artistic **expression**. For example, the *medium* in painting may be defined as paint (oil, water, egg tempera, acrylic, etc.) applied to a **surface** (canvas, wood, stone, etc.). This level of generality in definition is required in order to attempt to encompass the very wide range of types of painting practice that have existed over thousands of years. **Artists**, in addition, have painted with other malleable substances upon paper and glass, or with solution-based pigments upon both the dry and wet plaster walls of buildings. Many other **modern** kinds of paint and types of surface support have been used – both in the past and in **contemporary** art **production** (e.g.: in Fabian Marcaccio's **hybrid^ artefacts** made from fused metal and plastic that are then painted and embossed with **photographic^ imagery**, such as his *Time Paintant: Image Addiction Paintant* (1999)). A similarly wide range of materials have been used as media by sculptors in the past (clay, stone, bronze, wood, silver, plastics, etc.), while contemporary **installation** artists utilise an extraordinarily wide range of 'mixed media' of both **traditional** and novel kinds (e.g. as in Janine Antoni's machine *Slumber* (1993), made from a loom, yarn, a bed, nightgown, an EEG machine and the artist's body).

Though *media* is often used to designate only the **visible**, expressive material transformed through the production process into manifest form – for example, the painted surface of a **picture**, such as that of a Jackson Pollock drip-painting (e.g.: *Number 32 1950* (1950)) – in practice this manifest, **visible**, and visual form has come into existence as the result of the interaction of a much wider range of materials, those both physical and intellectual (the latter not usually **identified** as media at all). These include all the tools that help to constitute the techniques and **technologies** of artistic production. It is readily admitted that the brushes and knives of various kinds used in oil painting are part of the medium's media. It might be less easily acknowledged that certain kinds of electric light used in studios or heating and cooling systems active in studios, may also **influence** physically the **look** and **meaning** of the works produced – for instance, affecting the artist's sense of colour or materially determining how paint dries upon a particular kind of surface. Yet, as what may be called 'shaping conditions', these factors *do* arguably form part of the broader media of production (e.g.: consider the variety of poured and chromatic qualities characterising Morris Louis's **abstract** paintings, such as *Saraband* (1959)).

The reluctance of art historians to recognise all these elements active within production is linked to the **idealist^ conception** of artistic expression still prevalent in the discipline. Though the **concept** of expression generally acknowledges that artists must work in media that are external to their **bodies** and minds, a preconception remains that their **intending** wills manage, **masterfully**, to **mediate** (speak through) this visual form. Artists in the twentieth century, such as the **surrealists**, set about trying to undermine this assumption, showing the **mediating** roles of accident, randomness, and contingency in production (e.g.: Max Ernst's 'decalcomania' technique of making **images** from accidental 'blot' patterns). However, beyond those important attempts that often led to a scrupulous 'carefulness of carelessness' in making, *media* should be recognised as a fully **social** as well as material category, encompassing all the techniques, knowledge, and **values** that artists acquire, consciously or unconsciously, within particular **societies**.

Further Reading

Crow, Thomas *Modern Art in the Common Culture* (Yale University Press: 1996).
de Zegher, Catherine (ed.) *Inside the Visible: An Elliptical Traverse of Twentieth Century Art* (MIT Press: 1994).

Hallin, Daniel *The "Uncensored War": The Media and Vietnam* (Oxford University Press: 1986).

Krauss, Rosalind *"A Voyage on the North Sea": Art in the Age of the Post-Medium Condition* (Thames and Hudson: 1999).

MEDIATION *MEDIATE, MEDIATOR*

In general terms, how a thing is transformed or seen differently because of its place in relation to something else. *Mediation* is one of a group of related **concepts** that became important in the study of **contemporary**^ **art** from the early 1970s onwards, and which have **formed**, since then, a key '**conceptual** problematic' (system of **ideas**) in both art **theory** and **postmodernist** theory. In the case of art theory, interest in forms of mediation followed the introduction of new and combined **materials** into art **practice**. These included **photography, film,** video, DVD, and computers: all of which, either used by themselves, with written/spoken **texts** in various ways, or combined with **traditional** two-dimensional **visual** art **media** (e.g.: **paintings** and print), raised important issues and questions about the kinds of **languages, cultures, meanings,** and **values** active both in visual **representation** and its **explanation** (e.g.: Robert Rauschenberg's print/painting *Tracer* (1963) and David Reed's DVD/painting/ **installation** *Judy Bedroom* (1992)). Partly **produced** in reaction to the **dominance**, in the 1950s, of the supposedly 'pure' media of painting and **sculpture** (e.g.: **abstract**^ **expressionist** works by Jackson Pollock and David Smith), photo-montage, mixed media, and installation practices continue a **critique** of art and art theorising that had been mounted by the **minimalists** and **conceptualists** active in the later 1960s.

Mediation in the self-critical sense present in contemporary art and cultural theory may be characterised as an examination of the interposed 'stages or processes *between* stimulus and result'. Though this is a definition drawn from **psychology** it fits well the attempt **artists** and writers have made to **identify** and examine the various layerings of meanings, values, and contexts active in the **art world** and, beyond that, in the wider **culture** and **society**. An example of the latter is the way in which newspapers and **TV** news present 'stories' and **pictures** of events taking place elsewhere, and make sense of them – effectively **creating** their existence, meaning, and value – for a **mass** audience located elsewhere (e.g.: TV coverage of the war and occupation of Iraq presented to European and US **viewers**). Rauschenberg had

alluded to this mediation process in his print/painting 'combines' containing Cold War political elements in **artworks** such as *Almanac* (1961), which included prints of photographs of what look like military buildings and vehicles overlaid with black ink. Andy Warhol, in his 1960s prints series (e.g.: *Jackie* (1963)) combined the themes of fame, politics, and death, and his **artefacts** mediate photographic and televisual **images** in a variety of subtly processed and **reproduced** ways.

Both postmodernist art and theory seek to explore and exploit, visually and semantically, the seemingly endless mediations of meaning now current in a world containing so many interacting powerful systems of **communication** (most recently the internet). Radical claims have included the view that, within such a world sodden with mediation, **original** truth or **reality** no longer exists – or, at least, if it did, it can never be found. It was for this reason that Jean Baudrillard, a **poststructuralist** writer, notoriously asserted that the First Gulf War (1991) 'never happened': meaning, that is, that for most people not actually living in the region, it was only ever a televisual, essentially 'made-up', event. It would be foolish, however, to conclude that the war – 'fictional' in this particular, itself mediated sense (that is, Baudrillard's sense) – has not had real, and dramatic, effects since then around the world.

Further Reading

Baudrillard, Jean 'Mass Media Culture', in *Revenge of the Crystal: Selected Writings on the Modern Object and its Destiny* (Pluto Press: 1990).
—— 'The Reality Gulf', in the *Guardian*, 11 January 1991.
Kittler, Friedrich *Gramophone, Film, Typewriter* (Stanford University Press: 1999).
McRobbie, Angela *Postmodernism and Popular Culture* (Routledge: 1994).

MEDIEVAL ART/MEDIEVAL/MIDDLE AGES *MEDIEVALISM*

Though perhaps the most **conceptually** vague and imprecise of all the major **period** terms in **western^ art^ history** (in comparison, for example, with **renaissance, baroque**, and **romanticism**), the idea of *medieval art*, or 'art from the middle ages', remains powerfully active **symbolically**. That is, the term most importantly functions within a still-**influential**, if highly **abstracted**, distinction between the **modern** and the pre-modern in art, **culture**, and **society**. This

basic and dramatic distinction has been in existence, in one variant or another, for at least two hundred years – since the **emergent**^ modernity of the French Revolution in 1789. It is in the early 1800s that the **forms** of modernisation still characteristic of *our* age became salient: the beginnings in western Europe and the US of industrial-**capitalist** society, struggles for political democracy (and the dangers of **nation**^-**state** totalitarianism), the rise of individualism, and the decline of religious **ideology** and power.

Within twentieth-century art historical scholarship, however, the **epoch**^ **represented** by the general term *medieval* has been broken down into many **complex** temporal and geo-spatial subdivisions – the idea of a homogeneous, continuous phase of **history** stretching from, say, the fifth century CE (the ending of the Ancient epoch symbolised by the decline of the Roman empire in Europe) to, say, the fourteenth century (the time at which the renaissance is claimed – for instance by Petrarch – to begin to lift its noble head) is, in analytic terms, entirely unsustainable. The concepts of romanesque and **gothic**, for instance, are used to designate phases in the later stages of the medieval era. These terms refer both to **styles** of **architecture** and to a model of society as a whole based on the predominance of ecclesiastical **institutions**, religious knowledge, and **values**. (Romanesque **paintings** and **sculptures** typically elongate **figures**, stylise vegetation, and construct geometrically interlaced patterns.)

In the early nineteenth century, however, some **contemporary**^ **artists** disaffected by the events of the French Revolution began to study, and simultaneously invent, their own sense of the **meaning** and value of the medieval, in art and social life (e.g.: the right-wing Christian group of painters who called themselves the 'Brotherhood of St Luke', based in Vienna and Rome). For them, pre-renaissance art symbolised a *positive* religiously inspired sacred culture and community unsullied by all the evils and uncertainties of modern life after the French Revolution and its destabilising impact on all of Europe. They claimed to reject, too, what they saw as the alienating rationalism of renaissance **design**, and attempted to recreate what they believed were the **primitive** virtues of art understood as a spiritual, personal reflection upon a mysterious world created by God, not measurable or explicable in **human** scientific, philosophical, or political terms (e.g.: Johann Friedrich Overbeck, *Joseph Sold into Slavery by His Brothers* (1816–17)).

So began a series of medieval revivals (medieval**ism**) in that century which have continued, notably in **filmic** form, into the late twentieth century and beyond. The *Lord of the Rings* trilogy (based

upon the novels by J. R. R. Tolkein), for instance, both evokes elements of an actual historical time in Europe's past and yet openly **mythologises** this construct. The equivalence still made, for example, in popular **discourse** between the middle ages and 'irrational cruelty' (e.g.: in **TV** news coverage describing acts of Islamic terrorism as examples of 'medieval barbarity') indicates the still potent sense the term carries. This emphasis, however, is actually entirely modern, or even **postmodern**, given that western fears and anxiety over 'the war on terror' are partly rooted in the belief – or pretence – that the Euro–US **civilisation** brought about by modernisation since the renaissance is now seriously threatened.

Further Reading

Camille, Michael *The Gothic Idol: Ideology and Image-making in Medieval Art* (Cambridge University Press: 1989).

Kelly, D. *The Medieval Imagination: Rhetoric and the Poetry of Courtly Love* (University of Wisconsin Press: 1978).

Morris, William 'The Revival of Architecture' (1888), in Nicolaus Pevsner (ed.) *Some Architectural Writers of the Nineteenth Century* (Oxford University Press: 1972).

von Goethe, Johann Wolfgang 'Of German Architecture' (1772); in Eric Fernie (ed.) *Art History and its Methods: A Critical Anthology* (Phaidon: 1995).

METROPOLITAN *METROPOLIS*

Within accounts of the nineteenth and twentieth centuries in particular, the study of what might be called the **cultural** geography of **artistic^ development** has become increasingly important. This has focused on the relations (spatial, socio-economic, cultural) between **artists** and centres of wealth and power in the world. Though such questions had always in fact been central for scholars writing about the **renaissance** – for example, how artists found **patrons** and **commissions** in the fifteenth–sixteenth centuries' independent city-**states** of what is now Italy – it is not coincidental that interest in the role of **modern** *metropolitan* areas is linked to an increasing recognition of the impact of **western** imperialist colonisation in Africa and Asia since the French **Revolution**. *Metropolis* **originally** meant 'mother city or parent-state of a colony' and recent scholarship has considered, for instance, how artists in countries such as Algeria, Egypt, India, and Pakistan **produced** works in relation to the colonial

regimes imposed by the French and British in those countries. *Third Text* magazine, published in London, and edited by Karachi-born artist and writer Rasheed Araeen, has pioneered this research.

As the latter examples testify, western imperialism was *not* a nineteenth-century invention and it is possible to map 'metropolis-province' relations not only in India and Pakistan, but also in the colonisation of North America, and in large parts of what is called South (or Latin, i.e., Spanish/Portuguese-colonised) America. *Metropolitan* is used in a variety of intellectual contexts within art history, some of which never had, or have since lost sight of, the colonial reference. Usually the term is posed within a dyad, or pair: 'metropolitan-provincial' (emphasis on relations of economic and political **dominance** and subordination in a given area), 'metropolitan-rural' (emphasis on the relations between city and countryside, or peasant life and culture), and 'metropolitan-suburban' (emphasis on the relations between sectors in large cities).

These **meanings** for *metropolitan* have migrated, in some cases, into more **abstract** terms, **discourses**, and debates dealing with the same kinds of issues. These have become **specialisms** in art history, cultural studies, and **visual^**-cultural **analysis**: 'centre-periphery studies' and 'subaltern studies' are two cases in point. Here the **conceptual** focus extends from geographical-cultural **analysis** to questions of **ideology**, politics, and **social** relations: why certain groups of people have felt – and been made to feel – marginal, or inferior, or insecure in relation to others with whom they are locked into interdependent relationships. The situation of the Palestinians living in Gaza and on the West Bank of Israel is a pressing case in point – though the suffering is common, though different in kind, to both the citizens of Israel and the displaced Palestinians, for whom access to their holy city of Jerusalem (a metropolis central to no less than three major world religions) has been interrupted and limited for many years. Palestinian Elia Suleiman's film *Divine Intervention* (2001) explores the everyday life of his people hemmed in by the military security system Israel operates in an attempt to control the behaviour of its reluctantly dependent/subaltern population.

Further Reading

Huggan, G. 'Decolonizing the Map; Post-colonialism, Post-structuralism, and the Cartographic Connection', *Ariel* 1989 (20): 4–14.

Kaufmann, Thomas Da Costa *Towards a Geography of Art* (University of Chicago Press: 2004).

Said, E. *Culture and Imperialism* (Chatto and Windus: 1993).
Seers, D. *Dependency Theory: A Critical Reassessment* (Pinter: 1981).

MINIMALISM *MINIMALIST*

Term coined to describe the **expressive** character of **artefacts**^
produced by a number of **artists** who **emerged** in the US in the
mid 1960s, principally Carl Andre, Donald Judd, and Robert Morris.
The terms *minimalism* and *minimalist* initially suggested a sharp reaction
against the **forms** and **conventions** of artistic expression pre-
dominant in twentieth-century **modernist**^ **art**. The objects Andre,
Judd, and Morris produced differed radically, in terms of **visual**
appearance, **materials**, and tone from modernist **sculptures** by
artists such as Henry Moore and Anthony Caro (e.g.: Moore's *Four-
Piece Composition: Reclining Figure* (1934); Caro's *Midday* (1960)).
They also appeared to reject the 'hot' expressiveness and 'signature'
individualism associated with modernist **paintings** by the **abstract
expressionists**. The metal boxes, arrangements of bricks and tiles,
and platform-like things **exhibited** by Andre and Judd seemed
deliberately to contradict the then **dominant** definition of modern-
ism offered by **critics** such as Clement Greenberg (e.g.: Judd's *Unti-
tled (box with trough)* (1963), Morris's *Untitled (Table)* (1965); Andre's
144 Lead Square (1969)). And to describe their producers as 'artists'
seemed, at least in some senses, to be intuitively inappropriate
because their artefacts appeared to have very little or even no con-
ventionally recognisable expressive or **symbolic** features.

However, a consideration of near-**contemporary**^ abstract
paintings made by Barnett Newman and Ad Reinhardt – both
regarded as abstract expressionists – suggests that the minimalists had
not entirely invented an idiom. Newman's so-called 'colour-field'
paintings too can be read as quite flat, inert blocks of colour, sug-
gesting little actively-expressive or symbolic **meaning** (e.g.: *Vir her-
oicus sublimis* (1950–51)). It is possible, then, to see a number of
connecting artists 'between' – that is, bridging in some ways –
abstract expressionism and minimalism. Frank Stella, for instance, was
sometimes ranked as a minimalist in the early 1960s, though the critic
Michael Fried argued strongly against this designation, claiming him
as a modernist in the **tradition** running from Édouard Manet to
Jackson Pollock, even though his unusually shaped **paintings** (made
sometimes from metal) seemed **intended** to confuse the categories of
painting and sculpture (e.g.: the 'L', 'U', 'N' and 'T' shaped canvases).

Minimalism, then, whatever its prehistory, signalled a shift in feeling – from expressive 'hot' to ironic, contemplative 'cool' – as much as a change in **techniques** and materials. Dan Flavin, hovering between minimalism and **conceptual art**, built his objects from flourescent light tubes. Andre and Judd, both highly articulate writers, clearly *did* see their artefacts as (then unconventionally) expressive and meaningful. They were interested in new production processes and the differences and relations between stages in **artistic^ conception**, execution, and **interpretation**. Similar issues, explored in very different ways, arguably preoccupied Andy Warhol and some other **pop** artists. Minimalism remains **significant** in that its use of sparse and non-**traditional** materials has continued in the work of many 'mixed **media**' and **installation** artists active since the 1960s. Michael Fried's 1967 attack on minimalism as the 'opposite of art' – a kind of 'theatre' of objectification that corrupted, he believed, the purity of authentic modernist artistic expression – remains relevant to radical **critiques** of 'spectacle' and alienation in **contemporary^ capitalist^ society**.

Further Reading

Battcock, Gregory (ed.) *Minimal Art: A Critical Anthology* (E. P. Dutton: 1968).
Fried, Michael 'Art and Objecthood' (1967) and 'Shape as Form: Frank Stella's Irregular Polygons' (1967), in *Art and Objecthood: Essays and Reviews* (University of Chicago Press: 1998).
Krauss, Rosalind *Passages in Modern Sculpture* (Viking Press: 1977).
Meyer, James *Minimalism: Art and Polemics in the Sixties* (Yale University Press: 2001).

MODERNISM/MODERN *MOD, MODERNISATION, MODERNIST, MODERNITY*

Central **theoretical** and **critical** term within the cluster of **concepts** and themes that **dominates** discussion of the **socio^-historical** place of **art** since the mid nineteenth century. *Modernism* refers – sometimes confusingly – both to the **visual** and tactile character of selected **artworks^ produced** in this **epoch** ('the modernist **tradition**') *and* to **influential** accounts of them, concerned with their **origin, meanings**, and **significance**. Its most important critics since about the 1910s have included Benedetto Croce, Clive Bell, Roger Fry, Clement Greenberg, Michael Fried, and Rosalind Krauss. These two senses are *not* actually finally separable: typical descriptive

accounts of the appearance, say, of a **cubist^ painting** by Pablo Picasso (e.g.: *Head of a Young Girl* (1910 or 1911)) or an **expressionist^ sculpture** by Alberto Giacometti (e.g.: *Man Pointing* (1947)) entail **interpretative** assumptions and **values** informed by modernist critical **discourse**. This is an important recognition because these critical judgements and theories – declaring modernist art to be a continuum of evolving, **autonomous**, and self-critical **practices** – came to constitute an **institutionalised** orthodoxy after the Second World War. Until the 1970s this account remained largely unchallenged, although it had always offered only a partial account of the **nature, development**, and value of new art since Édouard Manet – regarded by these critics as the first modernist painter. **Formalism** became the term – used in both positive and negative ways – to **identify** this critical **perspective**.

Under its interpretation the significance of the work of the **impressionists**, of Paul Cézanne, of Picasso and Georges Braque, of Henri Matisse, and the **abstract expressionists** understood as **canonically** modernist 'greats' became *official*: taught and **reproduced** as unassailable fact within the universities, art **schools**, and **museums**. This development was ironic partly because some of the **artists** awarded (marginal) places in the modernist canon – for instance, Camille Pissarro, John Heartfield, George Grosz, and the **surrealists** – had seen themselves as part of an **avant-garde** wishing to undermine the whole of modern bourgeois **society**, including its stock notions of art and value. Ironic, too, is that some of the critics (e.g.: Clement Greenberg), complicit in this institutionalisation of the modernist canon during the 1960s and 70s, had also earlier professed a **marxist** opposition to the **capitalist^ social order** as a whole.

That said, modernist critics identified astutely the elements of technical and **aesthetic** radicalism that constituted what they thought of as the best modernist art made between the 1860s and the 1950s – for example, the impressionists' intertwined rejection of **traditional^ academic** training focused on doctrines of **compositional** coherence and 'finish', and their urge to paint modern life in terms of **narrative, symbolism**, and **subjective** experience. These artists, that is, were interested in their own modernity both as individuals and as members of new social groups and **classes**, and they wished to **represent** the modernity of the world they inhabited, particularly the cities of Paris, London, Berlin, and New York in the **period** between the 1860s and the 1930s. Greenberg and Fried asserted in the 1950s and 1960s, however, that the best modernist art – cubism, Matisse's paintings, the work of the best abstract expressionists – sought and

achieved a decisive autonomy from this social world torn by world wars, **revolutions**, and the alienations of capitalist society. By claiming this they attempted to break the long-established link between aesthetic and socio-political transformation in the **visual** arts. At worst, their formalist **perspective** was a clear misreading, against the evidence that they simply counted out of relevance. By the later 1960s they came under attack from many newly-politicised artists and historians who began to recover and rediscover the modern art and artists the modernist critics had left on the margins.

Further Reading

Foster, Hal, Rosalind Krauss, Yves-Alain Bois, and Benjamin Buchloch, *Art Since 1900: Modernism, Antimodernism, Postmodernism* (Thames and Hudson: 2004).

Frascina, Francis and Jonathan Harris (eds) *Art in Modern Culture: An Anthology of Critical Texts* (Phaidon: 1992).

Frascina, Francis and Charles Harrison (eds) *Modern Art and Modernism: A Critical Anthology* (Harper and Row: 1982).

Harrison, Charles and Paul Wood (eds) *Art in Theory: 1900–2000: An Anthology of Changing Ideas* (Blackwell: 2003).

MOVEMENT

Term used in **art^ history** to **identify^ artists** belonging to *groups and collective entities* of various kinds, often carrying the implication that their involvement was both conscious and clearly manifest. The bewildering range of these collective entities, however, tends to undermine the **theoretical** and **historical** bases upon which the notion often rests. For example, though it might be shown through argument and evidence that Salvador Dali belonged to a *movement* called the **surrealists**, active in a number of European countries in the 1920s and 1930s, it is far less evident that the German **painter** Caspar David Friedrich and the American painter Mark Rothko both belonged in any comparable kind of way to something called the '**romantic** movement' – in existence, it's generally believed, from the late eighteenth until the mid twentieth centuries. These two examples indicate some of the problems presented by *movement*.

In the first sense the term refers to a grouping of individuals who *themselves* sought to **create** a definite, tangible collective **identity** based on a range of agreed activities and shared beliefs. These involved writing and signing a manifesto (to 'manifest' their shared **identity**),

exhibiting together in shows, and taking part in surrealist **public events** – **performance** eventually became one general term for this kind of public action involving the artists themselves, as well as, or instead of, **artworks** such as paintings or **sculptures**. In the second example, however, the **concept** of a romantic movement spanning over a hundred years is based upon a series of necessarily **abstract** and *retrospective* claims (though some were related to careful **interpretations** of specific **pictures** by, for example, Friedrich and Rothko). Romanticism is not, then, a collective entity in the sense that surrealism was: though its **ism** suggests a *distinct* thing, romanticism is a 'trans-historical' category intended to account for much more than the art **produced** by one or several individuals interactive over a relatively short amount of time (for instance, a single generation of twenty-five years).

This is *not* to claim, however, that the notion of a romantic movement is necessarily **meaningless** or **analytically** unhelpful: its most serious proponents go on to make arguments for the importance of the links they believe are identifiable between artists living in different times and places. In the case of Friedrich and Rothko, for instance, this has been couched in terms of their comparable sense of individuality and aloneness in the world, although these worlds were separated by more than a hundred years. Friedrich's painting *Monk by the Sea* (1809–10) and Rothko's *Green, Red, Blue* (1955) both show what has been **read** as a kind of 'horizon', though Friedrich's is an obvious beach, sea, and sky scene with a cloaked **figure** depicted facing the view, while Rothko's painting is simply the meeting of two bands of colour. A **real** effort has to be made to see this abstract picture as **symbolically** representing a horizon.

Movement in this example – whatever its interpretative attractions – remains in large part an imposed, art historical designation, running the risk of conflating artists and artworks according merely to the **values** of the person claiming some connection between them. The older German term **zeitgeist** – literally meaning 'spirit of the time' – is perhaps less misleading, though it brings with it problems of its own: how extensive, for example, is the meaning of 'time' (zeit) in this idea which seems similar to the much more familiar concepts of **period** and **epoch**.

Further Reading

Eisenman, Stephen F. 'The Intransigent Artist *or* How the Impressionists Got their Name', in Francis Frascina and Jonathan Harris (eds) *Art in Modern Cultural: An Anthology of Critical Texts* (Phaidon: 1992).

Kemal, Salim and Ivan Gaskell (eds) *The Language of Art History* (Cambridge University Press: 1991).

Rosenblum, Robert *The Northern Romantic Tradition: From Friedrich to Rothko* (Harper and Row: 1975).

Williams, Raymond 'Formations', in Williams *Culture* (Fontana: 1981)

MURAL PAINTING *MURALISM*

In general, the term refers to the **practice** of **painting^ pictures** directly onto the walls of buildings of many different kinds – an activity that has gone on for thousands of years in many different places around the world. Some of the earliest of these include paintings on walls of tombs, such as at the pyramid tomb of Chnemhotep, near Beni Hassan (now Egypt, *c.* 1900 BCE) and at Elmali, in Persian-dominated Lycia (now south-west Turkey, *c.* 500 BCE). *Mural paintings* have been made in both **public** and private spaces – for instance, in the domestic dwellings and civic halls at Roman Pompeii, though the distinction between 'public' and 'private' is in large part a **modern** invention. Christian **narrative** mural painting took place in churches, over many hundreds of years – using both wet and dry fresco **techniques** associated particularly with the Italian **renaissance** (e.g.: Fra Angelico da Fiesole's *The Annunciation*, in the Monastery of S. Marco, Florence, *c.* 1440). In the case of wet fresco the paint itself actually chemically bonded with the **surface** of the wall's plaster – literally locking the mural narrative into the **social** and **symbolic^ function** of the church.

Though the **contemporary** notion of a 'public building' would, of course, include **art** galleries and **museums**, in practice, in general, twentieth-century mural painting – sometimes also known as mural**ism** – has been rooted in **forms** of political protest and **organisational** activity that sponsored the location of murals in buildings (often official **institutions** such as town halls and court houses) given over to **popular** political and civic-democratic purposes. This is true, for instance, both in terms of works by the **revolutionary^-nationalist** Mexican muralists – Diego Rivera, David Alfaro Sequeiros, and José Clemente Oroszco, active in the 1920s–40s in their own country and in the US – and of the many hundreds of mural paintings **commissioned** by the liberal-reformist New Deal government headed by President F. D. Roosevelt in the US between 1935–40. Rivera is particularly well-known for his murals at the Detroit Institute of Art (1933) and the controversial

'Man at the Cross-Roads' panels which he painted in the Rockefeller Center entrance hall in New York in 1933–34 (controversial, as the mural – showing scenes of modern **history** and the rise of communist leaders – was destroyed on the orders of his corporate **capitalist^ patron**, John D. Rockefeller). In the early 1940s the **abstract^ expressionist^ artist** Jackson Pollock claimed that a new kind of mural painting might be **emerging**: though intended to have a public, declarative **meaning** and **value**, this muralism was to be articulated through means of **figurative^ abstraction**, and large-scale free-standing paintings – *not* pictures painted directly onto walls – were to be its vehicle (e.g.: *Mural* (1943), painted for Peggy Guggenheim's house in Manhattan, New York). Ironically, this abstract public art of the Cold War era, **intended** to revive the social radicalism of earlier twentieth-century muralism – though lacking its party-political commitment – found its way mostly onto the walls of rich private benefactors and the new (and often private) museums of modern art in the US and Europe.

More recently, in Belfast, Northern Ireland, after the outbreak of sectarian violence there between Irish nationalist and British loyalist groups in 1969 both sides encouraged the painting of murals on the outside walls of their supporters' houses. As well as generating propagandistic **visual^ symbols** and pictorial narratives in the political and **cultural** conflict that **developed** between these organisations, the location of the murals worked to demarcate territories and borders within a land whose ownership and meaning had become violently disputed.

Further Reading

Borsook, Eve *The Mural Painters of Tuscany* (Oxford University Press: 1980).

Brown, Matthew Cullerne *Socialist Realist Painting* (Yale University Press: 1998).

Harris, Jonathan '"Technologies of the Soul": Federal Art in Institutions', in Harris *Federal Art and National Culture: The Politics of Identity in New Deal America* (Cambridge University Press: 1995).

Rochfort, Desmond *Mexican Muralists* (Laurence King: 1993).

MUSEUM *MUSEOLOGY*

The term's Greek root refers to the nine 'muses' – the daughters of Zeus and Mnemosyne (goddess of memory) – believed to be the inspirers of learning and the **arts**, especially of poetry and music. By

the eighteenth century the term *museum* in many respects had acquired its basic **modern** sense: that is, a specific place for the holding, conservation, **classification**, and **public^ exhibition** of **valued** items of various kinds. The first such public museum of **visual** art was the Luxembourg Palace (in modern Belgium), opened as a museum in 1750. It was this **public** accessibility – though who *qualified* as part of this public remains a **complex^ historical** question: an entry fee was charged – which differentiated such places from existing rooms for the private display of **artworks** to invited guests. The first art museums were highly **significant** because their inauguration signalled the **identification** of a **meaning** and **aesthetic** purpose for art *separable* from the continued religious and **state**-propagandistic uses that had **developed** for **paintings** and **sculptures** since the **renaissance**. The museum also betokens the gradual arrival of new kinds of **art world** professional expertise and knowledge: these include **curators**, responsible for selecting and caring for the **artefacts**, and exhibition **organisers**, deciding how to arrange and **interpret** the meaning of a collection of works brought together for public exhibition.

In many ways the terms 'museum' and 'gallery' have come to mean the same thing when used in relation to visual art: the **National** Gallery in London and the **Metropolitan** Museum of Art in New York both hold, conserve, classify, and exhibit artefacts produced over many hundreds of years from around the world. Such **institutions** are also important **nationally** and internationally: in relation to the former, they have **represented** and **embodied^ ideals** about the higher purposes of the **state** and its claimed commitment, on behalf of its people, to **civilisation**; in relation to the latter, they function **influentially** to organise and improve standards of care for their artefacts and to promote travelling exhibitions as a type of **cultural** diplomacy.

However, when the first institutions were established in the mid twentieth century to collect and display modern art one *different* sense to the terms 'museum' and 'gallery' became apparent. Museum seemed the name for an organisation that looked after old, if not actually ancient, objects – while the Museum of Modern Art (founded in 1929) and the Guggenheim Museum in New York (founded in 1930) wished to exhibit artworks that were no more than a few decades in age at most. In contrast, London had its Tate Gallery devoted to art **produced** from the nineteenth century onwards. Whatever the choice of name, these institutions have become powerful in many respects and are deeply implicated in the

financial and **art historical** evaluation of **artists** and artworks. They are increasingly involved in pedagogic and 'citizenship' or 'social inclusion' activities funded by the state; and, through their own **architectural^ design**, are important **symbols** of culture and **contemporary** city-life in the nations of the **west**. Tate Modern, for example, has become the most visited art gallery in the world, though it might be argued that the large-scale building (a converted electricity-generating plant on the South Bank of the River Thames) tends to overwhelm all and any of the art exhibited within it.

Further Reading

Carbonell, Bettina Massias *Museum Studies: An Anthology of Contexts* (Blackwell: 2003).

Evans, Jessica and David Boswell (eds) *Representing the Nation: A Reader in Heritage and Museums* (Routledge: 1999).

Vergo, P. (ed.) *The New Museology* (Basic Books: 1989).

Whitcomb, Andrea *Re-Imagining the Museum: Beyond the Mausoleum* (Routledge: 2003).

MYTH *MYTHIC, MYTHOLOGICAL*

Term with two **meanings** in **contemporary^ art^ historical^ discourse** – at first sight they appear very different, but in fact they relate in a number of important ways. The first sense is familiar enough: *myths* are the stories and **symbolic** events, typically Greek and Roman, that have featured in the **narratives** of **western^ painting** and **sculpture** for hundreds of years (e.g.: Pinturicchio's *Exploits of Osiris* (1493–95); Guido Reni's *The Dawn (Aurora)* (1613); Angelica Kauffmann's *Venus Showing Aeneas and Achates the Way to Carthage* (1769); Anne-Louis Girodet's *Funeral of Atala* (1808)). In the **period** between the fifteenth and the mid nineteenth centuries these stories, when **visually^ represented**, took on a range of contemporary **allegorical** meanings – combining senses that might be read, simultaneously, as psychological, **sexual**, and **socio**-political. At the end of the nineteenth century Sigmund Freud, the inventor of **psychoanalysis**, exploited their openness to multiple **interpretation** by using certain Greek stories and characters in his accounts of the **nature** of **human** family and sexual life – for instance, his **theories** of the 'Oedipal' and 'Electra' **complexes**.

Myths in this sense, then, are tales about the actions and interactions of gods and men that have circulated and evolved over dozens

of human generations – within spoken and written **languages** (e.g.: Homer's *Iliad* and *Odyssey*) and in their **portrayal** in paintings and sculptures. For instance, a delight with the intellectual stimulation gained from mythic representation characterises Sandro Botticelli's well-known paintings *The Birth of Venus* (1485) and *Primavera* (1482) – works ambiguously combining Christian and Romano-Greek symbolism – while, in the early nineteenth century, the French **academic** painter Thomas Couture used the myth of 'the decline of the Roman Empire' to create a pointed allegory of contemporary political corruption in France (*The Romans of the Decadence* (1847)).

The second **meaning** to *myth* was articulated by the French writer and scholar Roland Barthes, in an **influential** book called *Mythologies* (1957). His chosen myths, however, were resolutely **modern**: accounts, that is, of **iconic** aspects of contemporary French **popular^ culture** and society – 'the Citroen', 'the wrestling match', the 'cover of *Paris Match* magazine showing a French colonial black soldier saluting the Tricoleur' (French flag). Barthes' purpose was to show through these examples that magazine stories, **photographs**, and **advertising** could take on a range of **complex** and extending meanings that **embodied^ ideologies** (myths) about the character of French **national** life. Mythology was the study of these myths. Neither ideology nor myth in Barthes' sense necessarily meant 'untrue' or 'fictional' – they came to **signify**, rather, abiding stories with **real** effects that led people to **identify** with **symbols** tied to **abstract** beliefs, such as a patriotic 'love of nation'. Barthes' method of **analysis, identifying** 'first order' (literal or denotative) and 'second order' (**metaphoric** or connotative) meanings at work in literature and visual representation, in **TV** and **film**, helped to found the study of contemporary **visual culture**. His focus on allegory understood as ideology, in addition, led to important re-theorisations of **traditional** notions of myth within **art^ history**.

Further Reading

Bull, Malcolm *The Mirror of the Gods: Classical Mythology in Renaissance Art* (Allen Lane: 2005).

Kampen, Natalie Boymel (ed.) *Sexuality in Ancient Art: Near East, Egypt, Greece, and Italy* (Cambridge University Press: 1996).

Warburg, Aby 'Albrecht Dürer and Classical Antiquity', in *Meaning in the Visual Arts* (Penguin: 1993).

Wind, Edgar *Pagan Mysteries in the Renaissance* (Yale University Press: 1958).

NARRATIVE *NARRATE, NARRATOLOGY*

This term means an *account* of something. Typically, in **art**^ **histor-ical**^ **discourse**, *narrative* refers to stories and depicted stories – that is, stories both told verbally and in written **form**, and **visual**^ **representations** of these stories (some of which incorporate actual words and sentences, as in **medieval** illuminated manuscripts). Christian devotional **paintings** and **sculptures**^ **produced** in Europe in the **period** from about the fourth century CE through to the nineteenth century contain many examples of such narratives: stories, for instance, from the old and new testaments in the Bible, illustrated through various kinds of combined **symbolic** and narra-tive **conventions** (e.g.: the anonymous, illuminated manuscript *Christ Washing the Apostles' Feet*, from the Gospel-book of Otto III (*c.* CE 1000); the anonymous, stone sculptural relief *The Death of the Virgin*, in the southern transept of Strasbourg Cathedral (1230); Konrad Witz's altar painting *The Miraculous Draft of Fishes* (1444); and Grunewald's painting *The Resurrection*, Isenheim Altar (*c.* 1515)). It was common, for example, for **renaissance**^ **artists** to depict pro-tagonists in Biblical narratives more than once in a single scene – partly it was an economical way of showing several scenes from the stories in question (e.g.: Masaccio's *Life of St. Peter* cycle in Santa Maria del Carmine in Florence (1425–28)).

Story, though, has one sense **meaning** fictional – 'made-up' – and therefore perhaps unreliable as a guide to things in the world that have actually happened. For this reason it is unusual to find reference to documentary **photographs** containing stories – for this meaning of the term tends to undermine the factual truthfulness claimed to be contained within the evident narratives of such **pictures** (e.g.: Dor-othea Lange's *Migrant Mother* (1936); Lisette Model's *Sammy's Bar* 1940)). However, it is commonplace to hear references to newspaper and **television** 'news stories' where the assumption remains that a factual recounting, rather than a fictional account, takes place. 'Recount' itself contains an ambiguity: it suggests both an account 'of things that actually happened' and a 're-telling' of an already existing narrative or story. Given these layers of ambiguity, scepticism regard-ing *any* claims made about the factual reliability of narratives within visual representations (and those verbal or written, for that matter) should not really be surprising.

The study of types of narrative in visual and verbal representation has been given the name narratology: literally, a knowledge, or sci-ence, of narrative. This **specialist** activity within art history and art

theory has **developed** particularly over the past thirty years or so – reflecting the impact upon all the **humanities** disciplines of **linguistic** accounts of meaning **originating** within **structuralist** and **poststructuralist** philosophy. One focus in this work has been upon the interaction of verbal and visual **signs** – an ever-growing field, in one sense, because *all* visual art can only be made intelligible through its relations with verbal (cognitive-intellectual) **explanation**. Narratology is the theoretical study of these relationships. **Critics** of the field, however, have emphasised the difficulty of **creating** a **historical** narratology – recovering, that is, the actual meanings given to art by past **viewers**. Narratology, as a structuralist-inspired development, tends to emphasise the superior role of the **analyst** as creator or 'decoder' of meanings, leaving **socio**-historical **interpretation** to others in the discipline not concerned principally with theories of language.

Further Reading

Bal, Mieke *Double Exposures: The Subject of Cultural Analysis* (Routledge: 1996).
Bal, Mieke *Narratology: Introduction to the Theory of Narrative* (University of Toronto Press: 1997).
Barthes, Roland *The Pleasure of the Text* (Hill and Wang: 1975).
Bryson, Norman (ed.) *Visual Theory* (Blackwell: 1991).

NATION *NATIONAL, NATIONALISATION, NATIONALISM, NATIONALITY, INTER-NATIONAL, TRANS-NATIONAL, NATIONISM*

Though *nations* – **meaning** countries occupying defined geographical-territorial areas with single **state** legal systems – have only **dominated** the world's population since the late nineteenth century (the United Nations **organisation** only came into existence in 1945), it has long been a presumption within **art**^ **history** that 'national **identities**' fundamentally shaped **cultural**^ **production** for many hundreds of years before that. The **ideal**, and **ideology**, of the 'Italian **renaissance**'^ **symbolises** what might be called the cult of nation**ism** (if not nationalism) that still underpins much of the discipline – Italy, however, only came into existence as a single sovereign nation-state in 1860. This art historical presumption is not surprising in one sense, given that all art historians now active, and most that lived and died during the twentieth century, have experienced their own world in terms of the dominance of, and catastrophic world conflict between, strong competing nations.

Recent radical review of the claimed national basis to art and **artists** has occurred partly because **theorists** now believe that an evolving 'world-system' threatens the nation-state system that rapidly **developed** over the **period** since the end of the Second World War in 1945. However, accounts of **globalisation** and **postcolonialism** in general have *not* suggested that nations have ceased to be primary in terms of their organisation of **social** relations between their peoples.

They have proposed, however, that the power of nation-states has become **significantly** eroded, and that non-state **institutions** and forces in the world – acting transnationally – have become extremely **influential**. **Capitalist** corporations, for instance, with plants employing tens of thousands of people in many countries but substantial independence from practically all of them, are one example. So is the phenomenon of what is called 'global Islamic terrorism': relatively small groups of people from different countries not involved simply in violent opposition to the presence of a foreign nation's troops or workers in a particular society (e.g.: Iraq or Saudi Arabia), but antagonistic to the power of one country in particular – the US – across the whole world.

Postmodernist theories and **histories** of art **produced** since the 1980s have attempted to deal with socio-**cultural** aspects of this 'new world order': an unprecedented situation in which, for example, **televisual** and internet **technologies** may effortlessly penetrate nearly all national borders, **creating** possibilities for **communication** and collaboration between physically divided peoples. Some nation-states, their ruling elites threatened by this eventuality – such as the People's Republic of China – have attempted to prevent this kind of border-crossing and internationalisation of contact by blocking access to websites and email systems. In another direction, the internationalisation of **contemporary** art – brought about partly by the spread of biennial **exhibitions** held around the world and the **emergence** of a global market for art bought and sold across several continents – has eroded the previous national rootedness of many artists who now move constantly around the globe, producing work in shows held regularly in, for example, Sao Paolo, Liverpool, Singapore, and Santa Fe.

Further Reading

Bochner, S. (ed.) *Cultures in Contact: Studies in Cross-cultural Interaction* (Pergamon Press: 1982).

Hobsbawn, E. J. *Nations and Nationalism since 1780* (Cambridge University Press: 1990).

Pratt, M. K. *Imperial Eye: Travel Writing and Transculturation* (Routledge: 1992).
Saini, M. K. *Politics of Multinationals: A Pattern in Neo-colonialism* (Gitanjali Prakashan: 1981).

NATURALISM *NATURALISTIC, NATURE*

Used in **art^** **history** with two chief senses, *naturalism* refers (1) specifically to a group of **paintings^** **produced** by **artists** active in the last two thirds of the nineteenth century in **western** Europe, and (2) in general terms to a kind of art claimed to be evident in many different sorts of **artefacts** produced over centuries – even thousands of years – of **human^** **history**. In this second, **epochal** definition, naturalism exists within a **stylistic** continuum at the other end of which is an equally generalised notion of art given the label **abstraction**.

In the first usage, naturalism is the name for a **visual** style and active **intention**: that is, the **desire** to depict, as accurately as possible, the appearances of things in the world. In French art of the nineteenth century this designation was applied to artists such as Jean-Francois Millet, Rosa Bonheur, and Gustave Courbet. Though the category of naturalism overlaps in complicated ways with that of **realism** in a number of respects, the former – as the root of the term suggests – was related to a particular concern with what was sometimes called the 'faithful' rendering of the natural world: animals and **landscapes**, and with humans at work and rest on the land. For example, the Barbizon **School** of painters – Jean Baptiste Camille Corot, Theodore Millet, Théodore Rousseau, and Narcisse Virgile Diaz de la Peña – painted scenes of peasant life and the landscape around the village of Barbizon in the Forest of Fontainebleau in France in the 1830s, 1840s, and 1850s (e.g.: Corot's *View Taken in the Forest of Fontainebleau* (1831), Rousseau's *The Torrent* (1830), Diaz de la Peña's *Descent of the Bohemians* (1844)).

Naturalism, along with all art historical **ism** terms, however, presents many **analytic** dilemmas. The **concept**, for example, was *not* adopted and used by these (and other) artists themselves in any self-conscious or programmatic **manner** – they were not party to a 'naturalistic manifesto', as the **surrealists** were. These artists were also as much **influenced** by **pictures** by earlier painters (such as those associated with eighteenth-century **rococo** scenes of **nature**), as motivated by an urge to show the empirical world they studied on a day-to-day basis. The second usage to the term *naturalism* highlights very clearly the problems which actually attend also upon the first. To

call all western art from the **renaissance** to the twentieth century in some general sense naturalistic (or motivated by the **desire** to imitate appearances – E. H. Gombrich's claim in his influential *The Story of Art*, 1950) – not only generalises hugely across times, producers, and places – it is also oblivious to, or ignores, the question of *whose* notions of 'the real', 'fidelity', 'appearances', and 'convincing likeness' are relevant or under scrutiny.

Within an even broader art historical analytic time-frame, sweeping back to **civilisations** existing in the centuries and millennia before the Roman Empire, it has been common to refer to these 'macro-phases' of **cultural** production as, by turns, naturalistic or stylised, or geometric, or abstract. Sometimes, for example in the case of the **marxist** Arnold Hauser, these designations were related to – seen as evidence of – the character of a whole **social order**: the belief that naturalism, for example, represented a **society** more interested in its surroundings and in producing new knowledge of the world, and less bound up in religious or mystificatory rituals (e.g.: *Old Man* from the East Pediment of the Temple of Zeus in Olympia, *c.* 460 BCE; Hauser cites this stone **sculpture** as an example of the naturalistic conception of early **classical** art.) In this example, as in all the earlier ones, it is clear that naturalism, far from being a neutral category – showing things just 'as they are' – implies a set of art historical **values** and beliefs about the role of art and the changing **function** (and self-**identity**) of its producers.

Further Reading

Boime, Albert 'The Counterrevolutionary Origins of Photography and Modern French Landscape Painting', in *Art in an Age of Counterrevolution: 1815–1848* (University of Chicago Press: 2004).

Clark, T. J. *The Absolute Bourgeois: Artists and Politics in France 1848–1851* (Thames and Hudson: 1973).

Eisenman, Stephen F. 'Realism and Naturalism', in *The Nineteenth Century: A Critical History* (Thames and Hudson: 1994).

Hauser, Arnold 'Old Stone Age: Magic and Naturalism', in *The Social History of Art*, vol. 1 (Routledge: 1999).

NEOCLASSICISM

One of the major terms in the **art^ historical** sequence that plots the phases and **epochs** of **western^ art** from the fifteenth century up to the mid nineteenth. The trajectory runs '**renaissance** →

mannerism → **baroque** → **rococo** → *neoclassicism* → **romanticism** → **realism** → **modernism**'. Neoclassicism is usually dated from the early 1700s – when Roman **architectural, painted,** mosaic, and **sculptural** remains began to be discovered in sites across southern Europe – up to the 1810s, the latter **period** during which models of art from antiquity became used by **contemporary^** **artists**. The term is inescapably associated particularly with **developments** in French art and **society** in the phase after the 1770s.

Neoclassicism, then, was partly but importantly a reaction against the perceived aristocratic corruption of the baroque and the 'Ancien Regime' frivolousness of the rococo **style** in favour of an art of restrained moral seriousness based on a selection and **interpretation** of recently disinterred Roman **forms**. The 'neo-' (literally **meaning** new) indicates this revision of contemporary artistic **conventions** in order to meet the recognised past attainments of Roman **culture** and society within revolutionary France. **Classical** refers to this precedent – the **civilisations** of ancient Greece and Rome – although the suffix **ism^ identifies** neoclassicism as a *re-invention* in the present and is an example of a self-conscious artistic revival.

In the middle decades of the eighteenth century, discoveries of Roman ruins at Herculaneum and Pompeii (in what is now southern Italy) provided evidence of what ancient buildings, **pictures,** and sculptures had looked like, and, though this revival of interest had been underway for a long time before then, the scholar (and early art historian) Johann Joachim Winckelmann, author of *On the Imitation of Greek Works* (1755), became the leader of a self-consciously **modern^ formation** seeking to emulate what were considered the best aspects of art in this ancient culture – 'its noble simplicity and calm grandeur' (though Winckelman actually had little access to **original^ artefacts**). In the eighteenth century, however, virtually nothing was known at first hand of Greek culture, hence the association, then, of neoclassicism altogether with Roman civilisation. Major discoveries of Greek antiquity occurred in the period at the end of the eighteenth and beginning of the nineteenth centuries.

Neoclassicism in **academic** French painting is closely associated with Jacques Louis David, and particularly his work *The Oath of the Horatii* (1785), a picture that drew **allegorically** on a story from Roman history to illustrate contemporary moral and political questions bound up with loyalty to the French state and the **nature** of civic duty. It became understood as a direct **criticism** of the authoritarian aristocratic rule of France under Louis XIV. Neoclassicism, however, never had a single **meaning** or **value**: different

emphases within it, leading to different forms of artistic and socio-political belief – across a number of European countries – can be found in, for example, sculptures by Antonio Canova and John Flaxman, paintings by Anton Raffael Mengs and James Barry, and etchings by the architect Giovanni Battista Piranesi.

Further Reading

Boime, Albert 'The Seven Year's War and Its Aftermath (1756–c. 1783)', in Boime *A Social History of Modern Art: Art in an Age of Revolution 1750–1800* (University of Chicago Press: 1987).

Crow, Thomas *Painters and Public Life in Eighteenth Century Paris* (Yale University Press: 1985).

Honour, H. *Neoclassicism* (Penguin: 1968).

Hope, H. M. *The Theory and Practice of Neoclassicism in English Painting* (1988).

NEW ART HISTORY

Term which entered the currency of the discipline in the early 1980s, though in its initial uses inverted commas and a question mark were often appended to indicate that the phrase should be **viewed** as provisional, speculative, and examined with scepticism (e.g.: 'Is there a new art history?'). This was in large part because the **socio**-political radicalism of those who used the term to **signal** a break or division within the discipline over key arguments, issues, and **values** sharply *excluded* the wish to see established simply another orthodoxy or 'official' knowledge of how to do **art^ history.** By the mid 1980s, however, this scepticism had mostly been swept to the margins and many academics, along with (or under pressure from) their publishers, were prepared to use the term effectively as a kind of brand **identity** – and so *new art history* became the label for what was **represented** as a set of novel 'methods' and 'approaches' to the **subject.** Within this use (which continues), new art history chiefly refers to **feminist, semiological, structuralist, psychoanalytic,** and 'social context' **specialisms** of art historical **analyses.** Sometimes, particularly in US academic parlance, these are all lumped together and called 'contextualist approaches' to art.

Historical study of the **development** of the discipline (historiography) shows, however, that these kinds of interest had existed in earlier **forms,** though some were unnamed as such (feminist **critiques** of art history, however, were unprecedented in the later 1960s). **Marxist** studies of art, for example, had been **produced** in the

period before the Second World War, along with other related, sympathetic, scholarship that tried seriously to deal with facets of art's **social** and historical significance. T. J. Clark wrote about this earlier work in an **influential** 1974 essay entitled 'The Conditions of Artistic **Creation**', citing the writings of Aby Warburg and Erwin Panofsky. Clark's purpose was to suggest that there was an important *continuity* in radical, questioning scholarship – a need, in fact, to return to these earlier **authors** and the key arguments about the social **meanings** of art upon which their inquiries had focused – though the social conditions of the 1920s and 1930s differed enormously from those in the post-1970 period that saw the **emergence** of the new art history.

Whatever the arguments over the term itself, the radicals interested in art history (art historians, **artists**, critics, curators, students, or teachers) connected their intellectual efforts to a socio-political involvement with socialist and feminist **movements** *outside* the lecture theatre, seminar, **museum**, and studio. These were bound up, in the 1970s and early 1980s, with various campaigns – against the US war in Vietnam, in favour of civil rights for minorities in the US, Europe, and South Africa, and, later, for the defence of gay and lesbian **sexual** preferences. By the early 1990s, however, following the defeat of the 1984–85 miners' strike in the UK, the reinvention of the British Labour Party as business-friendly 'New Labour', and the end of the Cold War in 1991, this broad movement of aligned groups for **progressive** social change had begun to dissipate, leaving the new art history mostly as an **academic** radicalism – stranded in the universities, with its leading representatives fully, though somewhat ironically, established in their senior tenured jobs, if not quite part of the establishment.

Further Reading

Doy, G. *Materializing Art History* (Beng: 1998).
Foster, K. 'Critical Art History, or a Transfiguration of Values?', *New Literary History* 3: 3 (1972): 459–70.
Harris, Jonathan *The New Art History: A Critical Introduction* (Routledge: 2001).
Rees, A. L. and F. Borzello (eds) *The New Art History* (Camden Press: 1986).

NEW MEDIA

This term has a literal, and then a potentially confusing – because **metaphorical** – sense. On the face of it, *new media* refers straightforwardly to the introduction into **contemporary^ art** of recently

developed^ forms and **techniques** of **production**. Such production includes, for instance, the systems of video, DVD, and computer-generated **imaging**, along with the techniques and **conventions** used in their application as **expressive** devices. These productive means are readily accepted as new media (though video was actually available as long ago as the late 1960s). Together these **material** and conventional resources constitute innovative technologies: novel ways of *doing,* but also novel ways of *thinking* about **visual^ representation** and the **meanings** they **create** (e.g.: Tony Oursler's disturbing video images of disembodied faces projected onto spheres and other three-dimensional, shaped **surfaces**, such as *We Have No Free Will* (1995)). Beyond this relatively simple sense, however, the status of these media as 'new' raises a series of key issues.

'New' can mean both additional and recent. The former sense *appears* neutral, but in **art^ historical^ discourse** the vast bulk of scholarship has made **conceptions**, and **ideals**, of **painting** and **sculpture** *normative:* that is, they are the models and standards of visual representational **practice** against which all others tend to be defined and judged. In this sense, 'new media' is a metaphorical or euphemistic term whose referents will probably *always* remain additional or supplemental – that is, added on to art history's core concern with painting and sculpture. 'New' meaning *recent* raises equally as fundamental an issue: when does 'recent' become 'old', established, or **traditional**? Again, this is not simply a matter of dating: 'traditional' is also a *normative*, evaluative term (e.g.: 'a traditional Christmas or Thanksgiving dinner'). **Photography**, for instance, has been a practice used by **artists** – along with many other kinds of workers – for about 180 years (the first photographs were produced in the late 1820s). Yet in relation to art history's sense that painting as a practice has existed for thousands of years in many different forms, photography will remain regarded as 'new', meaning both very recent *and* peripheral. Although photographic history and theory is a **specialism** within the discipline its focus is a set of practices, producers, **artefacts**, and images likely to remain indefinitely secondary to the study of painting and sculpture.

New media, then, is a term containing both positive and negative connotations, depending upon who uses and **evaluates** the term, along with the objects to which it can be made to refer, in any particular disciplinary context. Its prevalent use by **exhibition^ curators** and publishers since the 1980s who wish to stress what they regard as its 'selling features', such as **originality** and links to **popular culture**, have also given the term a further set of complicated senses. For

instance, Eddo Stern's use of computer-generated 'virtual **reality**' animation in his work *Deathstar* (2004) – a compendium of sequences from actual interactive 'Kill Osama bin Laden' games marketed in the US since the attacks on the World Trade Center in New York on – attempts to subvert the **genre** while running the risk of becoming itself a victim of the exploitation of both gamer and virtual target that such games routinely involve.

Further Reading

Foster, Hal *The Return of the Real: The Avant-Garde at the End of the Century* (MIT Press: 1996).

Graham, Dan *Video, Architecture, Television: Writings on Video and Video Works: 1970–1978* (The Press of the Nova Scotia College of Art and Design: 1979).

Taylor, Paul *Post-Pop Art* (MIT Press: 1989).

Wagner, Anne 'Performance, Video, and the Rhetoric of Presence', *October* Winter 2000: 59–80.

NUDE

Along with **landscape**, **still life**, and **portraiture**, **images** of unclothed **human^** **bodies** have existed within **western^** **art** since ancient Greece (e.g.: fresco of a nude maenad (bacchante), dancing with cymbals, south wall of the Villa dei Misteri, Pompeii (60–50 BCE)). Since the late eighteenth century the *nude* has been a recognised **genre**. That is, since the 1780s, teachers, writers, and **artists** such as Sir Joshua Reynolds (first president of the Royal **Academy** in London), **theorised** the **value** of sketching and **painting** nudes as a necessary part of the training of competent academic artists. Although given a proportionate – and relatively minor – status within this education that valued **history painting** above all other genres (though many examples of history painting integrate nude bodies into their **compositions**; e.g.: Jacques Louis David's *The Love of Paris and Helen* (1788); Henry Fuseli's *Satan Rising at the Touch of Ithuriel's Spear* (1802); Pierre Paul Prud'hon's *Divine Justice and Vengeance Pursuing Crime* (1808)), by the mid nineteenth century **representations** of male – and increasingly female – nudes had become a much more **significant** theme or *motif* for artists.

This occurred because the breakdown of genre-hierarchy in the nineteenth century, along with deterioration in the **social** and political power of the academies in European countries, had both reflected and contributed to the **development** of new **forms** of humanism in

philosophy, political **discourse**, and **aesthetics**. These **ideas** radically re-valued and re-**imagined** the individuality, corporeality, **sexuality**, and humanity of the undressed body (a development anticipated in some examples of **romantic** art: e.g. Eugène Delacroix's *Death of Sardanapalus* (1827)). The nude, set free from its place in **traditional** academic painting, became a vehicle for a wide range of novel social, sexual, and **symbolic^ meanings**, in paintings, prints, drawings, and **sculptures** by, for example, Gustave Courbet, Édouard Manet, Paul Gauguin, Paul Cézanne, and Henri Gaudier-Brzeska (e.g.: Courbet's painting *The Origin of the World* (1866); Manet's painting *Olympia* (1863); tamann wood with painted gilt carving by Gauguin, *Figure of Hina* (1891–93); Cézanne's painting *The Large Bathers* (1895–1906); Gaudier-Brzeska's wood carving *Red Stone Dancer* (1913)).

Though these artists were regarded as **avant-garde**, many other **contemporary** painters and sculptors *not* associated with **technical** and social radicalism also continued to paint nudes which, as a genre, remained highly **popular** throughout the twentieth century. This popularity is largely because the nude's evident **subject matter** seems intelligible (and directly **sexually** pleasurable) in ways that, generally, **modernist** art has not been. Exceptions, though, include Henri Matisse's painted nudes, as well as those by, for example, Gustav Klimt and Egon Schiele in which a forthright eroticism remains prominent. In the 1970s the **critic** John Berger made an important distinction between 'nude' and 'naked': the first, he claimed, referred to a set of stock **conventions** or 'ways of seeing' (and showing) the *idea*, and **ideal**, of the unclothed body; the second was the actual, unidealised, **reality** of the naked body. Artists such as Francis Bacon and Jenny Saville have attempted such a revelation of true nakedness although, perhaps ironically and interestingly, both resorted to **techniques** of **abstraction** and **subjective^ expressionism** in attempting to achieve it (e.g.: Bacon, *Two Figures in the Grass* (1950–53); Saville, *Plan* (1993)).

Further Reading

Gent, L. and N. Llewellyn (eds) *Renaissance Bodies: The Human Figure in English Culture: c. 1540–1660* (Reaktion: 1990).
Nead, L. *The Female Nude: Art, Obscenity, and Sexuality* (Routledge: 1992).
Ockman, C. 'Profiling Homoeroticism: Ingres' *Achilles Receiving the Ambassadors of Agamemnon*', *Art Bulletin* June 1993: 259–74.
Sidlauskas, Susan *Body, Place, and Self in Nineteenth-Century Painting* (Cambridge University Press: 2000).

OPPOSITIONAL *OPPOSE, OPPOSED*

One important **theoretical** category in a set of three – the others being **specialist** and **alternative** – that seeks to **identify** and **explain** the importance of **modern** and **avant-garde^ artistic^ forms** and **movements** within the **historical^ development** of **culture** and **society**, particularly since the later nineteenth century. Along with these other two terms, *oppositional* is a **concept** whose **value** in **art^ history** lies in how it may help to explain the place of, for instance, an artist, or **artwork, style**, or artists' **formation** in a particular historical and social moment.

In the first third of the twentieth century a wide range of movements had **emerged** following the decline of **academic** art, the **state^ institutions** that supported it, and – in Britain – the conservatism of Victorian culture and social **values** in general. In an essay on the 'Bloomsbury group' of artists, **critics**, and writers, Raymond Williams identified this **formation** based in England (living in the Bloomsbury district of central London) during the 1920–40s as *alternative* – rather than oppositional – in **aesthetic**, social, political, and intellectual terms. By this he meant that, though, for instance, the group's **modernist** art critic Clive Bell and **feminist** novelist Virginia Woolf emphatically rejected Victorian culture and Tory political and philosophical values, their own proposals for transformation in modern art and civil society offered only to gradually improve – rather than fundamentally challenge – the class **structure** then constituting British social-democratic **capitalist** society. As a miniature social world of its own, the Bloomsbury group itself formed an alternative way of life – in aesthetic, social, **sexual**, and moral terms.

In contrast, it is possible to identify, for example, the central European **dadaists** as oppositional in their direct attacks upon the **conventions** of bourgeois culture, the power of the Church, and the **nationalistic** militarism of the great **western^ nation**-states during and immediately after the First World War. That is to say, manifestations of their artistic and cultural values – for example, their calculated disruption of **public** events, such as theatre **performances**; printing of anticlerical pamphlets and obscene drawings; attempts to avoid military service; the later involvement of some, such as George Grosz, in the German Communist Party; and **creation** of 'anti-art' objects such as Marcel Duchamp's *Urinal* (1917) – constituted a **revolutionary** rejection of, and opposition to, the prevailing **social order**. This set of terms – oppositional/alternative/specialist – seems particularly suited to **analysis** of late-nineteenth-century and 1900–1950

avant-garde artists' groups. This is because the **period** saw the general **emergence** of **mass** democratic, industrial and **consumer^**-capitalist societies in Europe and North America – modernity – within which (and sometimes *against* which) artists forged their varying senses of **identity** and role. By the 1950s and 1960s, however, avant-garde art and culture had, to an important extent, itself begun to become institutionalised – collected by state art **museums**, funded and encouraged by government arts councils, and made a part of official **cultural policy**. In this sense it could be argued that most artistic avant-gard**ism** shifted from its earlier oppositional or alternative stances, and became reduced to a niche, or specialist, element within the massively-expanded consumer-culture of the last thirty years.

see also: **specialist** and **alternative**

Further Reading

Nochlin, Linda 'The Depoliticisation of Gustave Courbet: Transformation and Rehabilitation under the Third Republic', in Michael Orwicz (ed.) *Art Criticism and Its Institutions in Nineteenth-century France* (Manchester University Press: 1994).

Parker, Rozsika and Griselda Pollock 'Fifteen Years of Feminist Action: from Practical Strategies to Strategic Practices', in Parker and Pollock (eds) *Framing Feminism: Art and the Women's Movement 1970–1985* (Pandora: 1987).

Ratcliff, Carter *The Fate of a Gesture: Jackson Pollock and Postwar American Art* (Westview Press: 1996).

Williams, Raymond 'The Bloomsbury Group', in Williams *Problems in Materialism and Culture* (Verso: 1980).

ORGANISATION *ORGAN, ORGANISED*

In its most familiar **art^ historical** sense, *organisation* refers simply to **public^ bodies** that have sponsored and regulated the **production**, **exhibition**, and **interpretation** of **artworks** over many centuries. These would include, for example, the Medici family's (private, religious, and civic) **patronage** in Florence in the fifteenth to sixteenth centuries, the Slade School of Art established in London in 1871, and the Chicago Art Institute opened in 1879. Note that often organisations are **identified** closely with particular buildings – the two senses are sometimes combined in the related term **institution** – while in other cases an organisation may **represent** its activities in a variety of

ways, some tangible **visually**, others not (the Medici family is a good example, having **commissioned** buildings and artworks of various kinds, but also operated **socio**-politically through legal, civic, religious and economic activities in **renaissance** Florence and Rome).

Beyond this concrete definition, however, organisation in an **abstract** sense refers to the relations existing *amongst* institutions that have constituted, both in the past and in the present, bigger and more **complex** social **structures**. The **concept** of the **art world** is an example of this: an identifiable, though in some ways amorphous, entity made up of individuals, groups, institutions, and other elements linked in various ways (through, for example, friendships, legal contracts between galleries and **artists**, art magazines, **museums**, writers, and teachers working in universities and colleges, etc.). In addition to this kind of organised **structure**, artists, their **practices**, and **products** are bound up with particular physical places – such as cities – and with the society of a whole country, most now organisationally identified as **nation^-states**. The 'macro-organisation' of artists has taken a variety of **forms**: artists in the twentieth century have increasingly been integrated, for example, into (1) the national economy of societies and their tax and legal frameworks; (2) they have sometimes been employed directly as wage-labourers by governments (as in the USSR and the US during the 1930s); and (3) they have been supported, indirectly, by grants and awards issued by governmental organs (councils and departments of various kinds), especially since the 1950s. In this way artists and art are now systematically integrated into nation-state cultural and social organisation. But the work of artists is not simply a form of luxury commodity production within this societal matrix: it plays a part in the broad **reproduction** and transformation of such societies – for example through public art commissions and the 'social inclusion'/citizenship **discourses developed** within museum exhibition and education policies over the last ten years.

The activities of artists are now also importantly inter- or transnational. Events such as biennial exhibitions, competitions for major commissions, and the possibilities provided by some **new media**, such as 'virtual **reality**' and internet **technologies**, have led to the unprecedented **globalisation** of artistic production. The challenge these developments pose to art history is serious: can the discipline invent – or **appropriate** from other fields of study – **theoretical** and conceptual tools able competently to recognise and assess these fundamental changes in artistic organisation since the end of the era of **avant-garde** art and **modernist^ criticism** in the 1960s?

221

Further Reading

Beck, U., A. Giddens, and S. Lash *Reflexive Modernisation: Politics, Tradition, and Aesthetics in the Modern Social Order* (Polity: 1994).

Beetham, D. *Bureaucracy* (Open University Press: 1996).

Bourdieu, P. 'Cultural Reproduction and Social Reproduction', in R. Brown (ed.) *Knowledge, Education, and Cultural Change* (Tavistock: 1973).

Valentine, Jeremy 'Art and Empire: Aesthetic Autonomy, Organisational Mediation, and Contextualising Practices', in Jonathan Harris (ed.) *Art, Money, Parties: New Institutions in the Political Economy of Contemporary Art* (Liverpool University Press/Tate Liverpool: 2004).

ORIENTALISM *ORIENT, ORIENTALIST*

Term coined by the comparative literature and **cultural^ history** scholar Edward Said. His 1978 book *Orientalism: Western Conceptions of the Orient* sought to **identify** the broad seam of **western** ('occidental') culture and knowledge based on perceptions of the Orient (or the East). *Orientalism* was Said's name for the fascination that Europeans and Americans took in a world that appeared radically 'other' to them: in **theory** it includes *all* aspects of that world which become **represented** in western accounts – in both positive (**idealising**) and negative (**critical**) ways – though **humanities** scholars have tended to concentrate on orientalist **pictures**, decorative **arts** and **crafts**, **architecture**, novels, and poems (e.g.: **paintings** by: Jean Auguste Dominique Ingres, *Odalisque with a Slave* (1840), Jean-Léon Gérôme, *The Moorish Bath* (1870), Eugène Delacroix, *Algerian Women in their Apartments* (1834); buildings such as The Royal Pavilion in Brighton, remodelled in an Indian **style** by John Nash (1815–23)). The term's **ism** has two senses. It emphasises (1) that oriental is the name for a set of ideas or **perspectives** or representations **created** in the west; and (2) that this knowledge historically was part of a **movement** – the European and later US **domination** of the Middle East through **imperialism**, colonialism, and economic penetration.

Orientalism remains, however, a **complex** and, in some ways, confusing notion. This is partly because 'western' (its apparently opposite term) is an equally difficult notion – though it tends to be equated with western European and US power in the world. Another word for 'western' is *Americanisation* – a process which since the end of the Second World War however has infiltrated European **societies** as much as any other further to the east. The term **globalisation** has also been used more recently to attempt to deal with similar questions concerning how regional powers of **influence** and dominance have

changed and spread, particularly in the **period** since 1945. And while *orient*'s broadest dictionary **meaning** refers ambiguously to 'all countries east of the Mediterranean sea', Said's own tight focus had been on what (in the west) is called 'the Middle East': specifically Egypt and those places to the immediate north-east called Palestine, Israel, Lebanon, and the 'occupied territories'.

These competing and obviously loaded **alternative** names, in one sense, make Said's broader point extremely well: not only have Europeans and Americans labelled and defined the orient in their own terms (in maps, histories, guides, etc), they have also literally attempted to remake, through colonial imperialism, the land and people themselves.

Less effort, comparatively speaking, has gone into dealing with orientalist representations of the Asian regions east of Iran: for instance, Pakistan, India, Indonesia, Vietnam, Korea, China, and Japan. Though **art history** in Europe and North America has long recognised the **visual^ cultures** of these regions, it has not **subjected** this knowledge to the kind of scrutiny that Said turned on the meanings the west **produced** about the 'Middle East'. However, in one sense west and east/orient are entirely relative terms: they depend, literally and **metaphorically**, 'where you stand'. Is there, perhaps, for example, a 'non-eastern' subject who is also not western? A 'southern subject' in art history? Western tends to presume a worldwide dominance and seemingly even has the power to nominate its opponent/**opposed** term. How might the cultures and societies of Latin America, Africa, and Australia get effectively represented in art history, given the dominance of the 'west-east' model reinforced by Said's notion of orientalism?

Further Reading

Gibson, R. *South of the West: Postcolonialism and the Narrative Construction of Australia* (Indiana University Press: 1992).
Said, Edward *Orientalism: Western Conceptions of the Orient* (Penguin: 1991).
—— *Culture and Imperialism* (Chatto and Windus: 1993).
Spivak, G. *The Post-colonial Critic: Interviews, Strategies, Dialogues* (Routledge: 1990).

ORIGINALITY *ORIGIN, ORIGINAL, ORIGINALLY*

The beginning of something or something not done before. Along with **creativity**, *originality* is one of the core – though now rather clichéd – **evaluative^ concepts** of **art^ history**, though the term

itself was only coined in the mid eighteenth century. It was at this time that the invention of this perceived **quality** or attribute occurred when **artists** and the first **critics** were considering the impact that the then-recent discoveries of Greek and Roman remains would have on **contemporary^ painters** and **sculptors**. One twentieth-century writer – the literary critic Harold Bloom – recast originality as the problem of **emulation** or what he called 'the anxiety of **influence**': that is, how can artists both sufficiently acknowledge their debt to others who have come before them (or accompanied them) and yet prove their decisive independence from this influence?

Originality enters art historical **discourse**, then, as a new **meaning** and **form** of **value**. The term, however, has a genealogy (an inheritance of meanings) traceable back to the person usually regarded as the first art historian, Giorgio Vasari, whose *Lives of the Artists* (1550) culminates in ecstatic praise for the 'divinely-inspired' Michelangelo. Vasari's notion of a shaping influence emanating from God Himself is paradoxical. On the one hand, as a compliment it is intended to separate Michelangelo from all other artists, living or dead: he is undoubtedly the best, the greatest, the most accomplished. On the other hand, the highest form of praise Vasari can **imagine** is to confide to his **readers** that God, rather than the mere man Michelangelo, must ultimately be responsible for this greatness. Is Raphael's or Leonardo da Vinci's lesser greatness, then – not a form of divine creation – better, or more interesting, at least in the sense that these two men are held entirely responsible for their achievements?

Originality radically supplants the notion of divine inspiration, locating artistic achievement and value squarely 'in' the artist's mind, **body**, and **expressive** capacities **materialised** in **artefacts** – though various **explanations** of the **nature** of this quality will be offered. Originality becomes tied to the slightly earlier **concept** of **genius**: a type ('genus') apart. Both terms are dependent upon, and related to, an **emerging** sense of individuality, along with powerful **ideologies** of individualism. By the mid twentieth century much art history had become fixated on this **ideal** of unitary, creative, original genius: the 'genius-worshipping' literature on Pablo Picasso exemplifies this. **Feminists** in particular assailed this scholarship as a mystifying **myth** during the 1970s, though others – for instance, **social historians of art** – also sought radically to undermine the claim that the meaning and value of art ('great' or otherwise) could ever really be individually – rather than **socially – produced**.

Debates about art's value, however, continue, within accounts that seek to provide social and **historical** defences for claiming that, for

example, Damien Hirst's mixed **media** artefact *The Physical Impossibility of Death in the Mind of Someone Living* (a shark preserved in a tank of formaldehyde), was, in 1991, a work of startling originality. Those sceptical of these claims point out that originality, in fact, says nothing about something being good or bad, and really only points to something's apparent unusualness.

Further Reading

Benjamin, Walter 'The Work of Art in the Age of Mechanical Reproduction' (1936), in Francis Frascina and Charles Harrison (eds) *Modern Art and Modernism: A Critical Anthology* (Harper and Row: 1982).

Duro, Paul *The Academy and the Limits of Painting in Seventeenth-Century France* (Cambridge University Press: 1997).

Krauss, Rosalind *The Originality of the Avant-Garde and Other Modernist Myths* (MIT Press: 1985).

Schefer, Jean Louis 'On the Object of Figuration', in *The Enigmatic Body: Essays on the Arts* (Cambridge University Press:1995).

PAINTING/PAINTER *PAINT*

A term with two **dominant** and interlinked senses: (1) An ancient **medium** and **practice** of **artistic**^ **expression** involving two indispensable elements – a substance called paint, and a front-facing flattish support **surface** to which the paint is applied; and (2) actual **artefacts** – *paintings* – that manifest these attributes and **qualities**. *Painting* in this second sense is also a collective noun for all the artefacts that meet this definition. The first definition, however, is at least partly based upon **theoretical** and **conceptual** hypothesis. For instance, what is it that conclusively distinguishes painting as a medium/practice from **sculptures** or pots that have been painted (e.g.: the painted clay relief *Monstrous Gorgon with her Child, the Winged Horse Pegasus* (*c.* 600 BCE); the Athenian white-ground *lekythos* (jar) by the Achilles Painter showing a *Muse Seated on Mount Helen* (*c.* 440 BCE))? The distinction depends on the necessarily vague qualification provided above: a painting has paint applied to a more-or-less flat support intended to face the viewer. This marked surface is intended to be **identified** as the chief feature of the artefact or as the **artwork** – it differs fundamentally in this sense from the whole **material**^ **form** which is a painted sculpture or pot.

In terms of **western**^ **art**, painting has really come to mean something like 'an **intended**^ **symbolic** expression **produced** by

colouring a defined and relatively flat surface area with a planned **composition**'. This certainly capacious definition includes, for example, paintings on the walls and ceilings of **natural^ structures** such as caves and **humanly** made buildings including tombs, houses, and churches; paintings on portable surfaces such as canvases and paper, as well as on materials such as wood, glass, and metal. It would be usable in relation to a range of artefacts produced over thousands of years stretching back towards the beginnings of human **communication** in ways other than through verbal **language**.

But this definition also leaves out a vast range of activities! Painting as a key *normative* (that is, **evaluative**) term in **art historical^ discourse** does not include the covering of a garden shed or wall with house paint or the protective coating applied to a fence or submarine. These *are* examples of painting, art historians would have to concede, but the artefacts produced can in no way be identified as paintings (in sense 2 above) – because the purpose of production in these cases has no relation to *any* discernible (though **historically** and **socially** variable) concept of painting as a medium of *artistic* expression. Equally clearly, most art historians would make a categorical distinction between painting understood as a distinct medium or practice of expression (sense 1 above) and the application of paint to the surfaces of artefacts identified as sculptures. For, while it is undeniably true that, for example, paintings *are* three-dimensional objects ('easel pictures'), their surface is flat and understood to be, for the **image**-making purpose literally at hand, two-dimensional. Sculptures, in categorical distinction, are held to have essentially three dimensions of expressive **form** and **meaning** (though relief sculptures on the sides of buildings, for example, can – in a sense, imitating paintings – be very shallow in physical depth; e.g. Andrea Pisano's *A Sculptor at Work*, on the Florentine Campanile (*c.* 1340)). The painted objects produced by **minimalists** in the later 1960s were clearly **designed** to confuse the categories of painting and sculpture, and much mixed media and **installation** work since has continued to undermine the distinction (e.g.: Anthony Caro, steel painted brown and black, *Twenty Four Hours* (1960); Donald Judd, *Untitled (Box with Trough)* (1963); Frank Stella, mixed media, *Queequeq in His Coffin* (1989).

Further Reading

Acton, Mary *Learning to Look at Paintings* (Routledge: 1997).
Bomford, David, Jill Dunkerton, Dillian Gordon, and Ashok Roy *Art in the Making: Italian Painting before 1400* (National Gallery London: 1989).

Wollheim, Richard *Painting as An Art* (Thames & Hudson: 1987).
Wright, Beth S. *Painting and History during the French Restoration* (Cambridge University Press: 1997).

PATRIARCHY *PATRIARCHAL*

Literally meaning 'the rule of the father', *patriarchy* entered **art^ historical^ discourse** in the late 1960s as a **critical** term used by **feminists** both to attack what they saw as misogyny (hatred of women) in the discipline, and to mount a fundamental interrogation of the **subject's** intellectual parameters. The rise of the women's **movement** during this **period** included the **emergence** of feminist challenges to virtually all areas of **academic** teaching and research in the **arts, humanities**, and social sciences (a 'feminist science' however, was, and is, yet to be **conceived**, though a radical critique of male-**dominated** science procedures, **values**, employment **structures**, and **institutional** hierarchies was begun in the early 1970s).

In academic art history the **gender** imbalance between teachers and students was especially evident: the vast majority of professional scholars working in universities were men (and white middle **class**), while their undergraduate students were, by the mid 1970s, mostly women. Similarly, men dominated the running of **museums** and galleries, in which women were employed, if at all, as a subordinate class of assistants and secretaries. Feminists realised that this division of labour, power, and status **reproduced** patriarchal social relations in the **society** at large. It was inescapably true, then, that any feminist intellectual and political challenge mounted *in* the universities – and *to* art history's concerns and interests – had to be connected to an **analysis** of patriarchy in the broader society.

Critiques of patriarchy in the dominant **practices** of art history had two interlinked levels: (1) the study of **gender** relations and hierarchies in past societies undertaken in order to establish how basic economic, **cultural**, political, and **ideological** factors shaped and limited artistic **production** according to the relative power of men and women; and (2) the study of how the writing and teaching of art history itself had been **influenced** by gender relations, as well as, for instance, by factors to do with social class, **ethnicity, sexual** preference, etc. Feminists concluded, depressingly, that throughout most of human history – in societies and cultures around the world, not just in the **west** – women had occupied subordinate positions. This situation had certainly *not*

fundamentally altered by the end of the twentieth century: patriarchy was still – perhaps in some ways even more – powerfully gripping the general **organisation** of socio-cultural, and artistic, life.

A broad distinction may be drawn between US and British feminist critiques of patriarchal **structures** and ideologies in art history during the 1970s and early 1980s. In England the **analysis** conducted by scholars such as Griselda Pollock initially related gender inequalities to social class within a **marxist**-feminist **perspective**: the two political and intellectual **perspectives** sitting uneasily but productively together for a number of years, the one enriching, complicating, and questioning the other. In the US, in most cases, feminist activism in the academy was unrelated to the socialist and marxist **tradition** – a consequence of the marginality of socialist political organisation throughout the twentieth century and the long-term impact of anti-communism in the US during the 1950s. Despite these differences, women *were* successful in both countries in bringing about important changes to the curriculum of art history, to the **composition** of teaching staff, and to the assumptions about the **meaning** and purpose of art and culture and the value of its **historical** and critical **interpretation**. In neither countries now, however, would it be correct to say that a **revolution** (a fundamental 'turning over') of male and middle-class dominance has occurred as a result of feminist activism.

Further Reading

Ecker, G. (eds) *Feminist Aesthetics* (Women's Press: 1985).
Mies, M. *Patriarchy and Accumulation on a World Scale: Women in the International Division of Labour* (Zed Books: 1986).
Spivak, G. *In Other Worlds: Essays in Cultural Politics* (Methuen: 1987).
Walby, S. *Patriarchy at Work* (Polity Press: 1986).

PATRON *PATRONAGE, PATRONAL RELATIONS*

Though the earliest **meanings** of *patron* were positive – the term meant protector, advocate, and defender – the term in the late eighteenth century acquired its still active negative senses as both verb and adjective: 'don't you patronise me!'; 'don't talk to me so patronisingly!' In **art^ history**, detailed studies of patronage (sometimes known as 'patronal relations') have been undertaken mostly in relation to art **produced** in the **period** from **medieval** times up to the late nineteenth century. This is the **epoch** during which the **social^**

relations of production and consumption^ were predominantly **commission**-based: that is, the contract for the production of, say, a **painting** or **sculpture** was directly arranged between an **artist** and the person (or **organisation**) for whom the work would be done. Though there were many variations within this basic relationship, they all shared in common this direct connection between producer and patron – the two were involved in a tangible social relationship of which the **artwork** was the product.

In the late nineteenth and twentieth centuries this **dominant** patronal relation broke down and **artists** began to produce works increasingly for what was (and still is) called the 'free market': a system or network of now largely *socially-unconnected* artists, buyers, sellers, and **influential** intermediaries (such as dealers, **agents**, and **critics**). In one sense, this transformation remains regarded as highly positive: through it artists were 'freed' from hitherto **restricting** controls, such as the highly specific demands of patrons and the related restrictive powers of **academies** that had selected and regulated artists and their works for hundreds of years. **Avant-garde** artists and their supporters, in particular, saw and experienced a kind of liberation: artists were freed to **create**, and to explore their **emergent** senses of individuality unhindered. One can see here how the meaning of patronage could shift from a positive to a negative sense – patrons loaded artists with demands that had to be met.

On the other hand, as the critic Clement Greenberg put it in an essay in 1948, the other side of such new-found freedom is *isolation*, which he thought was the 'natural condition of **high art** in America'. The free market for commodities in a **capitalist** economy can offer no patronal 'protection' or 'defence'; a market – being a system or mechanism – cannot 'advocate' or 'support' in the way a patron can. Artists lost what Greenberg called 'the umbilical cord of gold'. Those artists who do not sell (and choose not to find other kinds of work) will starve – and the age-old cliché of 'artists starving in the garret' is a concomitant truth about the potential consequences of freedom in a free market. However, the interwar period in the twentieth century saw a rebirth in corporate patronage, though this time under the aegis of the **nation^-state**, in the US, the USSR, nazi Germany, and fascist Italy. In the US, for instance, artists were employed, directly, as wage-labourers (1935–39, on the Federal Art Project), though within programmes which were mostly held at 'arm's length' from direct government political control and **ideological** manipulation. In the latter three countries, art was seen by the state as a straightforward propaganda vehicle. In this way, twentieth-century state patronage of

art in officially atheistic communist and nazi societies – Catholic Italy was a partial exception – ironically mirrored the religious **function** of art produced in the **renaissance**.

Further Reading

Antal, Frederick *Florentine Painting and its Social Background* (Routledge and Kegan Paul: 1947).

Garnham, N. 'Towards a Political Economy of Culture', *New Universities Quarterly* Summer: 1977.

Greenberg, Clement 'The Situation at the Moment' (1948) in John O'Brian (ed.) *Clement Greenberg: Collected Essays and Criticism*, vol. 2 (University of Chicago Press: 1988).

Marrinan, Michael *Painting Politics for Louis-Philippe: Art and Ideology in Orleanist France, 1830–1848* (Yale University Press: 1988).

PERFORMANCE ART/PERFORMANCE

Term which entered **art^ historical** and art **theoretical^ discourse** in the later 1960s and early 1970s – though it has been used to describe and **explain** the **meaning** and **value** of some artistic and **art world** events and activities which occurred at least as far back as the 1910s (e.g.: Marcel Duchamp's staging of his alter-ego **identity** as the woman 'Rose Selavy'; and the inter-arts events held at Black Mountain College in the 1950s involving musician John Cage, dancer Merce Cunningham, and **painter** Robert Rauschenberg). The term's **emergence** in the 1960s coincided with the **development** of a wide variety of new **practices** proposed as part of, or at any rate closely related to, then **contemporary** art. These practices – for example, the 'happenings' at Andy Warhol's 'Factory' in New York; Yoko Ono's '**body** art' events (one of which, *Cut Piece* (1963) involved her inviting people to snip away parts of her clothes until she was naked); the countryside walks carried out and documented by the '**land** artist' Richard Long – had different, and even sometimes **opposed**, intentions and aims within the range of **isms** and **movements** that rapidly proliferated in the mid 1960s. Yet all have subsequently been sometimes grouped under the category of *performance* or *performance art*.

In one sense, the term *performance art* really is a **curatorial**, rather than an art historical, invention: it is capacious (or vague) enough to allow the co-**exhibition** and **interpretation** of a wide range of **materials**. Yet the defining problem in the curation of performance art has been the issue of its **representation** in **conventional^**

museum contexts. By definition, many of the earlier events that have been claimed to constitute its **canon** were planned (a) not to take place in, nor be recoverable by, orthodox museums and galleries; and (b) have consequently survived only in **forms** of ageing – and often decaying – documentation, such as **photographs**, notebook directions, and videos. Ironically, although the varieties of actions and events often subsumed as performance art had multiple and even radically antagonistic causes, purposes, and effects, what perhaps they *did* share (at the level of **intention** and aim) was a principled rejection of 'museum-ification', **institutionalisation**, and commodification.

Since the later 1980s, however, arguably a wholesale transformation of contemporary art into a kind of *macro-performance* has taken place: practitioners – such as the yBa ('young British **artists**') Tracey Emin and Damien Hirst – were both lionised and demonised by the **mass^ media** and, in turn, used this **mediated**-celebrity status within, as a component of, their artistic careers. Emin's notorious *Bed* (1999), for example, was successful and compelling in **aesthetic** and **socio^-sexual** terms to the extent that it was perceived as an authentic indicator of her 'mass-mediated' life and persona as a depressive, unlucky-in-love, occasional, hard drinker. This notion of performance as social theatre, however, has more in common with Guy Debord's idea of **capitalist** 'society as spectacle' than with any clearly discernible **critical** artistic intent on the part of Emin and others. The riddle of the **value** of her **artworks**, however, mirrors that of the personas and aims of Andy Warhol and Joseph Beuys, who might both deserve to be **identified** as two of the 'fathers' of performance art.

Further Reading

Banes, Sally *Democracy's Body: Judson Dancer Theater, 1962–1964* (Duke University Press: 1993).

Goldberg, RoseLee *Performance Art: From Futurism to the Present* (Thames and Hudson: 2001).

Jones, Amelia *Postmodernism and the Engendering of Marcel Duchamp* (Cambridge University Press: 1994).

Jones, Amelia and Andrew Stephenson (eds) *Performing the Body/Performing the Text* (Routledge: 1999).

PERIOD *PERIODISATION*

Blocks of time or *periods* of study in **art^ history** are entirely matters of **analytic^ perspective**: artificial devices for ordering and mapping

temporal (and in some ways spatial) relations between **artists, artworks, styles, cultures, societies,** and **theories** of artistic **development, progress,** and decay. A good deal of tension implicitly surrounds the existence of different 'periodisations' (period divisions; the **academic** imperialism involved in what has been declared the 'long eighteenth century' encroaching on the nineteenth, is a case in point). On the whole, however, art historians make allowances to enable their peaceful co-existence. Two types of period still **dominate** the discipline's **conceptual** framework: (1) the temporal span of an artist's life, with his or her **career** often divided into phases **identified** as 'early', 'mature', and 'late'; and (2) the temporal span thought to order and articulate collective styles or **zeitgeists** – for example, **gothic** (*c.* twelfth to thirteenth centuries), **naturalism** (*c.* 1830s–50s), or **abstraction** (*c.* 1910–65). Sometimes these period demarcations are **subject** to intense dispute. Many (perhaps most) of these nominations cross and confuse clear temporal starting and finishing points: naturalistic as well as abstraction**ist** tendencies in art co-existed in the twentieth century, and the general terms **expressionist** and **modernist** conveniently cater for their simultaneous presence in the works of, for example, Henri Matisse (e.g.: compare his *The Inattentive Reader* (1919) and *The Snail* (1953)).

Modern is a multi-purpose periodisation device, though it has been stretched so many ways that its convincing usage must now be specified and **qualified** extremely carefully. For some, the modern is everything after the end of Roman **civilisation** (*c.* fourth century CE – everything before this date is deemed *ancient*); for others everything following the **renaissance** (usually including the renaissance); or culture and society after the French **Revolution's** destruction of the *Ancien Regime* **symbolised** by the execution of King Louis XVI in 1793. Those interested in modernist art, however, have shrunk modern and the experience of modernity to the period since the later nineteenth century – usually claimed to usher in the **capitalist^ social order** and its art after (but including) the **painter** Gustave Courbet (e.g.: *The Stonebreakers* (1849)).

In **theory** periodisation **conventions** seem arbitrary or based entirely on unexamined orthodoxy. In art historical **practice**, however, scholars undertaking research programmes usually come to see their own chosen periods as substantial fact and unmissable truth about art and the world. This entails a commitment to particular kinds of **explanation**: to the belief, for example, that an artist's *oeuvre* (life's work) is fundamentally a response to his personal experiences (e.g.: his/her social **origins**, love-life, relation to children, and sense

of **identity**), or that a dominating and shaping **influence** from outside – say, the spiritual resurgence in **baroque** art of the counter-reformation (e.g.: in the case of Michelangelo Caravaggio) – finally determines the appearance and purpose of art. In many cases, though, art historians are pragmatically *eclectic* in their use of periods, combining and selecting elements from many periodisations as it suits them, a practice sometimes done consciously and with careful reflection, sometimes mechanically.

Further Reading

Cheetham, Mark A. (ed.) *The Subjects of Art History: Historical Objects in Contemporary Perspective* (Cambridge University Press: 1998).

Kemal, Salim and Ivan Gaskell 'Art History and Language: Some Issues', in *The Language of Art History* (Cambridge University Press: 1991).

Marx, K. 'The Eighteenth Brumaire of Louis Bonaparte' (1852), in *Karl Marx and Frederick Engels: Selected Works* (Lawrence and Wishart: 1968).

Schwartz, Vanessa R. and Jeannene M. Przyblyski (eds) *The Nineteenth-Century Visual Culture Reader* (Routledge: 2004).

PERSPECTIVE *PERSPECTIVAL SYSTEM, SINGLE-POINT PERSPECTIVE*

Literally **meaning** viewpoint, the term refers to the **development** of **technical** devices that enabled **artists** in the fifteenth century to project and record a **representation** of the world seen from a single position. In **art^ history** the **humanist** scholar and **architect** Leon Baptista Alberti is credited with inventing a reticulated net which he placed in front of him, through which he was able to observe, and draw – literally within the rational framework of the net – the scene he **viewed**. By meticulously transcribing the view through the net onto a sheet of paper – square by square – Alberti was able to depict how objects further away (in *perspective*) appear smaller. This innovation has attained nothing short of **mythic** status in the discipline: it is retold as the moment when various key aspects of **modern** existence start. It is, offered, for example, as **sign** and **symbol** of the rejection of a religion-centred view of the universe, expressed in pre-**renaissance^ pictures** that show things and people in strictly 'hieratic' or divine relation: God in the middle of a pictorial or **sculptural^ composition**, the biggest because most important entity; or by the choice of pigment colours, such as blue and gold, used **symbolically** in paintings to show the theological status of things depicted (e.g.: the

relief sculpture of *Christ with St. Peter and St. Paul*, from the sarcophagus of Junius Bassus, in the Crypt of St. Peter's (CE 359)).

Perspective, in contrast, has come to stand for a **human**-centred view of the world, and for a rational ordering of pictorial meaning based on both **visualisation** (optical) devices and visual-representational **conventions**. Perspectival systems enabled artists and architects – and later many other kinds of scientist and planner – to plot with extreme accuracy the size of objects, and their rate of getting bigger or smaller, within the perspectivally ordered visual field. Some artists became well-nigh obsessed with this new means of control over how things could be shown accurately and convincingly – consider Andrea Mantegna's *St. James on the Way to His Execution* (wall-painting formerly in the Eremitani Church, Padua (1455)) and Jacopo Robusti Tintoretto's *The Finding of St. Mark's Remains*, Milan (1562). However, artists continued to use these technical, rationalising innovations as part of painting **practices** bound up with Christian **narrative** schemes, and in the service of religious-devotional **institutions** and forces in **society**. Perspectival systems, along with the learning of **naturalistic** techniques for drawing and painting based on the direct observation of **nature**, *did not* bring about a momentous rupture with the broader **cultural** and social **ideologies^ dominating** European societies – though the **emergence** of an elite of **humanist** scholars (and those who would later become recognisable as scientists in the **modern** sense) *did* lead to a gradual fragmentation of the middle classes and the eventual **creation** of what was called, by the early twentieth century, an *intelligentsia*.

Perspective has a familiar common meaning in ordinary **language**: it refers to someone's **values** and situation. Interestingly, this is usually described as **subjective** and a matter of personal interests or opinion – reversing the judgement that perspective in renaissance art had led to a new kind of objectivity and truthfulness. By the nineteenth century, however, some artists concluded that perspectival systems had become aridly conventional and symbolic of a soulless hyper-rationalist outlook – part of modern knowledge, political philosophies, industrialisation, and the technology that had led to the apocalyptic clash of European **nations** after the French Revolution. The **romantics** reacted against this rationalism and its inhuman terrors, though sometimes they themselves had become obsessed with the sublime visions of grandeur that perspective had enabled (see e.g.: John Martin, *Belshazzar's Feast* (1826), an Old Testament bible scene portrayed as if it were happening in what looks like a colossal railway station).

Further Reading

Crary, Jonathan *Techniques of the Observer* (MIT Press: 1990).
Earl, Edward W. (ed.) *Points of View: The Stereoscope in America: A Cultural History* (Universities of New England Press: 1979).
Olin, Margaret 'Gaze', in Robert S. Nelson and Richard Shiff (eds) *Critical Terms for Art History* (University of Chicago Press: 2003).
Panofsky, Erwin *Perspective as Symbolic Form* (1927) (Zone Books: 1991).

PHOTOGRAPHY *PHOTOGRAPH, PHOTOGRAPHIC*

Literally **meaning** 'writing with light', *photography* was a means of **visual^ representation** invented during the nineteenth century which enabled a light-sensitive **surface** to register an **image** which could then be chemically **developed**, stabilised, and preserved as a print. This image was a representation of the **view** seen through the lens (often called an 'artificial eye') of the photographic camera. 'Camera', Greek in its **origins**, means a chamber or enclosed room. **Modern** – pre-digital – cameras receive the light that enters the lens, which falls upon the light-sensitive **material** (**film**) positioned at the back of the camera. These are the segmented 'exposures' that are developed into separate photographs. However, devices known as 'camera obscuras' had existed for thousands of years before the invention of photography: darkened boxes, sometimes bigger enclosed spaces, with an aperture (hole) allowing in light – sometimes **composed** of glass lenses able to magnify and focus. The image this light **formed** was projected inside the camera obscura, against the wall opposite the aperture.

This brief description indicates two things. First, that the **technology** of photography was *not* **created** all at once, but **emerged** and evolved over a number of decades from the late 1820s – when the first photographs were made – through to the early twentieth century, when, for example, colour film became available. Many technical innovations and changes occurred during this **period**, concerning, for example, the **production** and use of (1) ever-more sophisticated lenses; (2) light-sensitive materials for recording light inside the camera; (3) devices for enlarging (or reducing) to a certain size and projecting the 'negative' image captured on photographic film; and (4) the related technologies for printing. Throughout this period photography itself was a **concept** in transition, evolving new meanings, uses, and **values** as its practical, **social**, and **aesthetic** purposes were transformed. Second, the earlier existence of the

camera obscura device suggests that long-standing **discourses** concerning the veracity (**realism**) or documentary truth of photography – the belief that such visual representations show reality truthfully or objectively (compared, for instance, with **paintings** or drawings) – had an important pre-**history**, in the sense that the possibility of producing images of the world mechanically had been known about long before the nineteenth century.

Since the 1970s the technology has continued to change, as mechanical photographic devices have been linked to, or superseded by, electronic and digital systems for image-production, transmission, and reception. This adaptation process has, in one sense, *never* stopped: the technological innovation of the 'movies' (silent, and then with sound, black and white and then in colour) in the very early twentieth century connected photography to another range of highly **influential** social, **institutional**, and aesthetic **practices** in **cinema**. **Television**, video, DVD, and computer-generated imaging technologies have followed. While many of these techniques, technologies, and representational systems have taken a place in the **visual** arts (having **complex** relationships with both painting and, more recently, mixed **media** and **installation** art), they have also been used extensively in social, medical, publishing, political, legal, scientific, and military activities (e.g.: closed circuit TV cameras in British cities; **body**-scanning systems in hospitals; personal **identity** validation; and weapon-targeting systems in aircraft and tanks).

Further Reading

Barthes, Roland *Camera Lucida: Reflections on Photography* (Hill and Wang: 1981).

Newhall, Beaumont *The History of Photography: From 1989 to the Present* (Little, Brown, and Company: 1999).

Solomon-Godeau, Abigail *Photography at the Dock: Essays on Photographic History, Institutions, and Practices* (University of Minnesota Press: 1991).

Tagg, John *The Burden of Representation: Essays on Photographs and Histories* (Macmillan: 1988).

PICTURE *PICTURESQUE*

Though this term's Latin root lies in **painting** (*pingere*: 'to paint'; related to the term *picturesque*, meaning an actual **view** that reminds one of a picture), the term is ordinarily used in **art**^ **history** to refer

to a graphic **representation** of something inscribed upon a **surface**. Interestingly, however, it is also common to talk of 'mental pictures' – sometimes prompted by considering literary **metaphors** – and '**images** or **visions** in our heads'. This usage suggests two at once combined and opposing elements to the **meaning** of *picture*: (1) something that is tangibly, **materially**, and recognisably depicted, yet which (2) may appear to be 'im-material' or fictive: the image of the picture received by our eyes and brains becomes a mental picture that will finally dissolve and disappear.

This paradoxical **quality** relates to drawn or painted pictures because it is often (even usually) the case that these contain visual **illusions** of various kinds. For instance, **perspectival** devices and systems, using line or colour to suggest depth of field, **create** illusions of something not literally present on the flat surface of a piece of paper or canvas (e.g.: Albrecht Dürer's perspective-stressing engraving of 'The Nativity' (1504) or the famous reversible 'duck-rabbit' drawings used in **psychological** testing). When viewing pictures in **museums**, or those illustrated in books, perspectival devices are usually very clearly **identifiable**, and understood as, **conventions**: that is, they have *not* been **produced** in order to trick viewers into believing they are looking at an actual three-dimensional world. Other pictures, however, *have* been created in order to amaze and trick, or are used socially and **institutionally** in ways that suggest they contain truths that, in other circumstances, might well be doubted. An example of the former is that category of pictures called *trompe l'oeil* (literally, from the French, 'deceive the eye'), for instance painted depictions of **architecture** in churches and other **public** buildings that suggest a higher tier above and beyond the actual height of a **structure** (e.g.: Andrea Pozzo's ceiling painting Allegory of the Missionary Work of the Jesuit Order, in the Church of St. Ignazio, Rome (1691–94)). Examples of the latter include some kinds of **photographs** that are accredited with especial legal 'truth **value**' in **contemporary^** society: images of moving vehicles, for example, used to prosecute drivers accused of speeding, or passport photographs regarded by immigration officials as definitive proof of someone's physical appearance and **identity**.

In both these latter cases, however, it is clear that such visual representations must be read and **interpreted** in particular, conventional ways: their respective 'truthfulness', that is, is based on their conforming to certain **discursive** rules and conventions that govern their meaning. For instance, passport photographs are required to show faces head-on (not profile), in a neutral expression supposed

to be 'without affectation'. If these conventions are not adhered to then the picture is likely to be regarded as invalid – legally un**readable**. Since the attacks on the World Trade Center in New York in 2001, however, the veracity of these pictures has been undermined and new conventions of **identification** proof introduced, involving, for example, eyeball and fingerprint scanning systems as well as DNA testing. Yet in all these cases, too, these determinations of truthful identity can be, and have been, challenged in legal disputes. The same is true, in fact, of all pictures: they remain images (semantically unstable visions) intelligible to viewers who use knowledge, **techniques**, and experience to make sense of what they see (whether they are aware that those aptitudes and skills **influence** their interpretation or not).

Further Reading

Berger, John *About Looking* (Pantheon Books: 1980).
Jay, Martin *Downcast Eyes: The Denigration of Vision in Twentieth Century French Thought* (University of California Press: 1993).
Mitchell, W. J. T. *Picture Theory* (University of Chicago Press: 1994).
Zizek, Slavoj *Looking Awry* (MIT Press: 1992).

POP/POP ART/POPULAR *POPULARITY*

Pop is a contraction from popular and pop **art** – the term was coined by the British **critic** Lawrence Alloway in the mid 1950s to describe the **emergence** then in that country of a whole **culture** blatantly at odds with old-fashioned English establishment, vernacular, and conservative **taste**. This context is highly important in understanding the **original**^ **significance** of the term. Pop was **identified** by a group of British **artists**, critics, and writers at this time as a distinctively *American* **form** and attitude derived from a US **social**^ **development** alien to, and in some ways directly antagonistic towards, Britain's Victorian and imperialist past. Neither was pop in its earliest sense restricted to a narrow definition of use within the **visual** arts – indeed, pop was, in one sense, a clearly 'anti-art' term embracing all the forms of, for instance, display, entertainment, **advertising**, commodity branding, and signage found in then **contemporary** US society. (Pop's anti-art facets found **representation** in a related term – explicitly connected to a much earlier **oppositional**^ **avant-garde**^ **movement** – which also appeared in the early 1960s: 'neo-**dada**'.)

The Independent Group – a **formation** of artists and critics active in London in the mid 1950s, who met at the recently-opened **Institute** of Contemporary Arts, including writer Reyner Banham, artists Peter Blake, Richard Hamilton, Eduardo Paolozzi, and **architects** Peter and Alison Smithson – **produced** a range of visual and **textual^** **artefacts** that illustrated and celebrated this whole graphic universe of American **consumer**-culture. In 1956 they **organised** an **exhibition** at the Whitechapel Art Gallery called 'This is Tomorrow'. Richard Hamilton's **photo**-montage poster for the show, **titled** *Just what is it that makes today's home so different, so appealing?* included **images** of a vacuum cleaner, a body-builder, a **TV** set, and the earth seen from space. Its montage **technique**, as well as its thematic elements, indicated a rejection of **traditional^** **painting** and **academic^** **compositional^** **conventions**. Implicit in this work – and in all early pop – was a challenge to **viewers**' tastes and expectations, though its shock-**value** decreased rapidly during the 1960s (e.g.: Roy Lichtenstein, *Popeye* (1961); Andy Warhol, *Lavender Disaster* (1963); Claes Oldenburg, *Soft Toilet* (1966)).

This occurred because pop became successful in art market terms and, later, its producers found their artefacts collected and exhibited by the **museums** whose institutional conservatism they had set out initially to challenge. In addition, if pop had begun in a self-conscious **manner** as a British response to US **capitalist** culture and society, then its later American **practitioners** produced works for a new constituency of affluent middle-**class** art buyers whose tastes, on the whole, had *never* been much **influenced** by European **high art**. Not surprisingly, pop was (and remains) exposed to a range of critical attacks – ranging from those defending a notion of high art in either **humanist** or avant-garde 'anti-**mass culture**' terms (e.g.: Max Kozloff, Clement Greenberg, and Benjamin H. D. Buchloh) to **feminists** who condemned pop's **subject matter** as **sexist** and misogynist (such as paintings by Mel Ramos, for example *Tabacco Rose* (1965)). Pop has enjoyed a long after-life in a strain of recent art produced from the 1980s onwards, including works by Jeff Koons whose choice of overtly banal and kitsch objects for representation and display continues a theme prevalent in Warhol's art of the 1960s (e.g.: **photograph**, *Jeff in the Position of Adam* (1990); **sculptures** *Michael Jackson and Bubbles* (1998) and *Inflatable Balloon Flower* (1997)).

Further Reading

Foster, Hal and Mark Francis *Pop Art* (Phaidon: 2005).

Lippard, Lucy *Pop Art* (Thames and Hudson: 1966).

Robbins, David (ed.) *The Independent Group: Postwar Britain and the Aesthetics of Plenty* (MIT Press: 1990).

Whiting, Cecile *A Taste for Pop: Pop Art, Gender, and Consumer Society* (Cambridge University Press: 1997).

POPULAR CULTURE

Though an **analytical** term and area of enquiry generated within the comparatively recent field of **cultural studies**, the **concept** of *popular culture* has become increasingly integrated – **theoretically** and empirically – into the concerns of **art**^ **history**. In one sense, before the phrase itself had been coined, art historians had recognised for a long time that many of the **artefacts** they studied – for example, devotional **paintings** and **sculptures** in churches, prints and drawings sold in multiple copies, the decorative and vernacular arts and **crafts** – circulated and **functioned**^ **historically** (at least in their **original** contexts of **social** use) as part of a broad **public** culture and society.

Renaissance paintings, for example, had a manifest and primarily religious-**ideological** purpose in the city-**states** in Europe **dominated** by the Catholic Church. Though the **emergence** then of the **humanists** eventually **produced** a social **class** of intellectuals increasingly sceptical of Christianity's status as the ruling belief-system in the European **nation**-states of the eighteenth and nineteenth centuries, devotional art was used by the Church in the fifteenth and sixteenth centuries to engage and integrate the **mass** of the people in its socio-political, as well as theological, dominion. Mass, in one sense, is a neutral term: it can be used to mean simply 'all' or the 'majority' of the people. This, after all, was its Catholic liturgical sense. However, like popular, **public**, and folk, mass can be given sharp positive or negative connotations. If 'public' in the eighteenth century actually referred to a very small minority of people who had status, property, and wealth – the accumulation of which entitled them to **representation** in the fledgling democratic parliaments of countries such as Britain and France – then popular meaning 'people' suggested an amalgamation of sectors of society **significantly** *beyond* this narrow group (though including elements of the public who shifted their political and social allegiances towards democratic reform).

Though, like *mass*, a term of political rhetoric – for instance, used as a rallying call in the French **Revolution** for those opposed to the King and the domination of that country by an alliance of the monarchy, the aristocracy and the Church – popular began also to be used

in the later nineteenth century to describe certain **tastes, artefacts,** and **values** associated with the **development** of **modern** industrial-urban society. These included: new and cheap newspapers and magazines, **photographs** and prints; day-trip (and 'package') holidays on trains and buses; and, later, **films, television,** and kinds of 'pop music' such as rock and roll – both that played live to an audience and recorded on disc for sale. By the early twentieth century, then, notions of **high** (and **academic**) art, popular-, folk- (suggesting rural or pre-modern), and **mass culture** had begun to co-exist and to an extent even merge. Was pop art mass or popular culture? What about songs by the Beatles, described by some musicologists at the time as comparable in **quality** to the work of some **classical** composers? Mass culture, a mid-twentieth-century term with **complex** origins on both the political left and right, became used by commentators aggressively and rhetorically to condemn the products and processes of urban-industrial **consumer^-capitalist** society. Popular, in contrast, retains – perhaps uneasily – the earlier political sense of being **progressive**: an alliance of groups and interests forming an overall democratic majority, and opposed to the prejudices, privileges, and power of a narrow elite.

Further Reading

Fiske, J. *Understanding Popular Culture* (Unwin Hyman: 1989).
Frith, S. 'The Cultural Study of Popular Music', in L. Grossberg, C. Nelson, and S. Frith (eds) *Performing Rites: On the Value of Popular Music* (Oxford University Press: 1992).
Storey, J. (ed.) *Cultural Studies and the Study of Popular Culture: Theories and Methods* (Edinburgh University Press: 1997).
Strianti, D. *An Introduction to Theories of Popular Culture* (Routledge: 1995).

PORTRAITURE *PORTRAIT, PORTRAYAL*

The making of **visual^ representations** containing likenesses of actual people (including the **artists** themselves), in a variety of **media** including **painting**, drawing, and **sculpture**. In this general sense, *portraiture* has been in existence for thousands of years, given the reasonable likelihood that those **producing^ images** of people probably often drew on those they knew whose appearance they directly attempted to convey with the **materials** at hand (e.g.: over life-size sculptural bust of the emperor Vespasian (*c.* CE 70), in the Museo Nazionale, Naples; painted portrait of a man, from a Mummy

found at Hawara, Egypt (*c*. CE 150)). On the other hand, **historians** of **western**^ **art** tend to regard the **renaissance** as the phase in **western** art when an explicit nomination of particular **subjects** (individuals) for portrayal **developed** rapidly. In this latter sense, then, portraiture only became a recognisably distinct **genre** – involving the codification of its **conventions**, **meanings**, and **values** – in the sixteenth, seventeenth, and eighteenth centuries, as part of the **academy**-system for training, accrediting, and **exhibiting** the work of artists (examples include Jacopo de'Barbari's *Portrait of Fra Luca Pacioli* (1500); Raphael's *Portrait of Baldassare Castiglione* (1516)).

Portrait painting, within, for example, British, French, and Spanish **societies** during this **period** was almost entirely an 'honorific' process intended to commemorate and celebrate individuals who were powerful, wealthy, or **symbolically**^ **significant** (often a combination of all three attributes). Only certain individuals – and *kinds* of individuals, therefore – would be, and could afford to be, depicted. These included kings and lords; high-ranking soldiers, civil servants, politicians, and philosophers; popes and bishops; burghers, bankers, and their wives (e.g.: Jean-Antoine Houdon, bust of Voltaire (1778); Joshua Reynolds's *Mrs. Siddons as the Tragic Muse* (1789)). It is during this time, too (the early seventeenth century) that the **concept** of a specifiable *individuality* in terms of physical appearance, attributes, and character, **emerges**. Portraiture, then, both contributes to, and reflects, this immensely important social development. Artists, at the same time, began to depict *themselves* within representations that constitute a sub-genre – 'self-portraiture' (e.g.: Peter Paul Rubens's *Self-portrait* (*c*. 1639)). Portraits and self-portraits were produced in both group- and single-subject scenes, indicating that 'social belonging' as well as a new emphasis on individual **identity** co-exist (e.g.: Diego Velazquez's combined Spanish royal family group portrait and self-portrait *Las Meninas* (1656), and Rembrandt van Rijn's group-portrait of a troop of soldiers *The Company of Frans Banning Cock Preparing to March Out*, or *The Night Watch* (1642)).

Many other kinds of **identifiable** portraiture were produced in the following centuries: including painted representations of children and animals (e.g.: Joshua Reynolds's *Portrait of Miss Bowles with Her Dog* (1775)) and studies of the old and the mad (e.g.: Edgar Degas's *Uncle and Niece* (1875); Chaim Soutine's *The Idiot* (1915)). In the twentieth century an effectively new kind of artistic '**psychological** interior' self-portraiture evolved, based not on **naturalistic** or **idealised** depictions of facial and **bodily** features, but on objects – such as plants and **landscapes** – represented **expressively** as indices (inani-

mate **signs**) of personality. Vincent van Gogh's *Sunflowers* and *Pair of Boots* (1888 and 1886 respectively) are early examples of what might be called this **abstracting** of portraiture in modern society: the two **pictures** are conventionally **interpreted** now as indications of van Gogh's state of mind. Tracey Emin's *Bed* (1999), an **installation** of what had been her own bed, along with a carefully selected range of personal belongings strewn upon it and around it, has similarly become known effectively as a self-portrait.

Further Reading

Bell, Julian *500 Self-Portraits* (Phaidon: 2004).
Brilliant, Richard *Portraiture* (Reaktion Press: 1991).
West, Shearer *Portraiture* (Oxford University Press: 2004).
Woodall, Joanna (ed.) *Portraiture: Facing the Subject* (Manchester University Press: 1997).

POSTCOLONIAL *POSTCOLONIALISM*

One of a cluster of core terms used within **theoretical** and **historical** discourse concerned with issues of how the world, and our knowledge of it, has changed especially since the mid twentieth century. Only within the last ten years, however, have these questions about **culture**, **society**, **imperialism**, and systems of knowledge found a prominent or consistent place in **art^ historical** scholarship. Three of these **concepts** – *postcolonial*, **postmodernism**, and **poststructuralism** – share a **complex** and in some ways confusing prefix. The difficulty partly arises because these terms have been in existence now for several decades, though the 'post-' might suggest they're intrinsically provisional. To the contrary: they are all firmly established as concepts and **forms** of **analysis** which do not function simply as appendages to earlier or more important notions (those concepts respectively of colonialism/**cultural imperialism**, **modernism**, and **structuralism**).

The prefix 'post' carries two related senses. First, it refers to a '**state** afterwards' – a changed situation and how it has been brought about. Second, it contains the implication that this changed situation in some way remains significantly intelligible in terms of the prior condition or state. *Posthumous*, to take a simpler example, literally means 'after being buried' (from the Latin): the term refers to the **significance** or **meaning** of the person after his or her death. The 'afterness' of death is tied forever to the prior life of the **body**

and actual person – death can only be meaningful, indeed, in relation to this life.

Postcolonial, in turn, refers to the situation of a people or society or culture *after* it has been exposed to the presence of those who have come to that people or society or culture with the intention of subjugating, controlling, exploiting, and even improving it. Though in **popular** usage *postcolonial* is usually intended to refer to the state of that people or society or culture after the colonising force has *left* (for instance, after the British army and colonial administration physically, politically, and militarily left India in 1947), the term has pressing analytic **value** relating to the condition of the **subject** people or society or culture *as soon as* the initial colonial contact occurs. In the case of India, this was in the seventeenth century, when British traders, settlers, and government **representatives** first arrived there and began to affect the society and its people – inventing, of course, a name for that country for the colonising population: India (and later, similarly, Australia, New Zealand, Rhodesia, etc.).

Part of the complexity of postcolonial **identity** is to do with how a colonised people or society or culture absorbs the meanings for itself invented and imposed by a colonising force. When colonised states achieve their 'independence' politically and militarily from a colonising country their new sovereign status is usually an uneasy mixture of earlier (pre-colonial) elements and forms of identity **created** during the colonisation process. This is dramatically the case, for example, with Iraq – a **nation**-state whose existence as a unified singly entity was wholly the invention of the British who occupied and colonised the land in 1914. The tribal and religious distinctions and divisions within **contemporary** Iraq have come to the fore – and impeded the planned **development** of a **western** European-**style** nation – because the ending of Saddam Hussein's regime also removed key parts of the stabilising state-apparatus inherited from the days of direct colonial rule (ended in 1921) and pro-US 'client-regime' status (ended in 1963).

Further Reading

Chatterjee, P. *The Nation and its Fragments: Colonial and Postcolonial Histories* (Princeton University Press: 1993).

Clayton, D. and D. Gregory (eds) *Colonialism, Postcolonialism and the Production of Space* (Blackwell: 1996).

Easton, S. C. *The Rise and Fall of Western Colonialism: A Historical Survey from the Early Nineteenth Century* (Praeger: 1964).

Fanon, Frantz *Towards the African Revolution* (Penguin: 1964).

POSTCOLONIAL STUDIES

Over the past twenty-five years, **art^ historians** have increasingly turned their attention to the situation of art and **artists** in countries **subjected** to **western** imperial rule. A new and distinct area of study, in addition, has **developed** concerned specifically with the **analysis** of *all* aspects of these **societies** and their **cultures**: the inter-disciplinary field of *postcolonial studies*. This embraces and inter-relates **traditional^ subjects** such as **history,** geography, sociology, economics, political studies, literature, and the arts and **crafts**. The range of regions, societies, and peoples examined within postcolonial studies is vast (simply considering the history of western imperialism): the continents of Africa, southern and central America, Asia, and Australasia.

Beyond all these peoples and societies and cultures, however, postcolonial studies' **theoretical** scope reaches much further, to include the history of, for instance, British colonialism in what are now the sovereign **nation^-states** of Canada and the United States of America – two more societies that will forever remain, in one sense, themselves postcolonial. (The recognition that colonial **identity** can never finally be eradicated might partially explain why the US is fixated with the **concept** of its independence – from the British – officially dated from 1776 and why, though the US has over 600 military installations around the world, it would never permit another country, even a very close ally, to garrison troops in their own bases on American soil.) But beyond the North American societies, the extension of the remit of postcolonial studies goes further still. Britain itself may be defined, in a variety of important respects, as postcolonial. Relinquishing its empire fundamentally changed British society and culture, as well as its importance within Europe and the world beyond. After the Second World War and the British exodus from India the country's economic and political power declined rapidly across the globe. In the 1950s and 60s Britain took the decision to admit many tens of thousands of immigrants from its former colonies (renamed the Commonwealth countries), including those in the Caribbean, as well as India and Pakistan. These peoples settled in Britain and their presence has led to profound changes in the country's culture and social life – at the most obvious level, for example, in cuisine and musical **tastes**. Britain's former empire of subject peoples was recreated, displaced from these territories, in the 'mother-country' or **metropolitan** homeland – a process repeated to a lesser degree in the 1960s in France, Portugal, and Holland. All

these countries and their cultures have also become in this sense postcolonial.

Art historians, then, are involved in a much more wide-ranging investigation than those working in a single discipline may realise. Their studies of, for example, the power colonial regimes had in shaping the training of artists and **designers** in the territories they invaded and occupied – for example, the establishment of British art **academies**, such as the Calcutta Mechanics Institution and School of Art (founded 1854) – are part of a much broader radical social and cultural history of colonialism. Both **traditional** crafts activities and western notions of art and artistic **production** became meshed in the **creation** of this colonial culture. These societies – even after the retreat of the imperialists – were changed for ever in this process.

Further Reading

Richon, Olivier 'Representation, the Harem and the Despot', in G. Robertson (ed.) *The Block Reader in Visual Culture* (Routledge: 1996).

Thomas, N. *Colonialism's Culture: Anthropology, Travel and Government* (Polity Press: 1994).

Viswanathan, G. *Masks of Conquest: Literary Study and British Rule in India* (Columbia University Press: 1989).

Zavala, I. M. *Colonialism and Culture: Hispanic Modernisms and the Social Imaginary* (Indiana University Press: 1992).

POSTMODERNISM *POSTMODERN, POSTMODERNIST, POSTMODERNITY*

Term used to refer to fundamental **developments** in **culture** and the **arts** since the 1960s, although some **critics** and **theorists** have claimed that the **origins** of **postmodern^** **society** can be found much earlier on in the twentieth century. *Postmodernism*, like some related terms (such as **modernism** and **realism**) refers, sometimes confusingly, both to accounts, or theories of things, *and* to the things themselves. For instance, one of the earliest theorists of postmodernism in **architecture**, Charles Jencks, claimed that the new buildings he wrote about attempted to pastiche (copy) **stylistic** elements associated with **classicism** (e.g.: Charles Moore's Piazza d'Italia in New Orleans (1975–80) and Philip Johnson's A T & T Building in New York (1978–83)). This ironic and 'knowing' attitude towards the past is a central characteristic of postmodernist thinking which intrinsically sees its theoretical and critical pre-

decessors *retrospectively*: in a concluded past. Jencks (the postmodernist theorist) is critical of, for example, Le Corbusier (modernist architect and theorist) for holding that the **design** and appearance (**form**) of new buildings could and should simply 'reflect' their practical **function**. Jencks, in contrast, emphasises the playfulness and rhetorical effects of the buildings he calls postmodernist. A sense of **historical**, critical, and **creative** 'afterness', then, characterises all postmodernist art and theorising, as the prefix 'post-' indicates.

Why, then, this rejection of modernist theories and **artefacts**? If postmodern**ism** is centrally a sceptical *attitude* towards the past (and past styles) that finds various **media** within which to **express** this attitude (for example, the return – ironic and 'knowing' – to **naturalistic, narrative**, and expressionistic **conventions** which occurred in some early 1980s painting after many decades **dominated** by **abstraction** (e.g.: Sandro Chia, *Water Bearer* (1981); Francesco Clemente, *Waiting* (1982)), then postmoder**nity** is the term used to describe the changed economic, social, and political conditions themselves. By the early 1970s, for example, it had become clear that modernity's **material^ progress** and prosperity in the **west** had come to a stop with the oil crisis, ultra-high inflation, and unemployment. Second, **technological** and industrial development throughout the world had produced actual – and threatened future – ecological and social disaster for both the richer and poorer peoples in the world. **Globalisation** was the name later to be given to this general situation, caused by the spread of multinational corporations whose interests and commitments in different countries were highly vulnerable to energy, market, and technology changes. Third, the decline of belief in any viable **alternative** political system or **ideology**, such as socialism – a 'legitimating *meta-narrative*' of emancipation as Jean-François Lyotard called it – that might replace failing corporate **capitalism** *and* the authoritarian state-socialism of the USSR and its satellite **states**, led to widespread apathy and disengagement from civil society. Postmodernist art **signals**, then, a kind of 'adriftness' from the **myth** of twentieth-century modernity – its failed promises – though it is prepared to **appropriate** virtually any and all of modernism's cultural forms and resources.

While these conditions undoubtedly also helped to bring about new social **movements** for radical political change (such as 1970s **feminist**, ecological, and **postcolonial^ organisations**), along with some innovative developments in art and culture broadly (related to new technologies such as video and digital **image** manipulation), it appeared, by the late 1980s, at least to one **influential** socialist

intellectual – Raymond Williams – that the world had become 'stuck in the "Post"', with no positive **vision** of a really changeable and sustainable future beyond capitalism. Though the term *postmodernism* has become much less evident in the **period** since the mid 1990s, that general crisis of belief, and crisis over global development – economically, ecologically, politically, and militarily, not to mention culture and the visual arts – has, if anything, steadily worsened.

Further Reading

Foster, Hal (ed.) *Postmodern Culture* (Pluto: 1985).
Harvey, D. *The Condition of Postmodernity: An Enquiry into the Origins of Cultural Change* (Blackwell: 1989).
Huyssen, Andreas *After the Great Divide: Modernism, Mass Culture, Postmodernism* (Indiana University Press: 1986).
Lyotard, Jean-François *The Postmodern Condition: A Report on Knowledge* (Manchester University Press: 1989).

POSTSTRUCTURALISM *POSTSTRUCTURALIST*

Name, as its prefix suggests, for a set of **developments** in a range of disciplines and **theoretical** debates once **dominated** by positions that were given the name **structuralist**. The leading poststructuralist thinkers were Roland Barthes (literature and **cultural** theory), Jacques Derrida (philosophy, literature, and cultural theory), Michel Foucault (philosophy, **social^ history** and theory), Jacques Lacan (**psychoanalysis**, and related concerns associated with **surrealism**), and Claude Levi-Strauss (anthropology and **linguistics**). None, as this brief account indicates, had **career**-long or fundamental theoretical interests in the **visual^ arts** or **art history**, though all wrote essays or books which focused on the concerns of art historians either directly or indirectly.

Derrida's *The Truth in Painting* (1978), a highly **complex** meditation on the **meanings** of **style, authorship, and interpretation** in art, drawing on related writings by the early-twentieth-century German philosopher Martin Heidegger, **represents** the most *directly* sustained and important poststructuralist contribution to debates in philosophical **aesthetics** and art historical **explanation**. Lacan's personal involvement with the surrealist **movement** in Paris in the 1920s and 1930s – both as a psychoanalyst to its leading thinker André Breton, and whose own later hugely **influential** theorisations of psychoanalysis were indebted to this earlier experience – makes

him an important historical **figure** in the development of surrealism as an **avant-garde^ formation**.

But the general **significance** of the poststructuralists was in their attempts to show the active, constitutive role culture and representation play in the **organisation** and transformation of **human** societies and their **discourses** (**structures** of meanings and **values**). All stressed the central importance of language as a model of **communication** and meaning – like the structuralists before them. But they also radically *undermined* the accounts of language the structuralists had offered, seeing verbal and spoken discourse as open, changeable, and ambiguous, in contrast to the earlier **view** of them as coherent, fixed, and secure in their properties. Beyond that, as Derrida's, Lacan's, Barthes', and Foucault's studies showed, other **forms** of representations and signs – including **paintings**, prints, drawings, and **photographs** – had important roles in ordering human societies, their **institutions**, **ideologies**, and belief-systems.

Perhaps of most immediate interest to art historians is Barthes' set of essays on different facets of what would now be called **visual culture** contained in his book *Image Music Text* (1977), though his earlier studies *The Fashion System* (1967) and *Empire of Signs* (1970) – on Japanese culture – were instrumental in developing forms of analysis centred on the visualities and visibilities of meanings and differences in everyday cultural life. In that sense these books are part of the early history of **cultural studies**. Barthes's even earlier *Mythologies* (1957) and *Elements of Semiology* (1964) constituted important elaborations of **semiological^ analysis** bound up with theories of linguistic meaning, though he was already pushing far beyond the **formalism** of this **tradition** and connecting systems of meaning in culture and the arts to political and ideological values and interests. Michel Foucault, from a different philosophical vantage point, broached questions of visuality and power in a number of important essays of direct interest to art historians, including the chapter on Diego Velazquez's painting 'Las Meninas' in *The Order of Things* (1964) and 'Fantasia of the Library' (1967) in his *Language, Counter-Memory, Practice* (1977) which considered the impact of art **museums** on the work of **contemporary^ artists** in the later nineteenth century.

Further Reading

Derrida, Jacques *Writing and Difference* (Routledge and Kegan Paul: 1978).
Foucault, Michel *The Archaeology of Knowledge* (Pantheon Books: 1972).

249

Lacan, Jacques *Four Fundamental Concepts of Psychoanalysis* (Hogarth: 1977).
Sturrock, J. (ed.) *Structuralism and Since: From Levi-Strauss to Derrida* (Oxford University Press: 1979).

PRACTICE/PRACTICAL *PRACTITIONER*

Introduced into **art^ theoretical^ discourse** only in about the past twenty-five years or so, *practice* is one of a cluster of terms – along with **producer, product,** and **social^ relations of production and consumption^** – which together constitute a **materialist^ conceptualisation** of the **nature** of **western** art-making and its **explanation.** This is in sharp contrast to a much older **opposed, idealised,** conceptualisation, centred on notions of *individualistic* artistic **creativity** and **expression.** It is by no means the case, however, that these latter terms are simply **ideological** and therefore **analytically** unimportant – to the contrary: they remain crucial, in fact, within *any* serious attempt to explain how **artworks** both make sense within, as part of, particular **societies,** and yet sometimes may **critically** 'transcend', or become relatively **autonomous** from, these **original** conditions of production, offering resources to later **artists.** This issue of art's **historical^ value** has produced some of the most important **social history of art** scholarship on **canonical^ artists** in the **modern^ period** – for instance, Édouard Manet, Pablo Picasso, and Jackson Pollock.

To **identify** a **tradition** of art-making as a practice means to understand (a) its intrinsic material character as work-process and product and (b) its existence, **organisation,** and **meaning** as a social activity within a particular historical moment – that is, within definite economic, political, and ideological conditions of production. Take **painting,** for example, as work-process and product. In a general and therefore non-historical sense, this social practice – like any other – is what dictionaries define as 'the habitual doing or carrying out of something, a usual or customary action or **performance'.** In historical terms, however, actual painting has taken an extraordinarily diverse variety of *specific* social **forms:** at the levels of (1) the training and **institutional** support for its practitioners; (2) the actual material means of production (e.g. use of paints, **surface,** tools, studio facilities, etc.); (3) the types of **patronage, commission,** and other 'relations of exchange' that have governed the production of works, along with their thematic and social use in specific societies and **cultures.**

Part of any – and all – of these historically specific painting practices understood as 'work-process' and product has been the **language** of

description and **interpretation** *available to the practitioners themselves.* Artists themselves, that is, along with **critics** and other **agents**, have inter-related and evolving roles within the broad social conditions of production informing and supporting any particular, historical, artistic practice. Notions of **creativity** and **expression** – along with those of art and **artist** – are not simply art-historical concepts, then, but important bits of what might be called the 'meaning-**structure**' through which these practices themselves have been constituted, and through which their practitioners have understood and explained to themselves the **significance** and **value** of their own practice. A cursory examination of the related elements within any actual practice of painting – say, that of Pollock's drip-painting evolved in the **period** 1947–50 – indicates that it would be absurd to place 'making' (practice) in an opposition to 'explanation' (theory): the two were bound up together in Pollock's statements about his work, and in the account of these paintings given by his then most empathetic critic, Clement Greenberg. The works themselves make sense only within, as products of, this discursive practice (e.g.: Pollock's *Number 1* (1948)). Of this painting T. J. Clark observed – suggesting the import of the meaning of practice outlined here – that its central area of form and colour condenses 'the whole possibility of painting at a certain moment into three or four thrown marks'.

Further Reading

Bourdieu, Pierre *Outline of a Theory of Practice* (Cambridge University Press: 1977).

Foucault, Michel *Language, Counter-Memory, Practice* (Cornell University Press: 1977).

Habermas, J. *Theory and Practice* (Beacon Press: 1976).

Kuhn, T. *The Structure of Scientific Revolutions* (University of Chicago Press: 1970).

PRIMITIVISM *PRIMITIVE, PRIMITIVIST*

Term with a range of **traditional** and radical **meanings** in art^ historical^ **discourse**, all dependent, in different ways, upon the contrast with an apparently opposing idea and **value**: the **modern**. In one of its most **conventional** senses, *primitive* refers to art **produced** *before* the **technical** innovations in **composition** and **media** associated with the **renaissance**: devices, that is, for **naturalistic** and

rationalistic **representations** of space and three-dimensional objects (as seen in, for example, Piero della Francesca's *The Flagellation of Christ* (1450–60); Raphael's *Pope Leo X with Two Cardinals* (1518)). If the **paintings**, drawings, and **sculptures** of these and other **artists** stood for this modern **revolution** in the aims, methods, and meanings of **visual** art, then **pictures** from the thirteenth century and earlier were seen by post-renaissance commentators as crudely primitive (e.g.: bronze doors relief of Adam and Eve after the Fall, Hildesheim Cathedral (1015); 'The Annuniciation', Swabian Gospel manuscript (1150)). By the nineteenth century, however, certain groups of artists and **critics** active in Europe (e.g.: the Nazarenes and the Pre-Raphaelites) came to renounce – at least in principle – this judgement and to see (their own notion and selection of) pre-renaissance **artworks** as endowed with an authentic spirituality and moral force. These supreme **qualities**, they believed, had been corrupted and debased within the **illusionistic** trickery and diverting intellectual sophistication they **identified** at work in high renaissance art's **perspectival** systems, modelling techniques, and obscure **allegorical** references to **classical^ myths** (see e.g.: Dante Gabriel Rossetti, *The Girlhood of Mary Virgin* (1848–49); Ford Madox Brown, *Wycliffe Reading his Translation of the Bible to John Of Gaunt* (1847–61)).

This turnaround, presenting the primitive as *better* than the modern, can also be seen in some **influential^ historical**, critical – and artists' – accounts of **developments** in late-nineteenth and twentieth-century modernist art. In these examples, *primitive* might, variously, refer to the peasant **crafts** workers of northern France or the native peoples producing totemic **representations** of men, animals, and gods in Tahiti or Fiji. A high valuation of works made by these peoples and the communal life these works were believed to stand for can be found in the writings of nineteenth-century scholars J. M. Jephson and A. Le Braz, along with statements by Paul Gauguin, Émile Bernard, Odilon Redon, and Vincent van Gogh. Their own **artworks** attempted to incorporate and adopt these primitive **stylistic^ forms** and **expressive^ symbolic contents**, though within a *sophisticated* **appropriation** of techniques and **subject matter**. The production of these works was also dependent upon the **imperialistic** relation modern French artists had with the tribal societies and cultures of the Pacific islands and northern Africa that the **western** European **nation^-states** had invaded, conquered, colonised, and exploited (e.g.: Gauguin, painting, *Faa Iheihe* (1898); André Derain, painting, *The Dance* (1906); Henri Matisse, wood carving, *The Dance* (c. 1907)).

Pablo Picasso's *Les Demoiselles D'Avignon* (1907) is perhaps the most well-known example of modernist primitiv**ism** – its *ism* indicating that the primitive had become a **theory** articulated by artists, critics, **museum^ curators**, and art historians. Since **cubism**, primitivism in modern art has had a long and varied **career**, re-appearing under a set of names, including the German expressionist paintings of the group called Die Brücke (The Bridge), art povera (including **artefacts** and artists from Latin American countries), art brut (Jean Dubuffet), and – perhaps most recently, though with examples drawn from the first quarter of the twentieth century and earlier – 'outsider art' (a catch-all term for works made by insane and untrained people).

Further Reading

Flam, Jack D. (ed.) *Primitivism and Twentieth Century Art: A Documentary History* (University of California Press: 2003).

Goldberg, Robert *Primitivism in Twentieth-century Art* (Vintage: 1967).

Gordon, Donald *Expressionism: Art and Idea* (Yale University Press: 1987).

Rubin, William (ed.) *"Primitivism" in Twentieth-century Art: Affinity of the Tribal and the Modern* (Museum of Modern Art: 1984).

PRODUCER/PRODUCT *PRODUCE, PRODUCTION*

Producer **means**, obviously enough, 'a maker of products'. Its **value** to **art^ history**, however, lies in its *general* **analytic** and **theoretical** senses. In contrast, Raymond Williams once called the term **artist** a 'pre-sociological category', implying that its habitual use – descriptively and **evaluatively** – within art history, dealing with thousands of years of global **cultural** production, illicitly *assumes* and *projects* a set of partial meanings and values that have, in fact, been bound up only with a highly specific and very limited **historical** and geographical range of actual producers and **practices** (the term artist only entered the English **language** from French and Italian in the early sixteenth century). However, *no* terms within art history are ever inherently neutral or objective in their genealogy, associations, and uses: these two nominative **concepts** themselves – art and history – are laden with rich, complicated, and in some ways perhaps even contradictory senses.

Producer has the useful sense of being general and inclusive (all workers are producers of something) and from it (rather than from the value-laden and sometimes radically excluding notion of artist) a historian or **critic** can go on to specify particular *kinds* of producers

active at particular moments in certain **societies**, along with the names they were given, or gave themselves, in those societies. In contrast, the general use of artist tends to *impose* a category of values which is often historically and culturally completely inappropriate – when used in relation to, for example, the *Demba* ritual masks (early twentieth century?) made by the Baga people in Africa or fifteenth-century northern Thai statues of the god Pra Sing (the Lion Lord), for whose makers the **western** term artist never existed.

The term *cultural production*, like *producer*, entered art historical **discourse** about twenty-five years ago as part of an attempt by those who used it both to avoid and interrogate the connotations that the phrase 'artistic **creation**' brings with it. Those who used *cultural production* and *producer* – for instance, **marxists** and **feminists** – argued that **traditional** art history fundamentally **idealised** and mis-**represented** the **agents** and products it habitually **identified** as artists and **artworks**. Cultural production was adopted as, and understood to be, an **abstract** term for *all* **forms** of **human** work and practices associated with an individual's or group's representation of itself, place in society, and understanding of the world. The term was intended to be both historically and socially inclusive. In historical terms, for example, cultural production would include video game **design**, as much as **film** making, and oil **painting**. In social terms, it would refer as much to those called – or calling themselves – **advertisers**, as to designers and fine artists.

The **significance** of *producer* when set against *artist* lay in its **materialist** understanding of agency and practice: producers make things (**artefacts**) from existing material and intellectual resources. A de-mystification of notions of making was therefore intended through its use – an undermining, or at least a setting aside, of idealist accounts of creativity, artistic **genius**, and 'spiritual' **expression**. However, it is interesting to note that production in **contemporary** English is often associated particularly with low-skilled factory- or **mass**-manufacture. Issues and problems of creativity and innovation, though, have not gone away – in fact they have been re-addressed recently by some of those who **originally** proposed these **alternative** terms in the 1970s.

Further Reading

Benjamin, Walter 'The Author as Producer' (1934), in Francis Frascina and Charles Harrison (eds) *Modern Art and Modernism: A Critical Anthology* (Harper and Row: 1982).

Caughie, J. (ed.) *Theories of Authorship* (Routledge and Kegan Paul: 1981).

Gitlin, T. *Inside Primetime* (Pantheon Books: 1985).

Hannah, Fran and Tim Putnam 'Taking Stock in Design History', in G. Robertson (ed.) *The Block Reader in Visual Culture* (Routledge: 1996).

PRODUCTION *PRODUCE, PRODUCER, PRODUCT*

The German playwright and **marxist** Bertolt Brecht once remarked that the productive tools of a writer included a pen and paper, some ideas, a desk at which to write, and an umbrella for when he went to deliver his finished manuscript to the publisher in the rain. Brecht's point was that **artistic** *production*, exactly like any other **form** of **human** labour, requires the use and transformation of a range of **material** and intellectual resources. Production involves both work-process (motivation, materials, and skills) and final product. This is easy enough to see in the stages that, for example, any **painter** goes through. **Historically**, however, painters have produced their **artefacts** in very different ways. Compare, for example, a mid-nineteenth-century **academically** trained **history painter** with a mid-twentieth-century **abstract** painter (e.g. Horace Vernet's *Battle of Fontenoy, 1745* (1828) with Pierre Bonnard's *Studio with Mimosas* (1939–56)). The production process in both examples – and in all cases – involves a range of *necessary* **social^ relations of production and consumption^** specific to these two historical moments. The works artists produce – in terms of **subject matter**, **style**, references to previous art, etc. – are intelligible in terms of these initial conditions (though later generations of **critics** and historians always offer **interpretations** that are themselves always shaped by different circumstances).

Relations of artistic production and consumption are always, at once, material and **technical**, but also social, intellectual, and **aesthetic**. They involve the selection and combination of elements from an available **tradition** of **practice** involving **media**, tools and technologies, aptitudes, **conventions**, and **values**. This tradition will also have been rooted in a variety of social **institutions** within which artists have been trained and from which they have partially formed their **identities**. Broad social conditions shaping the relations of production are also crucial in **influencing** elements of the work-process and product: for instance, the available kinds of **patronage** and types of **exhibition** possible in particular societies at certain historical moments.

Beyond those circumstances, factors relating to the **critical** understanding of **artworks** come to play an important part in what

might be called the **discursive^ structures** through which particular artworks (and artists) attain **meanings** and values. In any actual society in which an artwork is made, for instance, a range of related productions and products may also be **identified**: **criticism**, for example, in the shape of essays and reviews published in art magazines, exhibitions, and catalogues produced by, perhaps, art galleries and **museums**, along with slides, **photographs**, and prints for **popular** and **specialist** use by groups such as students, etc. All these products are *also* produced within specific conditions and relations of production which all in all constitute a **significant** part of the whole society at a particular moment. These shaping conditions and relationships are sometimes referred to as the **art world** – an amorphous but important **concept^ originating** in the late nineteenth century indicating the growing and changing network of connections, activities, **agents**, and products in which, and out of which, artworks and artists are made.

Further Reading

Burgin, Victor 'Modernism in the *Work* of Art', in *The End of Art Theory: Criticism and Postmodernity* (Macmillan: 1986).

Goldman, Lucian 'Introduction to the Problems of a Sociology of the Novel', (1963), in Terry Eagleton and Drew Milne (eds) *Marxist Literary Theory* (Blackwell: 1996).

Smith, Terry 'Production', in Robert S. Nelson and Richard Shiff (eds) *Critical Terms for Art History* (University of Chicago Press: 2003).

Williams, Raymond 'Productive Forces', in Williams *Marxism and Literature* (Oxford University Press: 1977).

PROGRESS *PROGRESSION, PROGRESSIVE*

Like the term **development**, the idea of *progress* in **art** combines the senses of both *process* (involving change and/or transformation) and *improvement* (involving something getting better). If the former **meaning** is usually understood to be **analytically** neutral – that is, a change or transformation understood as being neither good nor bad in itself – then the latter is manifestly an **evaluative** judgement. For example: it was claimed by **formalist** art **critics** (e.g.: Clement Greenberg and Michael Fried) that **modernism** in the **visual** arts in the twentieth century *culminated* – reached its high point – in the development of **abstraction**. Fried, for instance, asserted that a process of **formal** development in modernist **paintings^ produced** by

the **artists** Édouard Manet, Paul Cézanne, Pablo Picasso, Henri Matisse, Jackson Pollock, Morris Louis, and Frank Stella constituted a progressive evolution of the **medium** – *away* from the pre-modernist objective of a **naturalistic^ representation** of the world, *towards* a concern with investigating painting's formal and **material** means of **expression**. Though Fried did not explicitly declare Stella a better artist than Manet, it is hard to avoid the critic's implication that the former's paintings were certainly a refinement and purification of the **practice** Fried calls modernist (for example, compare Manet's *The Bar at the Folies-Bergère* (1882); Stella's *Six Mile Bottom* (1960)).

Another prevalent example of the use of the term *progress* concerns the belief – pursued by E. H. Gombrich and many others – that the **history** of **western** painting from the **renaissance** until the mid nineteenth century was really the history of a progressively more accurate and truthful depiction of the appearance of objects in the world. Over several centuries, Gombrich claimed, artists developed **techniques** and **conventions** – for instance, devices of **perspective** and **illusionistic** modelling in line and tone – that increasingly faithfully rendered three-dimensional appearances within the two dimensions of painting and drawing. This **theory** of what Gombrich called 'schema and correction', in which artists proposed forms to represent things in the world and then continually modified these forms through the process of empirical looking and re-formulation in visual depiction (e.g.: Leonardo da Vinci 's *Anatomical Studies (Larynx and Leg)* (1519)), inevitably focused on one aspect of art's development at the expense of many others. Gombrich was obviously aware of these other aspects (such as the religious-devotional function of sixteenth-century Florentine church painting, or the civic-commemorative role of seventeenth-century Dutch group **portraiture**), but chose to stress what he appears to have seen as the most important – perhaps *because* progressive – **value** of the western **tradition** in art as a whole.

A third example of *progressive's* evaluative sense concerns the belief held by many **marxists** and communists in the first half of the twentieth century that certain kinds of **realist** and **socialist realist** representations in painting and **sculpture** were better (philosophically, politically, and morally) than any others because they were part of a socialist pedagogic and propagandistic programme (e.g.: Diego Rivera, **mural painting**, *History of Mexico: From the Conquest to the Future*, south wall, National Palace, Mexico City (1929–35); Aleksandr Deineka, oil painting, *Building New Factories* (1926); Isaak Brodsky, oil painting, *Lenin in the Smolny Palace* (1930)). These **pictures**

were held up and counterposed to other **styles** of art – including those both naturalistic and **abstract** – claimed by some marxists to be inherently bourgeois and decadent (e.g.: Salvador Dali's *Soft Construction with Boiled Beans: Premonition of Civil War* (1936)).

Further Reading

Gombrich, E. H. *Art and Illusion: A Study in the Psychology of Pictorial Perception* (Princeton University Press: 2000).

Hitler, Adolf Speech inaugurating the 'Great Exhibition of German Art 1937' (1937), in Herschel B. Chipp *Theories of Modern Art: A Source Book by Artists and Critics* (University of California Press: 1968).

Marx, Karl 'Uneven Character of Historical Development and Questions of Art' (1857–58), in Terry Eagleton and Drew Milne (eds) *Marxist Literary Theory* (Blackwell: 1996).

Zhdanov, Andrei 'Speech to the Congress of Soviet Writers' (1934), in Charles Harrison and Paul Wood (eds) *Art in Theory 1900–1990* (Blackwell: 1992).

PSYCHOANALYSIS/PSYCHOLOGY *PSYCHIC, PSYCHOANALYST,PSYCHOANALYTIC, PSYCHO-SOMATIC*

Psychoanalysis grew up as a discipline, as a **practice**, and as a set of **ideas** at the same time as **art^ history** – in the early decades of the twentieth century in central Europe. In one suggestive sense the two fields shared a basic aim: to unmask and **explain** the **meaning** of a set of **formal** appearances. In the case of psychoanalysis these phenomena were claimed to be **signs** of the **human** unconscious – the actions and **representations** of an instinctive, **bodily, sexual** core to human **nature** that were believed by Sigmund Freud (the Austrian 'father' of psychoanalysis) at once to underpin, motivate, and subvert conscious, **organised** human life. These actions included *parapraxes* – 'Freudian slips' or mistakes in the use of **language** – and the representations of **desires** and anxieties found, for example, in dreams and 'doodlings' on paper.

In the case of the latter, these representations of the unconscious were also in various senses **visual** and based in **imagery**. Not surprisingly, the **surrealists** – a 1920s–30s **avant-garde^ formation** of **artists**, writers, and philosophers opposed to bourgeois notions of rationality, **manners**, morality, and **social order** – chose to attempt to induce 'dream-like' states and to represent these in their **paint-**

ings, drawings, **photographs**, and **films** (e.g.: Max Ernst, painting with attached objects, *Two Children Menaced by a Nightingale* (1924); Salvador Dali, photomontage, *The Phenomenon of Ecstasy* (1933); Luis Buñuel, film, *Un Chien Andalou* (1928)). The surrealists, like the **influential** psychoanalysts of this **period** before the Second World War – as well as individuals who straddled both **movements**, such as Jacques Lacan – saw the **value** and power of **metaphors** (many of them visual **symbols**). Both groups drew on the **narratives** and **mythic** personas found in ancient Greek legends: e.g.: Oedipus and Electra 'complexes' of human interaction between fathers, mothers, and children; myths of **origins** and endings, of seductions and transformations between human, animal, and mythic creatures.

While Freud himself had attempted several **critical^ analyses** – including famous studies of Michelangelo and Leonardo da Vinci, seeing their **creative** powers lying in a repression of their homosexual desires – in the post-Second World War period psychoanalysis was adapted and transformed by a variety of new interest groups, particularly **feminists** and 'queer theorists', who uncoupled the **original^ theories** from their therapeutic base and found new philosophical and political-poetic articulations during the 1960s and 1970s. Theories of sexual 'difference' and 'otherness', for example, were **developed** in the writings of scholars such as Gyatri C. Spivak and Luce Irigaray, who took elements from psychoanalytic accounts of **gender** and sexuality and redeployed these in work on **ethnicity**, **language**, and forms of representation.

Psychoanalytic accounts of art had become an established **specialism** within the discipline of art history by the 1990s – and were often strongly connected to critical writing on both past and **contemporary** art. Peter Fuller and Donald Kuspit, for instance, both attempted to use a critique of **modern** society and culture rooted in psychoanalytic concepts and argued that the best new art **produced** had to have a vital connection to themes of human feeling, intimacy and alienation in personal and social relationships, and – against the **formalism** of 1960s **abstract** painting – once again proposed the body as the core sign of this re-invigorated humanism (e.g.: paintings by Leon Golub, such as *Mercenaries (IV)* (1980) and Jenny Saville, *Reflective Flesh* (2002–3)).

Further Reading

Jung, C. J. (1917) *Psychology of the Unconscious: A Study of the Transformation and Symbolism of the Libido* (Routledge: 1993).

Kuspit, Donald *Signs of Psyche in Modern and Post-modern Art* (Cambridge University Press: 1993).

Metz, C. *The Imaginary Signifier: Psychoanalysis and Cinema* (Indiana University Press: 1975).

Spector, J. 'The State of Psychoanalytic Research in Art History', *Art Bulletin* March 1988: 49–76.

PUBLIC ART/PUBLIC

In one sense, the term *public art* seems to be redundant: surely isn't *all* **art** that is made for anyone besides its **producer** (and perhaps his or her immediate family) public art? While the answer to this question is 'yes', the term actually has a much narrower **conventional^ meaning**. Public art, a notion introduced into arts management – and then **art historical** – **discourse** in the **period** since the 1970s, really refers to the **structures** of art **patronage** controlled or financed by **national** and local government **agencies** and **institutions**. 'Public' in this context refers to the work of these **organisations** carried out on behalf of the people who have elected them to be their **representatives**. Public art is, in this sense, 'democratic art' – that is, selected or **commissioned**, paid for, and used, in a variety of different ways, officially to further the interests of democratic **society**.

Governments in **western^ societies** (principally in Europe, North America, parts of Latin America, and Australasia) have organised the patronage and production of public art through numerous administrative systems derived from certain principles and policies. In England after the Second World War, for example, the Arts Council of Great Britain was set up with the aim of *supporting* and *nurturing* rather than directly employing or directing **artists**. This, so-called 'arm's length', principle was intended to prevent government from *manipulating* the work of artists for crude propagandistic or **ideological** purposes (as had happened in the fascist countries between the wars and continued in the USSR-aligned communist countries through to the 1980s). It was based, too, on the **traditional^ idealistic** belief and principle that artists were inherently individualistic and that their **creations** should be set apart from any other kind of work done in a **modern** industrial-**capitalist** society. Arts Council patronage, then, really meant short-term financial subvention (funding) given to individual artists in order to allow them to pursue their self-defined interests – although some money was also set aside to establish art **museums** directly run by the Council (e.g.: the Serpentine Gallery in London's Hyde Park and the Hayward Gallery on the South Bank).

In the US, a similar 'arm's length' **organisation**, the National Endowment for the Arts (NEA), was inaugurated in 1965 to help usher in what President Lyndon B. Johnson called 'the Great Society' – meaning a wealthy and flourishing democracy with a rich and various **culture**. By the 1990s, however, other kinds of subventions became common as governments increasingly linked what they called 'arts initiatives' more directly to their social and economic 'inclusion' policies for the regeneration of particular regions and cities. Museums such as Tate Modern in London and The Baltic in Newcastle-Upon-Tyne benefited from large-scale financial aid directly from government or, indirectly, through lottery funding schemes. Governments – both national and local – continued to fund individual artists to produce **artworks**, though sometimes these became mired in controversy as clashes between notions of **popular** and **avant-garde^ taste** occurred. This occurred, for example, over the NEA-sponsored 1999 show 'Sensation' (an **exhibition** of recent British art, including Chris Ofili's dung-**painting** *The Holy Virgin Mary* (1995)) held at the Brooklyn Museum. Attacks on the show from publicly elected officials, including the then Mayor of New York Rudolph Giuliani, led to its cancellation and damning **criticism** of the NEA's principles. Given these attacks on funding over the years, public art has tended to become extremely banal in its **design – intended** to upset no-one, though inevitably leading to the charge that public art is inherently bland, 'middle of the road', and unchallenging both **aesthetically** and politically.

Further Reading

Deutsche, Rosalyn 'Uneven Development: Public Art in New York City', *October* no. 47 (1988): 3–52.
Mitchell, M. J. T. (ed.) *Art and the Public Sphere* (University of Chicago Press: 1993).
Selwood, Sara *The Benefits of Public Art* (Public Studies Institute: 1995).
Usherwood, Paul 'Public Art and Collective Amnesia', in Jonathan Harris (ed.) *Art, Money, Parties: New Institutions in the Political Economy of Contemporary Art* (Liverpool University Press/Tate Liverpool: 2004).

QUALITY *QUALITATIVE*

Term with two, sometimes overlapping, **meanings** in **art^ history** – one neutral and descriptive, the other clearly partial and **evaluative**. On the one hand, it might be said, for example, that Paul Cézanne's

Still-Life with Water Jug (1892–93) 'has the quality of a sketch-like **composition**: the objects depicted are placed tentatively and ambiguously in relation to each other, with elements of the bare canvas **visible** at certain points on the **surface** of the **picture**.' *Quality* here means simply 'aspect' or 'feature'. On the other hand, the same picture, the **modernist^ critic** Clement Greenberg might have remarked, 'is a work of **real** quality. The painting is miles and away better than the sentimental **academic** doodlings of **contemporary** Victorian **narrative^ artists** such as Lawrence Alma-Tadema (compare Cézanne's picture with Alma-Tadema's **neoclassical^ painting** *Coign of Vantage* (1895)). Quality in this second usage is plainly a term of positive judgement: of something being *better* than something else.

Though such critics as Greenberg are certainly renowned for their verdicts on the 'good' and the 'bad' **artworks** and **artists** from the modern **period**, art historians of all kinds make qualitative judgements too. The **analytic** bases for these evaluations, however, are various. What they usually share in common is a belief that these judgements are based on specifically artistic (though *not* always narrowly **aesthetic**) criteria: to do with, for example, how the artwork **looks**, how it has been **technically^ produced** – its level of skill and resourcefulness – and how the **artefact's** physical manufacture and appearance fits (or is at jarring variance) with its **subject matter**. Some of these criteria have highly **traditional** intellectual roots traceable back to the writings of the first critics and art historians (such as Giorgio Vasari, Leon Baptista Alberti, Sir Joshua Reynolds, Johann Joachim Winckelmann, and Heinrich Wölfflin) – notions of compositional 'harmony' and 'grace', for example. Critics of modern art, in contrast, have consistently downplayed the thematic, **narrative**, or **symbolic** qualities of **abstract** paintings, examining instead – and then pronouncing upon – the quality of the picture's surface as a self-sufficient or **autonomous** entity.

Though such apparently **formalist** judgements may sometimes seem unfounded, casual, or merely **subjective**, some modernist critics are able to claim – unlike many art historians dealing with pre-twentieth-century art – that the artworks they evaluate in this **manner** were produced by artists equally committed 'to making the best pictures of which they were capable' (Michael Fried). That is, that since the 1950s the best modern artists have themselves understood the account of modernism produced by its most articulate critics and attempted, *self-consciously*, to pursue the kinds of quality paintings these critics believed were entailed within the tradition of

abstraction traced back to Édouard Manet (see, for example, 1960s paintings by Jules Olitski, *Judith Juice* (1965); Kenneth Noland, *Bloom* (1960); and Frank Stella, *Takht-i-Sulayman* (1967)). The isolation of evaluative criteria **identified** in this way as *purely* aesthetic is a relatively recent **development**, and would not have been intelligible to painters – or their contemporary commentators – such as Raphael or Michelangelo Caravaggio or Jacques-Louis David, whose **careers, commissions**, and interests always merged religious, civic-political, intellectual, and aesthetic **values** and beliefs. Since the late 1960s, however, quality in the sense of 'the best' has been redefined in many different ways – according to criteria, values, and interests that were sometimes explicitly political and which, in some cases (e.g. **feminist** art **theory**), even appeared to abandon **conventional** ideas of the aesthetic altogether.

Further Reading

Clark, T. J. 'Clement Greenberg's Theory of Art, Michael Fried 'How Modernism Works: A Response to T. J. Clark', and T. J. Clark 'Arguments about Modernism: A Reply to Michael Fried', all in Francis Frascina (ed.) *Pollock and After: The Critical Debate* (Harper and Row: 1985).

Harris, Jonathan *Writing Back to Modern Art: After Greenberg, Fried, and Clark* (Routledge: 2005).

Wohl, Hellmut *The Aesthetics of Italian Renaissance Art* (Cambridge University Press: 1990).

RACE *RACIAL, RACIALIST, RACIST*

Term with three related, but clearly different and possibly even conflicting, **meanings** centred around the notion of collective **identity**: (1) A group or set of people, having a common feature or features; (2) A person's offspring or descendants; a limited group of people descended from a common ancestor; a family, a kindred; (3) A tribe, **nation**, or people, regarded as of common stock. In terms of **art^** history, *race* – along with **ethnicity** – has become extremely **significant** since the 1970s, when new groups of students and scholars from marginal and non-**traditional** (that is, non-middle **class**, white, male) backgrounds entered the universities in Europe and North America, encountering attitudes and procedures that were prejudicial and discriminatory. Though black and Asian people certainly constituted two of these groups, the range of definitions given above for *race* indicate that many other collective identities – for example

Jewish, Native American, Romany etc. – could have been and were implicated in this process linked to the expansion of higher education at this time.

There are clearly important differences between race understood as a matter of **surface** (skin) colour or bone **structure** (examples of a 'common feature or features'), as a matter of religious belief (the Jewish ancestral descent from Abraham, for instance), or as a matter of belonging to a particular **state** ('tribe, nation, or people'). However, the predominant **modern** meaning has been overwhelmingly that of the first definition: identity claimed to be based on some distinct biological root condition and shared ancestry, a key manifestation or sign of which has been skin pigmentation. But the civil rights **movement** in the US in the 1950s and 60s was *not*, in the main, rigidly 'biological-determinist' – rather, it saw black identity as a matter of shared **culture** and place, as well as to do with a common ancestry traceable back to African tribal community. It had been the common experience of enslavement and transport to America that bonded black people, as much as (if not more than) their – in one sense – accidental sharing of a darker skin than the white peoples they encountered there.

Identity – whether called racial or ethnic in character – must be **represented** in various ways and art history has, since the 1970s, opened up to a much wider range of people from many different backgrounds with interests and **values** very different from (and sometimes extremely hostile to) the white, European and Puritan-American middle class elite which had **dominated** and shaped the discipline, in its aims, methods, and values, since its **origins** in the early twentieth century. Clashes over these race-related values – for instance, over definitions of **civilisation** and culture – were a regular feature of heated debates in the **new art history** as much as over who was appointed to **academic** and **curatorial** jobs during the 1970s and 1980s. These kinds of antagonisms continue – reflecting wider ongoing socio-political struggles in **postcolonial^** **societies** around the world. Some **theorists** – such as Paul Gilroy – have turned sharply against the notion of homogeneous racial identity as the basis for political movement or social solidarity. Their point is not that thinking about oneself primarily as 'black' (or 'white' for that matter) is simply an **ideological** obsession, but that the actual **historical** *heterogeneity* – intermixing – of people ethnically and socially means that the **ideal** of racial polarity (having to be *one or the other*) is always effectively a rac**ist** proposition and recipe for a dismal ghettoisation of all future cultures and communities.

Further Reading

Gilroy, Paul *The Black Atlantic: Modernity and Double Consciousness* (Verso: 1993).
—— *Against Race: Imagining Political Culture Beyond the Color Line* (Belknap Press: 2000).
bell hooks *Art on My Mind: Visual Politics* (New Press: 1995).
Trigger, D. S. *Whitefella Comin': Aboriginal Responses to Colonialism in Northern Australia* (Cambridge University Press: 1992).

READER *READ, READING*

It has become commonplace in **art history** to refer to the 'reader of **artworks**', or to 'reading a **painting** or **sculpture**'. In one sense the terms *reader/reading/read* here are simply being used to mean the same as the **traditional** and familiar terms **viewer/viewing/view**. However, while it is obviously true that written or printed words, as well as **pictures**, *are* in some senses **visual,** and that the faculty of sight is required to read a **text** as well as to look at an **image** (remembering that written letters and words are always also **composed** of graphic, visible, and visual images), it is usually held that texts *primarily* constitute **conceptual^ meanings**, while visual **representations** *primarily* **create** sensual **impressions**. (Far more attention, however, has certainly been paid to the conceptual **significance** of visual artworks than to the visual significance of words and texts.)

Now, while quite a substantial part of visual representation from all around the world over many centuries actually included text of various kinds directly within its **compositional^ forms** (e.g.: Chinese and Persian illuminated manuscript pictures surrounded by text or sacred scripture, *Husband Reproving His Wife*, silk scroll, old copy after a work by Ku K'ai-Chi (*c.* 406); *Persian Prince Humay Meets the Chinese Princess Humayun in Her Garden*, from a Persian manuscript of a romance (*c.* 1450)) – or did so indirectly, via, for instance, titles and captions appended to **artefacts** – it was not until the twentieth century that **artists** began to include textual elements within artworks specifically with the aim of questioning, in conceptual and philosophical terms, the comparative **nature** and resources of visual and **language^ structures** (e.g.: **cubist** collages by Pablo Picasso and Georges Braque; such as Picasso's *Glass and Bottle of Suze* (1912); paintings by René Magritte, e.g.: *The Treachery of Images* (1929); combine paintings by Robert Rauschenberg, e.g.: *Rebus* (1955); and then, much more programmatically, Mel Ramsden, canvas and photostat, *Secret Painting* (1967–68); Victor Burgin, photolithographic

print, *Possession* (1974); and Barbara Kruger, **photograph** with text, such as *Your Comfort Is My Silence* (1981)). It is not merely co-incidental that it was also at about this time, in the 1970s and early 1980s, that the notion of 'reading a visual representation' entered art historical **discourse**. This was because it was then that artists and art historians began to assimilate **theories** of language and meaning **developed** within structural linguistics (part of a much broader intellectual investigation known as **structuralism**, which, for all its internal diversity, drew particularly on accounts of **human** language).

In this radical sense, then, to 'read a painting' or some other kind of visual representation meant to mount a theorised consideration of the particular formal systems of meaning and **discourses** located both 'within' the artefact but also 'surrounding' or 'informing' it in various ways (sometimes the latter became known, usually crudely, as part of an artefact's *context*). Although this sense to *reading* overlaps with the traditional art historical **practice** of looking carefully at, for instance, a painting or sculpture, it clearly implies *much* beyond this – both questioning the assumptions governing the activities of visual **analysis** (such as **iconography**) and relating these to accounts of meaning, signification, and **ideologies** generated in a range of other **humanities** and social science disciplines.

Further Reading

Althusser, Louis and E. Balibar *Reading Capital* (New Left Books: 1970).

Marin, L. 'Towards a Theory of Reading in the Visual Arts: Poussin's *The Arcadian Shepherds*', in S. Suleiman and I. Crosman (eds) *The Reader in the Text: Essays on Audiences and Interpretations* (Princeton University Press: 1980).

McCloud, S. *Understanding Comics* (Tundra Publishing: 1993).

Schapiro, Meyer *Words and Pictures: On the Literal and Symbolic in the Illustration of a Text* (Mouton: 1973).

REALISM/REAL *REALIST, REALISTIC*

Though an orthodox **stylistic** term in **art^ history** (sometimes combined and/or confused with **naturalism**), *realism* is also an important philosophical term standing for a **concept** of knowledge and account of the relationship between an observer and the world around him or her. The two senses are related, though on the whole art historians tend to be ignorant of, or underplay, realism's **theoretical^ complexities**. As a stylistic category, *realist/realistic* has been used in a highly

generalised way: the term has been applied to **representational^ artefacts^ produced** by many **artists** over several centuries, working in many different places, including, for example, the painters Michelangelo Caravaggio (*Supper at Emmaus* (1601)), Rembrandt van Rijn (*The Anatomy Lesson of Dr. Tulp* (1632)), John Constable (*View on the Stour near Dedham* (1810)), Francisco de Goya (*Disasters of War* **paintings**, etchings, and drawings (1810–13)), J. M. W. Turner (*Snow Storm – Steamboat off a Harbour's Mouth* (1842)), Rosa Bonheur (*Ploughing* (1849)), Jean-Francois Millet (*The Gleaners* (1857)), Eugène Delacroix (*Arab Horses Fighting in a Stable* (1860)), Gustave Courbet (*The Origin of the World* (1864)), Edgar Degas (*Dancer Taking a Bow* (1877)), Camille Pissarro (*Peasant Women Minding Cows* (1882)), George Grosz (*Street Scene* (1925)), Pablo Picasso (*Guernica* (1937)), Frida Kahlo (*Self-Portrait with Cropped Hair* (1940)), Francis Bacon (*Study after Velazquez's Portrait of Pope Innocent X* (1953)), David Hockney (*A Bigger Splash* (1967)), and Jenny Saville (*Closed Contact 9* (1995)).

Realism used in this general sense refers to the ways in which these painters, commentators claim, have been able convincingly to convey the *actuality* of various things – be it violence and terror depicted in Goya's *Disasters of War* prints, or Constable's **views** of clouds passing over the East Anglian **landscape**, or Pissarro's scenes of peasants and fields, or Bacon's **images** of **human** flesh. It is clear from these diverse examples, however, that realism as a stylistic term has a range of important nuances – Bacon's studies of **figures** have been equally aptly described as **abstract** and **expressionistic**. Realism, then, has one set of characteristics based in skills of careful, empirical, looking at/depicting things in the world (this partly explains its overlap with definitions of naturalism), but then another based on sensitivities and skills of selection and psychological emphasis. These reject **forms** of **academic^ idealisation**, however, and favour instead **techniques** of rendering that suggest or evoke the physicality and **materiality** of objects (including human **bodies**).

Another set of **meanings**, linking realism to explicit political **perspectives** and **ideological** belief-systems **developed** during the mid nineteenth century and continued through to the mid twentieth. These have been **identified**, respectively, as **social^ realist** and **socialist realist** art. Courbet is usually regarded as the chief exponent of the former, while many painters and **sculptors**, including Aleksandr Gerasimov, Isaak Brodsky, and Vera Mukhina produced **visual** representations **intended** to celebrate and propagate the post-**revolutionary** regime in the USSR after 1917 (e.g.: Mukhina,

bronze sculpture, *The Worker and the Collective Farm Woman* (1937)). Many **critics** of this art – usually also critics of the Soviet political regime – rejected this work as **aesthetically** worthless, seeing it as mere propaganda recycling nineteenth-century academic **conventions** and **values**. The realism in socialist realism, they claimed, was actually a form of dogmatic and sentimental idealism **reproducing** a set of beliefs that equally falsely represented actual totalitarian Soviet society.

Further Reading

Anreus, Alejandro *Orozco in Gringoland: The Years in New York* (University of New Mexico Press: 2001).
Buchloh, Benjamin H. D. 'Figures of Authority, Ciphers of Regression: Notes on the Return of Representation in European Painting', in Francis Frascina and Jonathan Harris (eds) *Art in Modern Culture: An Anthology of Critical Texts* (Phaidon: 1992).
Fer, Briony, David Batchelor, Paul Wood *Realism, Rationalism, Surrealism: Art Between the Wars* (Yale University Press: 1993).
West, Alicia 'The Relativity of Literary Value' (1937), in Terry Eagleton and Drew Milne (eds) *Marxist Literary Theory* (Blackwell: 1996).

RENAISSANCE

Referring to the 'rebirth' or revival of ancient **classical^ ideas** and **values** in the fourteenth to the sixteenth centuries, the idea of the European *renaissance* arguably remains the **central conceptual** lynchpin within **western^ art^ history** – profoundly shaping the discipline's core **meanings** and evaluations of art both before and after its claimed occurrence in southern (and then northern) Europe. It is necessary to say 'claimed' because the term *renaissance* only entered the English **language** from French in the mid nineteenth century – therefore those living during the fifteenth and sixteenth centuries didn't themselves have this term or its **modern** senses – and its initial **historical** meanings were closely bound up with late-nineteenth-century writings by the German **academic** Jakob Burckhardt, professor at the University of Basle (author of *The Civilisation of the Renaissance in Italy* (English publication, 1929) and *Reflections on History* (English publication, 1943)). Burckhardt's **intention** had been to provide a pre-history to an account of the nineteenth century's (and specifically Germany's) **cultural** and political supremacy which **represented**, he believed, the modern culmination of the roots of European **civilisation** sown in its earlier 'rebirth'. Renaissance, then,

is a highly self-conscious and retrospective notion, selecting and emphasising elements that fit into an already established **narrative** of events, **developments**, and meanings.

As this **contemporary socio**-political context for the **emergence** of the idea became increasingly submerged in the twentieth century, the renaissance became accepted within **institutionalised** art history as objective, accomplished, and undeniable 'fact'. Often still taught as the very first unit in undergraduate programmes, the renaissance is presented as a kind of artistic 'big bang' setting in motion many of the key facets, or **myths**, of modern western culture and society. These include: (a) a sense of the remote but still active **origins** of western civilisation in the renaissance's rediscovery of ancient – pre-Christian – Greek and Roman art and culture; (b) the impetus to look afresh, and empirically, at the physical **material** world and attempt to depict it in **visual** representations such as drawings, **paintings**, prints, and **sculpture**; (c) the related invention of new **techniques** and knowledges for creating a **human**-, rather than god-centred, understanding of the universe and the place of people within it; and (d) an apparently contradictory sense of a transcendent individualistic and mystic **artistic^ genius**.

Art history divides the renaissance into 'early' and 'high' phases – in both **stylistic** and socio-political terms, citing its **formal** origins in paintings by Giotto and Masaccio and its final triumphs in works by Leonardo da Vinci, Raphael, and Michelangelo. Its development is plotted through a number of related narratives linking innovation in **pictorial** techniques and skills, uses of ancient **symbolic** and **mythic** narratives, humanist-related scientific and **theoretical** achievements (e.g.: treatises by Leon Baptista Alberti elevating painting and **architectural** work to the status of 'liberal arts'), and relationships between its **artists** and evolving systems of **patronage** in the city-states of Florence, Rome, and Venice. A 'northern renaissance' typified by the empirical draughtsmanship of Albrecht Dürer and later colouristic genius of Rembrandt van Rijn follows, though the renaissance as a distinct socio-stylistic category begins to fragment by about the 1520s, giving way to the next sequential term in the standard art historical narrative: 'renaissance → **mannerism** → **baroque** → **rococo** → **neoclassicism** → **realism** → **modernism**'

Further Reading

Bambach, Carmen C. *Drawing and Painting in the Italian Renaissance Workshop* (Cambridge University Press: 1999).

Bober, P. P. and R. Rubenstein (eds) *Renaissance Artists and Antique Sculpture: A Handbook of Sources* (Oxford University Press: 1986).

Edis-Barzman, Karen *The Florentine Academy and the Early Modern State: The Discipline of Disegno* (Cambridge University Press: 2000).

Levy, M. *High Renaissance* (Penguin: 1975).

REPRESENTATION *REPRESENT, REPRESENTATIONAL, REPRESENTATIVE*

Though now a central **concept** within **art^ historical^ discourse**, *representation* has a broader **history** of important use in political **theory** and philosophy, and is the name given to the process through which 'one thing comes to stand, or be taken, for another'. Most **paintings** and **sculptures**, for instance, are **images** and objects that may be said to re-present the things they depict. This process of representation, however, can occur in a number of radically *different* ways. First, and perhaps most simply, through the representational **artefact** resembling, **visually** or physically, the object it stands for (e.g.: Henri Toulouse-Lautrec's painted **portrait** of Émile Bernard (1886) or Marino Marini's sculpture of a *Horseman* (1947)). Visual **signs** such as these are called **iconic** (though art historians have **traditionally** used the terms **naturalistic** and **realistic** to refer to these kinds of representations). Second, through the **convention** associating something depicted with an agreed **symbolic^ meaning** and **value** (e.g.: a dove denotes the holy spirit in Christian **narrative** paintings, such as in Giotto's *Adoration of the Magi* (1304–6)). Third, some signs communicate by standing as an *effect* of something else which is actually absent (e.g.: the trace of the **artist's** hand, or the movement of his **body**, represented in Jackson Pollock's **abstract** painting *Number 32* (1950)); these signs are called 'indexes'.

In **practice**, however, most if not all **artworks** *combine* several different kinds of signs and in that sense represent in **complex**, multi-dimensional ways. For instance, John Constable's *Haywain* (1819), though it may be said to depict *iconically* a farm cart drawn by a pair of horses, has also come to *symbolise* (accurately or not) a certain idea of the pre-industrial English **landscape** and agrarian way of life. Important 1980s **social^ history of art** scholarship concerned with the possible political connotations of Constable's **pictures** investigated what might be called the 'social representativeness' of these **views**. Compare Constable, for example, with works by the near-**contemporary** painter George Morland, whose paintings

270

sometimes showed the rural poor at rest or even drunk, rather than working diligently or behaving with servility in the fields of the landowners (e.g.: *The Alehouse Door* (1792) and *The Gravel Diggers* (undated)). How, and in what ways, did Constable's much more well-known landscape scenes include depiction of the lives of members of the rural working class? Or were these people marginalised or excluded altogether from this artist's **ideal** of the English countryside at the time that saw the beginnings of urban industrialisation? This brief example demonstrates how political meanings for representation have important relevance to the term's art historical use.

All art, however, whether that **identified** as naturalistic, or **social realist**, or abstract, represents – though in the latter case this is more likely to be a re-presentation of, for example, ideas or sensations, rather than a depiction of objects from the world (e.g.: Kasimir Malevich's *Suprematist Painting (White on White)* (1918), Mark Rothko's *Number 22* (1950)). No art is non-representational. Additionally, representation has come to **mean** – within the study of signs called **semiology** – an account of the **material** means and processes through which artefacts signify, and in that sense is preferable to the term image which tends to suggest something dreamlike, ephemeral, and **illusory**.

Further Reading

Crane, T. *The Mechanical Mind: A Philosophical Introduction to Minds, Machines, and Mental Representation* (Penguin: 1995).

Green, Nicholas and Frank Mort 'Visual Representation and Cultural Politics', in G. Robertson (ed.) *The Block Reader in Visual Culture* (Routledge: 1996).

'Knowledge and Representation'and 'Representation and Art' sections, in Charles Harrison and Fred Orton (eds) *Modernism, Criticism, Realism: Alternative Contexts for Art* (Harper and Row: 1984).

Summer, David 'Representation', in Robert S. Nelson and Richard Shiff (eds) *Critical Terms for Art History* (University of Chicago Press: 2003).

REPRODUCTION *REPRODUCE, REPRODUCIBLE, REPRODUCTIVE*

Reproduction has a clear *literal* sense in the study of **art** – referring to the purposes, **techniques**, and processes evolved over centuries that have enabled multiple copies of an **originally^ produced^ artefact** to be made, in the **form** of, for instance, drawings (and **texts**),

prints, **paintings**, coins and medallions, **photographs**, **films**, and **sculptures**. In addition, it has a connected sense, inherited from **social** and political **theory**, concerned with the **cultural**, political, and **ideological** means through which a **society** enables itself to carry on. This is called 'social reproduction'.

The two **meanings** *are* related: certainly it is impossible to **imagine** any **modern**, **complex**, large-scale society operating without the major means of technical **visual** reproduction available that generates, for instance, **advertising**, **television** and filmic imagery, **signage**, **design**, money, and commodity packaging. Reproduction in the first sense, however, has its origins in ancient times – the first copies of drawings and paintings were done by hand and could not (nor needed to be), in the main, *exact repetitions*. These images – which were also always **material** artefacts – served ritual, religious, and social-ceremonial purposes, all bound up with the **social order** of specific communities and larger-scale societies (e.g.: southeast Asian sculpture altar furnishings showing lions, Vishnu on Garuda deities, from the last period of Khmer rule; **portraits** of rulers on coins, medallions, and pendants, such as a head of Alexander with inscription on an engraved gemstone of tourmaline, late fourth century BCE). Mechanical, electrical, electronic, and digital technologies followed that allowed an exactness of detail to be repeated within a **theoretically** unlimited process of reproduction – and in many cases the notion of an original image or artefact became redundant. There is, for example, really no meaningful original television image – simply the scene photographed by the cameras and broadcast on air. Still photographs, though they may have been printed from an original, single negative, can also exist in any number and none are generally regarded as secondary in meaning or **value** to some primary version.

Variable **qualities** of reproductive means, however, do occur in all **media** depending, for instance, upon, the kinds of devices (such as screens, software, and printers) used by those seeking to make their reproductions. Andy Warhol's 1960s silkscreen prints of, for example, *Marilyn Monroe* and *Jackie Kennedy* exploited – literally and **symbolically** – a number of media **forms** and processes, and were **readable** as an ambiguous commentary on an American society fixated on celebrity and a **public^** **mass culture** of repetitious imagery and **narrative** (e.g.: *Marilyn Diptych* (1962)). In Warhol's work, then, the two meanings of *reproduction* outlined above were self-consciously brought together and his visual representations – printed copies, often nuanced and differentiated by his careful addition of painted highlights to eyes and lips – were themselves a **mediation** of, and meditation

on, what might be called the 'changing sameness' characteristic of social reproduction within a celebrity culture or 'society of spectacles' increasingly obsessed with visual **identities**. In such a society – **western^-style** might be another name for its now **globalised** existence – TV, advertising, and magazines now endlessly reproduce basically the same images of beauty and glamour and the same narratives of fame and fortune, although the names, the hairstyles, and the **fashions** vary week-by-week.

Further Reading

Alexander, Jonathan J. G. 'Facsimilies, Copies, and Variations: The Relationship to the Model in Medieval and Renaissance European Illustrated Manuscripts', *Retaining the Original: Multiple Originals, Copies, and Reproductions (Studies in the History of Art, Symposium Series VII)* 20 (1989): 61–72.

Althusser, Louis 'Ideological and Repressive State Apparatuses', in Althusser *Lenin and Philosophy and Other Essays* (New Left Books: 1971).

Bourdieu, Pierre *Reproduction: In Education, Society and Culture* (Sage: 1977).

Blumler, J. G. and M. Gurevitch 'The Political Effects of Mass Communications', in S. Hall, T. Bennett, G. Martin, C. Mercer and J. Woolacott *Culture, Society, and the Media* (Methuen: 1982).

Williams, Raymond 'Reproduction', in Williams, *Culture* (Fontana: 1982).

RESIDUAL *RESIDUE*

One of a set of three terms that the **cultural^ historian** and **theorist** Raymond Williams coined in order to **explain** the historical and **social** importance of twentieth-century **avant-garde^ artistic^ movements**, and **styles**. This group of **theoretical^ concepts** – **dominant**, *residual*, and **emergent** – are concerned with the duration, **influence**, and place of particular **forms** and **formations** in actual historical societies. In any selected historical moment in the life of a society, for example, it is possible to **identify** cultural groups and kinds of artistic **production** which occupy – broadly speaking – these dominant, residual, and emergent positions (though perhaps a fourth, that of the 'marginal', should be added.)

By the 1950s, for example, it could be argued that **cubism**, as a **compositional** strategy, or style, or philosophy in **painting**, had clearly become residual – another name for it had been 'School of Paris' painting and by the 1950s the centre of the **art world** had moved to New York. Though **modernist^ critics** such as Clement Greenberg believed that certain elements of cubism's **aesthetic** (such as very shallow **pictorial** space) could be discerned in **contemporary**

paintings by, for example, Jackson Pollock and Willem de Kooning, their **art** – soon to be known worldwide as **abstract expressionism** – assimilated these cubist elements within a wholly new idiom centred around the fundamentally new principles of large-scale format, 'all-overness' of pictorial **design**, and the absence of imitative **imagery** and **narrative** (e.g.: Pollock's *Alchemy* (1947); de Kooning's *Excavation* (1950)).

Residual, then, suggests 'a passing away', and a 'losing of **significance**'. As the cubism example indicates, however, there may be various degrees and kinds of residualness. Nor can the term simplistically *replace* other **analytic^ concepts**. Was cubism, for example, really the term only for certain paintings produced by Picasso and Braque between *c.* 1907–16, or did it name a much broader style whose features can be identified in works by a wide number of **artists** active between *c.* 1907–50? Greenberg's use of the term 'cubism' in relation to abstract expressionism suggests the latter (one of his most influential essays was called 'The Decline in Cubism' (1948) and 'decline', in part, is a synonym for residual).

In a different direction, *residual* may be used to characterise kinds of styles, **media**, or **practices** that, though persistently or increasingly marginal, *go on existing and changing* in relation to other styles and media. Since the 1980s, for example, it might be claimed that painting as an artistic medium has altogether become residual, or at least increasingly marginal – in the sense that **installation**, mixed media artistic practices, and **performance** (or practices combining two, or even all three of these) have emerged and now become dominant (e.g.: Paul McCarthy's installation *Tomato Heads* (1994), consisting of sixty-two objects made from fibreglass, urethane rubber, and metal clothing). It may be **valuable** to attempt to map these concepts – dominant/emergent/residual – on to Williams's other set: **specialist/alternative/oppositional**. In one sense, for example, painting now might be regarded as residual and either specialist or alternative to the **hegemonic** installation/mixed media mainstream: a **traditional** practice based upon notions of skill and **expression** that have become generally outmoded.

see also: **dominant, emergent**

Further Reading

Burgin, Victor 'The End of Art Theory', in *The End of Art Theory: Criticism and Postmodernity* (Macmillan: 1986).

Mainardi, Patricia *The End of the Salon: Art and the State in the Early Third Republic* (Cambridge University Press: 1994).

Naubert-Riser, Constance 'Marginality as a Political Stance: The Canadian Painter Jean McEwen', in Serge Guilbaut (ed.) *Reconstructing Modernism: Art in New York, Paris, and Montreal 1945–1964* (MIT Press: 1990).

Williams, Raymond 'Dominant, Residual, and Emergent', *Marxism and Literature* (Oxford University Press: 1977).

REVOLUTIONARY *REVOLT, REVOLUTION*

This term, with its **origins** in political **discourse** referring to a radical 'turn-around' or 'transformation', has found a marginal yet important place in **art^ history** – though in many respects it has been used more for rhetorical effect (e.g.: proclaiming a '**cubist** revolution' or '**surrealist** revolution') rather than as part of a sustained **theoretical** argument or comprehensive **historical^ analysis**. In the past, however, art and **artists** *had* become bound up with actual political *revolutionary* change in certain **societies**: in France, for example, in the 1780s through to the Revolution of 1789, the Terror of the 1790s, and the **emergence** of Napoleon Bonaparte as Emperor of the new French **state**. The **neoclassical** court-, and then state-, artist Jacques-Louis David, later an active and important political **figure** himself in the revolutionary government, or 'Directoire', of the 1790s, is seen by art historians as a revolutionary **public^ painter** committed to a new and **visual^ form** of civic-moral vigour modelled on Roman sources (e.g.: *The Oath of the Horatii* (1785)), as well as an artist caught up in the revolutionary events of his time.

To take another example, some Russian artists allied themselves with the Bolshevik uprising against the Czar and his limited parliamentary government which took place in Moscow in 1917, an event which quickly became known as the 'Russian Revolution'. Artists with a wide variety of political and **aesthetic** interests and **values**, in fact, had became **agents** within the social and political unrest in Russia from the long **period** before the 1917 uprising through to the Stalinist **period** of the 1930s and 1940s (e.g.: the 1880s social-liberal 'Wanderers' group; the **avant-garde** and **abstract** painters and **sculptors**, including Vladimir Tatlin, Kasimir Malevich, and Aleksandr Rodchenko who affiliated themselves temporarily to the Boshevik regime after 1917; and the **socialist realist** artists **dominant** after 1934 when Stalin outlawed **modernist** experimentation). To the extent that revolutions – this time of an ultra right-wing

kind – also happened in Italy under Mussolini's fascists and in Germany under Hitler's nazis, most modern artists in these countries also took sides. In both these cases it was *generally* the case that abstract and avant-garde artists were anti-fascist (and many pro-communist and socialist). In response, the nazi regime in Germany closed down the **bauhaus**, which it saw as part of a 'Jewish conspiracy', **exhibited** as a warning what it called 'Degenerate Art', and actively sought to imprison artists believed to be hostile to the proclaimed Aryan values of Hitler's Germany.

In contrast to these examples, then, the use by art historians and **critics** of phrases such as 'a revolution in **style**' (often referring to twentieth-century modernist **developments**, though 'reaction and revolution' is a cliché of nineteenth-century art history) seem mostly glib and rhetorical. Usually they indicate simply what the writer wishes to see as a novel and highly **original** change or development in art practice thought to constitute effectively a new beginning – and an end to something else. Rosalind Krauss made such a claim about the **significance** of Pablo Picasso's cubist collages – and made a case for the 'purity' of these **artworks** which sounded rather like the rhetoric associated with the political revolutions in France in 1789 and Russia in 1917. Indeed, **movements** in modern art, in many ways historically parallel with actual socio-political upheaval and the claimed revolutions in early-twentieth-century societies such as Russia or Italy, not surprisingly themselves took on the **language** and sometimes the aims and **values** of these new political forces – for instance, the Italian **futurists**.

Further Reading

Berger, John *Art and Revolution* (Vintage: 1969).
Boime, Albert *A Social History of Modern Art: Art in an Age of Revolution 1750–1800* (University of Chicago Press: 1987).
Klingender, Francis *Art and the Industrial Revolution* (Paladin: 1972).
Trotsky, Leon *Literature and Revolution* (Russell and Russell: 1957).

ROCOCO

Derived from the French word *rocaille*, meaning 'shell-' or 'rock-work', an eighteenth-century term – **originally** used as a **criticism** to suggest frivolity – and mainly associated with the decorative **arts**. *Rococo* is the name for one of the core **styles** that makes up **art**^ **history's**^ **narrative** of **developments** in **western**^ **art** since the

fifteenth century: '**renaissance** → **mannerism** → **baroque** → rococo → **neoclassicism** → **romanticism** → **realism** → **modernism**'. As with the other terms in this sequence, rococo hovers ambiguously between (a) denoting the thematic concerns of a set of **artists** and the **formal** attributes of their **artefacts** (the latter **exhibiting** lightness and gaiety of touch and effect, if not a frivolity implying superficiality) and (b) referring to the conditions of a specific **socio^-historical** period in Europe and **commissions^** **dominated** by royal and aristocratic **patronage**.

The term is used primarily to designate interior **design^** **practices** (rather than **painting**) in eighteenth-century France. In formal terms, these consisted of a move *away* from the excessive baroque splendour of the Versailles court after 1715 (the year King Louis XIV died) and the shift to Paris-based 'townhouse' **culture** of interior decoration based on 'c' and 's' scrolls, counter-curves, and asymmetrical patterns in, for example, room panelling, porcelain, and work in gold and silver. Particularly important in rococo **crafts^ production** were the porcelain factories at Sevres (directed by Étienne-Maurice Falconet, **sculptor** of nymphs and bathers) and at Meissen, near Dresden.

The great painters of the rococo **period** (which is deemed to decline, or become **residual**, by the late 1740s, followed by the **emergence** of neoclassicism) were Jean Antoine Watteau, J. H. Fragonard, and Francois Boucher, the latter a major decorator of royal residences and tapestry designer (e.g.: Watteau, *Fete in a Park* (1718), Fragonard, *The Park in the Villa d'Este in Tivoli* (1760), and Boucher, *Dejeuner* (1739)). In the Catholic south of the countries now called Germany and Austria, rococo was the name given to the style of fine churches and religious statuary designed by, for instance, Ignaz Gunther, Johann Balthasar Neumann, and Dominikus Zimmerman. Though the term has also been applied to paintings by Giovanni Battista Tiepolo in Venice (decorator of the Kaisersaal, or main **state** room, of the prince-bishop's Residenz in Wurzburg (1750–53)) and Francisco de Goya in Spain (tapestry designer and painter of the group **portrait** of the *Family of Charles IV* (1800)), its **conceptual** coherence and **analytic** usefulness seems ambiguous when used to describe these two artists motivated by a wide variety of aims and ambitions, although both did work on occasion for the royal patrons of Europe.

In manifesting this ambiguity of **meaning** and **value**, the term *rococo* – like all the others in the narrative sequence – manages to remain apparently necessary but also inadequate. **Traditional marxists** such as Arnold Hauser appeared to see the rococo essentially as a

frivolous (if not actually decadent or corrupt) style and plaything of the European royal courts in the period immediately before the onset of their downfall in France in 1789 and in other countries in the nineteenth century. Twentieth-century modernist historians, however, have pointed to the important decorative **qualities** of Watteau's **landscape** easel **pictures** and suggested that the style's prevalence **significantly** coincided with the emergence of a recognisably modern criticism of art in the mid eighteenth century, particularly in the writings of Denis Diderot.

Further Reading

Conisbee, Philip *Painting in Eighteenth Century France* (Oxford University Press: 1981).

Fried, Michael *Absorption and Theatricality: Painting and Beholder in the Age of Diderot* (University of California Press: 1980).

Hauser, Arnold 'The Dissolution of Courtly Art', in *The Social History of Art: Rococo, Classicism and Romanticism* (Routledge: 1999).

Kimball, F. *The Creation of the Rococo Decorative Style* (W. W. Norton and Co.: 1980).

ROMANTICISM *ROMANCE, ROMANTIC, ROMANTICISED*

Coming late within the sequence of terms that constitutes the great **narrative** of post-**medieval**^ **western**^ **art** ('**renaissance** → **mannerism** → **baroque** → **rococo** → **neoclassicism** → *romanticism* → **realism** → **modernism**'), romanticism is a broad and vague term with a range of **meanings**. Invented in the early nineteenth century, however, the term has **origins**^ **historically** very close to many of the **artists** who are regarded as its most important exponents: in France, Eugène Delacroix and Theodore Gericault; in Spain, Francisco de Goya; in England, William Blake, J. M. W. Turner, and Samuel Palmer; and, in what is now Germany, Caspar David Friedrich.

Though the term has the root meaning of 'romance' suggesting an **idealised** narrative of seduction involving flattery and possibly fantasy, the **dominant**^ **art historical** senses to the term are really concerned with (a) the depiction of heightened sensation, unusual **states** of being and experience, such as those **represented** in the **pictures** Turner made depicting violent storms at sea or the experience of a journey made on one of the first steam trains (e.g. *Rain, Steam, and Speed – the Great Western Railway* (1844)), or for instance

Goya's disturbing **representations** of war victims' decapitated and limbless **bodies** in his *Disasters of War* etchings and drawings (1810–13); (b) highly individualised heroic actions set against both the **social** and **natural** worlds, such as Gericault's scenes of shipwrecks and cannibalism (e.g.: *The Raft of the Medusa* (1818)); and (c) the relation between such extreme **human** experience and **visually** represented **symbols** of God and the abyss. This latter category would include, for example, the **landscape** paintings of Friedrich, such as *Monk by the Sea* (1809–10), that depict a single human **figure** facing a horizon in the **form** of an ocean or **view** of a distant mountain range. In these pictures a notion of God or of infinity beyond earthly existence is *subliminally* represented through an aspect of the **material** universe: it is shown through a symbol of the 'sublime', or that which is beyond actual human visibility and experience.

Although the depiction of an apparently natural order recurs in romantic paintings and drawings, all these artists were actually facing a rapidly changing modern **social** world in which political **revolution**, urbanisation, industrial **capitalism**, and war were becoming the **dominating** forces. Some of the romantics – politically conservative in their **perspective** – attempted to exclude the depiction of these circumstances entirely from their artworks, producing idealised representations of the land evoking biblical accounts of the Garden of Eden (e.g.: Samuel Palmer, *Scene from Lee, North Devon* (1835)). However, it was the onset of this new **social order** of modernity in nineteenth-century Europe, the US, and eventually the rest of the world that had brought the **discourses** of individualism, secular knowledge, and technocratic rationality into prominence. These were bound up from the **epoch** of the renaissance with notions of **artistic^ identity** and **creativity**. It is still commonplace to say that artists are romantics, meaning that, being unworldly or dreamers, they are somehow set apart from all others in modern society. Their bohemian life**styles** and **values**, however, *never* excluded the possibility of social action for radical political – as well as **aesthetic** and individual-experiential – purposes, as the history of **avant-garde** art **formations** in the later nineteenth and twentieth centuries clearly shows.

Further Reading

Honour, H. *Romanticism* (Harper and Row: 1979).
Lister, R. *British Romantic Painting* (Cambridge University Press: 1989).
Rosen, Charles and Henri Zerner *Romanticism and Realism: The Mythology of Nineteenth Century Art* (W. W. Norton and Co.: 1984).

Vaughan, W. *Romantic Art* (Thames and Hudson: 1978).

SCHOOL

With phrases such as 'the School of Paris' and 'the New York School', **art^ historians** have invented an inherently ambiguous *collective* **identity** for artistic phenomena which bears comparison with two other also rather amorphous **concepts** – **style** and **movement**. However, *school*, in another familiar usage – referring, that is, to a specific **organisation** or **institution** with teachers, students, and shared resources, following a curriculum and process of candidate entry selection, examination, and award (e.g.: **medieval craft** workshops and guilds, the French **Académie** des Beaux-Arts, the Slade School of Art, the **Bauhaus**, and Black Mountain College) – seems a very different and tangible thing. Might the two senses have any overlapping elements?

They do, because in the vast majority of cases, actual **modern** art schools, for instance, have produced graduates (and faculty) whose interests and working methods, though perhaps common in very broad terms or ethos, always differed and resulted in a range of outcomes – both in terms of teaching **practices** and in the **production** of **artefacts**. What might be called this *coherent generality* is, arguably, the same sense usually **intended** by the phrases 'School of Paris' and 'New York School'. Both terms refer, that is, to quite large numbers of **artists**, in many cases unknown to each other personally, who produced **artworks** over a number of decades within, or in relation to, a specific place. In the case of the 'School of Paris', this *grouping* – distinct from the more specified art historical terms movement and **formation** – is usually defined as those artists active in that city, and its related environs, starting with **cubism**, and continuing, as an agglomeration of producers, products, themes, and styles, between about 1910 and 1940. 'School of Paris' principally refers to Parisian residents Pablo Picasso and Henri Matisse – two modernist artists regarded as following *very* different **careers** and at times actually antagonistic towards each other in a variety of ways during this **period** of about thirty years. But 'School of Paris' also includes all the other Paris-based artists and groups thought to have derived their styles from Picasso's and Georges Braque's cubism produced in the early phase, *c.* 1908–16. In this sense, cubism is **represented** as an important sub-facet or instance within 'the School of Paris' as a whole that denotes a range of *shared* but very broad thematic and

pictorial concerns explored by artists including Picasso, Matisse, André Derain, Joan Miró, Férnand Leger, Marc Chagall, Paul Klee, and Jean Dubuffet.

Though it has been claimed that a 'School of Paris' persisted after the Second World War – and it is possible to assert that such a school continues even now, in that **contemporary** artists still work in the city and have inherited and/or claimed the artistic **culture** of the interwar period – art history overwhelmingly agrees that Parisian modernism was superseded, in **qualitative** terms, by artists based in New York (some of whom, however, were born in Europe), responsible for the style known as **abstract^ expressionism**, usually dated from the late 1940s. By the mid 1960s it had become common to talk about 'the New York School' encompassing art and artists based in the city, roughly between the late 1930s and the rise of **pop art**. Interestingly, though one of US pop's chief exponents, Andy Warhol, was a New York-based artist, his thematic and **formal** interests in the **iconography** of **mass culture** effectively excluded his work from clear definition as 'New York School', suggesting that the term had acquired by the 1950s a relatively tight conceptual sense based on principles of 'gestural' or 'hard-edge' abstraction, and **pictorial expressiveness** modelled on paintings by Jackson Pollock and Barnett Newman

Further Reading

Brown, Patricia Fortini *Venetian Narrative Painting in the Age of Carpaccio* (Yale University Press: 1989).

Green, Christopher *Cubism and its Enemies* (Yale University Press: 1987).

Sandler, Irving *The New York School: The Painters and Sculptors of the Fifties* (Harper and Row: 1978).

Williams, Raymond 'Cambridge English, Past and Present', 'Crisis in English Studies', and 'Beyond Cambridge English', in Williams, *Writing in Society* (Verso: 1983).

SCULPTURE/SCULPTOR *SCULPTURAL*

Like the term **painting**, *sculpture* has two linked but separable senses. First, it refers to a distinct **medium** of **artistic^ expression** in existence over an extremely long **period** utilising, exploring, and foregrounding three dimensions of **material^ form**. (In contrast, painters – until the twentieth-century **modernists** at any rate – focused overwhelmingly on the **imagery** of their **artefacts** rather

than their three-dimensional material 'objecthood'.) **Traditional** materials used in sculpture have included stone, wood, bronze and other metals, clay, and glass. Second, the term **identifies** *particular* artefacts, and can be used, like painting, in ways that combine both these singular and plural **meanings**: for instance, in the sentence 'the **abstract** sculpture of Constantin Brancusi'. The two meanings here are bound up together and it would be common sense to assume that a particular sculpture by Brancusi (e.g.: *Bird in Space* (bronze, 1927)), constitutes an example of the stable **conceptual** category of sculpture understood as a medium of expression. Sculptures have generally been carved, moulded, or assembled in a wide variety of manual and mechanical processes **developed** over thousands of years.

To reiterate, sculptures differ essentially from paintings in the very basic material sense that they are artefacts **intentionally** and self-consciously **produced** within three dimensions of material expressiveness – sculptures are **designed** to be **viewed** from a range of viewpoints and many, such as **public** monuments in town squares and on pedestals, have been made in order to be seen from 360 degrees, or 'in the round' (e.g.: Nelson's Column and the four lions around its base in Trafalgar Square, London (1843)). Some so-called 'relief' sculptures, however, are extremely shallow in material form – for instance those designed as decorative and **narrative** features for church doors – and in this way resemble paintings (e.g.: *Adam and Eve after the Fall*, from the bronze doors of Hildesheim Cathedral (1015)). Distinguishing sculpture from painting is therefore not as straightforward as it may at first seem: paintings **conceived** as images, though always artefacts made from materials existing in three dimensions, are often considered merely two-dimensional (see René Magritte's **visual** joke making this point, *The Treachery of Images (This is Not a Pipe)* (1929) – it's an image of a pipe). To complicate matters further, sculptures – indeed all objects – also present a single image to the eye when seen from a particular, and often intended, viewpoint (e.g.: Gianlorenzo Bernini, *The Vision of St Teresa*, altar in Sta. Maria della Vittoria, Rome (1644–47)). The use of slides and **photographs** of paintings and sculptures in teaching and in publications also tends to emphasise their character as image over the facts of their material three-dimensionality. Conversely, though paintings in all cases present what might be called an 'articulated **surface**' of pigment, other sub-stances, and sometimes bare canvas, this surface has not always been entirely flat, or even distinct from a **functioning** wall or other **structure**, and has also usually been visible from a comparatively quite wide variety of angles (compare: Morris Louis's *Iris* (oil painting

on canvas (1954) and Raphael's *The Liberation of Saint Peter* (fresco, Apostolic Palace, Stanza dell' Incendio, Vatican (1512)).

In the past fifty years some artists have sought deliberately to examine and sometimes undermine distinctions between painting, sculpture, and **architectural** space. With the objects produced by the late 1960s **minimalists**, as well as, more recently, by, for example, Greg Lynn and Fabian Marcaccio, it has become possible to talk of works that seem to lie *between* these categories, confounding normal principles of **identification** (e.g.: Robert Morris's *Untitled* (cut tan felt, various dimensions (1967–68); Lynn and Marcaccio's *Secession Project* (multi-media including nylon (1999)).

Further Reading

Fried, Michael *Art and Objecthood* (University of Chicago Press; 1998).
Lodder, Christine *Russian Constructivism* (Yale University Press: 1983).
Stewart, A. *Greek Sculpture* (Yale University Press: 1990).
Weyergraf-Serra, Clara and Martha Bukirk (eds) *The Destruction of Tilted Arc: Documents* (MIT Press: 1991).

SEMIOLOGY *SEMIOLOGICAL, SEMIOSIS, SEMIOTICS*

Name for the study of **signs** and sign-systems (*semiotics* is American-usage; *semiology* its European name). The founder of semiology was the Swiss **linguistics** scholar Ferdinand de Saussure, whose *Course in General Linguistics* – a book based on a series of lectures he gave at the University of Geneva in 1911–12 – **produced** the **conceptual** framework for the discipline of structural linguistics. Semiology, though its earliest exponents worked in a number of different countries in Europe and brought to their investigations quite a wide variety of **academic** backgrounds including philosophy, anthropology, and literary studies, initially rooted its concerns and methods both in response to and reaction against **theoretical** accounts of the **nature** of **human** spoken and written language.

In its later phases, semiology attempted to name and **analyse** *all* the kinds of signs that may be found in the world, and common to the work of virtually all semiologists has been the agreement that a sign is 'anything a person regards as a sign': that is, something given **meaning**. This would include, for example, the meanings given to all kinds of **natural** events – such as earthquakes seen as divine

wrath – by people at particular times living in particular places. Given the huge number of things, then, that have been, and might possibly be, construed as signs, it is not surprising that some of the leading semiologists – including the American philosophy-trained C. S. Peirce and the Czech linguist Roman Jakobson – set about constructing 'taxonomies', or **classifications**, of different types of signs which they claimed operated in particular, observable, ways.

While Jakobson was interested in signs, systems, and codes within language proper (particularly with what was called 'linguistic performance' or 'speech acts'), Peirce, who claimed to have **identified** literally thousands of different kinds of signs, examined **visual** and other physical signs – both those actually manufactured by people and those naturally occurring phenomena seen by them as 'sign-ificant'. Humanly made signs that generated meanings – the process of semiosis – via physical *resemblance* to the things they referred to he called **iconic** signs (e.g.: **portrait^ paintings, photography**, and **figurative^ sculptures**). Those based simply on agreed, or **conventional** meanings, he called 'signs proper' – such as the red and green of traffic lights **representing**, respectively, 'stop' (or danger, be alert) and 'go' (safe, OK). The fact, however, that these colours apparently are given these same general meanings universally by *all* **cultures** suggests the possibility that at least an aspect of their meaning is not conventional but somehow rooted in human biological nature or instinctual life.

Within **art history**, scholars including Meyer Schapiro attempted in the 1960s to codify the elements of visual meaning in graphic representations dating from the earliest examples of cave-painting – though Schapiro always understood these **pictures** to combine biological, **psychological**, and **social**, as well as **formal**, semiological, features (e.g.: the Altamira and Lascaux cave paintings of bison and horses made 15,000 years BCE). The literary **critic** and analyst Roland Barthes, similarly, stressed the cultural and **historical** circumstances within which signs became meaningful – emphasising, for example, the political and **ideological** role of photographs and their accompanying **texts** printed in **contemporary** print journalism (e.g.: the cover of *Paris Match* magazine in 1957 showing a Black Algerian soldier loyally saluting the French flag, during that colony's violent war of independence against France).

Further Reading

Barthes, Roland *Elements of Semiology* (Hill and Wang: 1967).

Bryson, N. and Mieke Bal 'Semiotics of Art History', *Art Bulletin* June 1991: 174–208.

Eco, Umberto *A Theory of Semiotics* (Indiana University Press: 1976).

Peirce, C. S. *Collected Papers of Charles Sanders Peirce*, 8 vols (Harvard University Press: 1931–58).

SEX *SEXUAL, SEXUALITY, SEXY*

Term with two usual senses: (1) the **state** of being either male or female in biological (genital) terms; and (2) activity between at least two people involving genital contact. In the former usage *sex* is distinguished from **gender** in that the latter is held to refer to **social** and **cultural** aspects of male or female **identity**. Within **art^** **historical** and **cultural studies^** **discourse**, however, sex, and its related terms, has attracted a range of **meanings** far beyond these simple definitions. Both sex and gender, for instance, in referring to the apparently fixed states of being *either* male or female appear to rule out the possibility of any other category (stable or shifting) of **human** biological and cultural existence and identity – yet **historically**, and in **contemporary** society, many examples of 'trans-sexual and 'trans-gender' life can be found. These have always been closely related to **visual^** **representations** of various kinds: of the **mythological** creatures, gods, and humans combining male and female (and animal) elements and relationships (e.g.: Sphinx, marble gravestone, near Athens (550 BCE); Ganesha, elephant headed god of wealth, Bara of Blitar (1239); 'Leda and the Swan' **iconography** in **western** art; cross-gender face masks of the Segu sub-**style** of the Bambara (Africa), worn by uncircumcised boys preparing for manly male society). Other examples include the deliberate masking and reversing of sexual and gender identities within **avant-garde** art (e.g.: Marcel Duchamp's cross-dressing 'Rose Selavy' character); and the literal physical remaking of **bodies** and gender/genital 're-assignments' now common in surgical-**sculpting** operations (enacted and represented in, for example, the videos the French **artist** Orlan has made of operations on her own body).

Beyond these examples, sex refers to the orientation of physical **desires**. In this sense sexuality, like sex, is also understood as a state, or a situation, or circumstance – often with the implication that this state is **natural**, fixed, and unchangeable. Usually people in **western** societies have sexualities **identified** as heterosexual (that is, they are attracted to people of the other, or 'opposite', sex), homosexual (that is, they are attracted to people of the same sex), or bisexual (that is,

they are attracted to those both other and the same). The fundamental contribution to art history made by the French **post-structuralist** historian and philosopher Michel Foucault was to show that, before the nineteenth century, sexuality was not understood as a fixed, determinate, and unchanging *thing*, but rather more a matter of sexual *acts* carried out by individuals. The belief that these actions thereby constituted, or confirmed, their agents as **subjects** within the *natural* categories of 'heterosexual', 'homosexual', or 'bisexual' came very late in what Foucault, in pointed distinction, called the *history* of **human** sexuality – as part of the novel **modern** system of knowledges **produced** within the medical, scientific, and industrial societies of the west since the late eighteenth century.

Over the last thirty-five years or so, art historians have investigated many aspects of the ways in which sexual activity, identity, and sexuality have been represented across a very wide range of **media**, cultures, and historical **periods**. Perhaps not surprisingly, these studies were often conducted by individuals and groups of scholars with radical – sometimes **new art historical** – socio-political **perspectives** on gender and sexuality: particularly **feminists** and gay or lesbian (queer) activists. Their interests, however, were as much to do with the politics of art history itself – for instance, its discriminatory university and **museum** employment policies and its characteristically 'straight' discourses and **values** – as with the study of, for example, gay, lesbian, or bisexual artists such as Rosa Bonheur, Oscar Wilde, Aubrey Beardsley, Charles Demuth, Jasper Johns, Andy Warhol, David Hockney, or Maggi Hambling.

Further Reading

Foucault, Michel *The History of Sexuality vol. 1: An Introduction* (Penguin: 1981).
Kampen, Natalie Boymel (ed.) *Sexuality in Ancient Art: Near East, Egypt, Greece, and Italy* (Cambridge University Press: 1996).
Kuhn, A. *Cinema, Censorship and Sexuality* (Routledge: 1988).
Merck, Mandy *The Sexual Subject: A Screen Reader in Sexuality* (Routledge: 1992).

SIGN/SIGNIFICANCE/SIGNIFICANT/SIGNIFYING SYSTEM *SIGNIFIED, SIGNIFIER*

The **concepts** of *sign* and *signifying system* have had a dramatic effect upon many facets of **art^ history** since the later 1960s, when – as part of the discipline of structural **linguistics** – many younger scho-

lars brought to their **analysis** of **visual^ representations** a variety of positions and **perspectives** generally known as **structuralist**. In broad terms the *significance* (meaning **value**) of the terms *sign* and *signifying system* lay in the belief that all kinds of representations – those both spoken or written, and **visual**, such as **paintings, sculptures,** and **film** – were intelligible through a method of study that focused on the *relationship* between the various **formal** elements constituting a representation. This so-called 'relational' method had been drawn from the study of **human** languages **developed** by the Swiss linguist and 'father' of structuralism, Ferdinand de Saussure. He had been adamant that **meaning** in language was not what he called 'positive' (that is, it didn't inhere in individual words), but rather was only a matter of the 'chain' of different sounds (signifiers) and concepts (signifieds) that language as a signifying system *as a whole* **produced**.

Perhaps not surprisingly, art historical interest in this notion of the sign followed from the rapid development of **semiological** studies of filmic **imagery**. For not only was a film a mode of visual representation that signified 'over time' in a chain of images, sequences, and **narratives**, but it usually also included other sign-systems such as dialogue and music tracks. In the 1960s the study of film (particularly in France) was also linked to a radical political and **aesthetic** perspective: the **critical** advocacy of **avant-garde** experimentation, particularly in films by Jean-Luc Godard, along with support for left-wing **social^ movements** in **western** countries and **revolutions** in the 'third world' (e.g.: the People's Republic of China and Vietnam). The concepts of sign and signifying system had, therefore, their own **ideological** import, signalling an understanding of meaning in art as **materially** produced, and *not* a matter of **idealised^ creativity**.

In art history scholars attempted to use this **theory** of the sign to overturn what they saw as bourgeois-**romantic** accounts of art understood as an **expressive**-intuitive activity. Though much interesting work was certainly done trying to establish the ways in which, for instance, paintings, **photographs**, and films do and don't work like a written or spoken language – for example, how they might be said to contain or not contain language-like properties of order, sequence, **narrative**, and **figuration** – the net effect of this effort, over perhaps twenty-five years, has been finally to undermine the belief that the huge variety of signs made by **humans** could all be rooted in, or understood as part of, a single, **dominant**, example or 'paradigm' – whether it be that of human spoken language or anything else. Scholars such as C. S. Peirce, for example, attempted to **classify** sign types – and this work has valuably aided analyses of

visual representations. Though Peirce's category of **iconic** signs (which work by visually or physically resembling the things they refer to) importantly connected to the **traditional** art historical study of iconography pioneered by Erwin Panofsky, Peirce's point was that this was only one kind of visual sign. Cultural **artefacts**, his work indicated, were often made up of a number of different kinds of signs and systems of signs – for instance, those such as illustrated manuscripts, cartoons, and films that combined visual imagery with written or spoken **text**. Beyond these questions of formal sign types, other scholars – such as Julia Kristeva and Norman Bryson – attempted to link visual signifying systems in **renaissance** and **neoclassical** painting to **psychoanalytic** concepts such as the **gaze**, and to notions of power and **desire**.

Further Reading

Lapsley, R. and M. Westlake *Film Theory: An Introduction* (Manchester University Press: 1988).

Pajaczkowska, Claire 'Structure and Pleasure', in G. Robertson (ed.) *The Block Reader in Visual Culture* (Routledge: 1996).

Silverman, K. *The Subject of Semiotics* (Oxford University Press: 1983).

Wollen, P. *Signs and Meanings in the Cinema* (Thames and Hudson: 1969).

SOCIAL/SOCIETY/SOCIOLOGY/SOCIO-
SOCIETAL, ASOCIAL

Many **art** and **art history** students first encounter the **concept** of *society* when they find it posed against, or at least set in distinction to, the concept of art. Courses called 'art *and* society' or 'the **artist** *in* society' help to establish – **intentionally** or not, through the work done by these words 'and' and 'in' – the assumption that the two terms refer to separated, **autonomous**, and sometimes even antagonistic things. It has also been common for artistic **creativity** and individualism to be depicted as threatened and undermined by society, the latter **represented** crudely as a constraining **structure**, setting limits and restricting artists' free impulses and interests. Yet, though the range of things grouped as *art* and those grouped as *society* can certainly be separated out **analytically** (for example, in examples of art historical and art **critical^ explanation**), they are always bound up together in the actual **organisation** of social life.

Society is usually defined in terms of the whole range of **institutions**, political, legal, social, and economic activities, relationships,

groupings, **traditions, history**, and **values** that a people (sometimes a **race**) has established in a distinct geographical place. The concept inevitably overlaps with both **nation** and **culture**: the former names territories which are recognised legal-political entities (such as the USA or France) and the latter the broad 'forms of life' of a people exemplified by, for example, their musical, literary, and **visual**-cultural **practices**. *Sociology* is the study of the history and structure of societies – a comparatively recent **academic** discipline which really grew up at the same time as nation-**states** came to **dominate** the world in territorial and political terms, from the mid nineteenth century onwards. Society and nation-state are distinct too from the important concept of **social order** – the particular *configuration* in which a set of forces, group interests, and values shape and dominate a society at a particular time.

From these definitions it should be clear that all artists, all components of artistic practice, and the **art world** as a whole necessarily *belong in, as part of*, society. Artists historically always have been, and are, in **contemporary** terms, individuals and members of groups living in particular societies (now, mostly all nation-states), who are involved in definite **social relations of production^ and consumption^** that enable, regulate, and limit their work – in economic and broadly political terms. Within all the different kinds of societies that have existed, these social relations have varied enormously, and the role and **meaning** of art and 'being an artist' within them has changed – and is continuing to change – radically. From the late nineteenth century onwards, **avant-garde** artists in France and other European countries began to disengage from mainstream society as they came to reject the bourgeois-**capitalist** social order – and this 'disengagement' or **desire** to find an 'outside' place (irrespective of whether it was really possible or not) led to the continuing belief that **modern** art and artists peculiarly *are* separate from, and in some cases radically opposed to, society as a whole. While this ideology is still powerful, arguably it has become **residual**: since the 1960s, with the **globalisation** of artistic production and consumption, successful artists have become increasingly assimilated to a corporate-capitalist art world –as purveyors of luxury commodities on the one hand (e.g.: Jeff Koons, Damien Hirst) and minor players within **media** celebrity-culture on the other (e.g.: Tracey Emin, Sam Taylor-Wood).

Further Reading

Durkheim, E. *The Rules of Sociological Method* (1895) (Macmillan: 1982).

Giddens, Anthony *The Constitution of Society* (Polity Press: 1984).
Morley, D. *Television Audiences and Cultural Studies* (Routledge: 1992).
Vazquez, A. S. *Art and Society* (Monthly Review Press: 1973).

SOCIAL HISTORY OF ART *SOCIAL ART HISTORICAL*

Term for a **tradition** of **art**^ **historical**^ **analysis** rooted in early-twentieth-century central European scholarship – particularly that of Aby Warburg and Erwin Panofsky – though now **identified** mostly with a group of historians active in Britain, continental Europe, and the US since the 1950s. These scholars, including Frederick Antal, Ernst Fischer, Francis Klingender, Arnold Hauser, Albert Boime, T. J. Clark, O. K. Werckmeister, Robert Herbert, Lucy Lippard, Horst Bredekamp, Fred Orton, Griselda Pollock, Carol Duncan, Francis Frascina, David Craven, Andrew Hemingway, Stephen Eisenman, Jonathan Harris, Tom Crow, Benjamin H. D. Buchloh, and Alan Wallach, all manifested in some of their key studies commitment to a **marxist** account of **society**, **culture**, and art. In broad terms their work all shares a concern to locate art and **artists** *within, as part of,* specific economic, social, political, and **ideological** contexts. Their studies examine art's **social relations of production**^ **and consumption**^ and the conditions shaping its later **critical**^ **interpretation**. Because of these principles their work may be described broadly as **materialist** in outlook.

These art historians, however, constituted no **organised**^ **movement** or 'tendency' (though some occasionally collaborated) and their writings have often demonstrated radical disagreements about methods and **values**. For instance, Pollock and Duncan, as **feminists**, both found aspects of marxist **theory** and politics highly problematic because of what they saw as its oppressive **patriarchal** elements and avoidance or dismissal of the issue of **gender** in accounts of artistic **production** and **creativity**. Similarly, Clark, Orton, and Crow regard the work of the older generation – particularly Hauser – as highly crude and reductive in that it was usually based on highly generalised **epochal** history writing rather than on careful analysis of specific historical conjunctures. Hauser's *The Social History of Art* (1951) is an example of this sweeping account, centred on highly **abstract** notions of **style**, ideology, and socio-political **development**, rather than on detailed discussions of specific artists and **artworks**. *Social history of art*, therefore, is the name for a living, changing, cri-

tical, and *self-critical* **tradition** of research, writing, and polemic aimed at politicising **academic** art history and associating the discipline with **revolutionary** (although **complex,** multifarious, and disputed) social and political **ideals** and activities.

A brief consideration of the historical 'waves' of social history of art production in the twentieth century indicates something of this extended, but internally differentiated, tradition of work. Relatively isolated scholars active before the Second World War had begun to consider culture and art as evidence of social history and development, but were not usually adherents of any named method or theory of analysis, much less of marxism, understood as a political creed or intellectual doctrine. By the 1950s and 1960s a much more systematised social history of art, some of it based mechanistically on versions of marxist philosophy and history (bred in the Cold War), had come into existence, producing much useful documentary history of culture, but generally not offering sustained analysis of artworks, or dealing in new ways with questions of, for instance, **creativity,** **value,** or the specific connections between social and artistic change.

Social historians of art active since the 1960s have centred their work on these questions, though some have been much more direct about this than others in their writing. What are the links between art and revolutionary social and political change? Social historians of art **influenced** by the events of May 1968 (e.g.: Clark, Lippard, Pollock, Orton) wanted to connect their work both to the **contemporary** moment – to their own commitment to socialist, and feminist politics in the later 1960s and 1970s – *and* to study of earlier revolutions where politics and art were inextricably mixed up: Jacques-Louis David and the 1789 French Revolution (Crow, Clark), Gustave Courbet and the 1848 Revolution in Paris (Clark, Linda Nochlin), and Kasimir Malevich and Vladimir Tatlin in Russia in 1917 (Clark, Buchloh). However, with the decline in socialist and feminist politics in the world since the 1980s the danger has existed that the social history of art tradition will become merely another academic **specialism,** with no living, radical moral or socio-political connection to the world outside the university.

Further Reading

Boime, Albert *A Social History of Modern Art* 3 vols (University of Chicago Press: 1987, 1990, 2004).

Clark, T. J. *Image of the People: Gustave Courbet and the 1848 Revolution* (Thames and Hudson: 1973).

Harris, Jonathan *The New Art History: A Critical Introduction* (Routledge: 2001).

Hauser, Arnold *The Social History of Art*, 4 vols (Routledge: 1999, general introduction and introductions to each volume by Jonathan Harris).

SOCIAL ORDER

Term referring to the specific **organisational** relationship of **classes**, groups, activities, resources, power, **cultures**, and **ideologies** present in an actual **society**. Though *social orders* undoubtedly exist in much smaller-scale groups – it would be possible, for example, to discuss the social order of the **surrealist^ movement** in the early 1930s, or those constituting the **structure** of **art^ academies** in the nineteenth century, or in **contemporary** university **art history** departments – the term has generally been used to **explain** how a whole society, understood to mean a **nation^-state** or country, operates. While the notion of social order is not particularly common in ordinary parlance, its opposite – the **reality** and threat of social *disorder*, of a society's order fundamentally broken down by criminality, or **natural** disaster, or terrorism – certainly is.

In virtually all of the **western** nations since the nineteenth century a social order has existed that has been defined as urban industrial-**capitalist** (often this has come to mean the same as saying **modern**). **Identifying** these primary organising features in this **fashion** also usually implies saying that the future **development** of these societies will be determined – or at least decisively shaped – by these factors and the ways in which they interrelate in specific social orders around the world. For example, it is often said that the US is the world's most dynamic, modern, and modernising society, with a social order that **historically** has been the *least* **traditional** (meaning conservative with a small 'c'). That is, **dominant** within US society have been corporate and entrepreneurial capitalist interests, bound up with a state and constitution that effectively recognises and defends the primacy of those interests (defined ideologically as Freedom and the American Way). The US has had, in addition, a disparate multi-**ethnic** population-workforce constantly refreshed since the nineteenth century by large immigrant groups who have sought pragmatically to better themselves *within the terms of this social order* rather than fundamentally challenge it. In contrast, the more traditional social orders in Europe and Asia have attempted either cautiously to adapt to these – often imposed, **globalising** – western

capitalist forces, or reject them altogether in the name of religions or **alternative** political systems such as socialism or communism, or ways of life based on pre-existing organic communities or **cultures**. The 'war on terror' since 2001 in one sense dramatically stages this apparently now global conflict and choice effectively between two **forms** of 'fundamentalism', represented by the modernising US on the one side and conservative dissident Islamic religious groups on the other.

Within the social orders of most societies, past and present, **visual^** **representations** of many kinds – and, in the twentieth century, **artists** and academic disciplines such as art history – have been given particular place and **value**. In the west, generally speaking, the **mass^** **media** of **television**, **film**, video, DVD, and internet **technologies** dominate the **popular culture** – all these visual forms and **means of production^** themselves having become important facets of contemporary industrial and corporate-capitalist **consumerism**. Given this situation it would be reasonable to conclude that art history – predominantly concerned still with the **residual** arts of **painting** and **sculpture** – has gradually become marginal and relatively anachronistic within the social order as a whole, while universities have moved to introduce mass media and **communications** programmes in order to meet the developing opportunities for employment now available in these societies.

Further Reading

Arnold, Matthew *Culture and Anarchy and Other Writings* (Cambridge University Press: 1993).
Poulantzas, Nicos *Political Power and Social Classes* (Verso: 1978).
Veblen, T. *The Theory of the Leisure Class* (Mentor Books: 1953).
Wright Mills, C. *The Power Elite* (Oxford University Press: 1959).

SOCIAL REALISM/SOCIALIST REALISM

In **art^** history *social realism* refers to a set of **stylistic**, **narrative**, and **compositional^** **conventions** characteristic of a wide range of **artefacts** – including **paintings, sculptures, photographs**, and **films** – thought to convey compellingly the actuality of life (e.g.: Ben Shahn's painting *Passion of Sacco and Vanzetti* (1931–32); Duane Hanson's sculpture *Supermarket Lady* (1970); Walker Evans's photograph *City Lunch Counter* (1929); Luchino Visconti's film *Rocco and his Brothers* (1960)). Though the term is sometimes used interchangeably

with the **concept** of **realism**, it would perhaps be difficult to include within it those **visual^ representations** that do not obviously **portray** people – either individually, or more typically, in groups. An exception, however, might be late-nineteenth-century **landscape** paintings by Camille Pissarro that show the 'worked' countryside without always actually depicting its peasants and other rural occupants (e.g.: *The Oise on the Outskirts of Pontoise* (1873), and *Appletrees* (1883)).

These two **pictures** might be said to represent a **natural** world made over into 'resources' for **human** use and transformed physically – as well as in **ideological** terms – by the **classes** and groups of people that have inhabited, exploited, and laboured on the land.

Social realism, however, brings with it all the problems of selection, **interpretation**, and **meaning** that also beset realism and **naturalism**. These terms have been applied to a very wide range of representations produced over hundreds of years, from the **renaissance** to the later twentieth century (e.g.: the painting by Vermeer van Delft *The Cook* (*c.* 1660) and Gerhard Richter's *October 18, 1977* paintings of the Baader-Meinhof Group (1988)). These artefacts differ in many respects – for instance, in terms of the **socio**-economic conditions of their **production**, their use of **materials** and **subject matter**, their relation to governing ideas and ideologies at the time of their making, and in terms of their subsequent interpretation – yet to **identify** them both as realist or social realist implies they share some common **quality** or **value**. However, notions of 'social' and 'realism' have also changed **historically** since these terms, used singularly and in combination, gained currency in the early nineteenth century.

To further complicate matters, from the 1930s social realism has co-existed alongside the notion of social**ist** realism – a term for **art** and literature that was explicitly 'tendentious' (biased) in its political meanings and purpose, **intended** as propaganda for claimed **revolutionary** activities and values. Yet Soviet and Chinese examples of this style in painting have been attacked for many decades as finally nothing more than 'late-**academic**'^ **idealism**, misrepresenting both the world and communist party history in these countries (e.g.: Aleksandr Gerasimov's *Stalin at the Sixteenth Congress of the Russian Communist Party* (1929–30), Nikolai Dormidontov's *The Steelworks* (1932)). Though Gustave Courbet's paintings from the mid nineteenth century still seem secure as the best examples of social realism (e.g.: *The Stonebreakers* (1849)), in their depiction of **class** and regional **identities** in France at that time, it remains necessary to rethink the

meanings of these two key words in order to consider including within the category, for example, both George Grosz's anti-war **expressionist** painting *Germany, A Winter's Tale* (1917–19) and James Rosenquist's extraordinary *F1–11* (1965), a **pop art** painting which drew together, in a montage **technique**, many aspects of US corporate, industrial-military, and **consumer^ culture** at a key moment of escalation in the Vietnam War.

Further Reading

Elliot, David (ed.) *Engineers of the Human Soul: Soviet Socialist Realist Painting 1930s–1960s* (Museum of Modern Art, Oxford: 1992).

Lahusen, Thomas and Evgeny Dobrenko (eds) *Socialist Realism without Shores* (Duke University Press: 1997).

Long, Rose-Carol Washton *German Expressionism: Documents from the End of the Wilhelmine Empire to the Rise of National Socialism* (Macmillan International: 1993).

Nochlin, Linda *Realism* (Penguin: 1971).

SOCIAL RELATIONS OF PRODUCTION AND CONSUMPTION

Within the study of **art**, **design**, and **visual culture** of all kinds, it is important to acknowledge that **producers** *always* make their **artefacts** within definite **social** and **historical** circumstances that both shape and limit their products; and beyond that, to also acknowledge that these products are always used and **interpreted** under specific, though changing, social and historical conditions. In the **marxist^ tradition** this **analysis** has been concerned with what are called the *social relations of production and consumption*. Though marxists turned to the study of **visual** art and **artists** comparatively late – only, that is, in the early twentieth century – they did so with the recognition that **artwork** was another use, and instance, of **human** labour, carried out by people selecting and transforming **material** resources, within, at any given moment, a historically specific *social and* **technological** *division of labour*. Within the general division and **organisation** of labour in a particular society (say, the mid nineteenth century in **western** Europe), artistic production – for instance, in terms of the **practices** of **painting** or **sculpture** – has taken specific **forms** related to factors such as the kinds of **patronage** and **exhibition** available, the nature of **institutional** training, and technological **development**.

Accepting this general principle of analysis, however, has by no means led to only one sense of the **value** or **meaning** of art. Marxist art historians, like those of any other **specialist** group of scholars, have offered different – and sometimes antagonistic – accounts of *which* artworks and artists are important. **Identifying** the social relations of artistic production and **consumption**, that is, does not lead to any necessary judgement about either **aesthetic** value or the **function** of art: disputes between marxists over the **qualities** of Pablo Picasso's anti-war painting *Guernica* (1937), or about the seriousness of **pop art** in the 1960s, are two examples. In both cases the underlying disagreement and evaluative complexities centred on definitions of visual **style** and socio-political efficacy – on whether **forms** of visual **representation** broadly characterised as **abstract** and **realist** best suited the purposes of **ideological^ critique** at particular historical moments. For instance, could *Guernica*'s ambiguous **expressionistic^ symbolism** adequately serve as anti-fascist propaganda? Could Andy Warhol's soup cans and Coke bottles escape definition as an example of what critic Max Kozloff called **capitalist** 'reactionary realism'?

By the mid twentieth century it was also becoming understood that it was not only artworks that were always produced within specific shaping social relations of production and consumption. Consumption, or the use and interpretation of artworks, was also a historically specific process conditioned by a set of interacting economic, social, and political factors – determining, for example, who had access to higher education, or could afford to visit art galleries situated in the capital cities not in the provinces. The study of these relations has developed extensively since the 1960s, especially within the scholarship of those committed to the **social history of art**. Recognition that *all* **viewers** of art are themselves socially- and historically-constituted in specific ways – involving factors of social **class**, **gender**, **sexuality**, and **ethnicity** (amongst many others) – has fundamentally altered the **theoretical** premises of the discipline of art history, itself **subjected** to multiple analyses of its own social relations of production and consumption over the past thirty-five years or so.

Further Reading

Chipp, Herschell B. and Javier Tusell *Picasso's Guernica: History, Transformations, Meanings* (University of California Press: 1991).

Crow, Thomas *The Rise of the Sixties: American and European Art in the Era of Dissent* (Abrams: 1996).

Ritzer, G. *The McDonaldization of Society* (Sage: 1993).

Saunders, P. *Social Theory and the Urban Question* (Hutchinson: 1981).

SPECIALIST *SPECIALISING, SPECIALISE*

Within the division of **artistic** labour in **modern^** **societies** (since the **renaissance**) **producers** have sometimes decided, or been required, to *specialise* in certain types of **artwork**. This could be a matter of only using one **medium** (such as watercolours) or restricting themselves to narrow **subject^** **matter** (such as **portraiture**) **popular** with a group of **patrons**. The range of reasons for this kind of *specialising* activity was wide: they involved, for example, objective factors, such as (1) the **art** market at a certain time and place for various kinds of product, and (2) the available skills training for artists living in certain locations with access to local **materials**. Subjective choices made by artists at a particular time might relate to beliefs and **values** – for instance, the idea that the use of egg-tempera **paint** on board rather than oil on canvas had a distinctive **expressive^** **quality** with important spiritual or moral connotations (a view held by the Nazarenes, or 'Brotherhood of St Luke', in early-nineteenth-century Vienna, who wished to revive Christian values in art).

By the late nineteenth century it is possible to see *specialist* production within **modern** art as a choice made by **avant-garde** artists who rejected **academic^** **institutional** training, **techniques**, and the **conventions** associated with life-drawing, **history^** **painting**, and the 'hierarchy of the **genres**'. But this was not simply a matter of practical or **aesthetic** values; or, rather, those choices – to do with **media**, techniques, and **composition** – were bound up with both implicit and explicit social and political positions and interests. For while some chose to specialise in types of painted **imagery** (for instance, Vincent van Gogh's concern to study and depict peasants at work and leisure, in *The Potato Eaters* (1885)), others, such as those who might be **identified** as some of the first 'art **photographers**' – such as Alfred Stieglitz and Man Ray – rejected **traditional** two-dimensional media altogether and attempted to find new **forms** and technologies of **visual** expression entirely unrelated to what they saw as painting's old-**fashioned** academic past.

The group of **theoretical** categories to which *specialist* belongs – the other two are **alternative** and **oppositional** – is best used, and most valuable within, actual **art-historical** inquiry, and exists to be tested and revised within that active and open study of actual artists and artworks. Specialist production, as part of a **complex** division of labour, has existed for many centuries. Indeed, the early, decisive, **development** occurred thousands of years ago when societies around the world became large and complex enough to begin to separate out,

and support, something identifiable as visual-**representational** production. This, in most cases, had religious or, at least, ritualistic, roots in social **organisation** and its **reproduction**. Consider, for example, the ornamental/**sculptural** bronze lamp-holders from Lach Truong, in the Dong-son **culture** of what is now China and Indonesia (500–200 BCE). But it was not until the sixteenth century in Europe that the **concepts** of art and artist in their modern senses came into existence. Specialist artistic production then increasingly became part of the development of a commodity-based economy within commercial, technocratic, and highly **class**-stratified societies.

see also: **alternative, oppositional**

Further Reading

Burnam, Renne George 'Medieval Stained Glass Practice in Florence, Italy: The Case of Orsanmichele', *Journal of Glass Studies* 30 (1988): 77–93.

Clarke, John 'Hypersexual Black Men in Augustan Baths', in Natalie Boymel Kampen (ed.) *Sexuality in Ancient Art: Near East, Greece, and Italy* (Cambridge University Press: 1996).

Kaplan, E. A. *Rocking Around the Clock: Music Television, Postmodernism, and Consumer Culture* (Methuen: 1987).

Simpson, Marc (*et al.*) *Uncanny Spectacle: The Public Career of the Young John Singer Sargent* (Yale University Press: 1997).

SPONSORSHIP *SPONSOR*

Similar in some ways to the more **traditional** term **patronage**, the **concept** of *sponsorship* has generally been applied to **forms** of corporate financial support (sometimes called subvention) for **artists** and **artistic^ production** within the twentieth century. Rather than being based on the interest of wealthy individuals in **art**, however, sponsorship has generally been an **institutional** and **public** policy tool used by governments and private **organisations**. Sponsorship has taken a variety of forms, in different countries at different times, and always reflects the kinds of **state^ structures**, government **agencies**, and economies found in particular countries. While individual patronage of artists in the centuries before the twentieth was usually a complicated mixture of private and public interests (royal **portraiture** being a good example), government sponsorship – at least in principle – has always been a matter of collective official policy and procedure. In **historical^ practice**, however, in countries **dominated**, for exam-

ple, by an individual ruler or by a family or group, very partial interests and prejudices have often been **represented** as 'the will of the people'. In Iraq under Saddam Hussein in the 1980s and 1990s, for example, thousands of state-**commissioned** portraits of the dictator effectively constituted the public art sponsored by the regime. Sponsorship by the Arts Council of Great Britain in the **period** between the late 1940s and the 1990s, to take another example, was often accused of really reflecting merely the partial interests of a powerful narrow clique from the English establishment (Oxbridge/University of London-educated, white, middle-**class** men from the southeast), whose traditional understanding of, and preference for, **high art** excluded many kinds of **producers** and products from any funding or institutional validation. Even **photography** (invented in the early nineteenth century), it has been noted, was excluded from Arts Council support until nearly the end of the 1980s as it was seen as a still new, 'unserious' – and perhaps too **popular** – mode of **visual** representation.

Many liberal social-democratic governments around the world in the post-1945 era have attempted to make publicly sponsored art more genuinely **socially** representative, setting up programmes (both **nationally** and locally) to encourage 'minority' group artists to take up opportunities for funding and other forms of support. In Britain since the mid 1990s, a clear attempt has been made to harness *all* state funding for the arts to principles and policies **designed** to foster the economic and political goals of what are called 'social inclusion' and 'active citizenship'. This governmental initiative began to shape the educational strategies of national public **museums** such as the Tate galleries as much as the increasing number of funding and support agencies involved in commissioning and aiding **contemporary** public art production. Some **critics** have suggested that this **development** constitutes a surreptitious kind of state propaganda and has adversely affected the **quality** of art. Arts sponsorship has also become bound up with policies for local economic and **cultural** *regeneration*, a policy with roots in the nineteenth century connected to, for example, the establishment of the Victoria and Albert Museum in London in 1852. By the 1980s, however, after riots in parts of economically depressed Liverpool, the then Conservative government began to fund cultural projects that led to the foundation of a Tate gallery there in 1988.

Further Reading

Institute of Contemporary Arts *Culture and the State* (ICA: 1984).

Jowell, Tessa *Government and the Value of Culture* (DCMS publication: 2004).
O'Connor, Francis V. (ed.) *Federal Support for the Visual Arts: The New Deal and Now* (New York Graphic Society: 1973).
Williams, Raymond 'Artists and Patrons', 'Artists and Markets', and 'Post-market Institutions' in Williams, *Culture* (Fontana: 1981).

STATE *STATISM, STATIST*

In the most general sense this term refers simply to a fixed thing or condition. In political **theory**, though *state* clearly overlaps with a number of other important terms (including **society, nation,** and country), the word has a very specific **meaning**. *State* refers, that is, to the constitutional, legal, governmental, police, and military **institutions** existing in a territory which – at least in principle – guarantee the **autonomy, identity,** and security of that territory and which regulate the activities of its citizens and foreign nationals. Before the nineteenth century a few such nation-states existed (e.g.: Great Britain, France, Spain, and the US), but these countries constituted a small minority within the world as a whole. Not surprisingly though – given their ability centrally to harness vast resources – some of them managed to acquire large **colonies** in regions where no local monopoly of power and control existed (e.g.: the British Empire in India, Africa, Australasia, as well as in the US before the Declaration of Independence in 1776).

It is very common, however, to find **art historians** referring to something they call the 'Italian-' or 'German **renaissance**' – though neither of these entities, as nations or unified states in the **modern** sense, existed until the later nineteenth century, when they were declared in 1860 and 1870 respectively. (Before those dates notions of Italianness or Germanness certainly existed – and could be felt or believed in experientially – but they were, at best, **cultural** and diffuse in character, rather than constitutional-legal or based on the existence and acknowledgement of a centralised state. At worst, however, these designations have involved retrospective fantasy.) In fact, during the renaissance, that is, in the fourteenth and fifteenth centuries, the land now called Italy was a **complex** chequerboard of distinct, separated, but inter-relating territories controlled by a number of 'city-states' coexisting in many of the ways associated with the interactions of modern nation-states. For example, these city-states – which at various points included Florence, Sienna, Padua, Venice and Rome – traded with each other, their peoples visited each other as tourists and students, their armies fought wars, and

sometimes invaded and conquered each other. Eventually one city-state above all – Rome – came, politically and militarily, to **dominate** the land south of the Alps (though parts of what later became the nation-state 'Italy' had been conquered and settled by the French and Spanish for hundreds of years, for example the regions around Naples and Venice, along with the islands of Sicily and Sardinia).

Italy is a particularly good example of a comparatively recent nation-state that still manifests sharp tensions between its geographical and administrative centre of state and government – Rome – and its regions. A sense of difference, rivalry, and sometimes acute antagonism betweennorth and south, with Rome itself caught in the middle and mistrusted by people from both Milan and Naples, continues and is **expressed** in social, cultural, and **artistic** ways. Rome, consequently, has never achieved the kind of dominance – nor positive **public** acceptance of being the capital – enjoyed for many centuries by, for instance, London in England and Paris in France. The city-state ethos remains strong, and may partially **explain** the faint-hearted fascism of the 1930s when, for a time, Benito Mussolini attempted – with some success – to unify all these places, peoples, and **traditions** as equally 'Italian', partly by allying himself, his party, and the fascist state he **created** to an **idealised^ myth** of the greatness of the ancient Roman Empire.

Further Reading

Blaut, J. M. *The National Question: Decolonizing the Theory of Nationalism* (Zed Books: 1987).

Hall, Stuart (*et al.*) *The Idea of the Modern State* (Open University Press: 1984).

Nairne, Sandy *State of the Art* (Chatto and Windus: 1987).

Poulantzas, Nicos *State, Power, Socialism* (Verso: 1979).

STILL LIFE

A distinct **genre** in **western^ art** since about the seventeenth century, concerned with the **pictorial^ representation** of ordinary objects within daily life. Scenes include the depiction of both **natural** things – plants and flowers, for instance, though these are often grown, picked, and arranged for display by people usually in an indoor setting – and a wide range of **humanly** made **artefacts**, such as jewellery, cups, plates, cutlery, and furniture (e.g.: Ambrosius Boschaert the Elder's *Bouquet in a Niche* (*c.* 1600); Willem Kalf's *Still-life with Nautilus*

Cup (*c.* 1650)). Before the late-nineteenth-century decline in the power of **academies** and academic definitions of **artistic^ practice**, *still life* was generally regarded as a lowly activity, compared with **history^ painting** and **portraiture**. Nevertheless, it was recognised by academicians in the late eighteenth century such as Sir Joshua Reynolds that – though its aims might be less morally elevated than those depicting, say, biblical **narratives** or histories of battles, and less challenging **compositionally** – still life painting and drawing required highly skilful **techniques** and a **subject^ matter** occasionally involving some philosophical implication.

In fact, it was assumed by **art historians** throughout most of the twentieth century that Dutch still life painting in particular was really a kind of **allegory**: scenes of human skulls and overripe fruit, for instance, contained a simple message that people should heed the finite nature and **value** of all life and possessions (vanity) and prepare for their impending deaths (as in Pieter Boel and Jacob Jordaens's *Vanitas* (*c.* 1630); Circle of Frans Francken the Younger's *Vanitas* (n.d.)). In this way these lowly scenes were themselves a kind of religious art – because devotion to Christ and a Christian way of living was believed to be the impulse behind the **production** of these pictures. This **metaphorical** reading has been applied to much earlier pictures with apparently similar content: the Greeks and Romans, for example, had their own kind of still life or *xenia* scenes – though the moral messages of these pictures could not have been Christian. Recent scholarship, particularly that of Svetlana Alpers however, has questioned the allegorical reading of Dutch still life, suggesting instead that some of these scenes, along with **landscape** pictures, should be **interpreted** rather as a kind of early **naturalism**: merely showing things 'as they were presented to the eye' – though often **mediated** through, it now appears, the mirrors and lenses that were in common scientific and technological use by this time (e.g.: Jan Vermeer's *View of Delft* (1660–61)).

By the very late nineteenth and early twentieth centuries, however, with the effective end of the doctrine of the 'hierarchy of genres', still life had become understood as a kind of picturing and **meaning**-making carrying a much wider range of connotations and values: Vincent van Gogh's *Sunflowers* (1888) is **viewed** as a scene **expressive** of that artist's intense emotional life – in a way, a kind of displaced, metaphoric self-portrait. It has also been argued that the **traditional** kitchen and dining room **materials** of still life gave women artists, as mothers and wives, a feminine-**gendered** – and later clearly **feminist** – space for representational testament to the

worth of their lives (as in Paula Modersohn-Becker's *Still Life with Blue and White Porcelain* (1900)).

Further Reading

Alpers, Svetlana *The Art of Describing: Dutch Art in the Seventeenth Century* (University of Chicago: 1983).

Bryson, Norman *Looking at the Overlooked: Four Essays on Still Life Painting* (Reaktion Books: 1900).

Sterling, Charles *Still Life Painting: From Antiquity to the Twentieth Century* (Harper and Row: 1981).

Young, Eric 'New Perspectives on Spanish Still Life Painting of the Golden Age', *Burlington Magazine* CXVIII (1976): 203–14.

STRUCTURALISM/STRUCTURE *STRUCTURALIST*

Name given to a wide field of **social** science and **humanities** studies **developed** in the twentieth century concerned with **identifying** the fundamental **organising** *patterns* and **forms** of human life – from the bases of **communication** in **language** (spoken and written), to structures of family-life (kinship), **representational** systems of all kinds, and the shaping of human experience in, for example, **sexual** and socio-**psychological** phenomena.

While *structuralism* is usually claimed to have begun with Ferdinand de Saussure's definition of human language as a structure of elements constituting a relational system of sounds and **meanings (concepts)**, this example – or 'paradigm' of **analysis** based on identifying a *synchronic* (simultaneously coexisting) field of related terms said to constitute a whole – spawned many others. In anthropology, for example, a structuralist method was developed by Claude Levi-Strauss investigating the orders of, for example, marriage and gift-giving relations in non-**western** societies. In **psychoanalysis**, the writer (and collaborator with the **surrealists**) Jacques Lacan proposed an account of human language-acquisition bound up with structures of sexual **desire** and social **identity**. In literary and **cultural^** **theory**, Roland Barthes claimed to recognise **complex** structures of 'denotative' (literal) and 'connotative' (**ideological**) meanings at work in **texts** of all kinds – stories and poems, but also in **photographs, films**, and **television** programmes. The word *cat*, for instance, refers literally to a small furry domestic animal (its 'denotative referent'), but in the linguistic code of 1950s black American jazz musicians 'cat' was also a positive term for a very cool person (its 'connotative referent').

In **art^ history** scholars have attempted to **identify** many differ-
ent kinds of structures at work in **visual** representation – and, in one
sense, **traditional** analyses of **composition** and **iconography** in
paintings were already structuralist methods in all but name. In the
late 1960s Meyer Schapiro **produced** an account of the psycho-
dynamics at work in looking at **pictures** understood as formal and
identificatory systems, drawing upon work in the psychology of
perception, anthropology, and social **history**. He was interested in,
for example, the **significance** of frames around paintings, the
meaning of **abstract^ artworks** hung without them, and how these
meanings related to other historical factors such as the use of colour,
illusionism, and the development of **perspectival** systems in the
renaissance. Mieke Bal turned her attention to a field of study called
'narratology' – the study of **narrative** forms and depictions of time in
visual and linguistic representations (this work drew on film theory but
attempted to explain how static **imagery** might evoke the passage of
time and sequences of events). In a very different direction, **marxists**
and **feminists** harnessed some aspects of structuralist analysis to the
study of the workings of ideology, arguing that senses of **class**- and
gender-identity are constructed in the work done by images such as
paintings and **advertisements** – as well as in the **discourses** of art
history itself. 'Construction' became one of the central analytic terms
in the 1980s – reflecting the valuable structuralist insight that artworks
were **materially** made and **communicate** through a knowable form
of meaning-building, rather than by a mysterious **expressive** or
intuitive process.

However, structuralist methods and assumptions generally left
questions of historical change unaddressed: how did, or could, the
meanings of art and language mutate over time? After all, all
human products, all discourses, necessarily exist in time as well as
space. The so-called **poststructuralists** (sometimes the same
scholars, such as Barthes) began to investigate these processes of
transformation, along with multiplicities of identity and meaning in
culture.

Further Reading

Bryson, Norman (ed.) *Calligram: Essays in New Art History from France*
(Cambridge University Press: 1988).
Hawkes, Terence *Structuralism and Semiotics* (Methuen: 1977).
Levi-Strauss, C. *Structural Anthropology* (Penguin: 1968).
Merquior, J. G. *From Prague to Paris: A Critique of Structuralist and Post-
structuralist Thought* (Verso: 1986).

STYLE *STYLE-ANALYSIS, STYLISED, STYLISTIC, STYLISTICS*

Greek in its **origins**, *style* once referred literally to an implement or tool (a stylus) for making a mark and thus implies a handmade inscription. Now the term has a very general sense: in **art^ history** referring to a distinctive, recognisable pattern or **form**. There can be many – as well as simultaneous – **authors**, or **producers**, of a style. The term is used to characterise both *individual* mark-making (for instance, Michelangelo's, Pablo Picasso's, and Auguste Rodin's styles of **painting** and **sculpting**) and a *collective,* **social** patterning (for instance, those styles called **mannerist, neoclassical**, and **expressionist**). If the term once denoted marks made by a single person using a pencil, nib, brush, or carving knife (thereby maintaining a direct physical connection between an individual **human^ body** and the **surface** upon which the mark is made), it has now been extended to include *all* forms of **visual^-representational^ media**, including those inherently collective in **nature**, so that it is commonplace to refer to, say, the 'style of Woody Allen's **films**' or the 'style of Harold Pinter's stage-direction'. In all these cases, however, remains the assumption that style refers to characteristic and relatively-fixed visual patterning and **compositional** devices and **effects** that originate from that person or group **identified** as its producer.

The art historical study of style and its constitutive elements (in literary studies called 'stylistics' or 'poetics') tends **theoretically** to place visual-formal **analysis** at the forefront of its concerns, sometimes – usually unintentionally – making peripheral or secondary questions of **meaning**. This distinction – sometimes posed as an antagonism – between form and **content** springs from this analytical procedure. The Panofskian method of **iconography** which starts with the **identification** of so-called 'pre-iconographic' visual **matter** (colour, forms, lines, tone, compositional devices, etc.) *appears* to suggest that the meanings (**symbols** and **cultural** context) 'come later', both analytically and experientially, as if the **artists** themselves had maintained a distinction in their heads between their visual forms or styles and the meanings that would or could be attached to them (by the artists and others). The term **subject^ matter**, though certainly vague in itself in some ways, has the potential advantage of avoiding this disabling distinction in stylistic analysis between something called 'the visual' and something called 'the **conceptual**'. Consider the issue of this distinction in relation to very different kinds of **artworks**, such as a painting with a recognisable iconography

(e.g.: Titian's *Concert Champetre* (*c.* 1510)) and one that doesn't appear to refer at all to material things in the world (e.g.: Mark Rothko's *Light Red over Black* (1957)). Are these two **artefacts** stylistic in the same kind of way?

Style remains one of the most contested and complicated **ideas** in art history, yet it seems indispensable within any attempt to **explain** an artist's work and the place or meaning of that work in a specific **historical** context. Some of the most **influential** attempts to define style as a historical category – mapped over centuries and even thousands of years – have resorted to very controversial claims. For example, Heinrich Wölfflin asserted in *The Principles of Art History: The Problem of the Development of Style in Later Art* (1915) that an impersonal **epochal** sway, or dialectic, between 'linear' and 'painterly' phases could be discerned in art. This **theory** bolstered mid-twentieth-century **modernist^ critics'** beliefs that painting, for example, had an intrinsic, internal logic or order of development – leading to **abstraction** – that had worked itself through over the centuries.

Further Reading

Elsner, Jas 'Style', in Robert S. Nelson and Richard Shiff (eds) *Critical Terms for Art History* (University of Chicago Press: 2003).

Gombrich, E. H. 'Style', *International Encyclopedia of the Social Sciences* (Macmillan: 1968).

Lang, Berel (ed.) *The Concept of Style* (University of Pennsylvania Press: 1979).

Schapiro, Meyer *Theory and Philosophy of Art: Style, Artist, and Society* (George Braziller: 1994).

SUBCULTURE *SUBCULTURAL*

Entering **art^ history** from what was called '**symbolic**-interactionist' **sociology** and the new field of **cultural^ studies** in the 1970s, the study of social groups, along with their means of presentation and self-**representation** within society as a whole, is the province of *subcultural* **analysis**.

Two facets of this field are of particular interest to art historians. First, **interpretations** and **explanations** of the socio-**historical** circumstances in which such **artistic** *subcultures* as bohemia and the **impressionist^ avant-garde** appeared in the later nineteenth century, and whose many successors have been a feature of **mod-**

ernism and the **art world** in the era since. The existence of sects, secret and manifest groupings, and other relatively 'closed communities' of many kinds has, though, a much longer history – they have been a perennial feature of **complex**, large-scale societies and may be traced back for thousands of years. During the **renaissance**, for instance, much artistic **production** was importantly regulated by relatively **autonomous** Catholic **institutions** of priests, brothers, and nuns – such as the Dominican and Franciscan orders – whose particular beliefs and **values** were partly encoded in fresco cycles and church statuary (e.g.: Giotto's *Legend of St. Francis series* **painted** in the upper church, San Francesco, at Assisi (*c. 1300)*). The **humanists** who **emerged** in the later fifteenth century might also be considered a kind of subculture. A group of individuals, that is, who discovered and re-read ancient Greek and Roman **texts**, sought to define the province and value of what they called the 'liberal arts', to investigate the **natural** world with methods and **techniques** that later became known as 'scientific', and who – perhaps most radically – began to question orthodox theological explanations of the world and the purposes of human beings.

This example raises the **theoretical** riddle of 'lived experience' versus historical **explanation** in subcultural analysis. Is the designation of a *group* **identity** for the renaissance humanists really a matter of retrospective analysis, rather than a verifiable **reality** in those **agents'** own personal life experiences? Did they see themselves as a group? Some cases are much more clear-cut than others. Avant-garde groups, such as the **surrealists** in the 1920s and 1930s, named themselves and clearly acted self-consciously as a **movement** through their **exhibitions**, collective writings, and **organised** social (and later political) events. The humanists, in contrast, were dispersed across both a wide geographical area and historical **period** – though actual, if small, groupings certainly existed in cities over a single generation, such as in Florence, between *c.* 1450–1500.

The second facet of subcultural **analysis** especially relevant to art history is the study of the **visual^-formal** means of self- and group-representation that particular subcultures generate for themselves. In the 1950s and 1960s the English teenage and young adult 'teddy-boys', 'rockers', and 'mods', for example, selected certain clothes **fashions**, hair **styles**, motor bikes and scooters, as well as music and dances, in order to **portray** themselves within the culture and society as a whole. These representational systems – modes of **signification** – worked both to enable their members to **identify** themselves as part of a group, *and* strongly to differentiate themselves from other groups,

and the **mass** of ordinary, and mostly older, people in society as a whole.

Further Reading

Hebdige, Dick 'A Report on the Western Front: Post-modernism and the "Politics" of Style', in G. Robertson (ed.) *The Block Reader in Visual Culture* (Routledge: 1996).

Lewis, H. *Dada Turns Red: The Politics of Surrealism* (Edinburgh University Press; 1990).

McRobbie, Angela *Feminism and Youth Culture from* Jackie *to* Just Seventeen (Macmillan: 1991).

Smith, Alastair *The Assisi Problem and the Art of Giotto: A Study of the Legend of St. Francis in the Upper Church of San Francesco, Assisi* (Oxford University Press: 1971).

SUBJECT MATTER

Term referring to the themes chosen by **artists** for treatment in their works. Typical claims, for instance, have been that John Constable's **pictorial** *subject matter* is the **real**, rather than prettified, East Anglian countryside in the early nineteenth century, or that Henri Gaudier-Brzeska's vorticist **sculptures** have, as their subject matter, the dynamic **portrayal** of elements from **modern** and **natural** life, or that Jackson Pollock's subject matter in his drip **paintings** is existential angst (see for example Constable, *Dedham Vale* (1828); Gaudier-Brzeska, *Birds Erect* (1914); Pollock, *Lucifer* (1947)). *Subject matter* contains two conjoined elements in these three examples: (1) the implicit reference to an **intended meaning**, involving a referent outside of the **artwork** (e.g. East Anglia; modern and natural life; existential angst); and (2) the claim or assumption that the vehicle carrying this meaning/referent is a specific kind of **visual** and **compositional** order discernible within, as, the artwork. These two elements find **alternative** – and *separated* **expression** – in two other familiar **art^ historical** terms: **form** and **content**, the distinction between which often, unintentionally and unfortunately, fosters the perception that meaning exists in, as, the latter, while the former is merely the 'carrier' or 'shell' for this meaning.

From only these three examples, however, it is clear that the term *subject matter* itself has a range of connotations. Constable's depiction of something called the 'East Anglian countryside in the early nineteenth century' *might* suggest a highly **realistic^ representation** –

that his oil-painting appears to have a factual truthfulness. Yet some scholars have argued the opposite; that is, that his selections of elements (people's activities, types of land, houses, skies, weather conditions) are in fact extremely partial, **subjective**, and contrast sharply with other **contemporary^ landscape^ imagery** – in compositional and socio-political terms. Gaudier-Brzeska's subject matter concerned with 'dynamic portrayal of elements from modern and natural life' uses **abstract**-expressive sculptural devices in order to convey something of the disorienting speed and change experienced by people within the twentieth century. This sculptural form might, in comparison with Constable's painting, be **interpreted** as an intensification of subjective representation – as if the artist's subject matter had in fact *become* **communication** of his subjectivity. This process is taken even further by Pollock, whose drip-painting seems, in one sense, *entirely* abstract – having form or forms of virtually no recognisable kind at all, and even defeating attempts at description. Yet, if Pollock's subject matter is 'existential angst' (a claim made by the contemporary **critic** Harold Rosenberg), then somehow these skeins of paint, flung and splattered on to the canvas laid upon the ground, managed to **symbolise** for that **viewer** an **identifiable** meaning – and **value** – beyond the sheer physical **reality** of the **artefact**.

Pollock's subject matter is often represented as the existential angst of his own subjective **identity** (though at a stage beyond Gaudier-Brzeska's expressive treatment of forms that are still recognisably drawn from nature). Other contemporary critics, however – unashamedly calling themselves **formalists**, or being condemned as 'mere' formalists by others – came to very different conclusions, stressing instead the **materialism** of Pollock's artistic **practice**. *Subject matter*, then, though a neutral-sounding term, *always* involves a work of interpretation and clarification, managing to combine in its two words the idea of a representation which is both subjective *and* objective (matter: 'that which occupies space in the **visible** world, as opposed to spirit'; a substance or material).

Further Reading

Cheetham, Mark A., Michael Ann Holly and Keith Moxley *The Subjects of Art History: Historical Objects in Contemporary Perspective* (Cambridge University Press: 1998).

Clark, T. J. 'Phenomenality and Materialism in Cézanne', in Tom Cohen (ed.) *Paul de Man and the Afterlife of Theory* (University of Minnesota Press: 1998).

Harris, Jonathan *Writing Back to Modern Art: After Greenberg, Fried, and Clark* (Routledge: 2005).

Williams, Raymond 'Forms', in Williams *Marxism and Literature* (Oxford University Press: 1977).

SUBJECTIVE/SUBJECT *SUBJECTIVISM, SUBJECTIVITY*

In general terms *subject* can refer to both an object and a person, while 'being subjected' to something means being forced to experience it. Beyond these common uses, however, *subject* has a range of **complex** philosophical **meanings**. For instance, it is often counterposed to *objective* (e.g.: within the familiar claim that **photographs** are, compared with **paintings**, objective and truthful **forms** of **visual^ representation**). *Subjective* and *subjectivity*, however, are better understood as terms which themselves refer to **real** entities or things, rather than names simply for what are held to be merely **imaginary^ states** or states within which there is a primacy of feelings over knowledge, or of opinion over fact.

Subjectivity, for example, is itself an *object of knowledge* in the disciplines of **psychoanalysis**, psychology, and philosophy: fields concerned with the **nature** and operation of the mind-in-the-**body** – the embodied faculty of all sensations and consciousness, and the condition of **human^ agency**. Subject in one of these senses is simply another name for this agent or actor (as in police note-taking: 'the subject in question was seen entering the premises from a ground floor window ... '). Seen from the position of someone else, as this example suggests, however, a human being can become an *object*. To say, for instance, that pornography degrades ('objectifies') the people it represents – as well as the people who look at it – is to say that they are rendered less capable of human subjective feeling, empathy, and agency.

An *excess* of feeling over engagement with the world of things, or a revelling in an interior world, is called a state of subjectiv**ism**: a refusal, or inability, to recognise and engage with the outside world. Bohemians and **avant-garde** groups of **artists** and writers from the later nineteenth century onwards manifested aspects of this attitude – actual retreat first into small and effectively closed communities (**social** dislocation), then into a kind of solitary or 'internal exile' hastened by, for example, travel to exotic and isolated locations (e.g.: Paul Gauguin's moves to Brittany, and then to Tahiti) or the use of 'mind-altering' drink and drugs (Lautreamont, Oscar Wilde, Jackson Pollock), or a combination of both.

All **artworks**, however, are shaped by a range of factors that are in different ways simultaneously objective (e.g.: artists' **medium**, tools; acquired skills; **social relations of production^** and **consumption^** in place at a specific time, etc.) *and* subjective (e.g.: psychological character of the producer, relationship to factors such as **gender**, social **class**, age, interests and **values**, etc.). And in each of these examples, arguably, objective and subjective elements are also combined. A person's character, for instance, is both partly inherited, or pre-determined (**natural**) and yet altered, or alterable, through circumstances (**historical/cultural**).

Subjectivity in its **modern** sense is a comparatively recent historical **development**, dependent upon the **emergence** of ideas and experiences of individuality and individualism in the **renaissance**. This was a process intimately bound up with the novel notion of the artist as a special kind of individual, especially **creative** and imaginative: subject, in fact, to **visions** that may have been caused by God or – as the **romantics** in the nineteenth century believed – by the **material** vicissitudes of the body and the corrupting, alienating effects wrought by urban life, industrial society, and war. Subjectivity, then, has had a profound history of change itself.

Further Reading

Coward, Rosalind and John Ellis *Language and Materialism: Developments in Semiology and the Theory of the Subject* (Routledge and Kegan Paul: 1977).

Dworkin, Andrea *Pornography: Men Possessing Women* (Women's Press: 1991).

Merleau-Ponty, Maurice *Phenomenology of Perception* (1945) (Routledge and Kegan Paul: 1962).

Rotenstreich, N. *Alienation: The Concept and its Reception* (Brill: 1989).

SURFACE

Within the **conventional^ art^ historical** distinction between two- and three-dimensional **artworks**, the **material** fact and **significance** of any **artefact's** *surface* remains central. Though *apparently* two-dimensional artworks – such as **paintings**, prints, drawings, and **photographs** – actually and necessarily always exist as physical objects in three dimensions, art historical **analysis** has overwhelmingly and understandably focused on the **quality** and **effects** of the flat surface support upon which **pictorial** marks – **imagery** – are made. Consider the **media** of paint, pencil, mechanical printing, and photo-projector 'imaging' devices. Notice, for example, the intense sheen of

the man's pink sleeves in Hans the Younger Holbein's oil **portrait** of Georg Gisze (1532); Pablo Picasso's *self-referential* depiction of an **artist** drawing a model, *Balzac's Le Chef-d'Oeuvre Inconnu* (1931); Rembrandt van Rijn's scratchy etching print of *Christ Preaching* (*c.* 1652); and Krzystof Wodiczko's fantasmic projection onto a building in his *Hirshhorn Museum Projection* (1988). It is ironic that **connoisseurs** and conservators – often regarded as the most old-fashioned **specialists** in art history – given their material involvement in identification and restoration work often operate with a sense of the **material^ reality** of artworks that is rather more profound than that of many **historians** and **theorists** preoccupied with questions of art's **meanings** and **values**, many of whom pay lip-service to 'materialist' **forms** of analysis.

Before the advent of **abstraction** in the twentieth century it was possible to see the painted pictorial surface simply as the carrier of an image understood as a kind of **vision**: materially made, it was conceded, but in essence the projection of an immaterial dream (e.g.: John Martin's apocalyptic *Bridge of Chaos* (1827) and Lord Leighton's Grecophile *Winding the Skein* (*c.* 1878)). Though some artists working long before Henri Matisse or Willem de Kooning had sometimes built up their surfaces with an emphatic depth of paint, layered on in a visibly three-dimensional way (e.g.: the sixteenth-century Venetian painters Titian and Jacopo Robusti Tintoretto), it was only with **modern** art and some of its most **influential^ critics** that the 'worked surface', or *facture*, of paintings and **sculptures** became an object of sustained visual-**analytical** and philosophical inquiry.

Basing their **perspectives** on an **interpretation** of Immanuel Kant's *Critique of Judgement* (1790), the American critics Clement Greenberg and Michael Fried made surface facture the basis of a system of **aesthetic** values in the **visual** arts that categorically separated off painting from sculpture, the latter held to be a different **tradition**, material **practice**, and art form rooted in its 'three dimensions'. Though all sculptures, too, necessarily have one surface or more (which is also an edge to the artwork beneath), this, according to the modernists, **signified** in a completely different way from that of a painting's. The surfaces of most **traditional** carved or moulded sculptures form a kind of enclosing skin for the artwork's physical existence as material **body** beneath (e.g.: Michelangelo's Medici Chapel **figures** of *Dawn* and *Day* (1505–34); Auguste Rodin's *The Burghers of Calais* (1884–86)). Yet examination of the full range of types of *assembled* modern sculpture by, for example, Vladimir Tatlin, David Smith, Anthony Caro, Robert Morris, Carl Andre, and Fabian

Marcaccio in the twentieth century suggests that Greenberg's and Fried's categorical distinction between painting and sculpture (and their respective kinds of surface) was grounded finally only in a self-serving choice of examples and exclusions selected to fit these critics' preferences and **taste** at the time (see for example Tatlin's *Monument to the Third International* (1920); Smith's *Five Spring* (1956); Caro's *Midday* (1960); Morris's *Untitled (Three L Beams)* (1965–66); Andre's *Equivalent (VIII)* (1966); Marcaccio's *Time Paintant: Image Addiction Paintant* (1999)). What these works made from such a wide range of materials and construction methods indicate, in fact, is that any categorical, single distinction between painting and sculptural surface becomes extremely difficult. In addition, some artists from the time of **minimalism** onwards sought to confound such a distinction deliberately by attaching what looked more like sculptures to walls or placing what looked more liked paintings in open space (e.g.: Marcaccio – *Time Paintant: Image Addiction Paintant* (1999))

Further Reading

Art and Language 'Portrait of V.I. Lenin', in *Art and Language* June 1980: 26–61.

Hausman, Carl R. *Metaphor and Art: Interactionism and Reference in the Verbal and Nonverbal Arts* (Cambridge University Press: 1989).

Orton, Fred *Figuring Jasper Johns* (Reaktion Books: 1994).

Potts, Alex *Flesh and the Ideal: Winckelmann and the Origins of Art History* (Yale University Press: 1994).

SURREALISM *SURREAL, SURREALIST*

Avant-garde^ movement established in the early 1920s by the French writer André Breton, and named after a term, roughly meaning 'above' or 'beyond **realism**', coined by the poet Apollinaire in 1917. Breton's succinct definition of *surrealism* was 'pure **psychic** automatism, by which it is **intended** to **express** verbally, in writing or in any other way, the true process of thought. It is the dictation of thought, free from the exercise of reason, and every **aesthetic** or moral pre-occupation.' Despite its **complex** literary, philosophical, and **psycho-analytic^ origins** and themes, however, surrealism has become known as the name mainly for a group of **painters** whose strange and sometimes disturbing **images** became, and remain – in comparison with any other twentieth-century **modernist** grouping – extremely **popular**: the works of Salvador Dali, René Magritte, Max Ernst, Yves Tanguy, Paul Delvaux, André Masson, and Joan Miró (e.g.:

Dali's *Soft Construction with Boiled Beans: Premonition of Civil War* (1936); Magritte's *The Murderous Sky* (1927); Ernst's *The Entire City* (1936–37); Tanguy's *Mama, Papa is Wounded!* (1927); Delvaux's *Pygmalion* (1939); Masson's *Battle of Fishes* (1926); Miro's *The Kiss* (1924)).

The popularity of surrealism lay in two factors: (1) its chief **artist**-members appeared to be colourful and charismatic individuals, self-publicists prepared to **organise^ public** events – later, in the 1960s, called 'happenings' – that attracted wide **media** attention; and (2) their paintings, **photographs**, and other **artefacts** adopted, adapted, and inspired the **techniques** and themes of modern **advertising**, with a strong focus on **sexuality**, depictions of the **nude^ human^ body**, and incongruous combinations of imagery that the surrealists believed could spark new **meanings** and insights. Sigmund Freud's psychoanalytic ideas about sexual **desire** and **identity** – themselves often attractively graphic in the sense of being partly based on stories and **myths^ represented** in ancient and **renaissance^ art** – often found illustration in surrealist **iconography**, and in devices of **image^-production** including a chance, random (*automatist*) element, such as 'decalcomania': pressing a **material** such as tin foil or wood against a layer of wet paint and removing it to **create** a pattern as the basis for a **picture**.

Though partly **formed** from the remnants of **dada** groupings in Europe, and therefore inheriting from these a **critical** – even **oppositional** – stance towards bourgeois **society** and **culture** in the aftermath of the First World War, the surrealists appeared, above all, to stress playfulness and wit in their **artworks**, collective manifestations, and writings (such as the *First Surrealist Manifesto* (1924), their first **exhibition** held in Paris in 1925, and the journal *La Revolution Surrealiste*, edited by Breton). This **public** image became ambiguous during the 1930s when one of its factions, led by the poets Paul Eluard and Louis Aragon, became actively involved in support for the French Communist Party (PCF) during the rise of fascism in Germany and Italy – a direction which, arguably, made the PCF as uncomfortable as the other surrealists who believed this political affiliation corrupted the movement's **ideals**. By 1938–39 a radical split had opened up between those surrealists backing the PCF, which supported the USSR, and those others – including Breton and the Mexican artist Diego Rivera, who backed Leon Trotsky against Joseph Stalin, calling for what was claimed to be a form of unaligned, anti-authoritarian, 'libertarian socialism' espousing social, political, and aesthetic freedoms. On the whole, however, the male surrealists had little concern for the freedoms or interests of women – several of

whom (such as Kay Sage, Leonor Fini, and Meret Oppenheim) themselves produced works under the aegis of the movement.

Further Reading

Breton, Andre *What is Surrealism?* (Haskell House Publishers: 1974).
Caws, Mary Ann (ed.) *Surrealist Painters and Poets: An Anthology* (MIT Press: 2001).
Foster, Hal *Compulsive Beauty* (MIT Press: 1993).
Nadeau, Maurice *History of Surrealism* (Macmillan: 1965).

SYMBOLISM *SYMBOL, SYMBOLIC, SYMBOLISE, SYMBOLIST*

Within the study of **meanings** in **artworks** the **identification** of symbols *as meanings* is indispensable. In one sense, *symbolic* simply means meaningful: for instance, a skull depicted in a **still life^** **painting** is often claimed symbolically to 'stand for' death and the finitude of **human** life (e.g.: W. C. Heda, *Vanitas* (*c.* 1630)). **Forms** of *symbolism*, however, are extremely diverse – both **historically** and in terms of **contemporary^ visual^ culture**.

Symbolism, or ways of **signalling** meaning, always relies on **conventions** of **interpretation**, though as often as people may know these conventions they may not, and so meanings are made by **viewers**, again both in historical and contemporary experience, that often bear little or no relation to the knowledge, expectations, or **intention** of an **artwork's^ producer**. This is true both *between* **cultures** and *within* them. The **postcolonial^ reading** which a white, middle class Englishman living in London in 1900 makes of a piece of 'sculpture' 'from' 'Nigeria' 'depicting' a 'hippopotamus' in 'bronze' exemplifies this: all these apparently simply descriptive terms ('sculpture', 'from', 'Nigeria', 'depicting', 'elephant', 'bronze'), far from being neutral, are **value**-laden notions forming and informing the basic assumptions this English man starts with when observing this object (e.g.: bronze-cast of hippopotamus, found at Ikot Ndemeno in Enyong Division of the Cross River State (*c.* 1825–50)). 'Sculpture', for example, is a term with a particular history and set of associations within the **western^ art^ tradition**. 'Nigeria' was the English name given to a part of middle 'Africa' (also an imposed name) by its British colonisers in the nineteenth century. 'Depicting' suggests the **intent** imitatively to **represent** in a **fashion** intelligible within, again, western conventions of art and is, at best, an *assumption* about the purpose of a

practice and the *referent* of an **artefact^ produced** within it. 'Hip-
popotamus' is the English word for an animal carrying a range of related
associations – scientific, **allegorical, metaphorical** – which probably
had little or nothing to do with those of an indigenous person from
'Africa'. 'Bronze' is, too, an English name for a **material** which is
chiefly understood as a **medium** of **artistic^ expression**, rather than
one selected or used by the artefact's producer for other purposes,
with other intended meanings and **values**.

As this brief discussion indicates, meanings are made – and symbols
invented by viewers – in ways which constantly exceed the **original**
circumstances of a work's **social^ relations of production and
consumption^**. This is *not* to say, however, that symbols and systems
of symbols have sometimes not been jointly and comprehensively agreed
and written down. A clear codification of elements in **pictorial**
composition and their meanings occurs in Leon Baptista Alberti's
famous treatise on painting, *Della Pittura* [On Painting] (1435), and,
by the late eighteenth century, a fairly rigid **academic** painting doc-
trine, set out in handbooks and lectures, had been established by the
royal academies in Europe. By the end of the nineteenth century,
however, a collapse of belief in such ordered meanings occurred and
modern artists and writers attempted to reinvent symbolism as a
kind of intuitive expressive process. Symbolism was reinvented as an
aspect of integral individual artistic **subjectivity**, drawing eclectically
on all previous kinds of symbols, and yet moving, in the **develop-
ment** of **abstraction**, towards the declaration of colour and form as
transcendentally symbolic – almost mystical – elements in themselves
(e.g.: Pierre Puvis de Chavannes, *Sacred Wood* (1884); Gustav Klimt,
The Knight (1902); Piet Mondrian, *Composition in Line (Black and
White)* (1916–17); Mark Rothko, *Number 7* (1951)).

Further Reading

Broadbent, G. (ed.) *Signs, Symbols and Architecture* (Wiley: 1980);
Gombrich, E. H. *Symbolic Images* (Phaidon: 1972).
Kristeva, Julia *Revolution in Poetic Language* (Columbia University Press: 1984).
Panofsky, Erwin 'Titian's Allegory of Prudence: A Postscript', in *Meaning in
the Visual Arts* (Penguin: 1993).

TASTE *TASTEFUL, TASTELESS, TASTY*

One of the five senses (along with **vision,** hearing, touch, and smell).
Taste is a **psycho**-biological capacity based on a two-way relay of data

between sense-data receptors on the tongue and in the mouth and the brain which **interprets** this information. Ironically, the notion of 'good taste' in **art** generally suggests an elevated intellectual facility rather than what taste actually is for most people: an involuntary **bodily** function evolved to help **humans** deal with their environment and the need for food. However, in terms of certain types of food, too, the belief has arisen that taste – though a **natural** capacity – can be educated to a high degree: wine **connoisseurship** being the best example.

In the later eighteenth century the first **modern** philosophers of art (**aestheticians**) began to argue that individual taste – **subjective** response to **artworks** – was essential to recognising the true **value** of art, which could no longer be a matter of, for example, the religious-theological or ritualistic function of **paintings** and **sculptures**. But while Immanuel Kant (author of *Critique of Judgement* (1790)) and others began a **tradition** of thought highly **influential** through to the present day, Kant did not claim that good taste was an aptitude or ability that simply occurred naturally in some people and not others (an inference made by some of the early-twentieth-century modernist **critics**, such as Clive Bell). Kant stressed, in fact, that **developing** good taste was necessarily a matter of **social** selection and social status: being well enough off financially, that is, to find the time to nurture this talent for discrimination and to be able to make judgements about 'goodness' and 'badness' in art that weren't corrupted by any other interests. In this sense, being 'disinterested' in matters of taste, then, was by no means the same as having objectivity – though, again, by the mid twentieth century other influential **critics**, citing Kant's work on aesthetics, did appear to claim that their judgements about high **quality** modern art, though admittedly personal, *were* objective. Clement Greenberg famously grounded his preferences in this way by talking of what he called 'authentic' modern art's 'place in the intelligible continuity of taste and tradition' ('Modernist Painting' (1960)). He meant to imply by this that the artists he particularly valued – for example, Édouard Manet, Henri Matisse, Jackson Pollock – were as great in their own way as the long-recognised **old masters** from the pre-modern era.

Modern art criticism, really a **product** of the mid nineteenth century in France, evolved on the principle that aesthetic judgement was a matter of individual or subjective taste. This **view**, however, reflected more a strong reaction against the then dictatorial, if declining, role of **state^ institutions** such as the Salon and government-funded art **academies** in France than a denial that one's actual

social circumstances (e.g.: education and place in the class **structure**) were likely to shape what one's tastes actually were. In the twentieth century new influential institutions in the **art world** came to replace those state-controlled **organisations** (e.g.: the Turner Prize, awarded annually since the 1980s to a Britain-based artist; international biennial **exhibitions** of **contemporary** art), though none like those in nineteenth-century Paris have anything near a monopoly on the definition of art or control the selection process for prospective **artists**. Greenberg himself, by the late 1960s – when the influence of his own ideas on contemporary art had begun to wane – made a point of emphasising that taste remained intrinsically 'immediate, intuitive, undeliberate, and involuntary' ('Complaints of An Art Critic' (1967)). At the same time, however, he also managed to suggest that he had had to fight against his own, deeper, naturally poorer taste for lower quality items such as academic flower paintings and 1960s **pop** music, which, nevertheless, he'd managed to suppress in recognising the high quality he saw in works by artists in the modernist **canon**. Since the 1970s no single critic has managed to **dominate** the **postmodern** art world as Greenberg had the earlier **period** and it's hard to see now how and why his personal views became so widespread.

Further Reading

Cheetham, Mark A., Michael Ann Holly, and Keith Moxey 'Immanuel Kant and the Bo(a)rders of Art History', in Cheetham (*et al.*) *The Subjects of Art History: Historical Objects in Contemporary Perspective* (Cambridge University Press: 1998).

Curl, J. S. *Egyptomania, the Egyptian Revival, A Recurring Theme in the History of Taste* (Manchester University Press: 1994).

Haskell, F. and N. Penny *Taste and the Antique: The Lure of Classical Sculpture 1500–1900* (Yale University Press: 1981).

Shusterman, Richard 'On the Scandal of Taste: Social Privilege as Nature in the Aesthetic Theories of Hume and Kant', in Paul Mattick Jr. (ed.) *Eighteenth-century Aesthetics and the Reconstruction of Art* (Cambridge University Press: 1993).

TECHNOLOGY/TECHNIQUE/ TECHNICAL *TECHNOLOGICAL*

Referring to skill or ability in a **practical** or manual activity, *technique* spawned the much more **complex^** **concept** of *technology* in the early eighteenth century. This term relates *technical* skills or abilities to

a knowledge or **theory** informing or directing it. **Emergent** in early-**modern**^ **society**, the term *technology* is generally used to refer to post-1800 mechanical, industrial, and electronic devices, systems, and processes – for instance, in phrases such as combustion engine technology, flight technology, medical technology. Yet the term could be used profitably to describe drawing, **painting**, and **sculpture** practices in the **west** which have been theorised and seen as the **products** (and themselves causes) of knowledge since at least the **renaissance** (e.g.: Leonardo da Vinci, *Anatomical Studies (Larynx and Leg)* (1519)).

To an important degree the **development** of these **visual^-representational** modes as 'theory-informed' practices was closely related to simultaneously-developing senses of 'scientific' and 'secular' – as distinct from religion-bound conceptions of the **nature** of the world and the purpose and social **organisation** of people within it.

For a long time, however, drawing and painting – and even **photography**, an early-nineteenth-century invention – have been seen as **traditional** (partly meaning old-**fashioned**), and perhaps even **residual** practices. In contrast, phrases such as 'new visual **arts** technologies' are applied to electronic and digital systems of **image**-generation and projection, including video, DVD, computer-simulation, and 'live' internet technologies. It is hard now to **view** a paint brush as a technological implement but in the late-nineteenth-century paint brush **design** and newly-available pre-mixed tube-paints were on the cutting edge of developments, importantly affecting applications of paint and the range of colours artists could select and combine.

Whatever examples are introduced, however, the **analysis** of a technology of visual representation – technology being generally defined as 'a way of doing and thinking' something – should include an understanding of the *social factors* shaping the **emergence** of that knowledge and its practical achievements. For instance, though it may seem that new techniques and full-blown technologies simply 'appear' – the invention, perhaps, of quirky isolated geniuses working in labs – it can usually be shown that developments in research and product application have been shaped by **public** and commercial interests seeking to exploit and enhance already existing means and systems for doing something (e.g.: cell phone technologies combined with video and internet connections; the 'research and development' overlap between video-game consuls and warfare training computers and software used by military pilots and weapons officers).

In terms of contemporary visual arts and their **art historical** study, technological **progress** since the 1970s has made the slide and slide-projector increasingly anachronistic – especially given that most

contemporary artists no longer work in traditional media of painting and sculpture and many **produce** moving image-based **artefacts**. An *asymmetry* has opened up, that is, between techniques of new art (and general **cultural**) production and established techniques for its study. The internet, to take another example, has become a source of unregulated information increasingly used by students preparing essays and presentations, making residual – if not yet redundant – library-bound books and journals. The full implications of these kinds of imbalance are not yet known, though the process of their rapid **development**, due to the sheer speed of technological change in the **art world**, seems irreversible.

Further Reading

Gray, A. *Video Playtime: The Gendering of a Leisure Technology* (Routledge: 1992)

Habermas, J. *The Philosophical Discourse of Modernity* (MIT Press: 1988).

Moores, S. *Satellite Television and Everyday Life: Articulating Technology* (John Libbey: 1995).

Williams, Raymond *Television: Technology and Cultural Form* (Fontana: 1974).

TELEVISION/TV *TELEVISE, TELEVISUAL*

While **art^ history** has gradually assimilated 'fine art' **photography** – and more recently and to a lesser extent video – into its disciplinary concerns, it is unlikely to do so with *television*. On the other hand, some recent and **contemporary^ artists** have made work directly involving this **technology** and its various **artefacts** – for instance, the Korean-American **installation** artist Nam June Paik, who used television sets within some of his earliest works, for example *TV Garden* (1974). Others, too, have addressed it indirectly, through broad themes such as the impact upon **society** of **mass** electronic **visual^-representational** systems – for example, Richard Hamilton and Andy Warhol in their 1960s **pop art**. However, television, understood as (a) a technology, (b) a means of **cultural^ production**, and (c) an **institutional**-commercial **organisation**, appears to have remained deeply unattractive to most art historians. There are a number of possible explanations for this.

At one level, it may be because, like **films**, television programmes are understood to be inherently the result of *collective* **authorship** and labour: they have no **identifiable** individual **creator**. **Conventional** art history, whatever its questioning internal **critiques** and radical dis-

putes over methodology since the 1970s, simply appears not to be able to **read** (i.e.: **explain** and **interpret**) collective production very well – though admittedly many **traditional** art **forms** central to art history, such as mosaics, frescoes, and **history paintings**, were themselves often produced in a variety of collective ways over thousands of years. At another level, television (again, like film) is regarded as **mass cultural** rather than **high art**: its **medium** of **communication** – **signals** sent through airwaves, satellites, or cables and received/ decoded by boxes with tubes that convert these signals into **pictures** and sounds – perhaps seems radically unintelligible ('foreign') in orthodox art historical terms. Yet, as a mass communicative device, television actually has some important technical, social, and **aesthetic** similarities with other media securely included within art history, such as all the pre-twentieth-century mechanical print technologies.

It was the new field of **cultural^** studies, established in the later 1960s in Britain, that took seriously the study of television as a variety of important objects of study. (1) As a social-institutional technology with deep (and deepening) connections to both **state** governmental systems and **capitalist** economies throughout, and increasingly connecting, the world. (2) As a communicative medium of both discrete productions (single programmes) as well as a continual (now never-ending) 'output' or 'flow' amenable to **analysis** through a variety of methods, including **semiotics** and **hermeneutics**. (3) As a distinctive cultural form in particular societies shot through **historically** with particular **values** and **intentions** – such as the 'Reithian' British Broadcasting Corporation (BBC) in Britain, committed to a notion of **public** service and championed, during the 1922–30 **period**, by its first director-general John Reith. (4) As a component within **postmodern** society, both reflecting and constituting novel social **identities** and experiences of community, **nation**, fragmentation, and alienation.

Television in the US followed a different path: continually a vehicle for commercial exploitation, art historians in that country have perhaps always (and rightly) seen TV there primarily as a fairly crude marketing device used by **advertisers** and corporations – though sometimes acclaimed film directors have moved into television and made interesting works within its format deserving serious critical attention (e.g.: David Lynch's drama series *Twin Peaks* (1990–91)).

Further Reading

Abercrombie, N. *Television and Society* (Polity: 1996).

Burns, T. *The BBC: Public Institution and Private World* (Macmillan: 1977).

Eco, Umberto 'Towards a Semiotic Inquiry into the Television Message', in *Working Papers in Cultural Studies* 1972 (3): 103–21.

Herman, E. and N. Chomsky *Manufacturing Consent: The Political Economy of the Mass Media* (Pantheon Books: 1988).

TEXT *TEXTBOOK, TEXTUAL, TEXTUALITY*

Though its ordinary **meaning** is clear – a *text* is the name for any book or piece of writing, and a *textbook* (like this) is one **intended** specifically for student use – *text* has another, related, but **complex** sense. It is the name for a **structure** or system of **signs**, or a **discourse**, that may be **read** (or, in more familiar terms, **interpreted**) in a number of ways, depending upon, for example, circumstances or context, the interests and **values** of specific readers, and the relationship between a particular text and others. This second definition, which includes within it what might be called a **theory** of *textuality* – that is, an account of the **nature** and **production** of meaning – importantly derives from the impact that **structuralist** and **poststructuralist^** **ideas** had upon the arts and **humanities**, including **art^ history**.

Though many texts in this theoretical sense *are* written – that is, **linguistic** in **form** – the radical **significance** of the **concept** of text within structuralist and poststructuralist thought was that it could be extended to include *all other* forms of **communicative** discourse, such as **paintings, sculptures, photographs**, and **films** – all of which were held to be meaningful, though readable, the poststructuralists argued, in different ways. Jacques Derrida, for instance, showed that the spoken word was textual in the sense described above – a system or chain of phonetic sounds/signs with attached meanings – and had always existed in a hierarchical relation of meaning and value *with* written-down discourse. Speech, though **traditionally** regarded as the seat of persuasive (and sometimes deceptively rhetorical) language, derived these associations necessarily *in relation to* its differences from written language, customarily seen as secondary to speech, a mere transcription or record of the prior, **authoritatively** meaningful, spoken word. Derrida sought to question, and even rhetorically to reverse, this hierarchy between the two terms (spoken and written discourse). His overall point, however, was that *all* kinds of communication could be shown (a) to be meaningful – textual – in a variety of ways, and (b) inter-dependent as forms or textual systems. The main legacy of Derrida's insight within art history and **visual culture** has been the **development** of what are often called

'**image**–text' studies: for example, those concerned with **medieval** illustrated manuscripts, filmic **visual^ narrative** and dialogue/music tracks, and **advertising**, which all harness visual imagery and persuasive language.

Beyond these examples of visual image–written/spoken text combinations, dozens of other systems of signs also became seen as textual: for example paintings, photographs, but also clothes and **design^ fashions**, kinship rituals, **sub-cultural^ styles** of behaviour and cultural preference. Many of these are intrinsically visual-**representational** or include **significant** elements that are. The 1980s and 1990s saw the discipline of art history draw upon theories of textuality advanced in literary, anthropological, philosophical, **psychoanalytical, semiological**, and **cultural studies** scholarship – for these areas had, in many cases, been the original homes of the structuralist and poststructuralist thinkers. By the late 1990s the term had **developed** another new and **popular** sense: 'texting', or sending linguistic messages graphically – in effect, as 'typed text' – through cell phones, a **technology** itself now combining visual imagery in terms of photographs, the internet, and specially-formatted films, along with written and spoken language.

Further Reading

Bryson, Norman and Mieke Bal 'Semiotics and Art History', *Art Bulletin* June 1991: 174–208.
Derrida, Jacques *Dissemination* (University of Chicago Press: 1981).
Fish, Stanley *Self-Consuming Artifacts: The Experience of Seventeenth Century Literature* (University of California Press: 1972).
Harris, Jonathan 'Terms and Texts', in Harris *The New Art History: A Critical Introduction* (Routledge: 2001).

THEORY *THEOREM, THEORETICAL, THEORETICIST, THEORIST*

Though a term often set off, and even *against,* others – as in the couplets 'theory/**practice**', 'theory/**history**', 'theory/**reality**' – its true **value** lies in its active relations *with* these other **concepts**, and in the **productive** self-**criticism** it can generate. In each of these pairs, for example, *theory* actually means an *active consideration of core principles and methods*, a consideration that may importantly shape and actually improve whatever its object is: be it an **artistic** practice, an account of history, or a sense of reality.

For instance, if *practice* refers to, say, **painting**, then its theoretical understanding refers to knowledge of, and reflection upon, the **materials**, skills, **traditions**, **conventions**, **meanings**, and values that have constituted the varieties of this **form** over hundreds of years. *All* painting practices have involved these elements (whether they have been acknowledged and considered as such, or not) – though it became common in the early twentieth century for some **modern** artists and **critics** committed to a belief in intuitive **creativity** to claim that theoretical understanding actually impeded practice. Their 'anti-theory' stance, however, was itself based on this unacknowledged theoretical assumption.

If history refers to, say, **narrative** accounts of the past (though the term is often used in a way that confuses this object – the past – with various methods for its **analysis**), then theoretical knowledge means a recognition of, and reflection upon, the concepts and values that underpin such narratives. For instance, one of these is the presupposition that history is really the study of the acts of great individuals, or **agents** (and **art^ history** only really the study of great individual artists, as Ernst Gombrich claimed in *The Story of Art* (1950)). Theoretical reflection, including reflection upon one's own background and interests, may actually lead to a **revolution** in historical aims, concepts, and methods, to the point of rejecting such an earlier **organising** belief altogether.

If reality is posed as a simple set of pressures or experiences *outside* and *pre-existing* human understanding (as in the cliché when left-wing students are informed they will eventually feel the pressures of this 'real world' and seek to join the 9–5 workforce), then *theory* offers a sceptical account of this 'real world', insisting that the **dominant** and *dominating* **ideas** and values that help to constitute and **reproduce** it may be questioned and even rejected – as happens in revolutionary upheaval!

By far the *least* useful and **productive** sense to *theory* is that which capitalises the term, making it, apparently, into an entirely separate thing – Theory. When formulated in this **manner**, theoretical reflection runs the danger of becoming an **abstracted**, aloof, and imperious activity, disdaining any heuristic (trial and error) engagement with evidence and experiences that may affect its airless pronouncements. In the 1970s the historian E. P. Thompson called this kind of disabled and disabling Theory 'theoreticist' – i.e. **academic** meaning *redundant*. No scholars or students, in reality, can afford to be Theorists in this sense: for all philosophical and conceptual analyses depend upon contact with evidential **materials** and **discourse** drawn from **human**

activities in the real world – including the materials of artistic production and art history.

Further Reading

Eagleton, Terry *Literary Theory: An Introduction* (Blackwell: 1983).
[multiple authors] 'Art History and its Theories: A Range of Critical Perspectives', *Art Bulletin* March 1996: 6–25.
Nelson, Robert S. and Richard Shiff (eds) *Critical Terms for Art History* (University of Chicago Press: 2003).
Thompson, E. P. *The Poverty of Theory and Other Essays* (Monthly Review Press: 1978).

TITLE *ENTITLED, TITULAR, UNTITLED*

The names given to **artworks** are really part of the **explanatory** problem or task that faces the **art historian**, not part of its solution. This might not seem obvious at first – after all, the *title*, one might think, gives the **viewer** of a **painting** or **sculpture** some basic information regarding the purpose and **meaning** of the **artefact**. In one sense this may sometimes be true, though the **significance** of this truth depends radically upon the way in which the explanatory problem or task has been established. Titles, that is, are often awarded to artworks through **complex^ historical** circumstances and do not necessarily reflect the **intentions**, or are the invention of, their **producers**.

If the art historical task is the recovery of the *provenance* (that is, the history of ownership) of, say, an oil painting by Jan Vermeer, such as his *Woman Reading a Letter at an Open Window* that has been passed down several generations since its production, though a precise date for this work in the mid seventeenth century is not known – during that subsequent time it has been possessed by, let's say, its **original^ patron**, several subsequent private collectors, and then two **public^ museums** – then the *range* of titles it might have accrued is necessarily part of this history. Changing titles in this case may tell us about the assumptions certain owners themselves made about the **subject** and **meaning** of the painting. In the study of an artwork's existence, art historians may find that (a hypothetical) artefact actually had no original title, but instead was listed in several ownership documents under different names. Perhaps only when acquired by a museum for public **exhibition** was it decided to screw a plate to the lower side of its frame with the name given to it by a **curator**. Many years later the same work might be renamed, after curators and historians have

reconsidered the work's history. The role of such an artefact's title,- therefore, certainly constitutes an important part of its puzzle as a historical object. Similar problems and disputes occur over the **identification** of producers – and Vermeer's output, for instance, has been steadily reduced over the decades as **specialists** have decided that many works once attributed to him were probably painted by others.

What if, however, the art historian is concerned with the title of an artwork believed to indicate something of the basic intention of its producer? Many titles in this sense tell us what, for example, a painting may be said to be 'of' (e.g.: Claude Monet's *Impression, Sunrise* (1872); Ernst Ludwig Kirchner's *Girl with a Cat* (1910)), but not really much about how they might be **interpreted**, or why they might be regarded as important. And the question of the origin of titles recurs as a fundamental historical and philosophical issue in the twentieth century. The **surrealists**, for example, were fond of holding sessions in which they allowed *each other* to name their works – deliberately setting out to disrupt the kinds of **conventional** associations and explanations of titles art historians like to construct. In fact, the convention that artists should *deliberatively* **conceive** and apply a title to a work thought, self-consciously, as subjectively 'theirs' is probably no older than about the 1880s. By the 1950s some, such as the **abstract^ expressionists**, had decided that titles were confusing diversions, opting to call, or have their paintings identified simply as, 'Untitled' – though this label, like the use of numbers or colours as titles, also led to speculation on the metaphoric meanings these terms themselves might suggest (e.g.: Willem de Kooning's *Untitled* (1944); Jackson Pollock's *Number 9, 1949* (1949); Mark Rothko's *Red, White, and Brown* (1957)).

Further Reading

Corris, Michael 'What Do You Represent? When Titles Do Not Say and Pictures Do Not Show', *Art History* December 1998: 603–8.
Fer, Briony *On Abstract Art* (Yale University Press: 2000).
Kermode, Frank *Not Entitled: A Memoir* (Farrar, Straus, and Giroux: 1995).
Welchman, John *Invisible Colours: A Visual History of Titles* (Yale University Press: 1997).

TRADITION *TRADITIONAL, TRADITIONALIST*

Term with two related senses particularly relevant to **art^ history**. First, it is the more-or-less neutral name for an **artistic** or **critical^**

practice that has persisted, though also **developed**, over a long **period** of time (e.g.: 'the **renaissance** *tradition*'; 'the *tradition* of **figure^** **painting**'). Second, its **value**-laden sense implies, or states directly, a highly positive judgement about the **meaning** and worth of a certain practice (e.g.: 'British *tradition*'; 'a *traditional* Christmas').

The term *traditionalist* encapsulates this second resonance: it refers to a person who, at a certain **historical** moment, continues and recommends a form of behaviour, or practice, or belief firmly rooted in the past, and thereby confirms the meaning and value of that behaviour, practice, or belief. A British Royal Academician like Sir Alfred Munnings, for example, who in the 1930s and 1940s persisted in **producing** paintings of race horses painted in a **naturalistic^ style^** **commissioned** by their landed-gentry owners, could properly be described as a traditionalist – though those **critical** of his work, and of the high **society** in which he moved, called him instead, in a derogatory way, conservative and 'old-**fashioned**' (e.g.: Munnings, *Under Starter's Orders, Newmarket Start* (1947)). Munnings, as president of the Royal Academy in the 1940s, directed an **institution** that saw itself as inherently traditionalist, in a time when 'received traditions' in **art**, **culture**, morality, society, and politics of all kinds in Britain were under severe attack following the end of the Second World War and the 'landslide' election of a Labour government in 1945.

Yet by the 1970s **modern** art itself had become perceived as traditional – no longer really capable of offering what the critic Robert Hughes had called the 'shock of the new'. That **avant-garde** could become traditional meaning conservative and even 'old-fashioned' indicates that a radical shift in culture and critical **discourse** had occurred: modernism, somewhat oddly, had become a thing of the past. Though many artists and critics have continued to defend the principles of modernist painting associated with the line of development, or **progress**, drawn from Édouard Manet through to Jackson Pollock, they have also acknowledged that this tradition *also came to an end* – an event signalled by the arrival of **postmodernism** in the early 1980s.

Tradition, in the first sense outlined above, of a continuing and possibly developing/changing practice, actually has several features in common with the apparently contrasting – and **originally** horticultural – notion of *hybridity* associated with postmodernist **theory**: the mixing and inter-breeding of elements. This term had started to become applied to **contemporary** art in the 1980s, and in part referred to the fusing of different **media** that occurred in **installation** and **performance** works – a process that undermined traditional distinctions between, for example, painting, **photography**,

and **sculpture**. Artistic hybridity had a pre-history, however, that could be traced back at least to the art of the 1950s; for instance, to Robert Rauschenberg's 'combine' **artefacts**, such as *Bed* (1955), and perhaps even earlier to Kurt Schwitters's *Merzbrau* 'collage-rooms' (1923–43). However, starkly to pose a notion of tradition *against* hybridity in this way would be historically and theoretically misleading: for in the very long, **epochal**, development of a practice such as painting (over many hundreds and even thousands of years), its **techniques**, **forms**, **materials**, and meanings have continually changed – at times dramatically – in ways that would be entirely unrecognisable to its earliest **producers**.

Further Reading

Atkinson, Terry 'History Painting and Recapitulation', in David Green (ed.) *History Painting Reassessed* (Manchester University Press: 2000).

Contreras, Belisario R. *Tradition and Innovation in New Deal Art* (Bucknell University Press: 1983).

Harris, Jonathan 'Hybridity versus Tradition: Contemporary Art and Cultural Politics', in Harris (ed.) *Critical Perspectives on Contemporary Art: Hybridity, Hegemony, Historicism* (Liverpool University Press/Tate Liverpool: 2003).

Horkheimer, M. 'Traditional and Critical Theory', in *Critical Theory: Selected Essays* (Herder and Herder: 1972).

VALUE/EVALUATIVE *VALUED, VALUES*

In its **technical** sense, *value* is an **art^ historical** term used in the **analysis** of colour and tone, usually in relation to two-dimensional **media**: it refers to gradations in levels of chromatic intensity (relative lightness or darkness). The definition is complicated partly because colour can mean both light – as in the pure colours in the light spectrum – and pigmentation **materials** or colouring **agents** used in particular graphic media. No strict separation between colour and tone is probably possible when considering their co-existence in actual **artefacts**. For instance, for hundreds of years **painters** have added what are called 'black' and 'white' pigments to other paint colours to alter tone and chromatic intensity, partly in recognition that tonal value contrast helps **produce** a convincing **illusion** of three-dimensional depth and partly to unify different colour intensities within their **compositions** as a whole (e.g.: Leonardo da Vinci, oil on wood, *Virgin and Child with Saint Anne* (1510)). Inverted

commas around black and white indicate that these are 'colours' only in the sense of pigment (for example, there are several different tones of black and white oil paint). Da Vinci, in some ways an incautious experimenter in techniques and materials, saw that adding them to other pigments reduced their unequal levels of chromatic intensity and thereby **created** a more homogeneous sense of **pictorial** space. Compare the work cited above with, for example, Giotto's *The Mourning of Christ* panel from his series in the Arena Chapel in Padua (1306), where the colours of the saints' robes clearly retain their varying chromatic levels. These **figures**, as a result, seem not to occupy the same pictorial space or convincingly to inhabit the same three-dimensional world as da Vinci's.

Beyond this important sense, however, *value* also refers to the meaning and **significance** attributed to an artwork or, indeed, to anything else. This active process of evaluation indicates that the value 'of', or 'belonging to', such items (e.g.: da Vinci's painting) is not, and can never be, intrinsic: *value is always awarded by someone and often through a process involving the power of* **institutions** *of one kind or another*. However, artworks – usually of a **traditional** and recognisably **conventional** kind – that have attained **canonical** status often *appear* to contain and exude their own value as if it were an intrinsic property. Da Vinci's 1503 painting of the *Mona Lisa*, for example, protected in the Louvre **museum** in Paris behind a bullet-proof glass screen and kept at a distance of several metres from its **viewers,** radiates an aura of greatness, **genius**, and ultimate artistic value that appears self-evident, undeniable, and irrevocable. This example testifies to the **influence** such institutions have in affecting and orchestrating the value attributed to certain artefacts. In securing this value over long **periods** of time, institutions such as museums and key art history **texts** play a key role in **social** and **cultural^ reproduction**.

However, art historians and social institutions also sometimes bring about *new* evaluations, enshrining and elevating objects with previously insecure or directly-denied **high art** status. Tate Modern's 1966 purchase of Carl Andre's 'Bricks' (*Equivalent VIII*), though not exhibited until 1974, is an instance of this production of value. Value, it should be noted, is usually a *relative* **concept** within analysis and its technical art historical meaning outlined above indicates that a scale or measure of values exists, and that any one item usually finds its place within this scale. Since the **development** of the **social history of art**, especially since the 1960s, value and significance referring to **aesthetic** and **human^ qualities** or worth have been **subject** to sustained **critique,** for instance from **marxist** and **feminist^ perspectives**.

329

Further Reading

Hall, Marcia *Colour and Meaning: Practice and Theory in Renaissance Painting* (Cambridge University Press: 1992).

Hecter, M., L. Nedel and R. Michael *The Origin of Values* (de Gruyter: 1993).

Kemp, Martin *The Science of Art: Optical Themes in Western Art from Brunelleschi to Seurat* (Yale University Press: 1991).

Pollock, Griselda *Avant-Garde Gambits: Gender and the Colour of Art History* (Thames and Hudson: 1992).

VIEW/VIEWER *REVIEW, VIEWING*

One of a group of **concepts** – including **look**, scene, **gaze**, and **reader** – concerned with the role of **visual** attention in **art**^ **historical** study. On the one hand, there is the person (sometimes known as the **subject**) doing the looking – the *viewer*. On the other hand, there is the object of this action – that which is seen, the *view*, or scene. But, as the complicated composite term 'visual **analysis**' suggests, there are *two* sides or elements within the process of viewing as part of systematic study. While the attention is visual in the sense that careful looking at **artworks** *is* a key part of art historical work, the analysis is only *partly* visual because the process also involves **linguistic** description, conceptualisation, and written elaboration.

View, like visual, also contains a range of related senses. When the term, for instance, refers to a scene depicted in a specific **pictorial**^ **representation** (e.g.: J. M. W. Turner's *Slavers Throwing Overboard the Dead and Dying – Typhoon Coming On* (1840)), rather than simply to all the worldly objects that fall into a person's actual line of sight at a particular moment, it is quite readily accepted that this view is partial and a construction or **composition** in itself – understood, in the stronger versions, as the **imaginative**^ **creation** of its **producer**. The term viewer, in contrast, *tends* to suggest a much more neutral and open-ended actor – perhaps because it includes the implication that the organ of sight is essentially a biological mechanism and therefore in some fundamental sense unprejudiced. In the mid twentieth century **modernist**^ **critics** (for example, Clement Greenberg) sometimes talked about their 'eye' for **paintings** as if the act of viewing was dis**embodied** and entirely free of **ideological** or any other partial interest. This was paradoxical and ironic, given that the **value** of Greenberg's 'eye', he claimed, lay in its ability to *discriminate* the highest **quality** in art ('discrimination' now being a term

almost always used in a negative way, to suggest someone is blind to the full picture: 'pre-judiced', or guilty of pre-judgement).

The **psychoanalytically** informed notion of the gaze used by **feminist** art historians since the 1970s fundamentally undermined the notion of viewing as essentially neutral. Instead, all acts and processes of looking were radically redefined as **gendered, classed,** and **sexually**-interested, and thereby profoundly related to questions of power and **domination** in **society.** Women artists as much as art historians used what might be called this 'political **theory** of viewing' to produce challenging, even subversive, works (e.g.: photomontage by Martha Rosler, *Bringing the War Home: House Beautiful* (1969–71); **photographic^ portraits** by Cindy Sherman in the **style** of **old master** paintings, e.g.: Judith and Holofernes, in *No. 228* (1990)). The term *viewer* – in a different but related way – was also rethought within **poststructuralist** accounts of **textuality**, and is now used almost to **mean** the same as *reader.* Though this has led to important gains, it has prompted the question: how is vision (or visuality) *not* like reading texts (or linguistic meaning)? View, then, has been *reviewed*: viewers are understood now to be always specific people, with a range of attributes and interests which affect the kinds of viewing or **interpretations** they will make of the things they look at. This redefined, **historically** specific viewer is much more believable than the theoretical 'he' or 'she' usually offered as the subject or object of the gaze which – along with much in psychoanalytic **discourse** – remains a kind of 'frozen' **ideal**-type, often presented as entirely dominated by non-historical psychic drives and processes.

Further Reading

Bataille, George *Visions of Excess: Selected Writings, 1927–1939* (Shocken Books: 1969).

Buck-Morss, Susan *Dialectics of Seeing: Walter Benjamin and the Arcades Project* (MIT Press: 1989).

Clark, T. J. 'The View from Notre-Dame', in Clark *The Painting of Modern Life: Paris in the Art of Manet and his Followers* (Princeton University Press: 1984).

Krauss, Rosalind *The Optical Unconscious* (MIT Press: 1994).

VISUAL/VISIBLE/VISION *INVISIBILITY, INVISIBLE, VISIBILITY, VISUALITY*

Three of the most **complex** and far-reaching **concepts^** developed within a host of **specialist** fields which have reconstituted **theoretical**

study in **art**^ **history** since the 1970s. These terms each have a number of related senses. The phrase 'the visual', for instance, suggests both a visible, **identifiable** *thing* (a noun) and a **quality** or *effect*. In one sense 'the visual' implies everything that can be seen by the eye, and is close in **meaning** to the 'phenomenal world', except that this latter entity also includes *all* other kinds of sense-data that **human** beings are able to register – for example, through hearing, **taste**, touch, and smell. 'The visual' in this quite **abstract** sense, then, both apparently promises to be highly inclusive and yet leaves out much of human experience *normally related to, or co-experienced with, the visual*. In contrast, visual used adjectively – in reference to the quality or effect of something – is more modest and intimately linked to **traditional** art historical methods of **analysis**. The established term **style**, for instance, typically refers to the visual appearance or character of **artefacts** such as **paintings**, **sculptures**, and buildings. 'Visual analysis' defined as the activity, for instance, of describing and comparing styles in **renaissance** painting or sculpture (or, for that matter, ancient coins and cutlery, or **modern** car **design**), with the **intent** finally to offer **classifications** – *taxonomies* or *typologies* of **form** – is a standard procedure.

The term 'visuality' operates both as a conceptual tool and offers itself as a name – another abstract noun – for the general **organisation** of visible things/the visible appearance of things in the world. In this sense it has links both to 'commodity' and 'spectacle' – two particularly philosophically-rich notions in **marxist** thought. Visuality has had a very complicated intellectual **history** bound up with developments in a range of disciplines including **psychoanalysis**, **semiology**, and some areas within philosophy, particularly phenomenology and the writings of Maurice Merleau-Ponty. His mid-twentieth-century essays on Paul Cézanne's paintings, for instance, focus on the idea of a labile (fluctuating) 'visible field': on the biological-**bodily** processes of seeing involved in both direct acts and habits in **looking** at the world, and on Cézanne's way of conveying this activity within his many **pictures** – often called **creative** visions (e.g.: *Mont Sainte-Victoire* (1888–89)) – depicting the mountain seen from **views** in southern France which the artist compulsively **represented** in drawings and paintings.

In a different direction, scholars and political activists have drawn attention to what they call the '**society** of the spectacle' in advanced **capitalism**, and analysed its visuality. This includes both the prevalence of visual **mass**^ **media** such as **TV**, video, DVD, and computer **technologies** (**producing**^ **real** and 'hyper-real', or simulated,

representations of a now **globalised^ culture**) and the related, progressive reduction of **identities** and meanings to visual and **surface** forms (e.g.: pornography, 'racialised sports', and spectacular news events, such as the hi-jacked planes flying into the New York World Trade Center towers in 2001, continually re-shown). In one sense this kind of visuality bears some relation to the biblical-apocalyptic visions painted by nineteenth-century **romantics** such as John Martin, whose visual **metaphors** of 'overload' and 'excess', **symbolised** in the artist's depictions of gigantic scale, evoke an out-of-control **natural** and social world teetering on the brink of oblivion (e.g.: *Pandemonium* (1827); *The Deluge* (1834)).

Further Reading

Bryson, Norman *Vision and Painting* (Yale University Press: 1983).
Elkins, James *The Domain of Images* (Cornell University Press: 1999).
Fry, Roger *Vision and Design* (1920) (Oxford University Press: 1981).
Nelson, Robert S. (ed.) *Visuality Before and Beyond the Renaissance* (Cambridge University Press: 2000).

VISUAL CULTURE *VISUAL CULTURAL*

Though one of the first scholars to coin this term (the **art^ historian**, Michael Baxandall) meant by the phrase the interconnected systems of knowledge and **pictorial^ representation^ developed** in Florentine **renaissance^ society** – powerfully shaped as these were by new **visual** skills and **techniques** involving measurement and ordering **conventions** used in both art and commerce – the term *visual culture* has mostly been applied to **modern** and **contemporary^ western** societies since the nineteenth century. In its proposed radical inclusiveness of objects of study (extending far beyond the range of items usually included within the **traditional** categories of art and **design**), the **concept** of visual culture implies a fundamentally revised account of the **ideas** and methods needed to understand these societies and the place of **cultural^ production** – and the activities and **identities** of their producers and **consumers** – within them.

In this sense, visual culture is as much the name for a new multi- and inter-disciplinary **analytic** synthesis as it is the name for the objects it would study. There are, perhaps, two versions of visual culture's ambitions: one modest and moderate, the other radical, seeking, in effect, to challenge other disciplines – such as art history –

and even to subsume them. In its modest **form**, visual culture brings together and studies kinds of **mass culture** that have had little or no place in traditional art history. These would include **film** and **television** – **media**, however, which have existed for many decades though undergone continual transformation in economic, technological, and **institutional** terms. Visual culture understood as a new disciplinary **specialism** concerned with *these* objects of study – along with **advertising, fashion**, graphic and product **design** – grew out of film studies and **cultural studies**, fields that **emerged** in the 1960s. In this modest guise, visual culture has begun to occupy a ground that art history – for a variety of reasons – has never really sought or been able to include in its own concerns.

In the radical version, however, visual culture wishes to turn *against* art history, questioning and rejecting its founding principles and **values**. In this interrogation, electronic mass media become Trojan horses for examining key assumptions/concepts that still **dominate** conventional art historical **discourse**. These include, for example, notions of individual **creativity**, manual skills, uniquely **original^** **artefacts, styles** and traditions understood as coherent formal and thematic entities, along with the belief that **western^** **canonical** art remains the final measure and guarantee of **taste** and **aesthetic^** **quality**. Beyond film, television, and the recently-developed digital **imaging** forms, technologies, and systems, this ambitious visual culture seeks to *redefine* the whole realm of 'the visual' in contemporary **global^-capitalist** societies, along with the character and **meaning** of this culture's spectacular visuality: its characteristic appearances, existential, experiential, and **ideological** impact on people and societies (e.g.: gigantic billboards, hypertext, surveillance, reality TV, 'embedded' war reporters). Sceptics, however, from numerous intellectual and political **perspectives** (including many in art history) wonder what this overtly sociological analysis will leave out. What space in visual culture is there, if any, for notions of aesthetic value, artists' **intentions, human^** **agency**, and artistic creativity?

Further Reading

Jencks, Chris (ed.) *Visual Culture* (Routledge: 1995).
Mirzoeff, Nicholas (ed.) *The Visual Culture Reader* (Routledge: 1998).
Robertson, G. (ed.) *The Block Reader in Visual Culture* (Routledge: 1996).
Walker, John A. and Sarah Chapin *Visual Culture: An Introduction* (Manchester University Press: 1997).

VISUAL PLEASURE

Term invented in the later 1970s with a variety of senses – though its core **theoretical^ significance** lies in the consequences **psycho-analytic^ concepts** appeared to **produce** for the study of the use of **visual^ representations**. If it was agreed, for instance, that **looking** at representations (not just **pictures** or **sculptures**, but at real people seen as **images** in the day-to-day world) was a process that encouraged **viewers** to **identify** with or against others in a variety of ways – e.g.: **sexually, racially,** or in terms of age or **nationality** – then the question arose as to how these patterns or **structures** of identification and 'dis-identification' (producing pleasure or repulsion) were located in what became known as the **gaze** of both men and women. The psychoanalyst and friend of the **surrealists** Jacques Lacan had formulated an intellectually difficult account of the gaze understood as a **gendered**, sexual psycho-biological property and drive, in writings that, in the 1980s, powerfully **influenced** the **development** of **semiological** and **poststructuralist** currents in the **new art^ history**.

From another **perspective**, however, *visual pleasure* was simply a fancy new name for the enjoyment that scholars, **critics**, and art appreciators had *always* got from looking. **Traditional** phrases such as 'art appreciation' and 'art lover' indicate that matters of pleasure and satisfaction had never actually been absent from the activities of those who went to **museums** and galleries, who bought art, and who chose to study it or become its teachers and **historians**. The invention of the **concept** of visual pleasure, however, was **designed** to **subject** these historical and **contemporary** experiences to new theoretical scrutiny – psychoanalytically, **socially**, and politically – by asking how the *individual* and subjective pleasures got from looking at art, and everything else, might be related importantly to background *collective* factors, such as **class, ethnicity,** and regional **identity**, as well as to matters of gender and sexual orientation.

A passage in an 1953 essay by Ernst Gombrich turns to the visual pleasures and **tastes** of the old and young, people from different **cultures**, and from upper and lower-class backgrounds, suggesting that this, then unnamed, 'experiential **reality**' was beginning to come under scrutiny. Gombrich, talking initially about food, remarks: 'The child is proverbially fond of sweets and toffees, and so is the **primitive**, with his Turkish delight and an amount of fat meat that turns a European stomach'. Moving on to art, he claims that an 'odious', 'atrocious', and 'disgusting' late-nineteenth-century **neoclassical**

painting of the *Three Graces* by the French **artist** Bonnencontre could be improved if it was viewed behind a sheet of wobbly glass – **creating** a kind of **cubist** effect. This **technique** could be used, he says jokingly, to improve a **picture** of 'The Monarch of the Glen' or 'Innocence in Danger', **meaning** that 'you need not throw it away or give it to the charwoman'. Gombrich, perhaps unconsciously, reveals here how senses of pleasure, **consumption**, and satisfaction are intimately bound up with many different aspects of social identity. Written over fifty years ago, his essay also indicates how what were once acceptable judgemental statements about others may appear shockingly rude at a later moment. This is partly ironic given that Gombrich may have had in his sights at the time the stuffy puritanism of some contemporary **modernist** critics (such as Clement Greenberg) who had wished to separate off a supposedly-pure **aesthetic^ value** from all other kinds of interest – including, for example, the pleasures of immersion in pictorial **narrative** and emotional identification.

Further Reading

Barthes, Roland *The Pleasure of the Text* (Hill and Wang: 1975).

Gombrich, Ernst 'Psycho-Analysis and the History of Art', in Gombrich *Meditations on a Hobby Horse and Other Essays on the Theory of Art* (Phaidon: 1978).

Pajaczkowska, Claire 'Structure and Pleasure', in G. Robertson (ed.) *The Block Reader in Visual Culture* (Routledge: 1996).

[Unknown] *Formations of Pleasure* (Routledge and Kegan Paul: 1983).

WESTERN *WEST*

Though in one sense *western* has a very clear **meaning** – that is, the world seen from a US and Western European **perspective** – from another position it is as confusing as its supposed opposite: the east, or eastern. Both terms refer to **global** 'points of view' but these, geographically and **culturally**, can never be stable or final, as the sense of what 'can be seen' inevitably shifts as one moves in either a westerly or easterly direction. The effect of this **movement** is that what was, apparently literally, *west* actually becomes *east* and vice versa. Given this modulation, it makes much more sense to see western and eastern as names for trends or patterns of **development**, rather than static entities.

This suggestion is by no means **intended** to undermine the **concept's^ critical** meaning. *Western* refers to a group of closely-

connected **societies** extremely powerful in the world as a whole in economic, political, and military terms which achieved a **historically** unprecedented global **dominance** by the nineteenth century, brought about by **colonial^ imperialism** and the exploitation of territories around the world, including the continents of Africa, Asia, and Australasia. Yet central within that history was the **emergence** of the US as the dominant western power itself from *within* the earlier colonial control operated by Britain and France in the eighteenth century. So *western* has a history of change and struggle located within it – and competition *between* the US and the western European countries has characterised this history since 1776 as much as the decisive moments of collaboration (e.g.: against nazi Germany and Japan during the Second World War). Western Europe, too, has had a fractured history: global imperialism during the nineteenth century and first half of the twentieth was much more a matter of different European countries (principally Britain, Germany, and France) struggling for supremacy – for instance, in two world wars – than a matter of them agreeing to impose a singular western European dominion across the world. The rise of central European countries in alliance with the USSR after 1917 also brought fracturing stresses to bear in the west, as Germany divided into two in 1945, and many other countries (such as Italy and France) developed communist parties – aggressively anti-American in some respects – with very strong **popular** support.

The idea (and **ideal**) of western art is similarly flawed: recent historical **analysis** shows that the supposed **origins** of this **tradition** – in Greek **sculpture**, for instance – had antecedence in Egyptian (African) **visual^ representation**, and that what is called the 'Italian **renaissance**' drew extensively on sources from the region now **identified** as the Middle East. This latter **art^ historical** shibboleth arguably owes its existence more to forces in nineteenth-century cultural **nationalism**, particularly the writings of Jacob Burckhardt, than to any self-consciously 'western feeling' or **zeitgeist** present in the fourteenth, fifteenth, and sixteenth centuries – a time, indeed, when the **modern**-day nations in southern Europe did not even exist.

Since the attacks on the New York World Trade Center towers in 2001 and US/British declarations of a 'War on Terror' against Islamic fundamentalist groups, discussion of western and eastern cultures has become overtly politicised. Though this *may* lead to important scholarly gains in art history, as hopefully more and better research and rethinking follows in the wake of the rhetoric, the violence, suffering, and fear generated on all sides has thrown the world – and the

global-system undoubtedly dominated by western economic and political interests – into highly dangerous instability.

Further Reading

Bernal, Matthew *Black Athena: The Afro-asiatic Roots of Classical Civilization* (Rutgers University Press: 1991).

Mohanty, C. T. 'Under Western Eyes: Feminist Scholarship and Colonial Discourse', *Boundary 2* Spring/Fall 1984: 71–92.

Rabasa, J. *Inventing America: Spanish Historiography and the Formation of Eurocentrism* (University of Oklahoma Press: 1993).

Spengler, O. *The Decline of the West* (Allen and Unwin: 1926).

ZEITGEIST ('SPIRIT OF THE AGE')

The idea that a particular time – **historical** moment, **period**, or **epoch** – has a specific, *singular* feeling or **quality** to it: for example, that the 1960s were a time of optimism and experimentation, or the years before the First and Second World Wars marked by a sense of impending disaster. Such a *zeitgeist* would be registered in the **cultural products** of those **societies**, especially those made by its **artists** and writers. The notion went through a variety of reformulations and guises during the twentieth century, following its use by scholars (and artists) with different and sometimes opposed interests. In its most general sense, zeitgeist meant an 'informing ethos or principle' thought to **influence**, or, more strongly, actually shape and **structure** a particular era. The **renaissance**, for instance, has been described as possessing the zeitgeist of **progress** – belief, that is, in the improvement, if not perfectability, of knowledge through scientific experiment and the **naturalistic** (truthful) depiction of the world through, for example, **perspectival** drawing and modelling **techniques** such as chiaroscuro (e.g.: note the sophisticated depiction of town and **landscape** set out in the background of Antonio Pollaiuolo's painting *The Martyrdom of St. Sebastian* (1475)).

If such a claim is recognised now as implausibly 'totalising' – that is, collapsing together many heterogeneous events, products, people, and places, and forging from them an unconvincing singular and unifying **meaning** – it is as well to remember that some of the early-to mid-twentieth-century **marxist^** **critics** of this kind of bald assertion, which they thought of as essentially 'bourgeois' and **idealistic**, sometimes produced, in its place, some almost equally crude

alternatives. The Hungarian literary scholar Georg Lukács, for instance, offered a sociological account of **styles** in art and literature (such as **realism** and **expressionism**) based – if not upon a *whole* society's claimed singularity – then upon monolithic social **classes**, which Lukacs **represented** as causes and carriers of *competing* zeitgeists or **ideological** 'worldviews'. Welsh cultural **theorist** Raymond Williams attempted to go beyond this crude socio-cultural **analysis** with his **subtler** concept of a 'structure of feeling'. These two terms suggest both the firmness and **reality** (structure) of a particular age experienced by its people, and yet its existence in im**material**^ **images** and mutating senses (feelings). Nevertheless, Williams's term also remains open to the charge that it too may falsely homogenise, select, and emphasise according to one retrospective **view**.

All these adaptations and refinements of the basic **concept** of *zeitgeist* share the assumption – sometimes a worked-out **theory** – that it is possible to **identify** 'causative relations' between some phenomena seen as primary (causal) and those seen as secondary (expressive, or effect). In **art history**, for example, the idea of style has persisted, understood as an expressive phenomena, though it has been attributed many alternative and sometimes even **oppositional** primary causes (for example, society as a whole, a particular social class, a class-fraction, or an individual's **creative** will). The 1980s **discourse** of **postmodernism** proliferated an immense number of what might be called 'mini-zeitgeists', as well as a number of overarching ones, such as 'the end of the belief in technological progress', or the 'end of the belief in socialism'. However, with the end of postmodernism itself as a convincing theoretical and critical **narrative** by the mid 1990s, **contemporary** culture seemed to lose even this rather dismal **organising** sense of 'the present constituting an ending' – a **development** possibly without **modern** historical parallel, and whose causes and long-term effects remain, at least in part, unknown.

Further Reading

Habermas, J. *Legitimation Crisis* (Heinemann: 1976).

Lukács, Georg 'The Ideology of Modernism', (1963), in Terry Eagleton and Drew Milne (eds) *Marxist Literary Theory* (Blackwells: 1996).

Rotenstreich, Nathan *Time and Meaning in History* (Kluwer Academic Publishers: 2001).

Williams, Raymond 'Structures of Feeling', in Williams *Marxism and Literature* (Oxford University Press: 1977).

INDEX